THE ART OF CARTOGRAPHICS

Published in 2017 by Goodman
An imprint of the Carlton Publishing Group
20 Mortimer Street
London W1T 3JW

10 9 8 7 6 5 4 3 2 1

© 2016 SendPoints Publishing Co., Ltd.

All rights reserved. This book is sold subject to the condition that it may not be reproduced, stored in a retrieval system or transmitted in any form or by any means, electronic, mechanical, photocopying, recording or otherwise without the publisher's prior consent.

A CIP catalogue record for this book is available from the British Library.

ISBN 978 0 23300 518 8

Printed in China

THE ART OF CARTOGRAPHICS

DESIGNING THE MODERN MAP

PREFACE

Jasmine Desclaux-Salachas[1]

I am told there are people who do not care for maps, and find it hard to believe.

... And the map itself with its infinite, eloquent suggestion, made up the whole of my materials. It is perhaps not often that a map figures so largely in a tale; yet it is always important. The author must know his countryside, whether real or imaginary, like his hand; the distances, the points of the compass, the place of the sun's rising, the behaviour of the moon, should all be beyond cavil.

Robert Louis Stevenson, spring 1893
My first book, *Treasure Island* (Tusitala Edition, vol. II, page XXV)

A gorgeous culmination of Stevenson's viewpoint from long ago, *CARTOGRAPHICS: Designing the Modern Map* ushers in a new and advanced understanding of mapping which links diverse disciplines through the use of observation, data, technological innovation, collage and illustration.

Mapping means using many techniques to express what must be said, constructing a visionary and universal language. To achieve this aim, cartographers must keep readers in mind all the way when producing maps, deciding what information needs to be included and what should be discarded in order to create a universal language that makes sense to readers at first sight.

Maps are travel companions, keeping us linked to space as we stroll through the world out of necessity or desire. They measure, trace and show our surroundings for us, helping us to understand the societies we encounter and the world in which we live – they function as a golden thread leading us through the maze of life. Anyone curious about our world can, through maps, find out detailed information and its origin, from local to global, or can even listen to dreams.

Inevitably, mapping is a complicated process. An accurate map always requires tons of work and effort. It means data collection and documentation of its sources, in order to produce a set of information, which is then graphically drawn, allowing spontaneous interpretation by readers. From this perspective, a map is a communication tool. An honest work must begin with a serious survey, which should investigate the situation of the target territory, like the measurement of the field and analysis of its objects on a 1:1 scale which characterizes much mapping.

"Civil mapping" is produced by first completing the so-called "base map", implemented to outline a series of topographical maps generated from those measurements. This then enables an in-depth reading of the territories and their intermingling issues and offers true information to each citizen, whoever they are and wherever they are, within a defined perimeter.

As a state-of-the-art scientific tool helping us to make decisions, maps can be found everywhere in our daily lives, representing the world in its smallest details, in any form and at any scale.

Today, though our digital tools create the illusion that a map can be produced in a few clicks, or is merely a quick illustration, designed on-the-go, in fact maps can be highly complex, opinionated, political or personal.

They are often handled by the traveller without any real awareness of the infinite care involved in their design and production: research, data acquisition or collection, methods to structure that data and the rigorous procedures involved in reproducing them.

Cartographers have worked unsparingly for generations at the forefront of technical progress enriched by a variety of related fields. They collaborate with geographers, historians, researchers and scientists from a wide range of disciplines in order to help them better express their views. They also work with technicians, who supply them with tools and reproduce their work, whatever the media of distribution.

The *Cafés-cartographiques* association, founded in France in 1999, welcomes the public into this universe usually known only to professionals. It is invaluable to provide opportunities for people simply interested in sharing knowledge and creativity to gather together in an informal setting focusing on mapping. Café gatherings offer occasions for all the curious and amateurs to meet students and professionals, and allow them to focus on little-known works of qualified authors.

We may consider that cartography remains a subjective art, a historical medium for ideological domination, propaganda and conquest, but not so in its civilian expression. A map can be much more. It is not merely an image, but a processing of multi-disciplinary data synthesized for a wide audience for the common interest. When information is designed with rigour and honesty, we can be rewarded with a beautiful outcome, intelligible to the public at large.

Maps are fantastic tools, enabling us to understand our world. Maps are able to bring together citizenships, curiosities, sensibilities and creativities. The following pages are a special invitation to enjoy this vision.

1 Jasmine Desclaux-Salachas: cartographer, cartography teacher, doctoral student and founder and director general of *Les Cafés-cartographiques*, founded in 1999.

CONTENTS

008–189

PART 1

**MAPPING
THE PHYSICAL
ENVIRONMENT**

190–253

PART 2

MAPPING HUMAN ACTIVITY

PART 1

MAPPING THE PHYSICAL ENVIRONMENT

This section features maps that portray the physical layout of a geographic area at a particular point in time. It includes transport networks such as railway maps, as well as fictional maps.

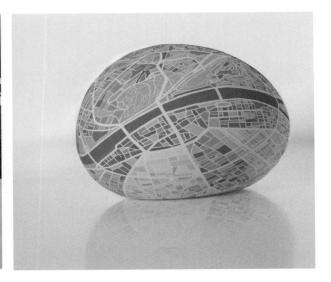
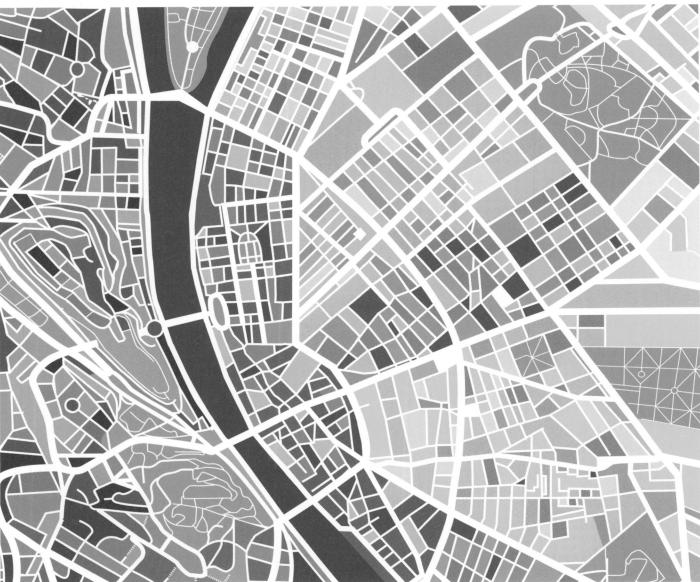

MAPPING THE PHYSICAL ENVIRONMENT

Egg Map

An egg map is a perfect gadget for people who want to avoid cumbersome printed maps or digital maps. It fits in your hand or your pocket and is lightweight, being filled with oxygen. Made of waterproof material, it can be used even in unfriendly weather conditions like rain, mud or snow. The map ball's most innovative characteristic, however, is its incredible flexibility, which means it has manual zooming: squeeze it to see a venue in magnified detail, and just keep zooming to find out more about sights, public transport or the nearest restaurant. Each area of the map is shown in a different colour, to aid navigation.

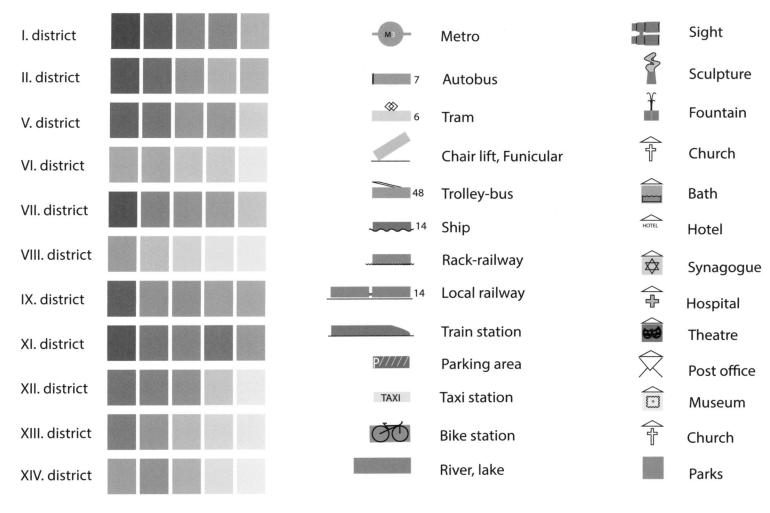
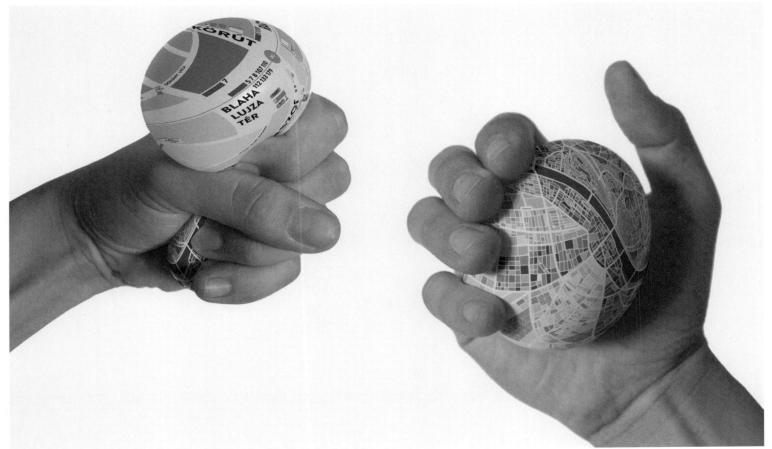

DESIGN Dénes Sátor COUNTRY/REGION Hungary

Unofficial Map

This map is based on a classic map of modern Colombia. It was redesigned to reflect the country's current character, and is full of the designer's reflections and thoughts about North and South America. The map purposely removes the focus from straightforward geographical circumstances, setting the capital, Bogota, as the central point from which all directions radiate. It dramatizes where conflicts took place and highlights the attributes and negative aspects of numerous small towns.

DESIGN Daniel Gaona AKA Mr Tacho COUNTRY/REGION Colombia

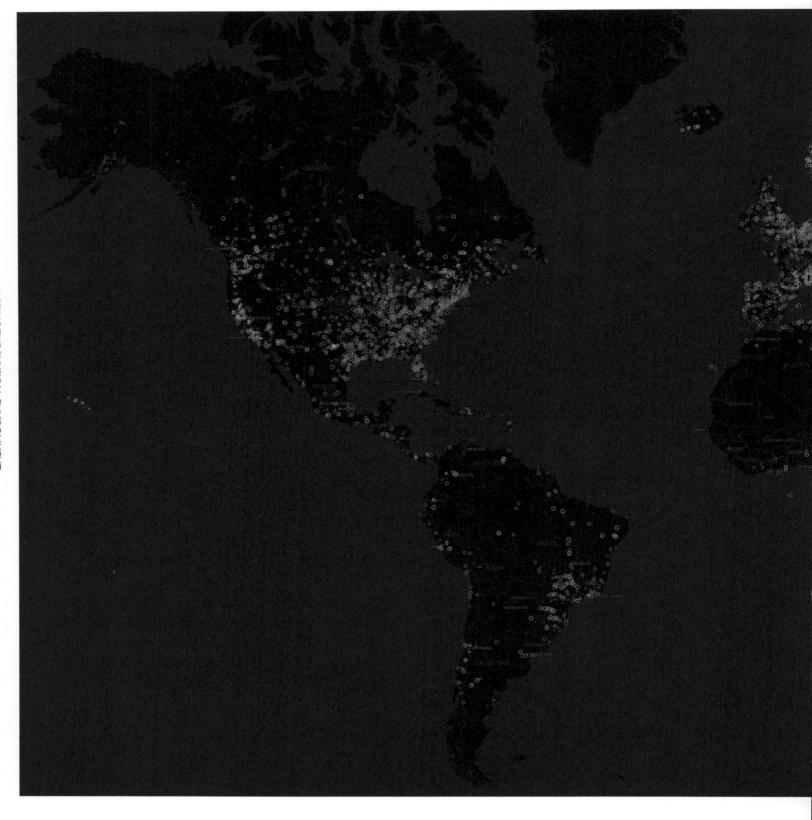

World Power Map

The map shows about 20,000 power plants of various types around the world, such as wind energy and solar power. The dataset was sourced from the site Enipedia and processed by Postgresql. The map is made using HTML5 and WebGL (Mapbox GL lib) and the basemap is OpenStreetMap rendered by CartoDB.

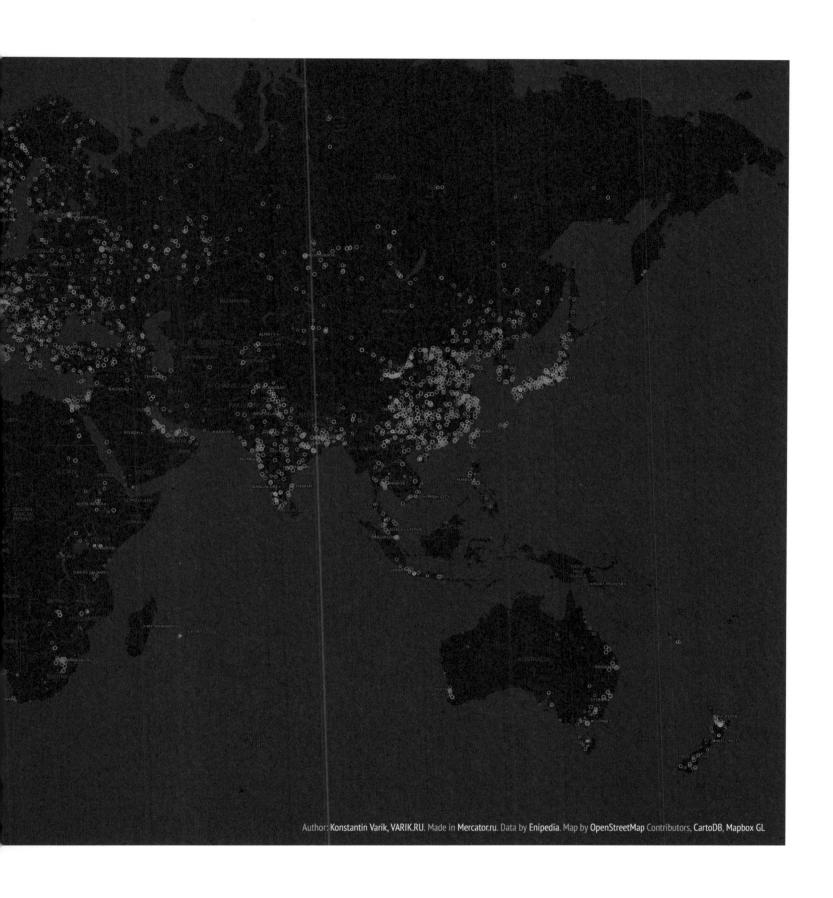

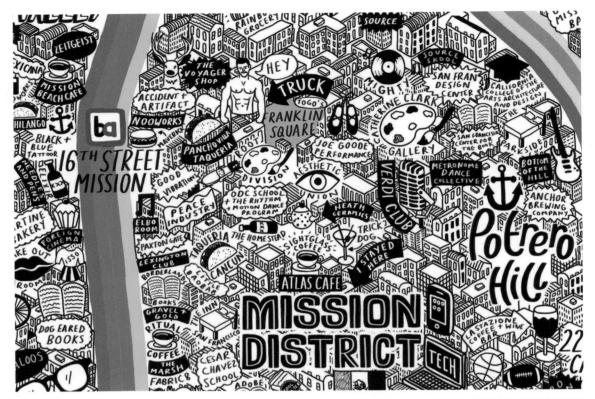

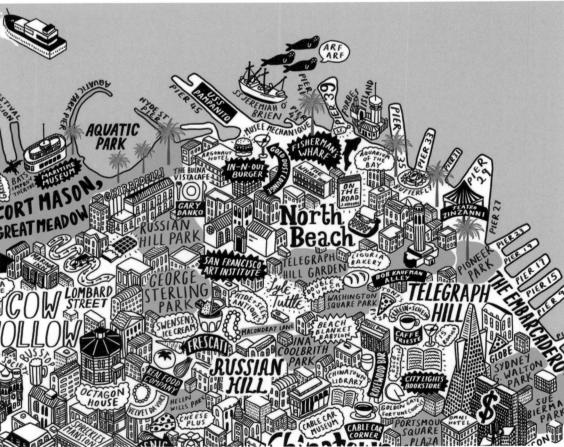

Hand-drawn Map of San Francisco

Commissioned by Evermade.com, the designer illustrated a complex map of San Francisco that showcased the city with its many facets. The map was created after months of research. Along with the main landmarks, it illustrates numerous local details, interesting facts, local subcultures, restaurants, shops and bars, etc. The map was created using a Wacom tablet and Photoshop, which meant that it was editable.

DESIGN Jenni Sparks COUNTRY/REGION UK

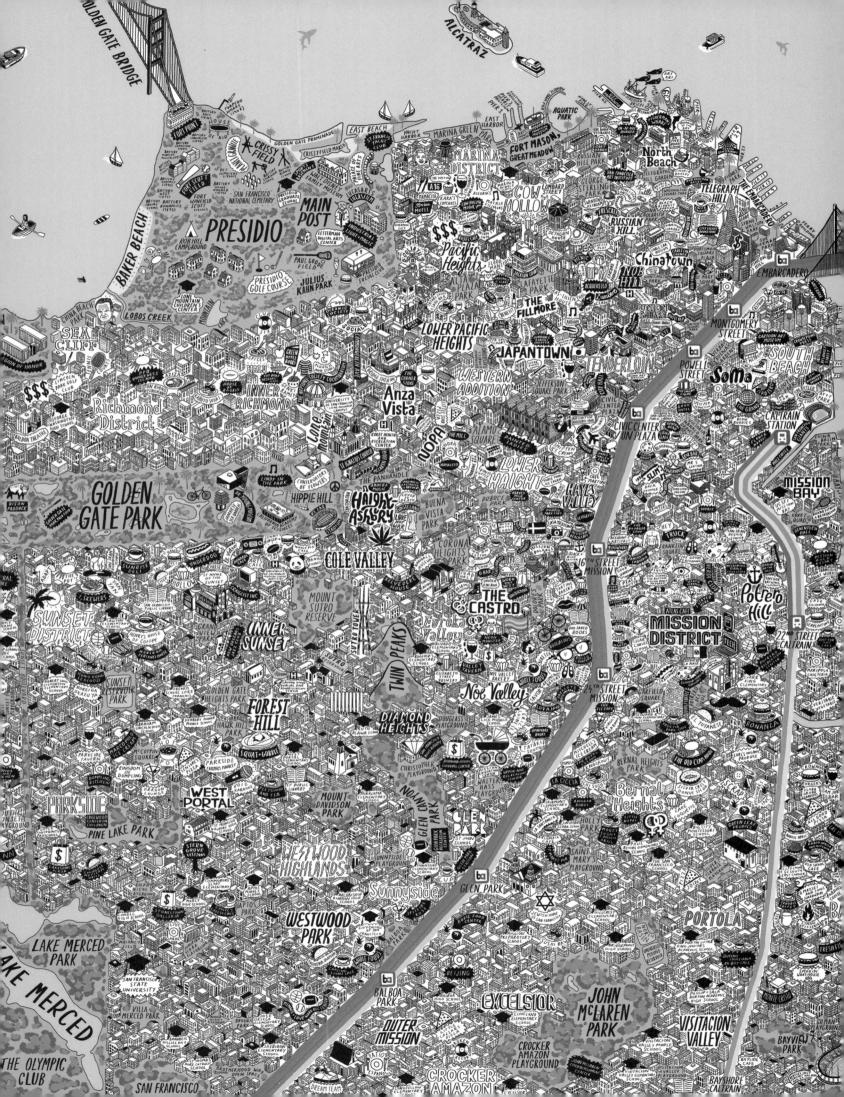

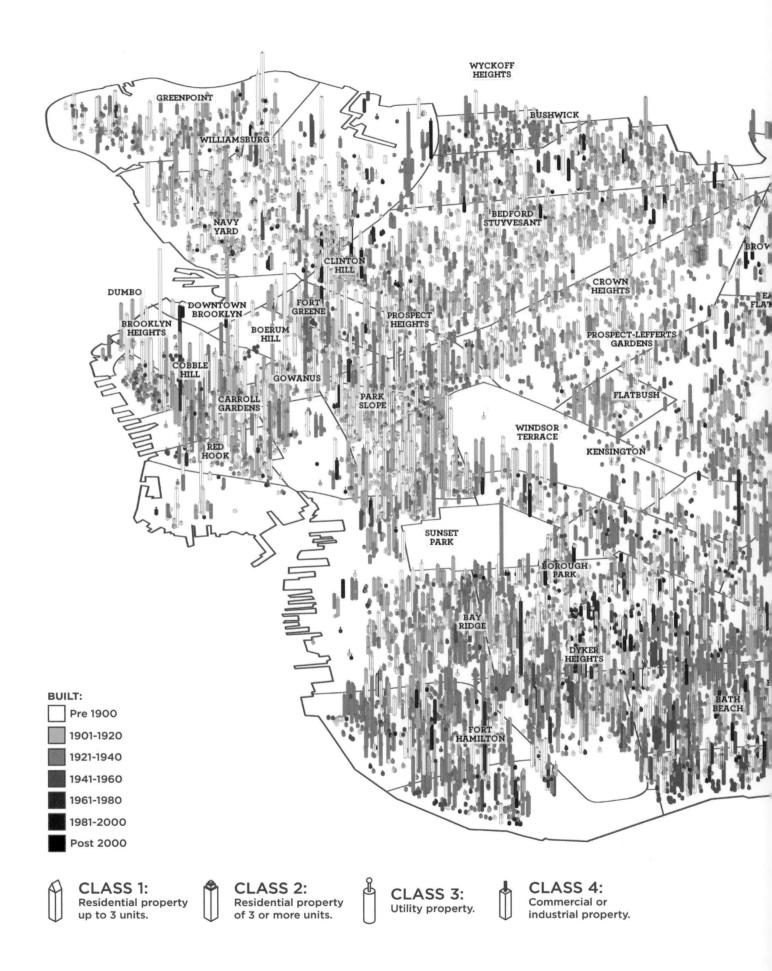

MAPPING THE PHYSICAL ENVIRONMENT

BUILT:
- Pre 1900
- 1901–1920
- 1921–1940
- 1941–1960
- 1961–1980
- 1981–2000
- Post 2000

CLASS 1: Residential property up to 3 units.

CLASS 2: Residential property of 3 or more units.

CLASS 3: Utility property.

CLASS 4: Commercial or industrial property.

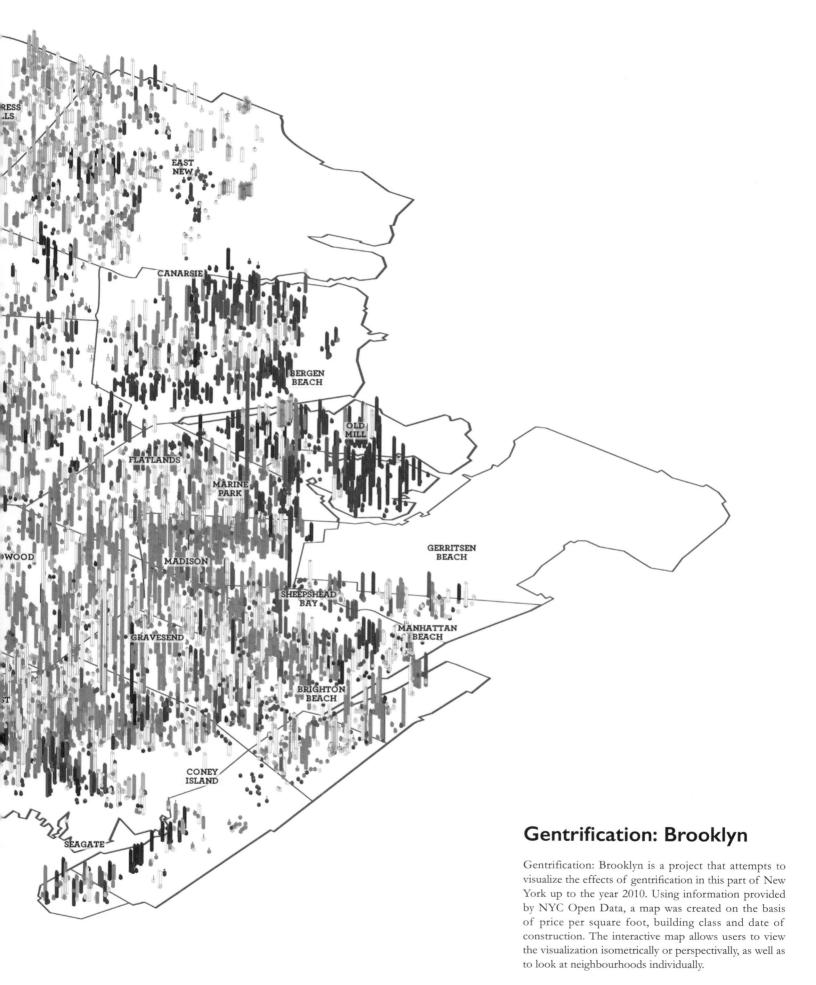

Gentrification: Brooklyn

Gentrification: Brooklyn is a project that attempts to visualize the effects of gentrification in this part of New York up to the year 2010. Using information provided by NYC Open Data, a map was created on the basis of price per square foot, building class and date of construction. The interactive map allows users to view the visualization isometrically or perspectivally, as well as to look at neighbourhoods individually.

DESIGN Paul Mathisen COUNTRY/REGION USA

Reproduced with the permission of the British Geological Survey.
© NERC. All rights reserved.

Bicentennial Geological Map of Britain

This map commemorates the two-hundredth anniversary of the publication of the first geological map of Britain, by William Smith (1769–1839). It depicts modern geological bedrock data in the style of Smith's early-nineteenth-century cartography.

DESIGN Craig Woodward COUNTRY/REGION UK

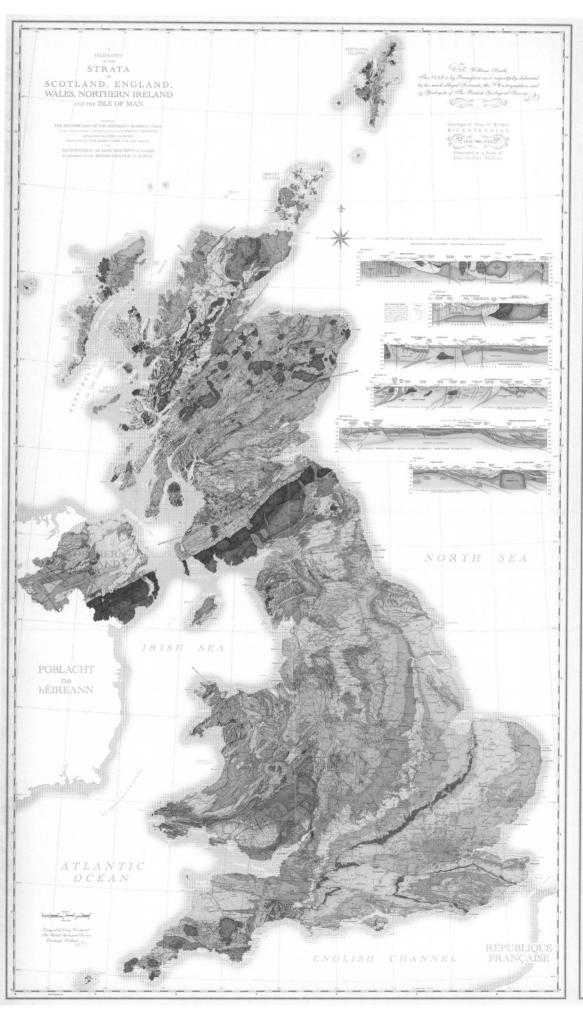

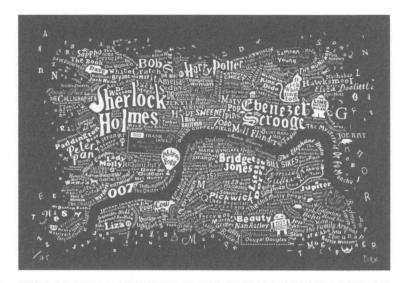
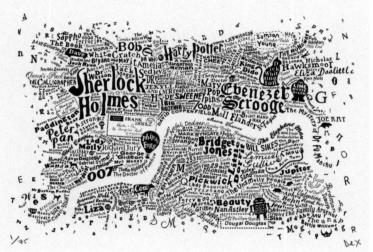
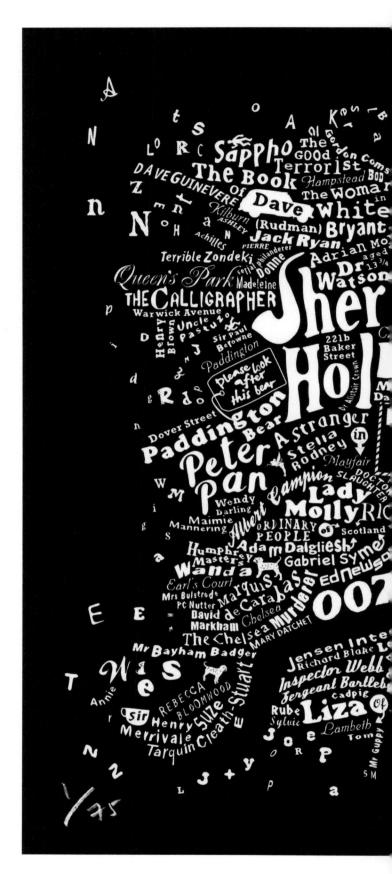

Literary London Map

This map of London features characters from the pages of novels based in the city, including the famous and infamous, the less well known and also those with an amazing moniker or brilliantly conceived nickname which are a credit to their creator. Each character has been plotted in the approximate corners of the city that they most liked to roam or called home (if sometimes at Her Majesty's pleasure). Combining hand-drawn typography and illustration, this piece mined more than 250 novels in the making.

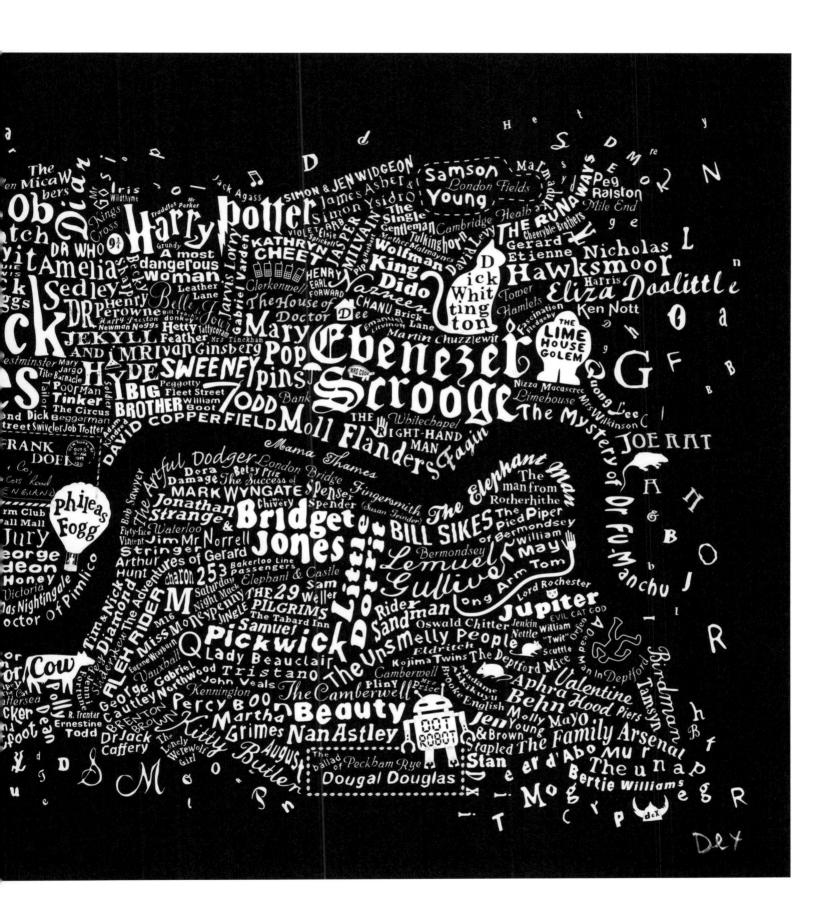

DESIGN Dex from Run For The Hills & Anna Burles COUNTRY/REGION UK

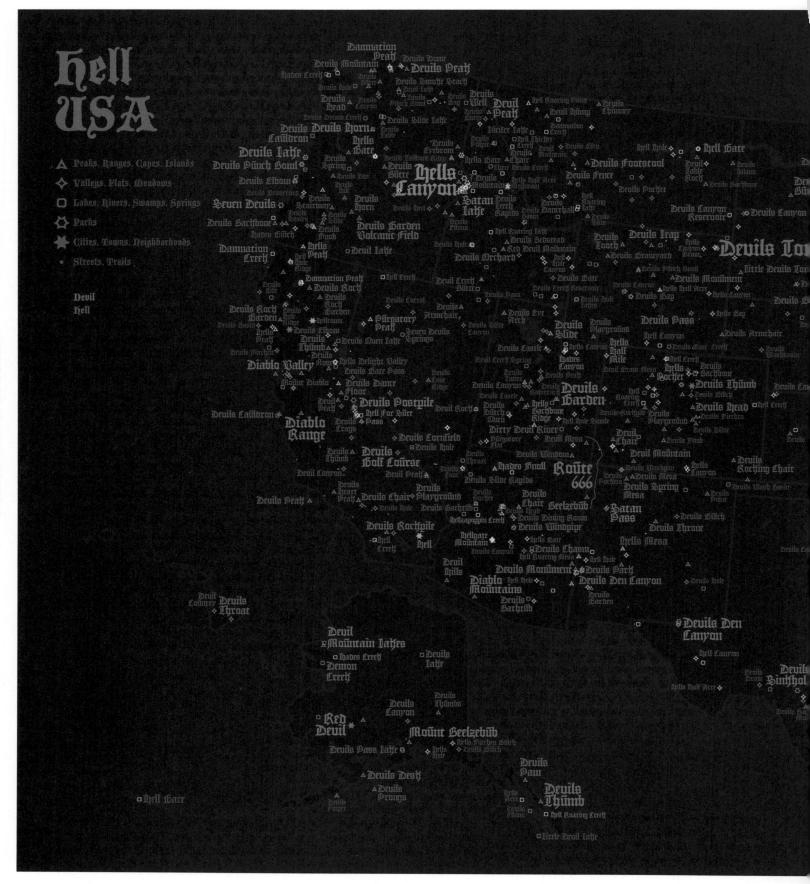

Hell USA Map

This map shows locations with the name "Devil" and accompanying "Hells" across the country. The data was sourced by the designer himself by various search methods. Here are some notable findings: the more interesting landscapes of the mountains and coasts generally appear to earn the infernal titles. There's a surplus of Devil's Den's, Backbones, Elbows, Kitchens and Hell Holes, besides the more unique brands like Devil's Cup and Saucer Island, Devil's Icebox and Satan's Kingdom. Another odd phenomenon is that none of the Apostle Islands bear apostles' names, yet a Devil's Island is included. Also, residential roads occasionally have names like Evil Lane.

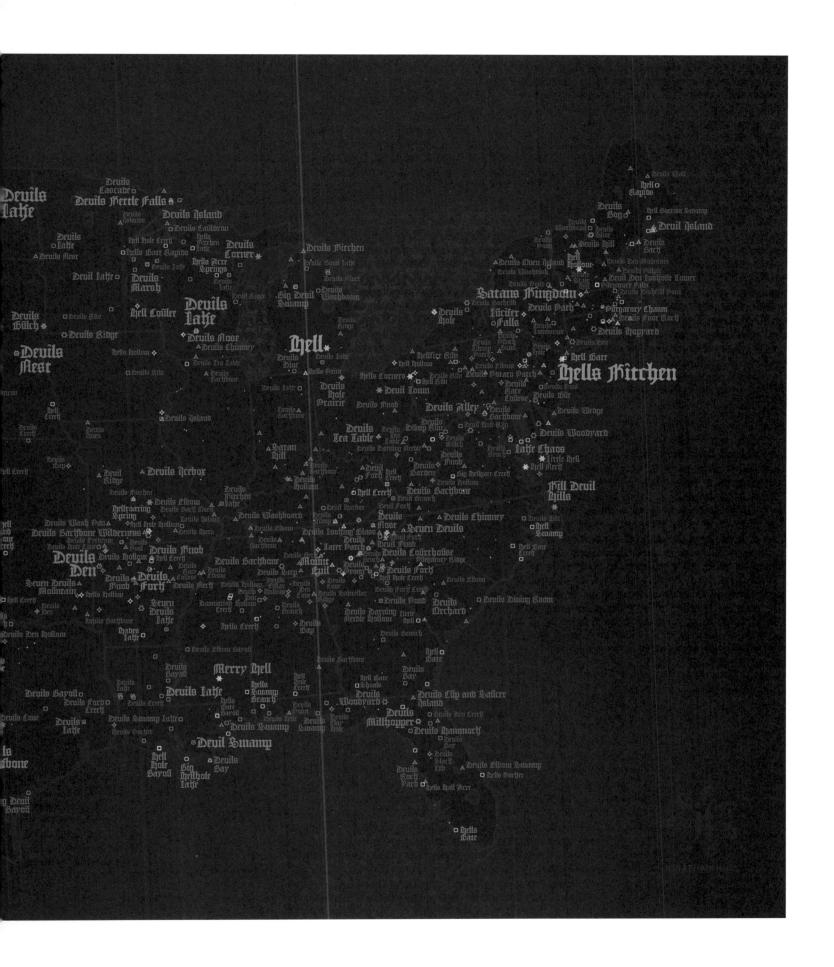

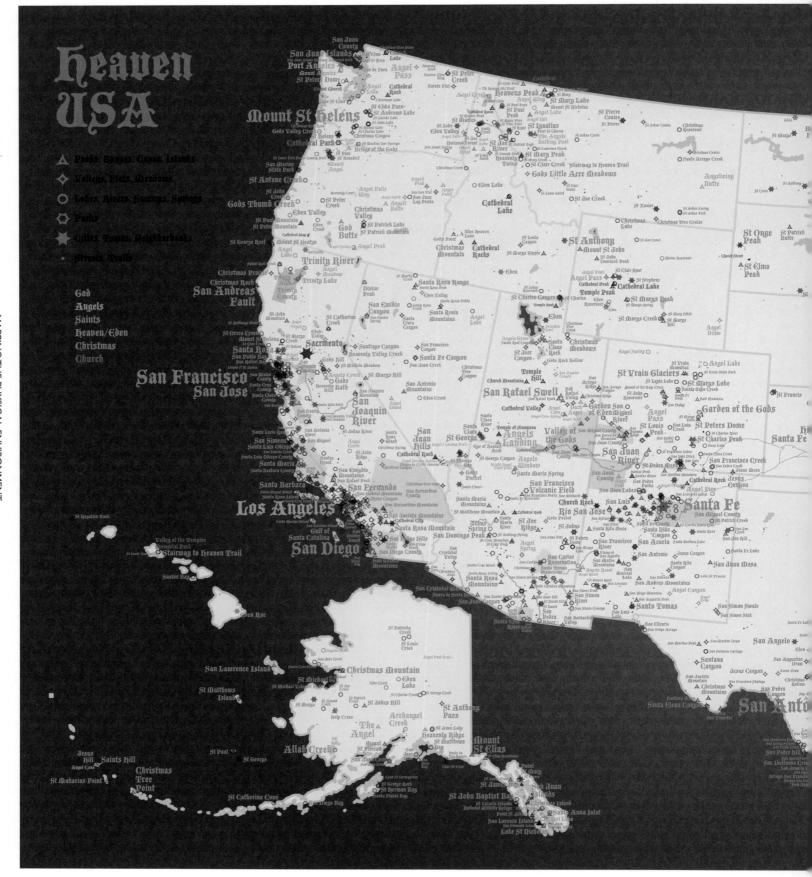

Heaven USA Map

A bit of Heaven on Earth in this graphic, which maps place names that derive from God, Heaven, Saint, Church, Angel and Christmas. Populated areas often hold more of the heavenly names, with particular concentrations in areas colonized by the Spanish and French. Quirky names include God's Bath, Angel's Trumpet Road, Angel Tear Way, In God's Hand Way and 6 Santa Claus Lanes. There are also intriguing titles as Bridge of the Gods across the Columbia, Stairway to Heaven Trail in Hawaii, Cathedral Caverns in Alabama and Angel's Landing in Zion National Park.

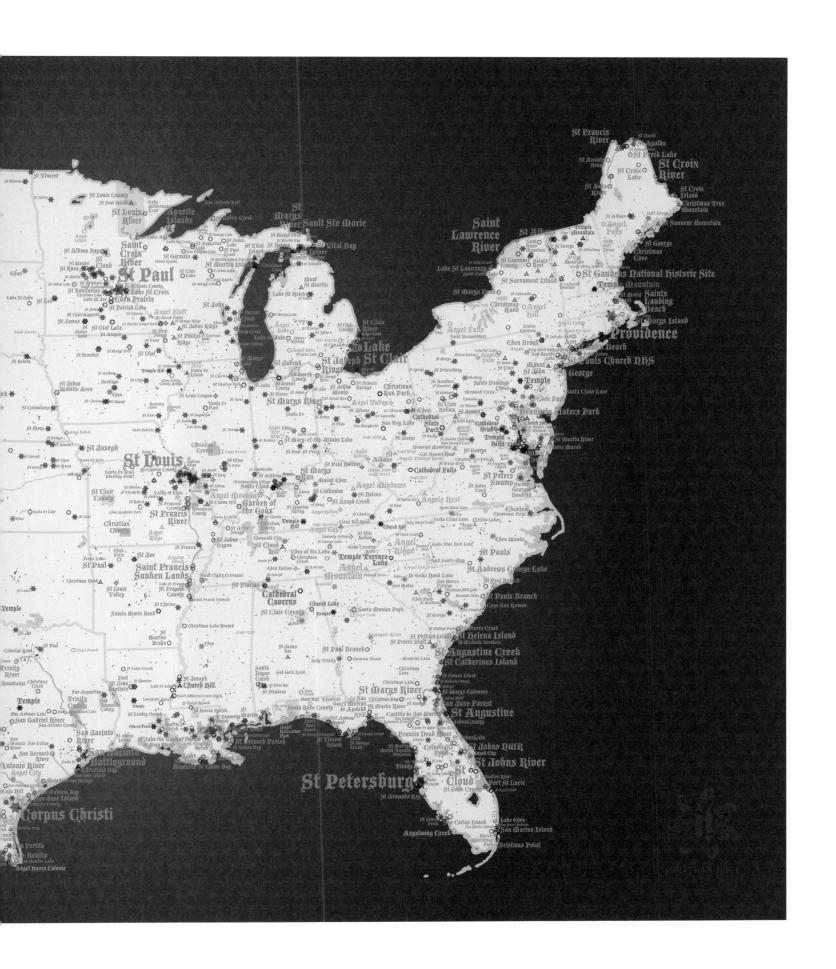

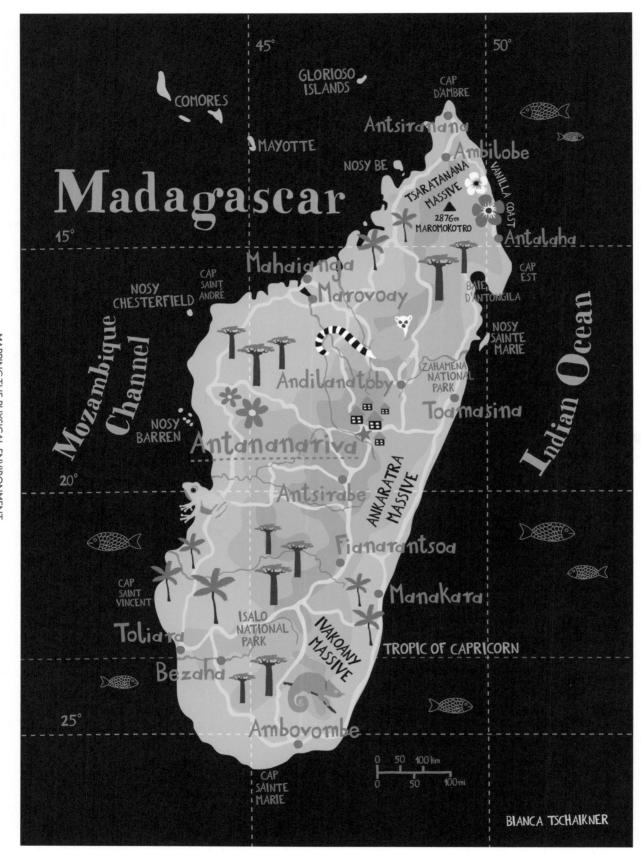

Illustrated Island Maps

These two maps of Zanzibar and Madagascar, off the east coast of Africa, are part of a series of illustrated maps of islands. Although simplified and more decorative than practical, they are geographically accurate, providing the primary information such as cities, islands, capes, bays and places of interest. At the same time they are fantastic colourful worlds populated by local flora and fauna, including chameleons, frogs, butterflies and exotic plants.

DESIGN Bianca Tschaikner COUNTRY/REGION Austria

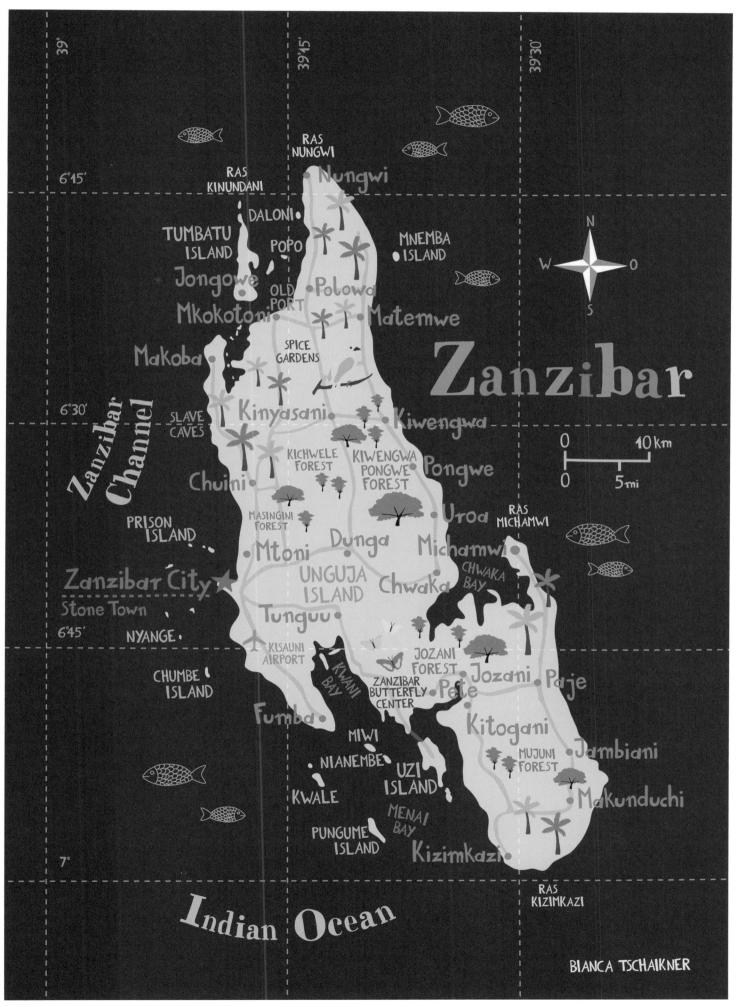

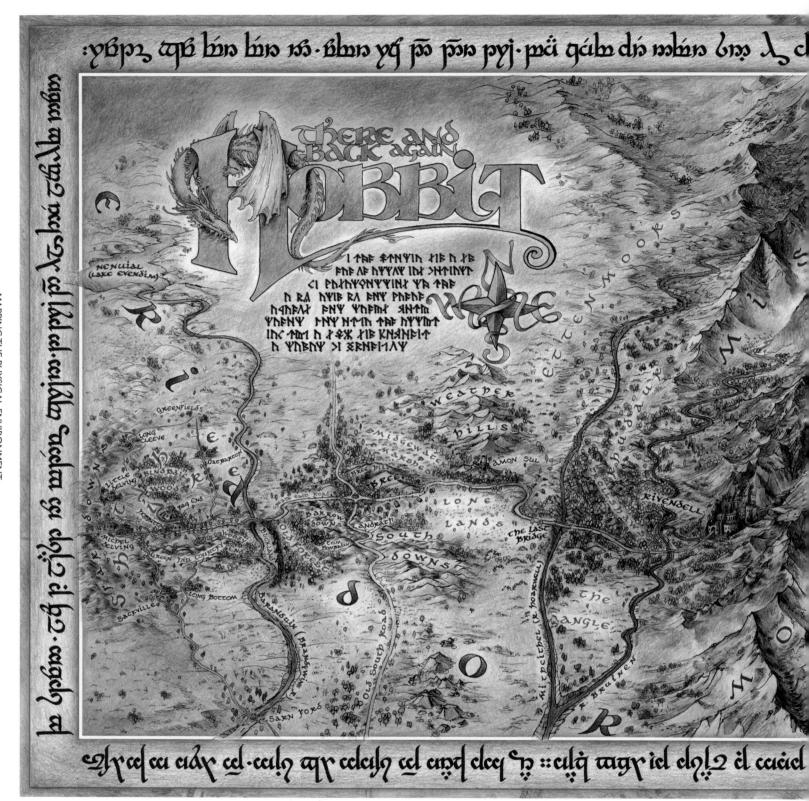

Map of Hobbit Lands

J.R.R. Tolkien's fiction inspired the creation of this map. It covers the area where *The Hobbit* takes place, from the Shire to the Lonely Mountain. The original size is 100 x 50 cm.

DESIGN Tomasz Kowal COUNTRY/REGION Poland

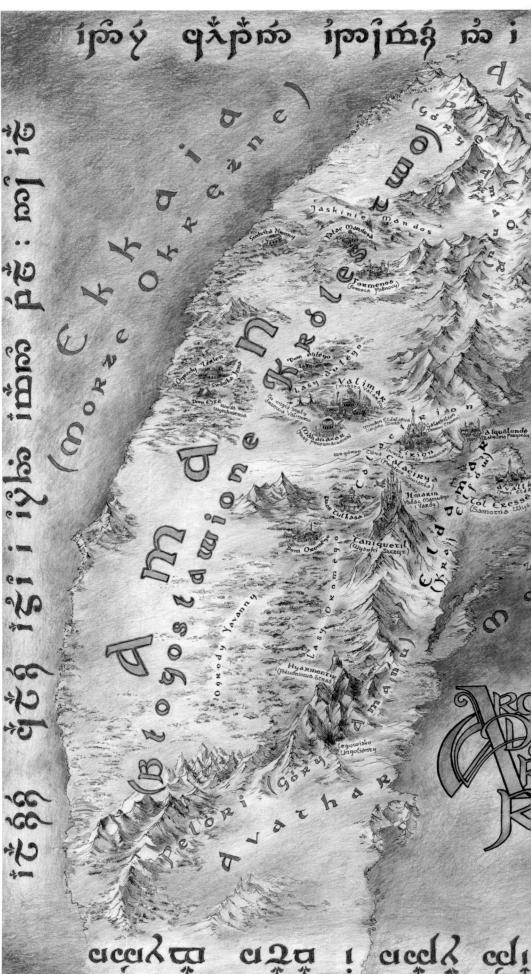

Arda, *The Lord of the Rings*

In J.R.R. Tolkien's legendarium, Arda is the name given to the Earth in a period of prehistory when the places mentioned in *The Lord of the Rings* once existed. The map of Arda includes Aman, Númenor and Ennor in the second era. On these pages, emphasis is placed on Aman, location of the Valar seats. Overleaf, Eridor, Rohan, Rhovdnion, Gondor and Mordor are depicted. This is the first such map for Arda, made on the basis of maps by K.W. Fonstad and R. Foster, the *Encyclopedia of Middle-earth* and Tolkien's works, and with the help of specialists. It is distinguished by high accuracy and artistic treatment of the topic. The map was made in fountain pen and colour pencil on paper. Its original size is 100 x 50 cm.

DESIGN Tomasz Kowal COUNTRY/REGION Poland

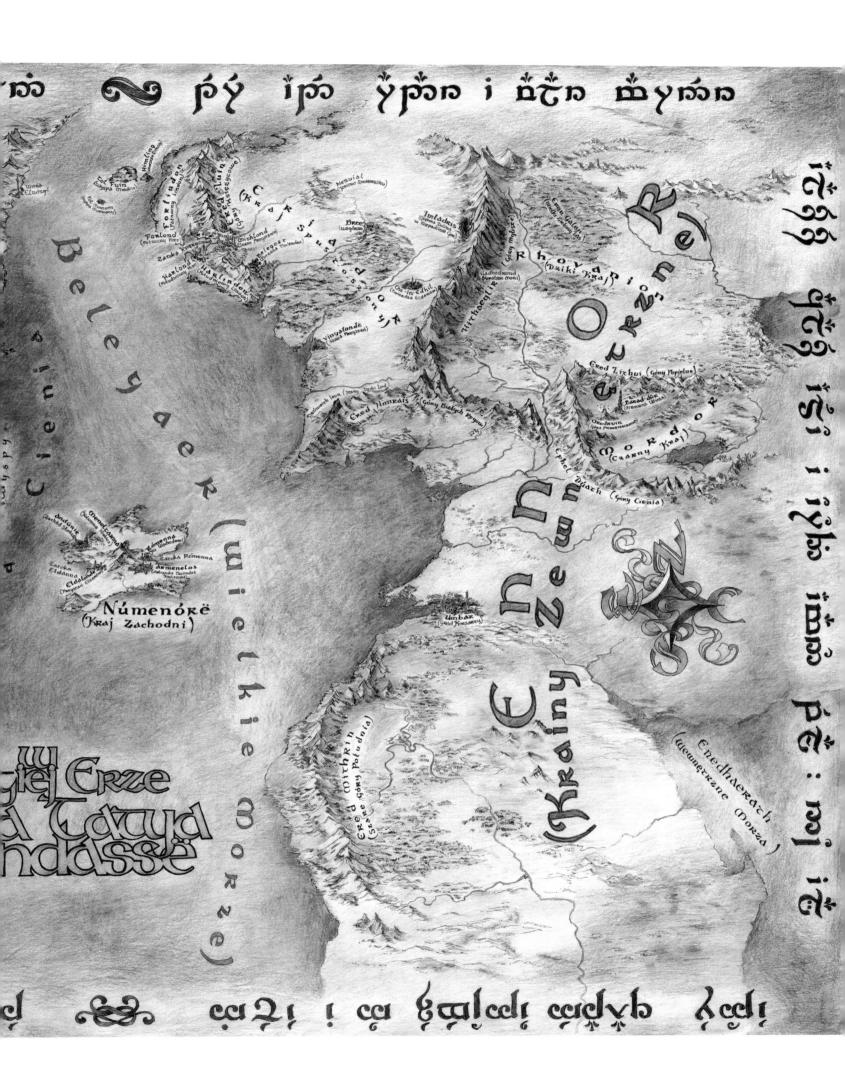

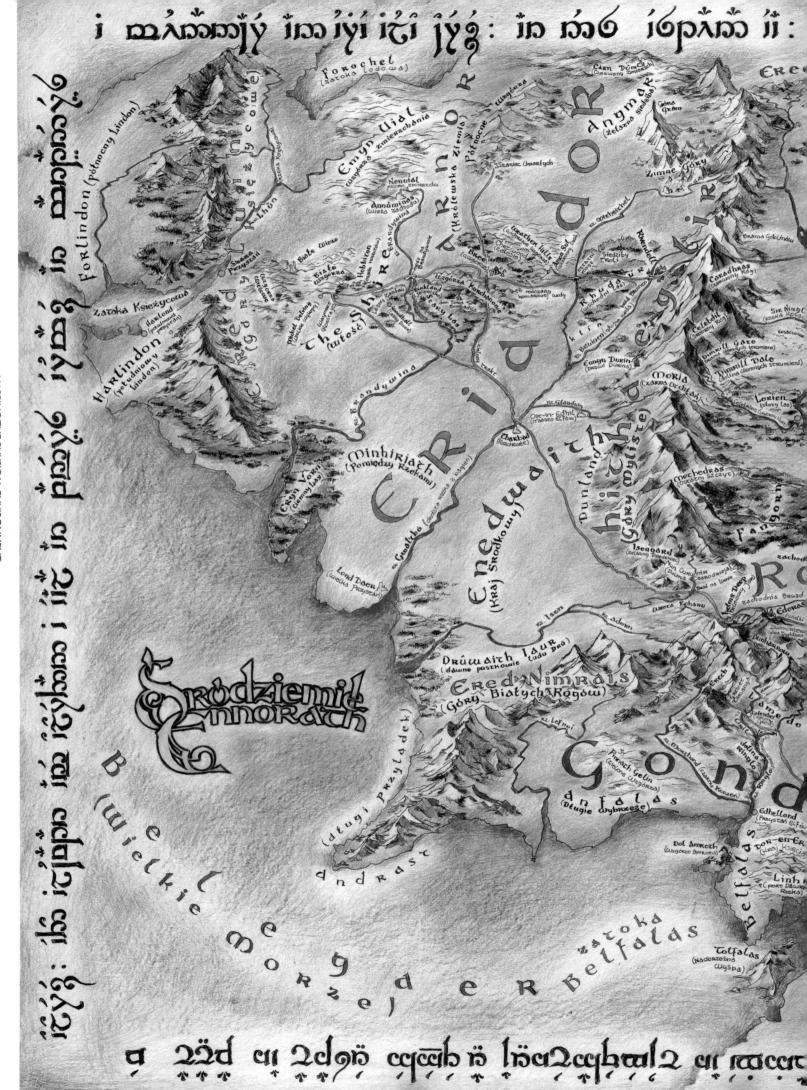

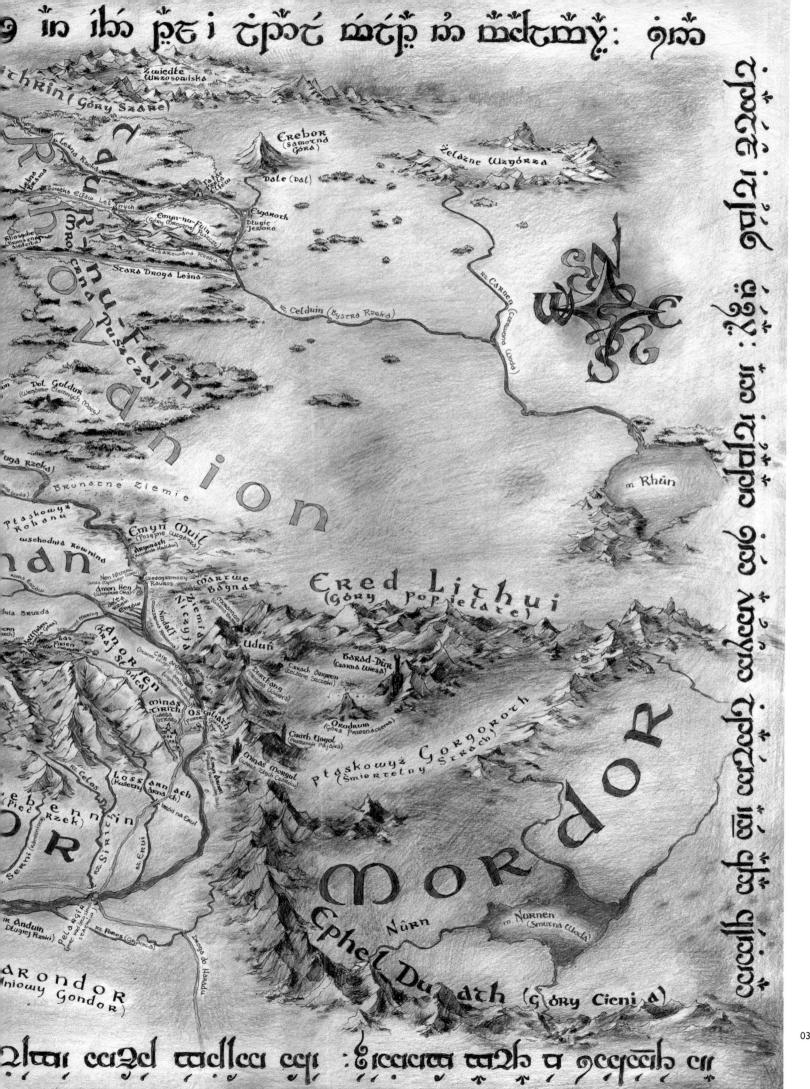

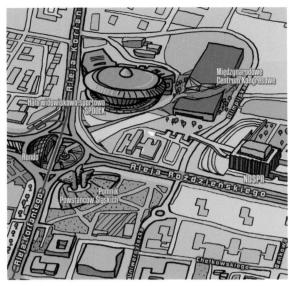

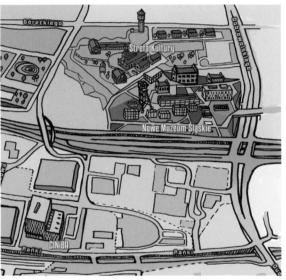

MAPPING THE PHYSICAL ENVIRONMENT

Map of Katowice City

This is a map of Katowice in Poland, drawn on a tablet. In the centre is a commercial district, showing some important buildings and distinctive objects in the downtown area. The original size was 50 x 70 cm.

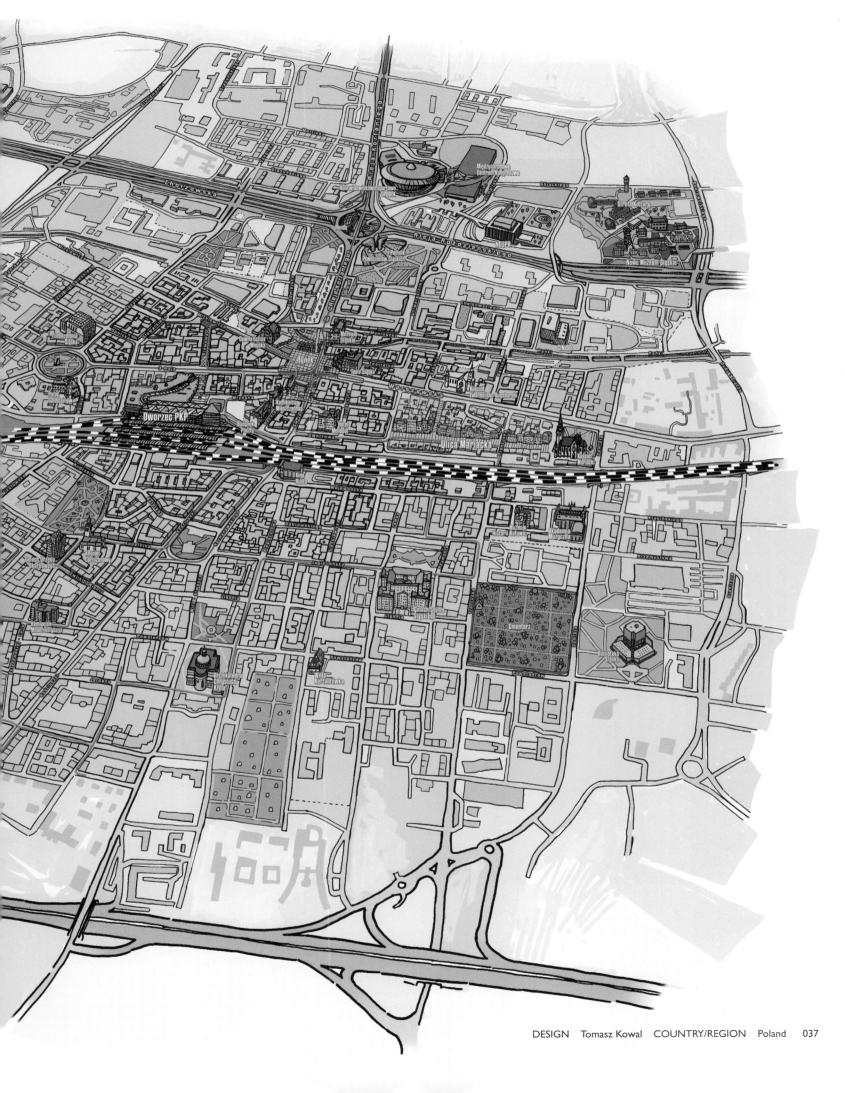

DESIGN Tomasz Kowal COUNTRY/REGION Poland

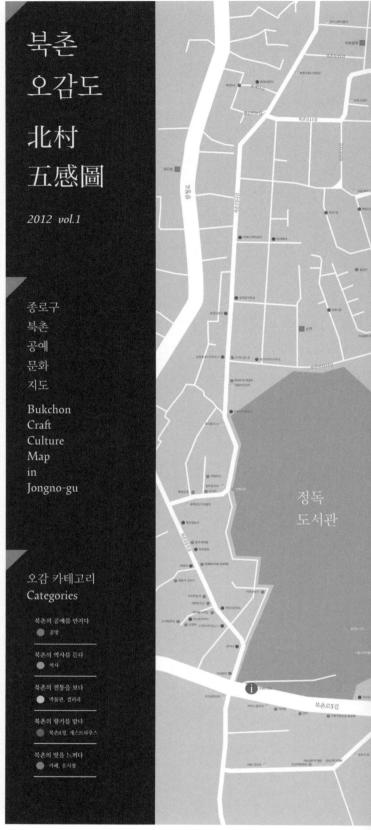

Bukchon Craft Culture Map, Seoul

This is a tourist map of Bukchon, in the Jongno-gu district of Seoul, where there are still traditional Korean houses. The concept was to focus on the locations of remaining traditional Korean craft studios in Bukchon. The map overleaf recommends five paths for tourists to visit the main streets and sub-areas. In Bukchon there are also various kinds of site-specific cafés, restaurants, historic places and guest houses. These are categorized based on the responses of visitors, assigning importance and preference. Given the scattered positions of these locations in Bukchon, a visual constellation idea was used. Five lines in different colours represent five suggested visiting routes and their respective interest-points, with descriptions. Moreover, QR codes are featured on the map for users to obtain information on the craft studios.

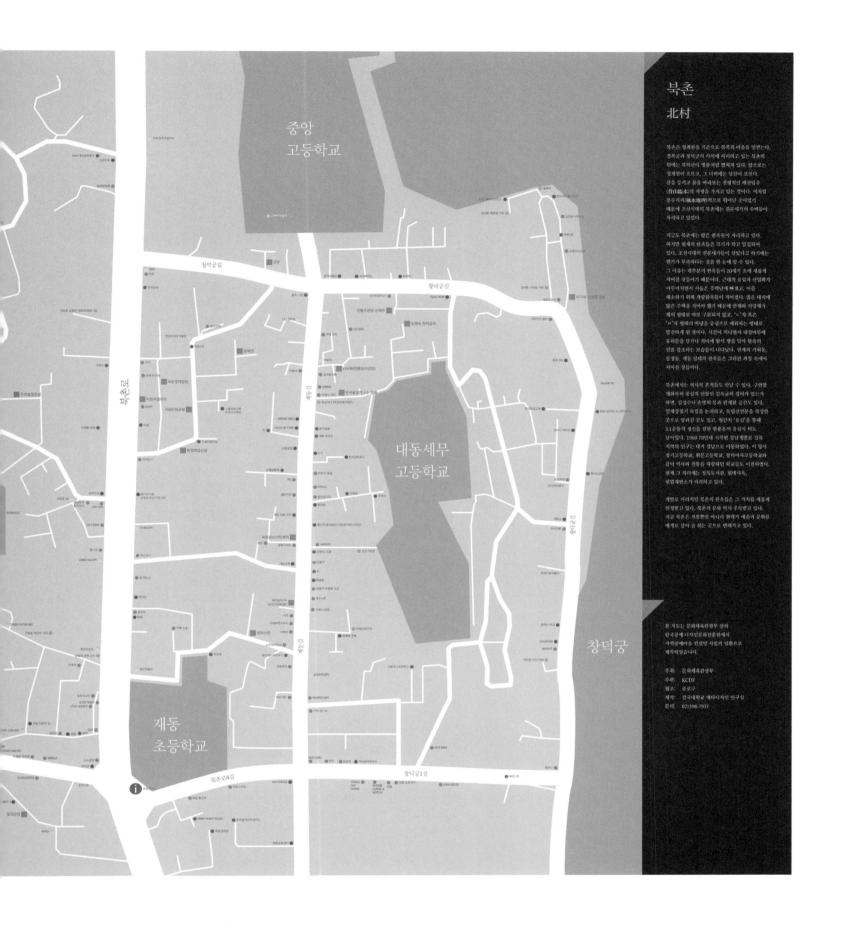

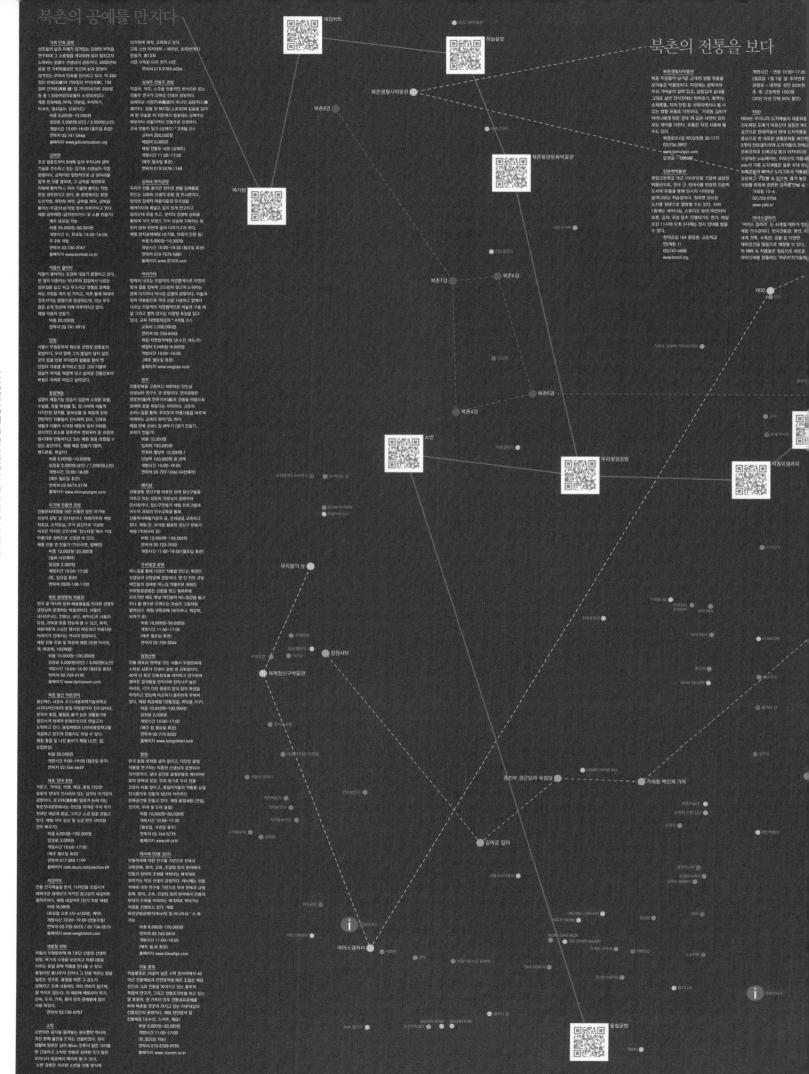

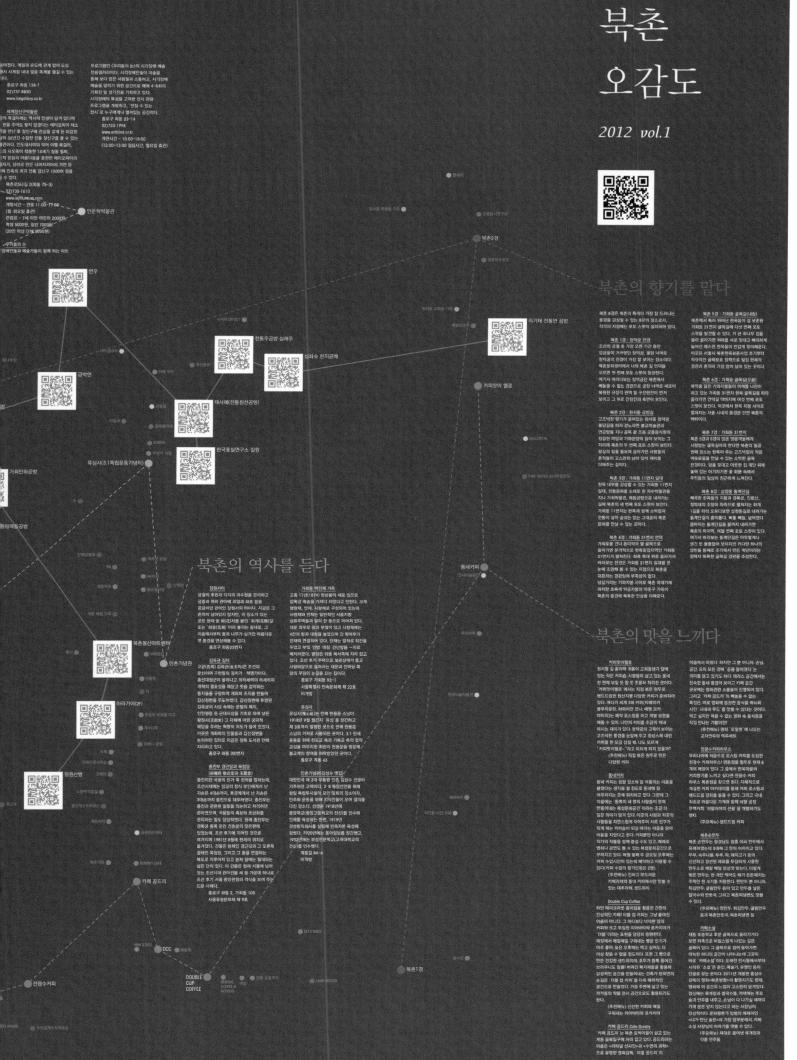

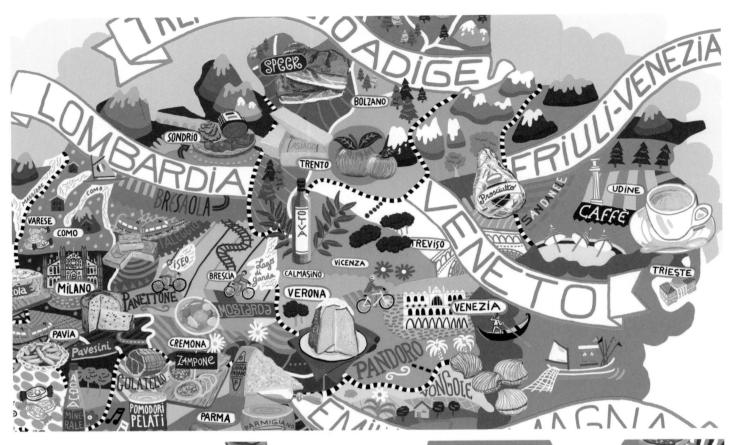
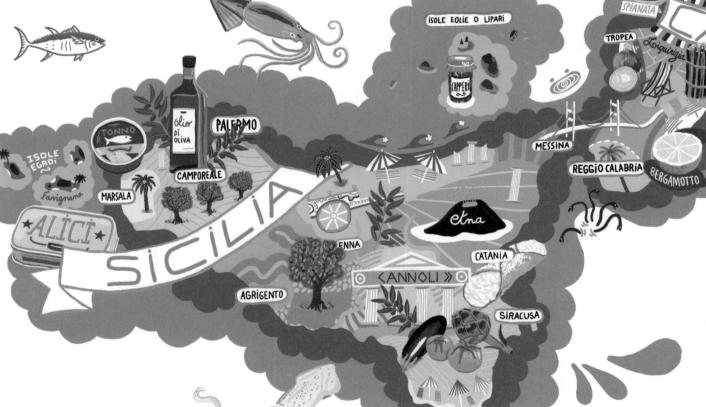

Prodotti Tradizionali Italiani

Prodotti Tradizionali Italiani is a large, detailed and colourful illustrated map of Italy and Italian food. It allows viewers to discover some of the wonders of Italian gastronomy and their areas of origin, from pecorino Romano or *carciofi* on *gambo* to delicious and tasty Ascolana olives and numerous other specialities, thereby vividly illustrating the geography of different regions of the country.

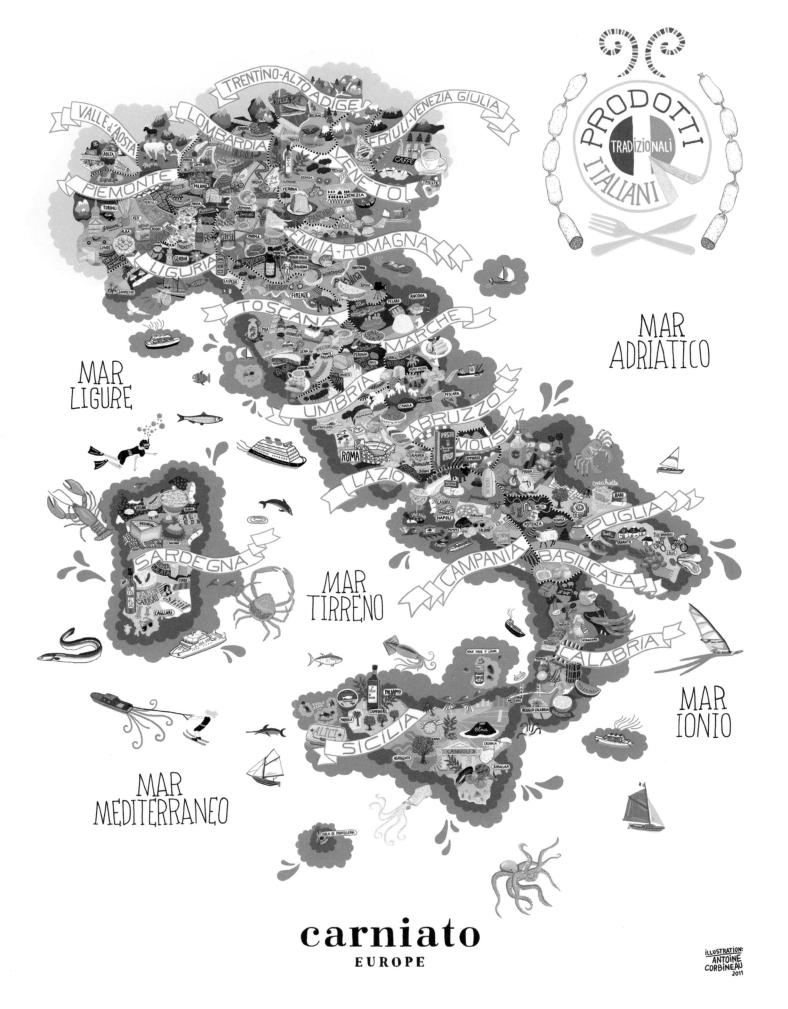

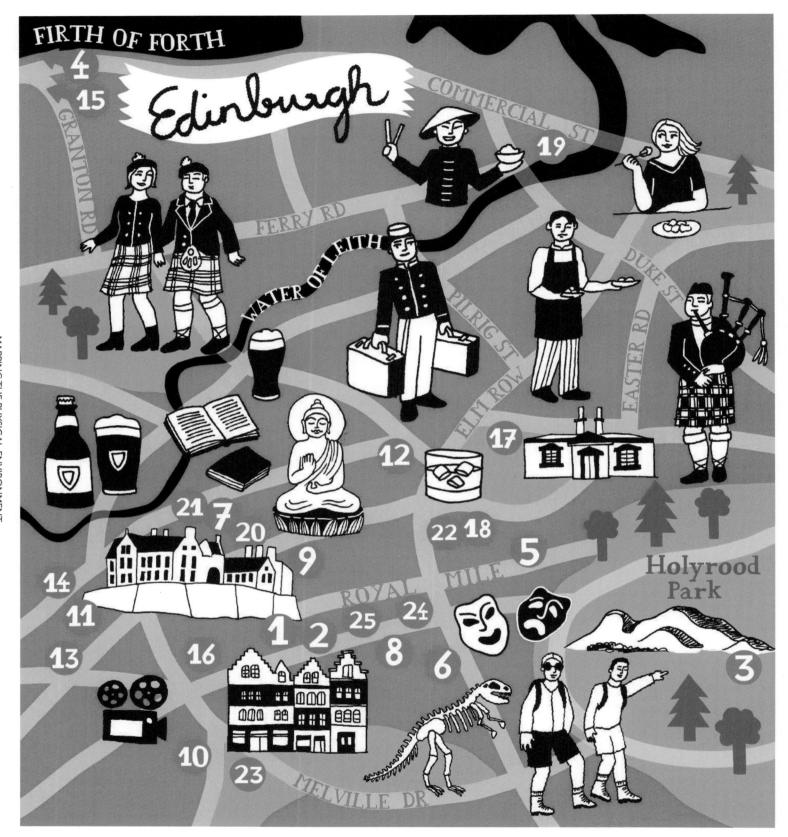

City Maps for *Let's Go with Ryanair!* Magazine

These European destinations are part of a series of illustrated city maps created for *Let's Go with Ryanair!* magazine, the inflight magazine of the discount airline RyanAir. They were created for the city guide section, which in the years 2012–13 published a monthly portrait of a European city, consisting of a map and a guide with recommendations. Cities such as Edinburgh, Paris, Brussels, Porto, the East End of London, Lisbon, Vienna and Rome were featured, to provide inspiration for trips and to help readers find their way around and discover the most interesting places in town. The maps show restaurants, bars, coffee houses and a selection of sights, and are decorated with drawings of little scenes with people and buildings to give an evocative feel of the atmosphere of the city. Although very simplified, they do offer a useful introductory overview.

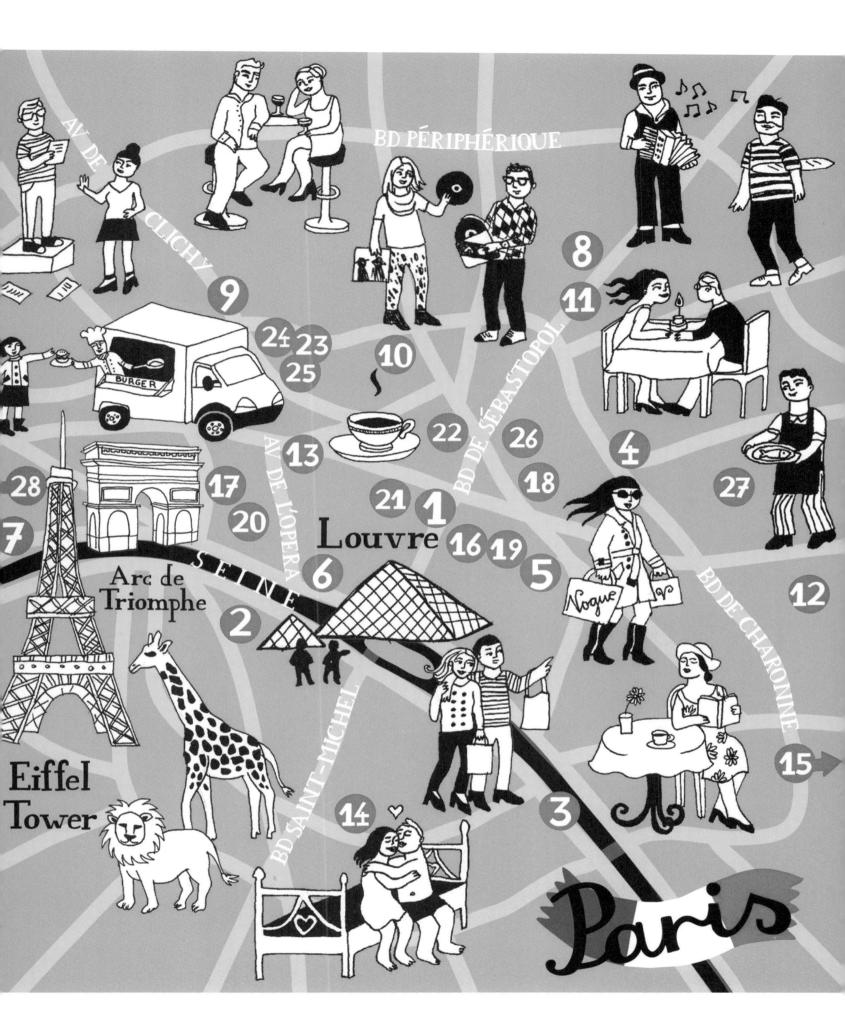

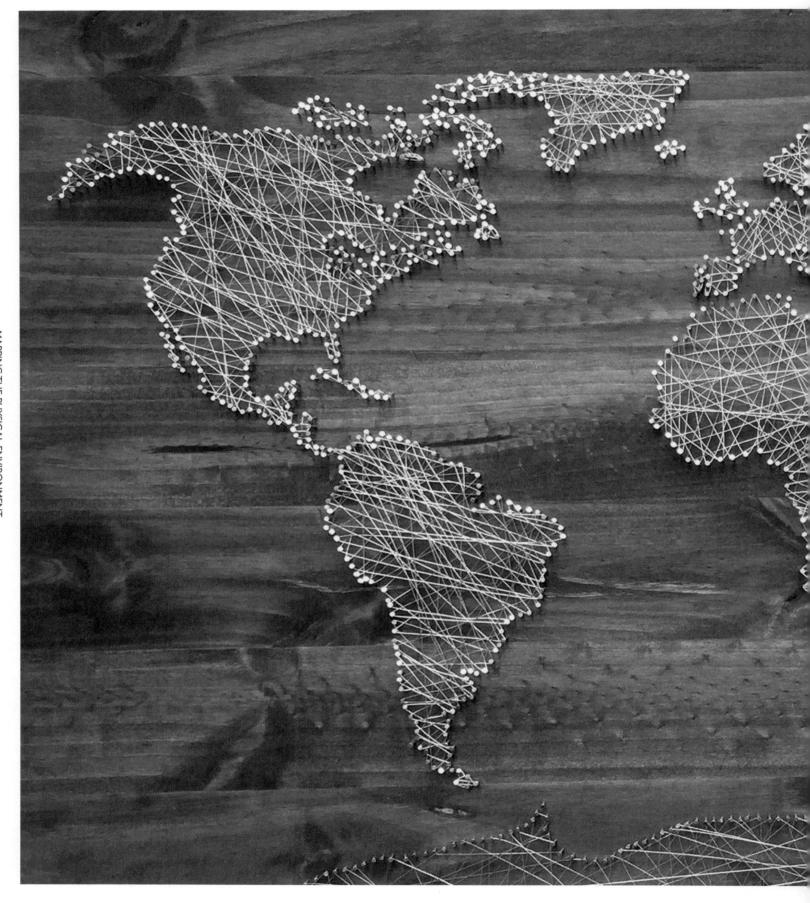

Wired World

Wired World was created as a donation for the *Boise Weekly* newspaper of Boise, Idaho. On a backdrop of oak, stained the colour of English chestnut, the piece is composed of over 1,000 steel nails and roughly 150 feet of aluminum wire. It aims to represent the infinite linkages within our world, regardless of physical or implied distance.

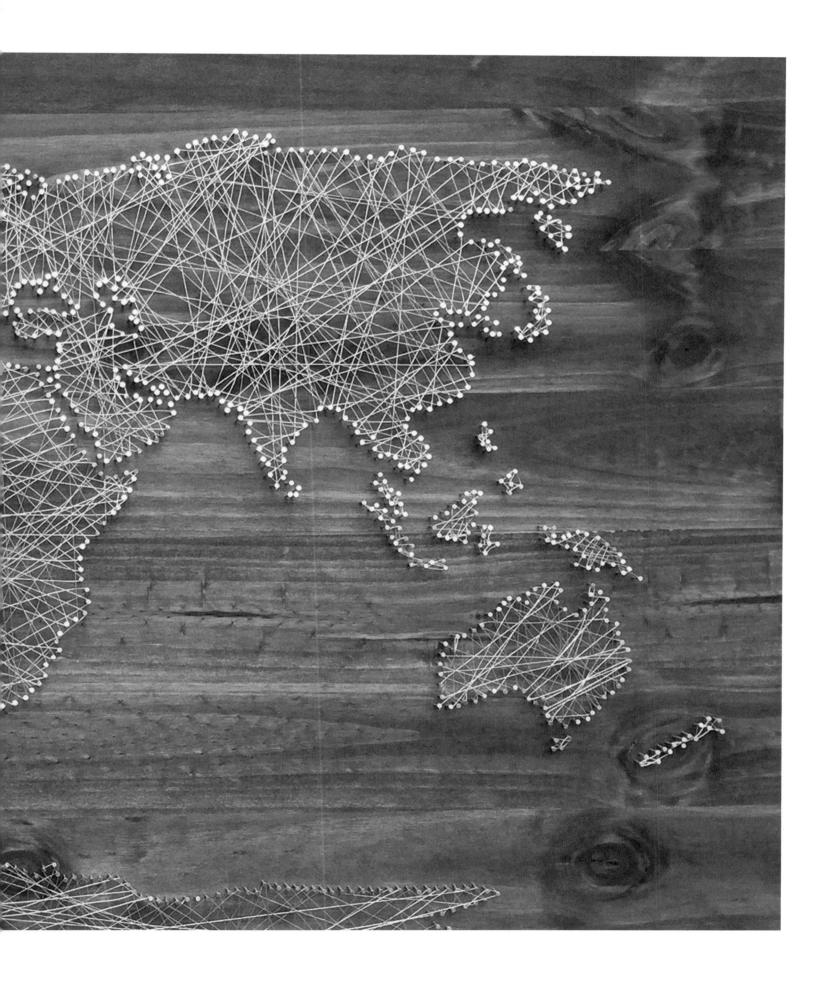

DESIGN Ciera Shaver COUNTRY/REGION USA

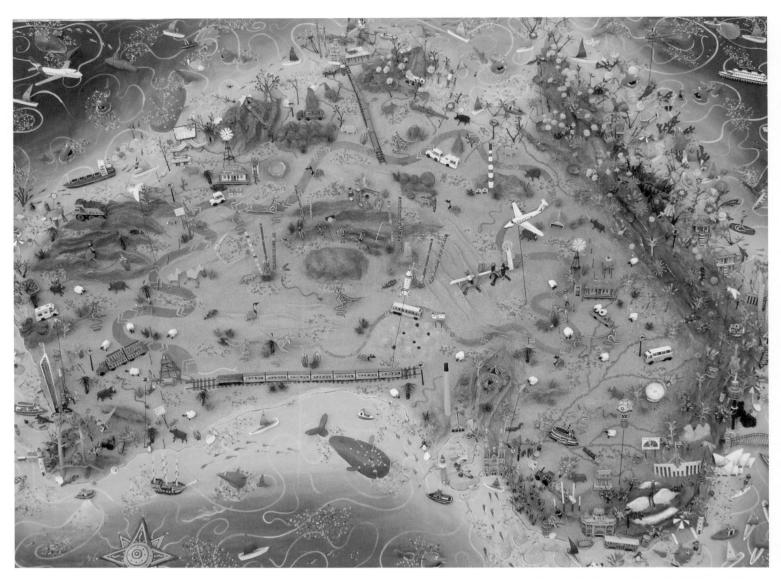

Illustrated 3D Map of Australia (120 cm x 120 cm)

Illustrated 3D Maps

These two colourful maps are from Drake's 3D map series, which are all hand sculpted and hand painted. The map base is built on foam board, which is covered in a fine layer of papier-mâché and then painted to form the background. The features on the map – including buildings and famous landmarks, food and wine, modes of transport and animals and plants – are all hand made, carved and painted from a mixture of materials including balsa wood, beads, wire and acrylic paint. Each map is different and made to commission so features can be changed or added to personalize each piece.

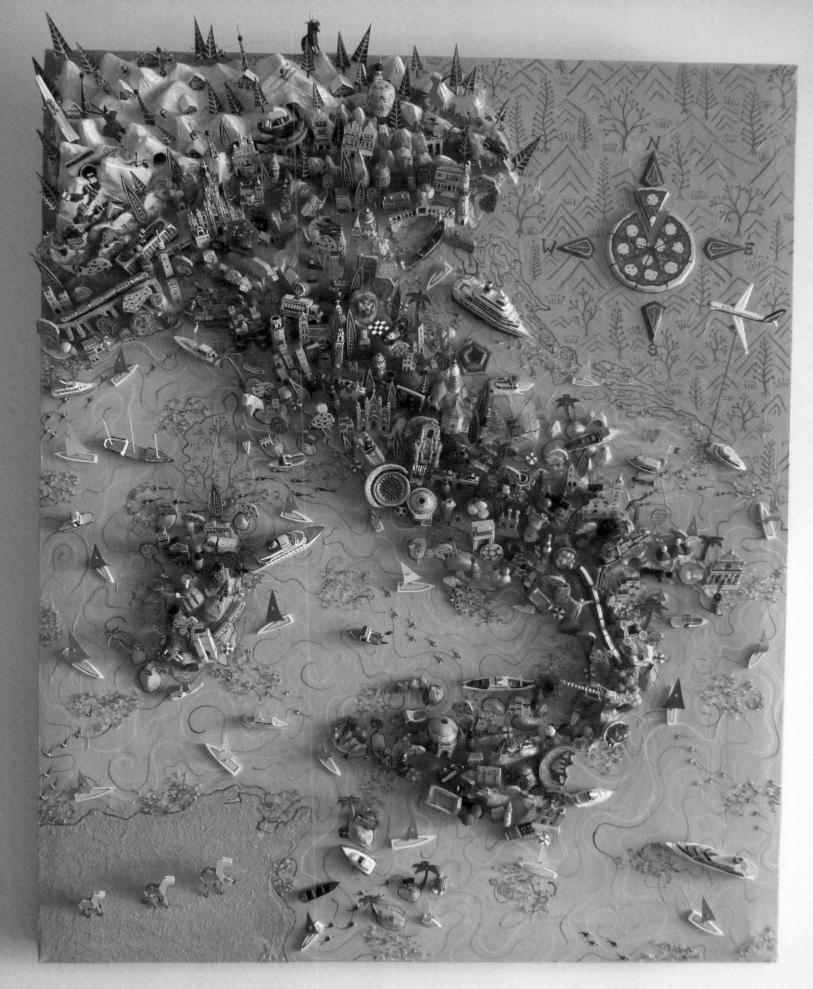

Illustrated 3D Map of Italy (50 cm x 70 cm)

DESIGN Sara Drake COUNTRY/REGION Australia

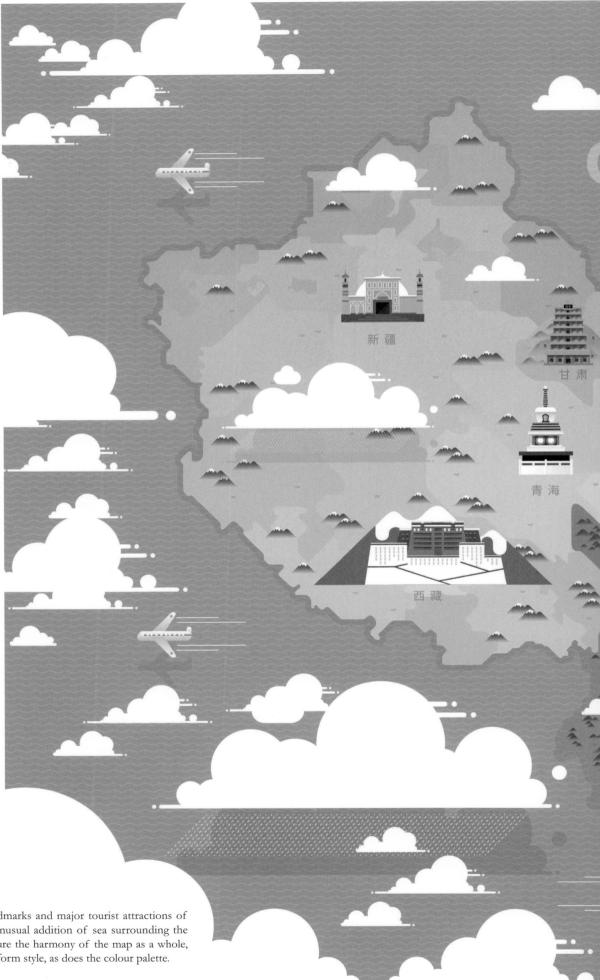

MAPPING THE PHYSICAL ENVIRONMENT

China Map

The simplified map presents the landmarks and major tourist attractions of each province in China — with the unusual addition of sea surrounding the nation as if it were an island. To ensure the harmony of the map as a whole, the illustrations follow a relatively uniform style, as does the colour palette.

050 DESIGN Z.CHENG LEO COUNTRY/REGION China

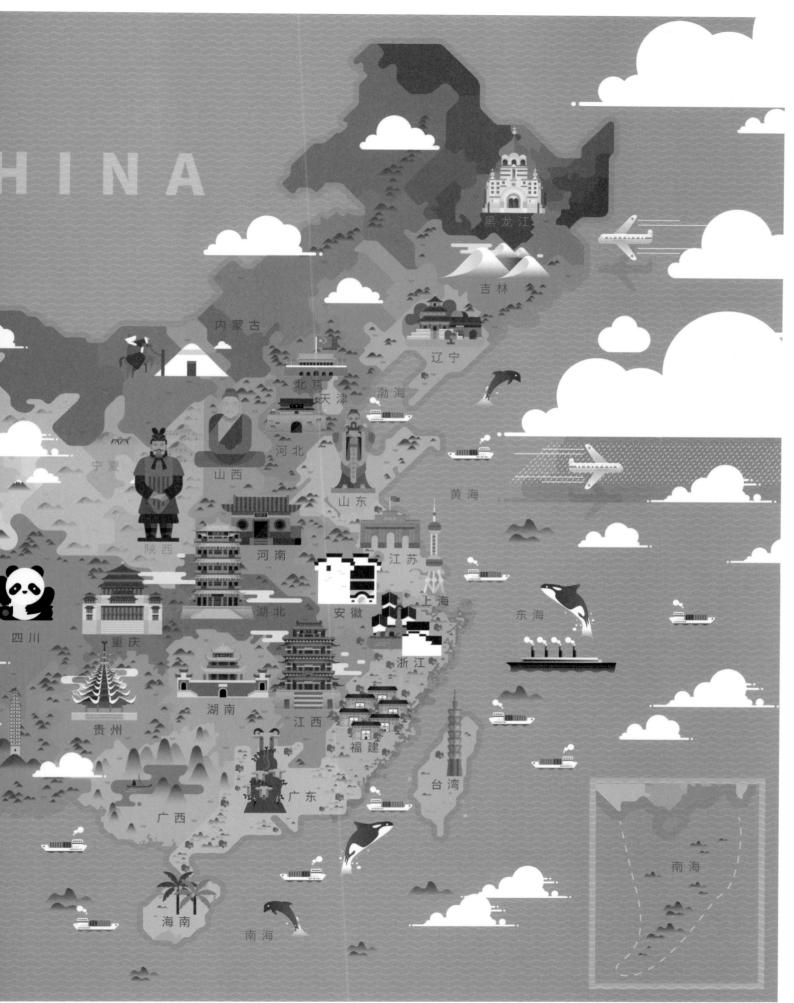

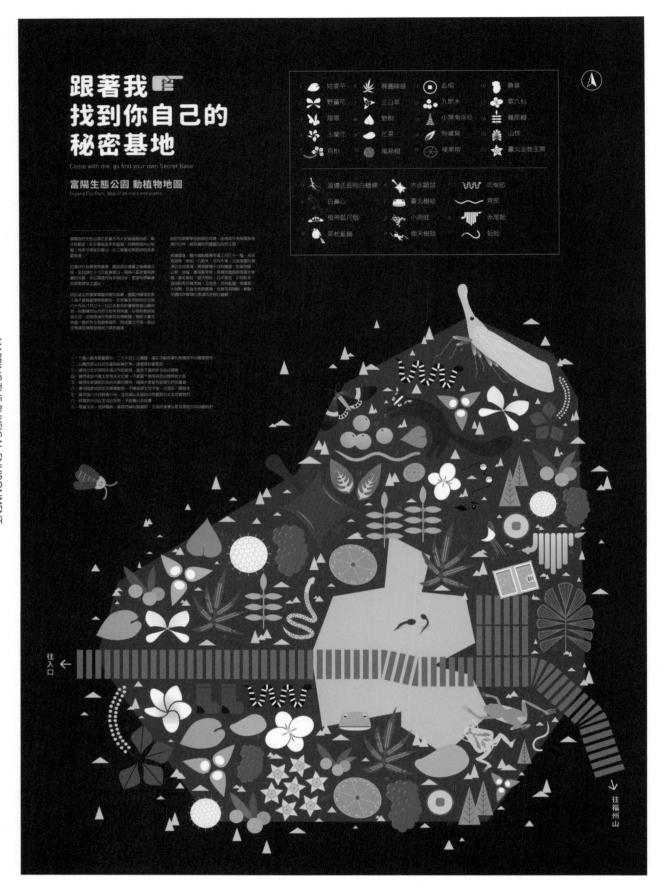

Fuyang Eco Park Map of Animals and Plants

This is a distribution diagram of the animals and plants around the eco-pond in Fuyang Eco Park, in Taipei, capital of Taiwan. The use of graphic illustrations makes the depiction distinctive from former eco maps.

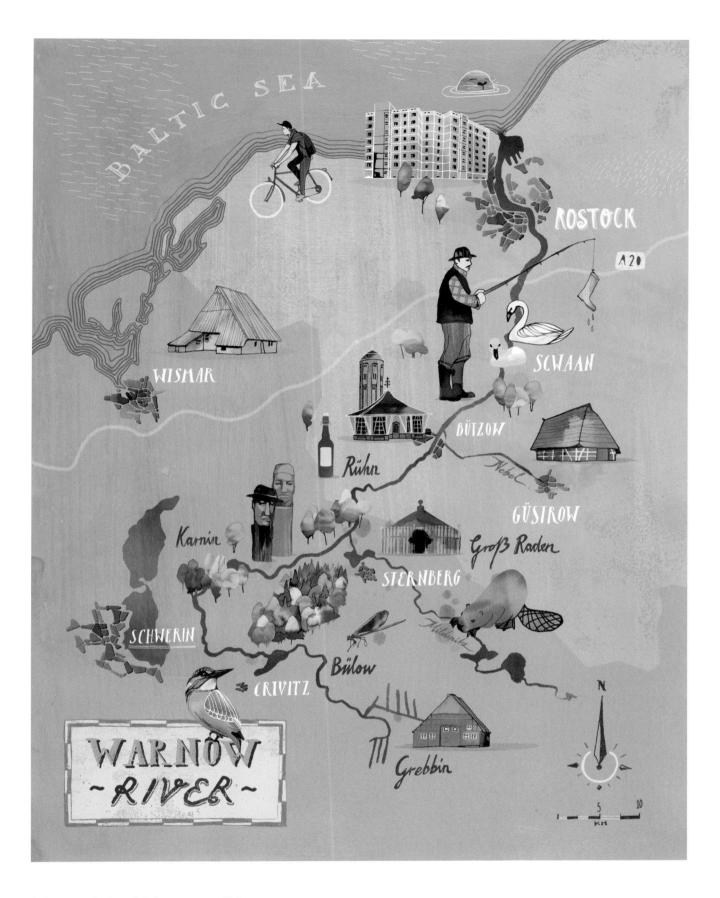

Map of the Warnow River

The Warnow river flows across the north of Germany through Mecklenburg. The clichés associated with this area are the white beaches of the Baltic Sea, green cow-pastures and fields of yellow blossoms. When drawing this map, Richter intended to avoid these stereotypes while still portraying the unspoilt nature along the banks of the river; shimmering colours and the irregular forms of ink drawing added to the natural look. He chose to portray the region in its September colours, when forests are still green but the warm shades of autumn are emerging. In contrast with the hinterland lie both the cool Baltic Sea and the city of Rostock, the biggest town in the area. Rostock marks the end of this quiet river.

DESIGN Tilo Richter COUNTRY/REGION Germany

World Map Illustration

This map was not intended to be a very functional piece. For the colour palette, only about eleven shades were used: loosely speaking, the blue/grey colours denote capitalist countries like the USA while reds (but not oranges) denote socialist ones such as China. But aesthetic matching was also taken into account. The typeface is meant to be a classic style that echoes the 1950s or 1960s, so a Rockwell-based font was used. The water pattern is derived from a satellite image of the sky so, far from revealing different depths of the sea, it is actually clouds in the water.

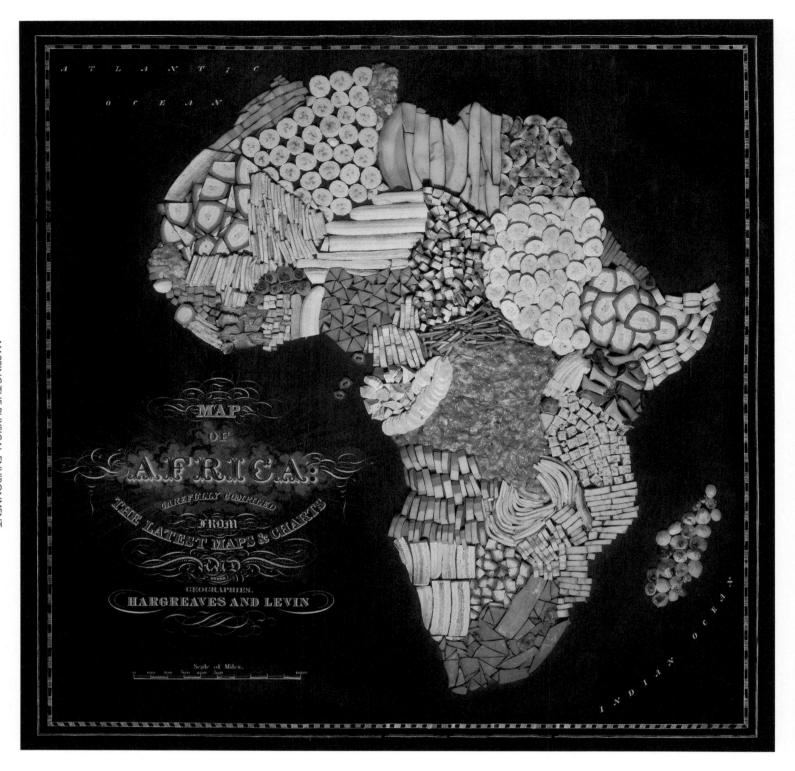

Food Map

Exploring new places through the food you eat there is often a portal to the cultural complexities of a new location. Inspired by a passion for travel, Caitlin Levin and Henry Hargreaves used many of the iconic foods of different places and turned them into a series of physical maps, representing their interpretation of food from around the world. The maps show how food has travelled the globe, transforming and becoming a part of new cultural identities. An example is that tomatoes originally came from the Andes in South America, but today Italy has become the tomato king. And most people would think of Australia at mention of shrimp and barbecues, while for those visiting France it is a must to eat bread and cheese. These maps try to speak to the universality of how food unites us, brings people together and starts conversation.

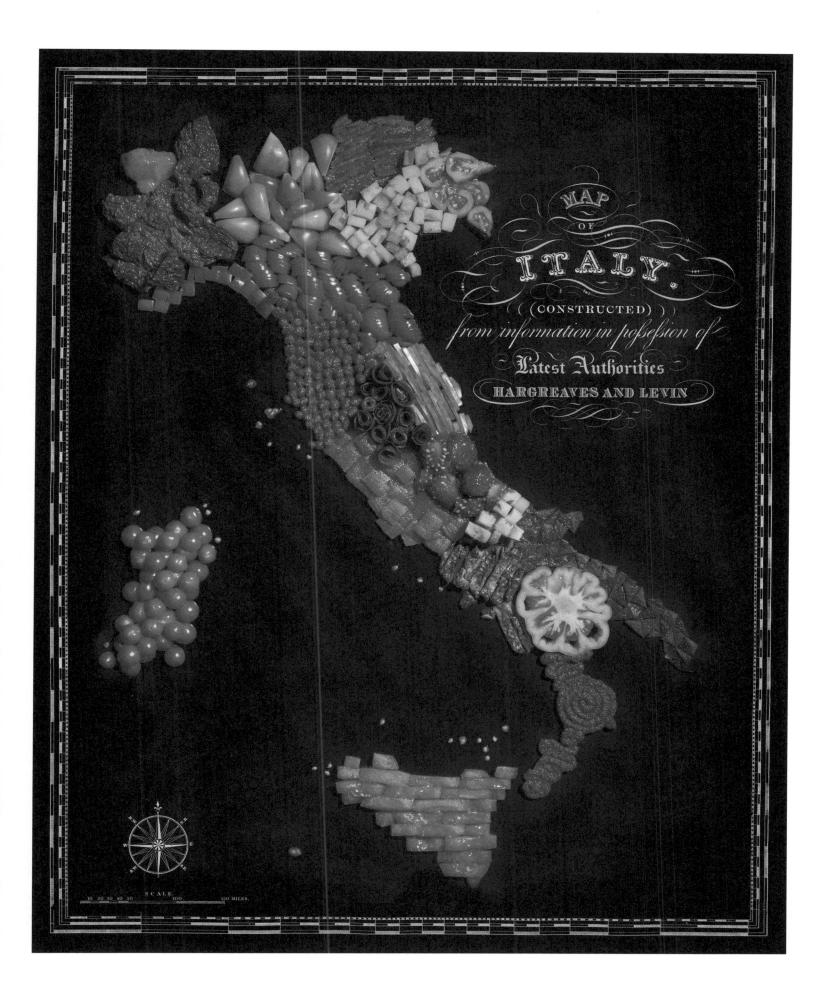

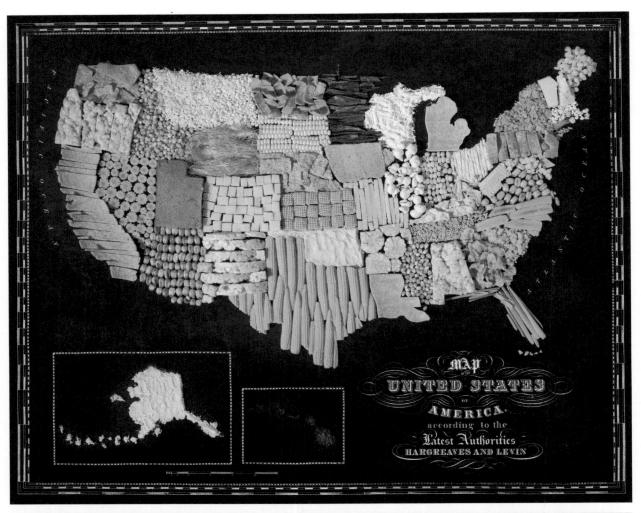
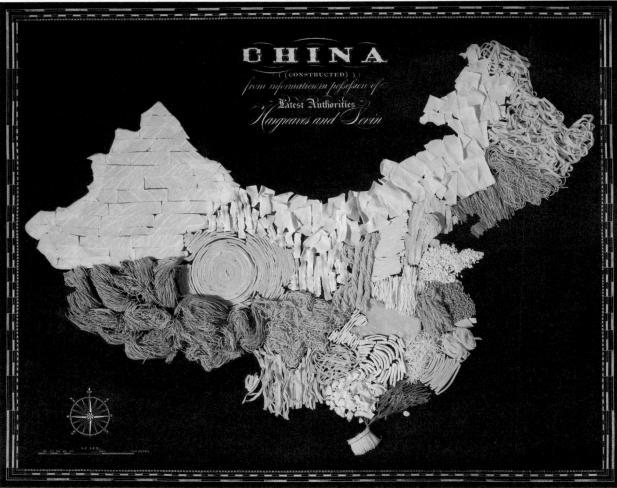

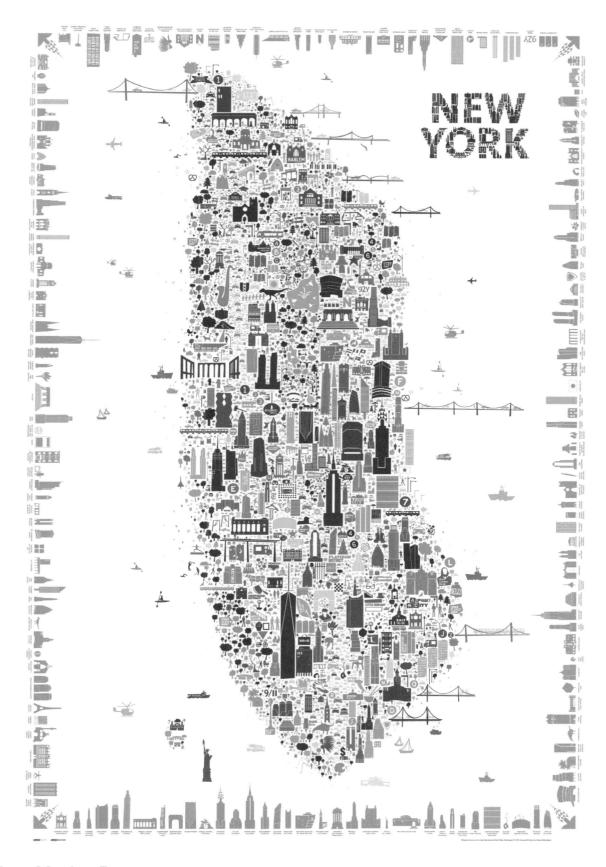

Iconic New York™ Poster

Rafael Esquer, the art director of this impressive piece, couldn't find the perfect New York souvenir for his friends and family when they visited. So he created it. Esquer designed a museum-quality poster that is becoming a favourite New York keepsake for visitors and residents alike. Painstakingly researched, drawn and composed, Iconic New York™ was two and a half years on the drawing board at Alfalfa New York. Esquer and his design team chipped away at the map of Manhattan, methodically converting the city's most beloved architecture and artefacts into artful graphic icons. Slowly but surely, from Washington Heights to Battery Park, the icons were meticulously assembled into a collage forming the shape of Manhattan itself.

DESIGN Alfalfa Studio COUNTRY/REGION USA

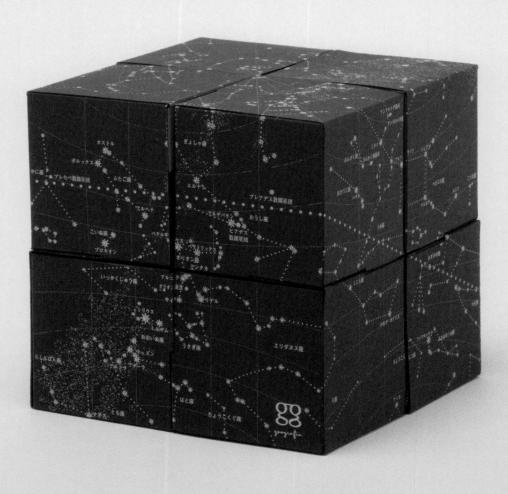

MAPPING THE PHYSICAL ENVIRONMENT

Geografia – Twistable Globe

This globe packs two aspects of the world into one cube, showing what the planet looks like from space and how space looks from Earth. By twisting the looped eight cubes, you can convert a terrestrial globe into a celestial globe.

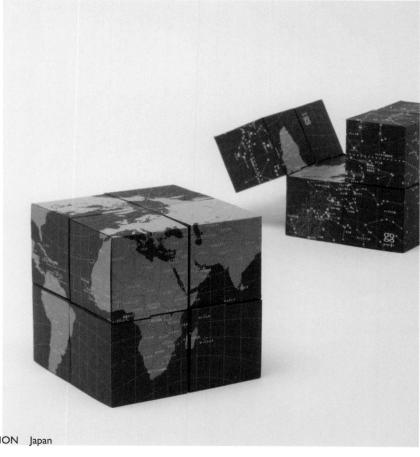

060 DESIGN Drill Design PHOTOGRAPHY Ryokan Abe COUNTRY/REGION Japan

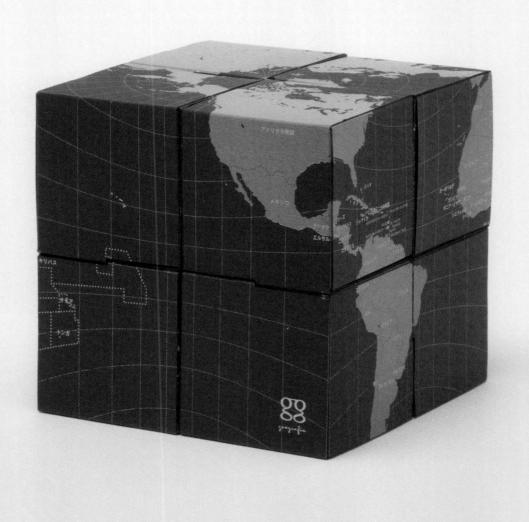
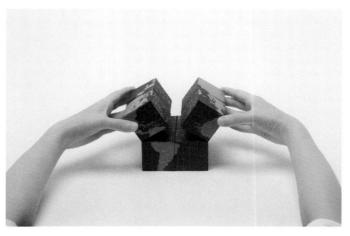
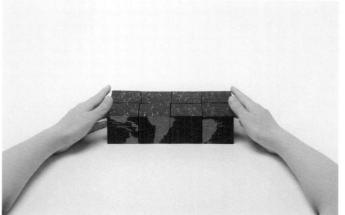
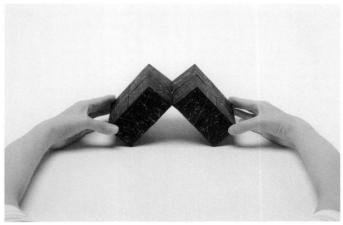
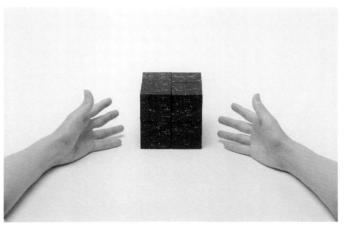

MAPPING THE PHYSICAL ENVIRONMENT

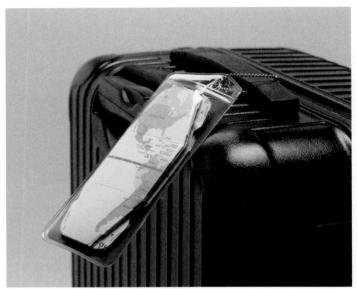
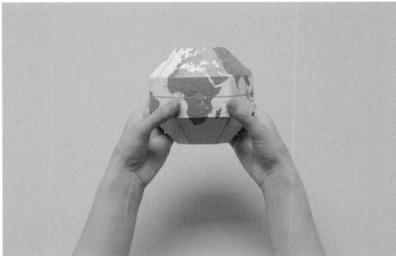
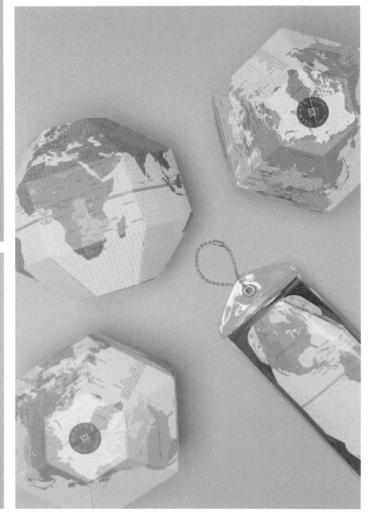
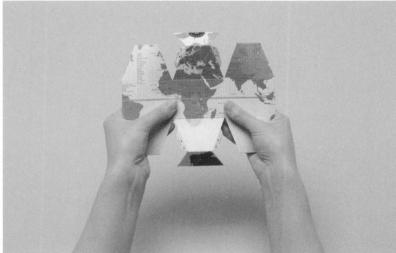

Geografia – Foldable Globe

This compactable globe is easily folded flat, in which form it is small enough to slip into a plastic case, attachable to baggage like a name tag. When opened out, it becomes an accurate map of the world.

DESIGN Drill Design PHOTOGRAPHY Ryokan Abe COUNTRY/REGION Japan

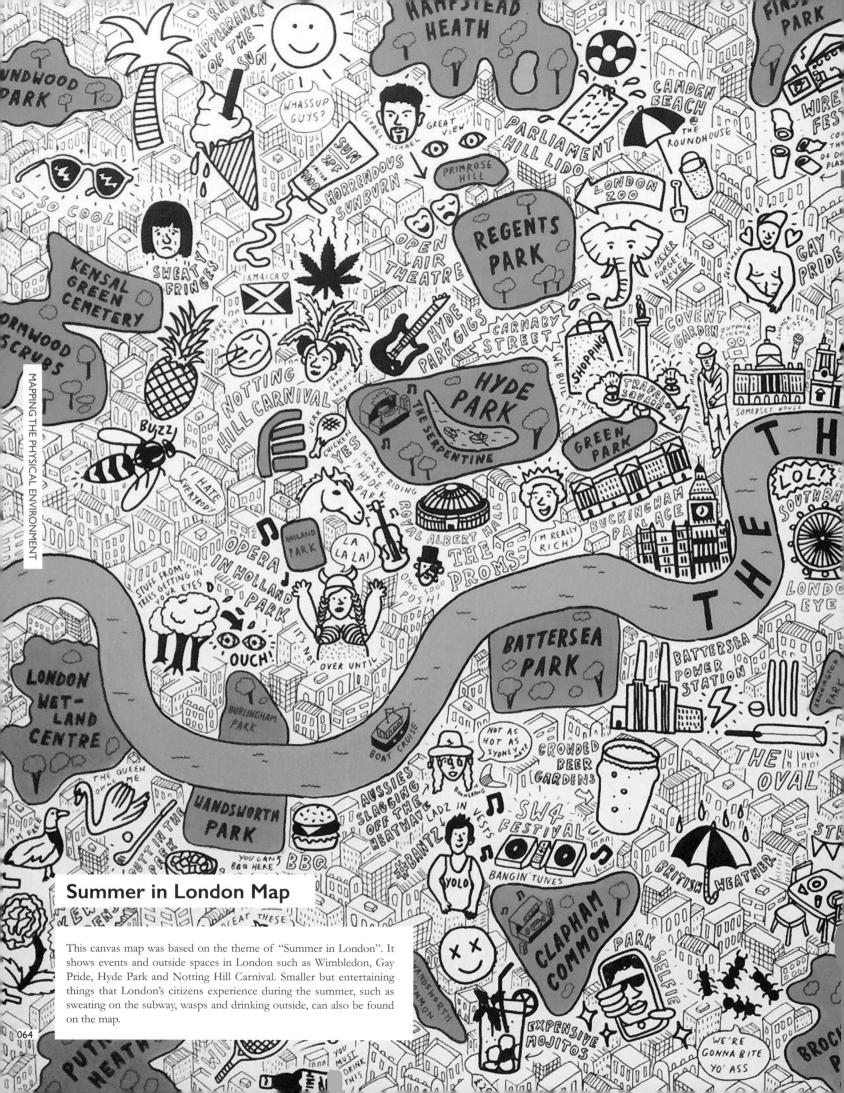

Summer in London Map

This canvas map was based on the theme of "Summer in London". It shows events and outside spaces in London such as Wimbledon, Gay Pride, Hyde Park and Notting Hill Carnival. Smaller but entertaining things that London's citizens experience during the summer, such as sweating on the subway, wasps and drinking outside, can also be found on the map.

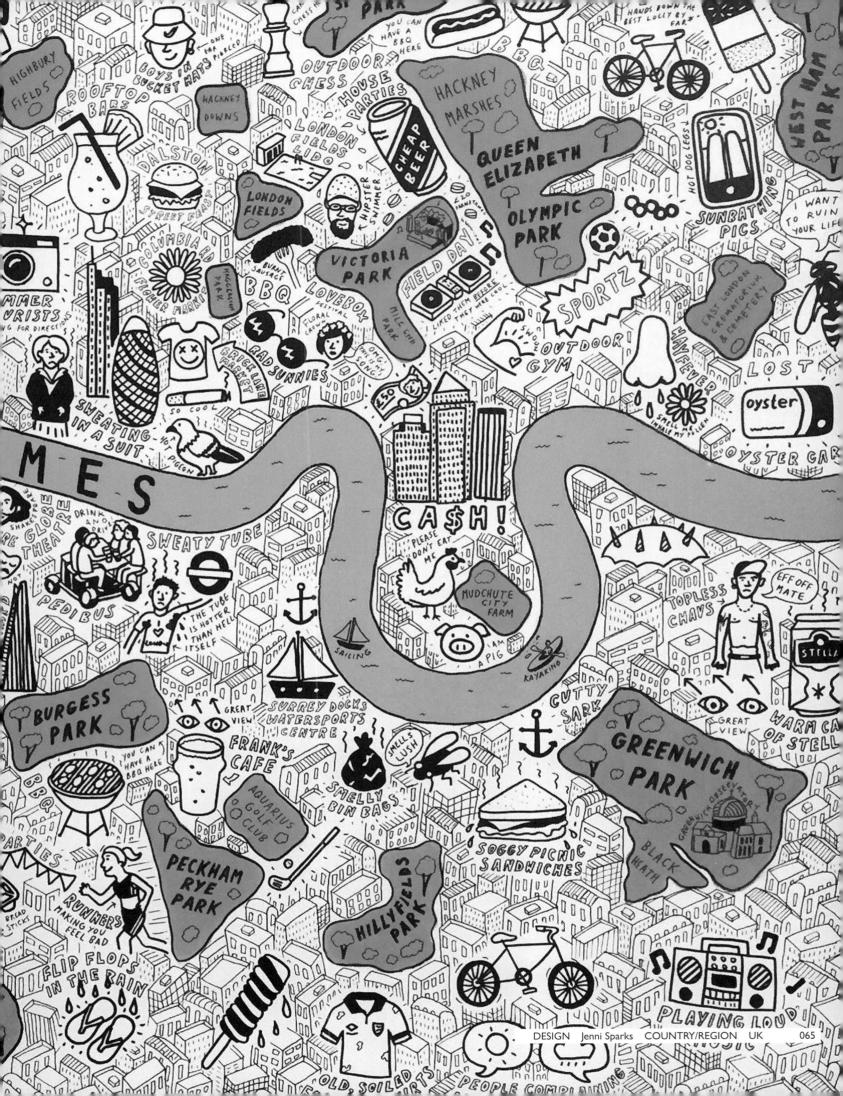

MAPPING THE PHYSICAL ENVIRONMENT

Global vision of the i[nternational air traffic]

| LAX | DEN | DAL | HOU | MIN | ATL | CHI | TOR |
| Los Angeles | Denver | Dallas | Houston | Minneapolis | Atlanta | Chicago | Toronto |

Introduction

This map is an original creation in partnership with READI Design Lab of l'Ecole de Design Nantes Atlantique. It represents the worldwide civilian air traffic in 2009, built out of the datasets from the website openflight.org, treated and visualized with the software Gephi. The map aim to a better understanding on how airports are distributed around the world, by showing the traffic with links them to each others. The density is highlighted to represent the importance of the major airports that are standing out and indicates the main world routes from North America to Europe to Asia. The map is built with an home made algorithms that sort 6344 nodes and trace 16684 edges, if a human would have to draw all the lines using the routes data sheet one by one it would take approximately 31 hours. (Nodes that are not connected are mistaken links of empty routes).

Legend

- 01 — NYC New York
- 02 — LDN London
- 03 — TOR Toronto
- 04 — PAR Paris
- 05 — AMS Amsterdam
- 06 — FRA Frankfurt
- 07 — CHI Chicago
- 08 — ATL Atlanta
- 09 — LAX Los Angeles
- 10 — MUN Munich
- 11 — ROM Rome
- 12 — MAD Madrid
- 13 — DXB Dubai
- 14 — NAY Beijing
- 15 — HOU Houston

Lucas Briceno, Bao-Anh Bui, Brendan Gerard — All right reserved, do not reproduce without written autorisations.

Flightviz

This map represents the worldwide civilian air traffic in 2009, built out of the datasets from the website openflight.org, treated and visualized with the software Gephi. It aims to visualize a better understanding of how airports are distributed around the world, by showing the traffic which links them to each other. The density is highlighted to represent the importance of the major airports and indicates the main world routes between North America, Europe and Asia.

DESIGN Lucas Briceno, Bao-Anh Bui & Brendan Gerard COUNTRY/REGION France

ernational civilian air traffic in 2009

| MAD | PAR | LDN | ROM | AMS | FRA | MUN | IST | DUB | MOS | BEI |
| Madrid | Paris | London | Roma | Amsterdam | Frankfurt | Munich | Istanbul | Dubai | Moscow | Beijing |

Anamorphic map

Spatial distribution

✈ #1382;Paris;CDG;Paris;49.012779;2.55

A 01
A 02
A 03+

Designer LUCAS Briceno BAO-ANH Bui BRENDAN Gerard

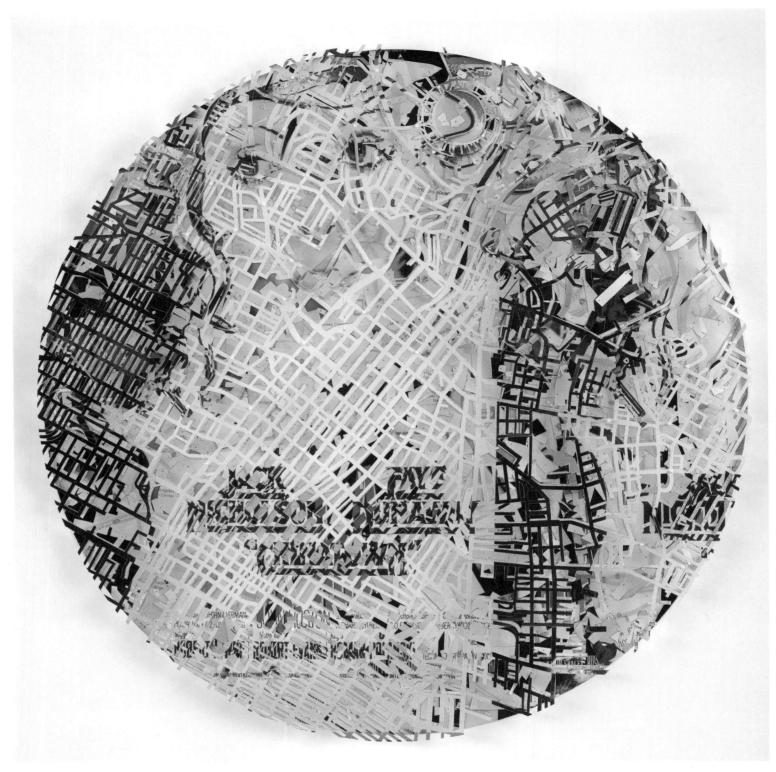

Los Angeles #1 *Chinatown*

Map Sculptures

These works map the terrain of cities as well as their historical and cultural landscape, reflecting each city's evolving individuality and idiosyncrasy. The sculptures interweave the narratives of personal and public history. Within the urban form this builds a portrait of a city layered with history and time. Picton is concerned less with creating a factual and objective record than with presenting an emotional and cultural history of the city, the non-objective mirror of history through the film, music, literature and visual art of the time.

Los Angeles #1 *Chinatown* is cut through on the surface from the poster *Chinatown*. This film by Roman Polanski, starring Jack Nicholson and Faye Dunaway, is about the corruption that accompanied the acquisition of the water rights from the Owens Valley in the early twentieth century. Partially visible underneath the sculpture is the poster from the film *LA Confidential*, which also illuminated the legendary corruption of the Los Angeles Police Department in the 1950s.

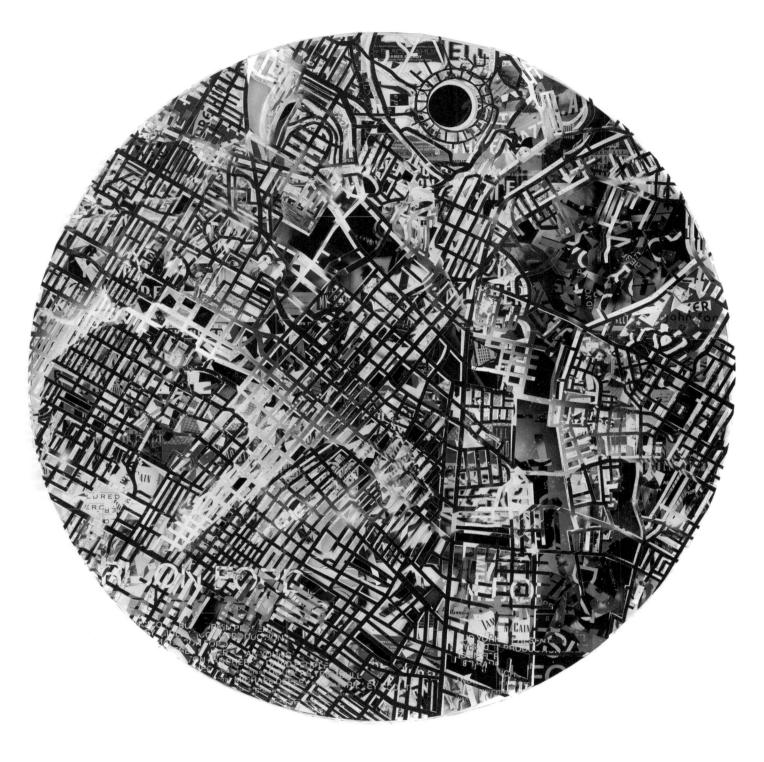

Los Angeles #2 *Bladerunner*

Los Angeles #2 *Bladerunner* is an extensively fictionalized city, where the line between actual history and that of a screenplay are completely blurred and intertwined. This sculpture is created from a cut-through poster of the classic 1982 dystopian neo-noir film *Bladerunner*, which was directed by Ridley Scott, based on the 1968 novel *Do Androids Dream of Electric Sheep?*. Behind this poster are fragmented book covers from some of the classics of noir fiction to have emerged from Los Angeles, such as *The Big Nowhere*, *White Jazz*, *LA Confidential* and *The Black Dahlia*, by James Elroy, and *Mildred Pierce* and *Double Indemnity* by James McCain. Between these layers and following the main street are lines of text and quotes relating to the history of Los Angeles. Finally the quote which runs the circumference of the work (although hard to detect in this instance) is by Carey McWilliams from the 1940s: "The belief in some awful fate that will someday engulf the region is widespread and persistent."

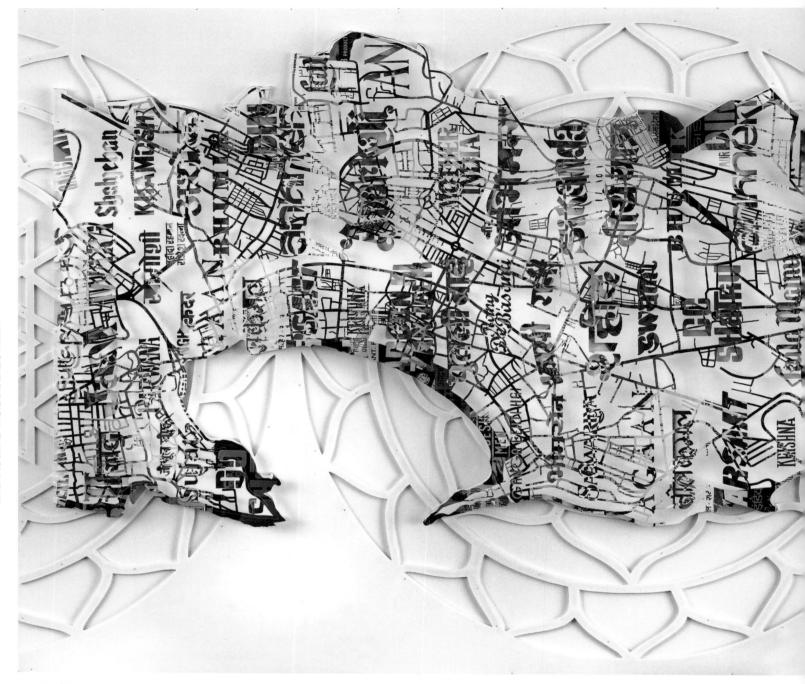

Mumbai/Bombay

The street maps of Mumbai have been created out of Bollywood film posters. Surrounding the form of the peninsula of Bombay in the ocean are white cut-out forms of the Shri Yantra, representing the beauty of three worlds – earth, atmosphere and sky – and the union of masculine and feminine divinity. This is one of the forms created for the annual Diwali festival in Mumbai. Diwali, a celebration of inner light emerging from spiritual darkness, is an ancient Hindu festival that takes place every autumn and centres on the new moon. The night of Diwali is the day Lakshmi, goddess of prosperity, chooses Vishnu as her husband and marries him. Prayers are typically offered to Lakshmi; lamps are lit to symbolize the sun, cosmic giver of light and energy to all life. Outside the houses in the doorways and entrances, women and children create Rangoli patterns in bright colours to surround their homes with auspicious symbols for the year ahead. The entire sculpture is underpinned and surrounded by the Shri Yantra, which is perhaps the most meaningful symbol of all.

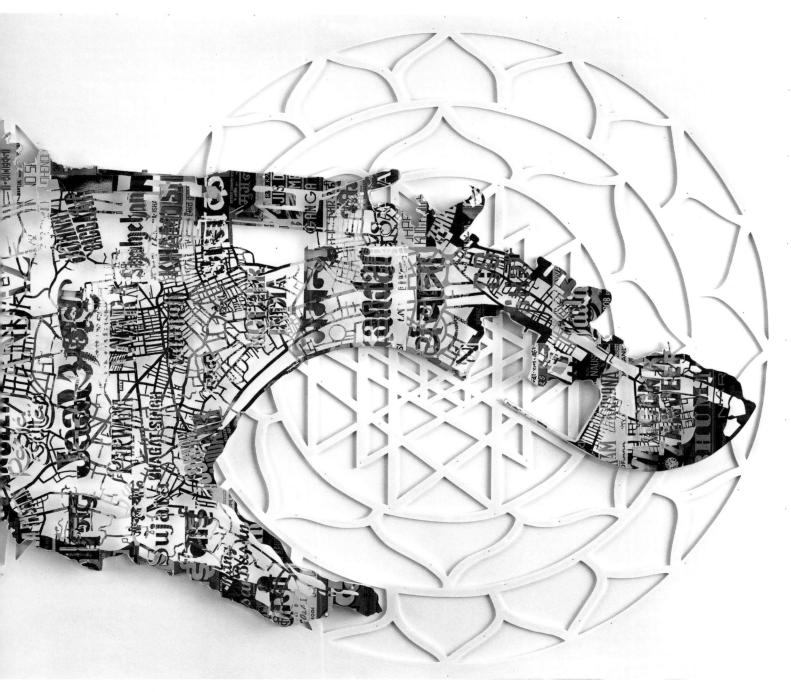
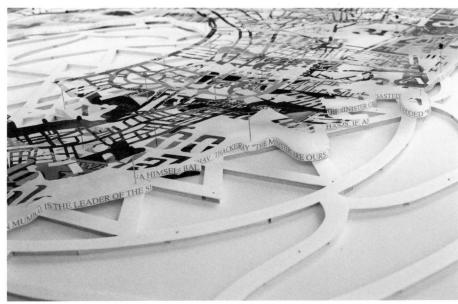

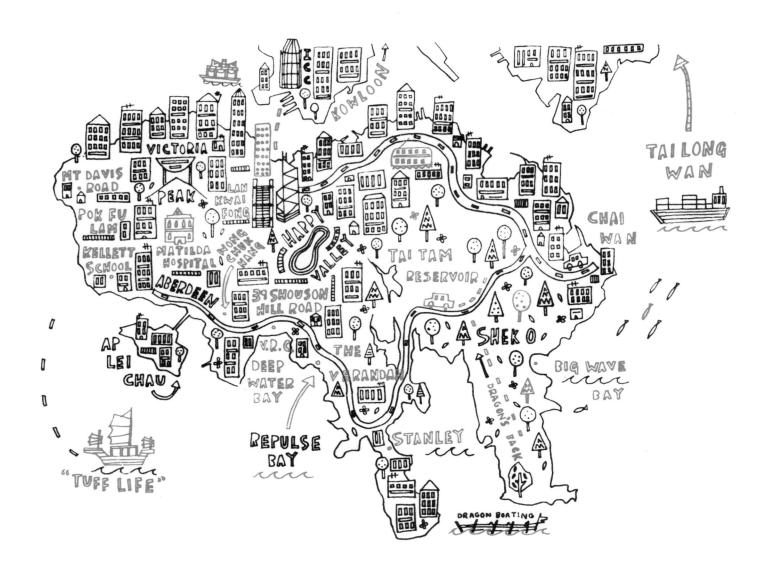

Hong Kong Illustrations

Both these illustrations are from Marshall's city map series. The first features the whole of Hong Kong island. Marshall designed the map based purely on line, incorporating well-known landmarks with places of personal significance to the client. The illustration was designed as a two-colour screen print with key features highlighted in a contrasting colour.
Similarly, the map on the right used contrasting colours with key features highlighted in red and other elements in blue. Based on the client's demands, the map incorporated key landmarks, including the Bank of China building and I.C.C., alongside places of more personal significance.

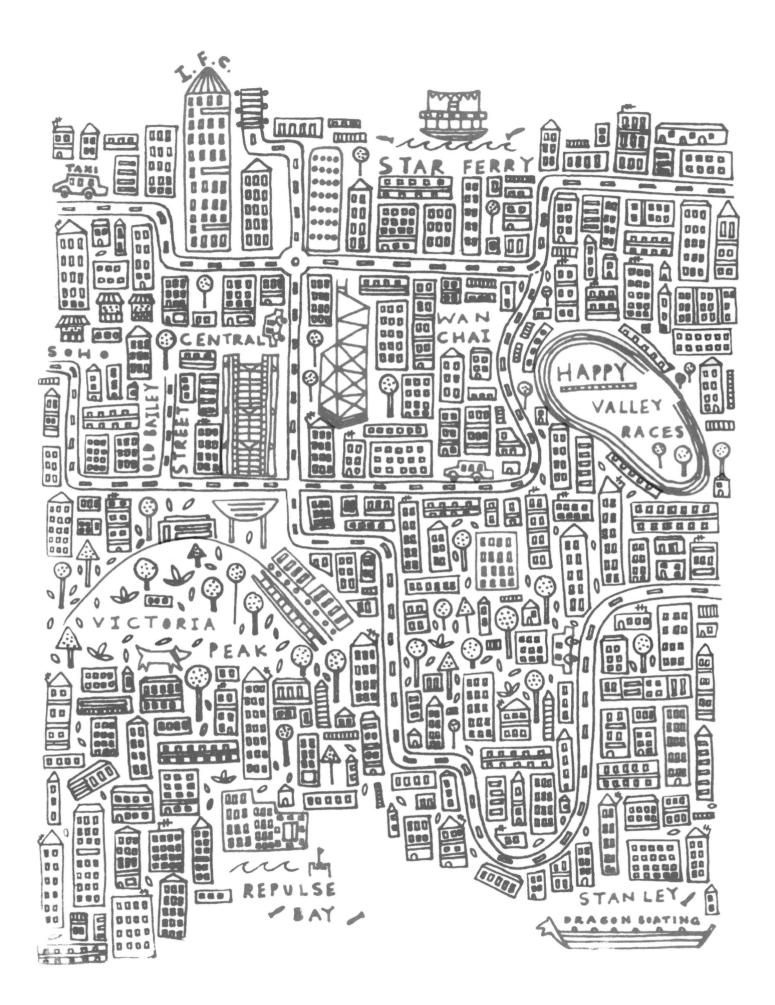

DESIGN Steph Marshall COUNTRY/REGION UK

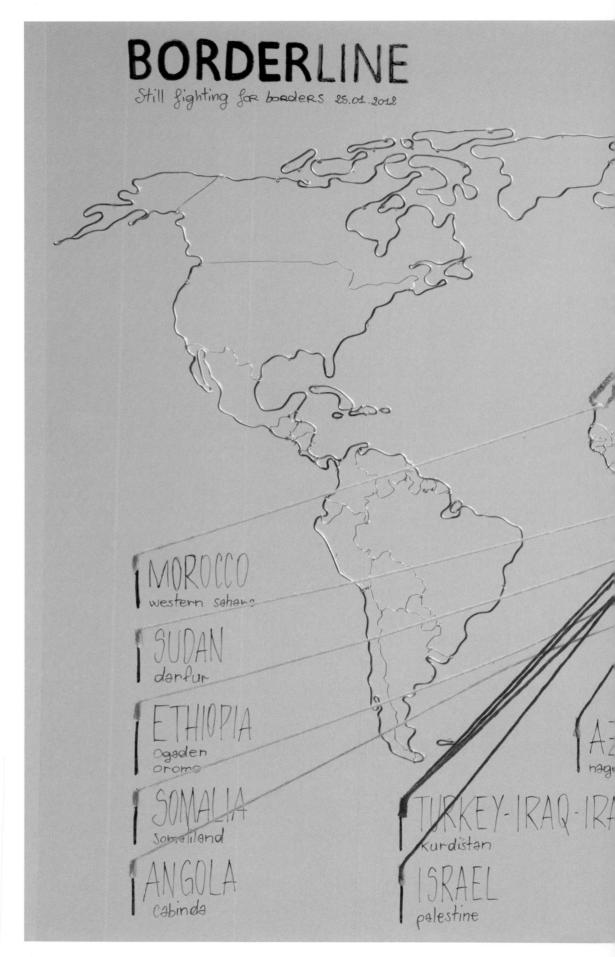

Borderline

The aim of this project is to reflect upon the purpose of national borders. To illustrate this idea, the map was made out of flexible metal wires on a transparent board. A few of the borders have been highlighted with coloured threads to express the possibility of upcoming alteration due to internal turmoil or struggles for independence. The project gives us an opportunity to think about the violence caused by something that is, by its very nature, arbitrary and unstable.

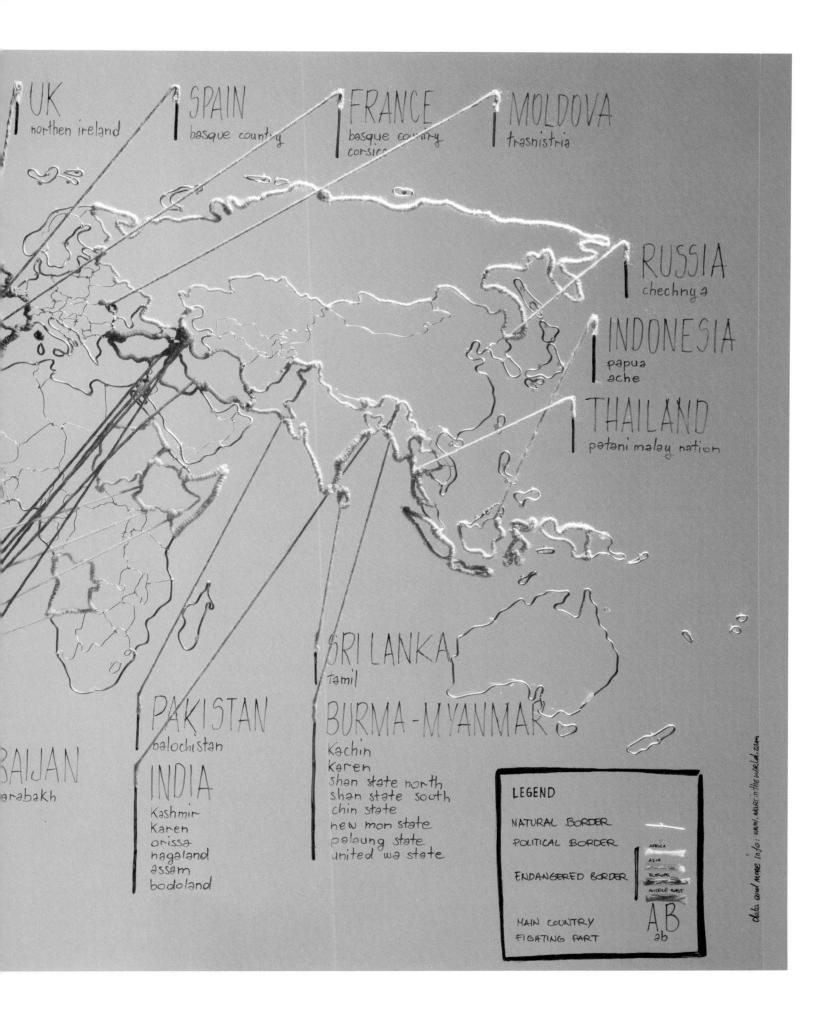

"Around the World" Illustrated Map

With its colourful design, the "Around the World" map takes you on a journey of discovery. Featuring an eclectic selection of famous landmarks, it can be used as an educational tool for children or to feed an exploratory mind. The map is printed on a magnetic board on which kids can mark with a dry-erase marker or place magnets on special places they have been to or would like to visit.

Typographic Heartland Map

This is a map of the Midwest of the United States. The aim was to create the map purely out of typography, using functional information. Though the resulting map is abstract, it is informative and results in a cool visual effect. The map was printed on Patriot Blue Classic Crest 80lb Cover, with cream-coloured ink. The Great Lakes were hit with a gloss varnish to add another subtle dimension to the map.

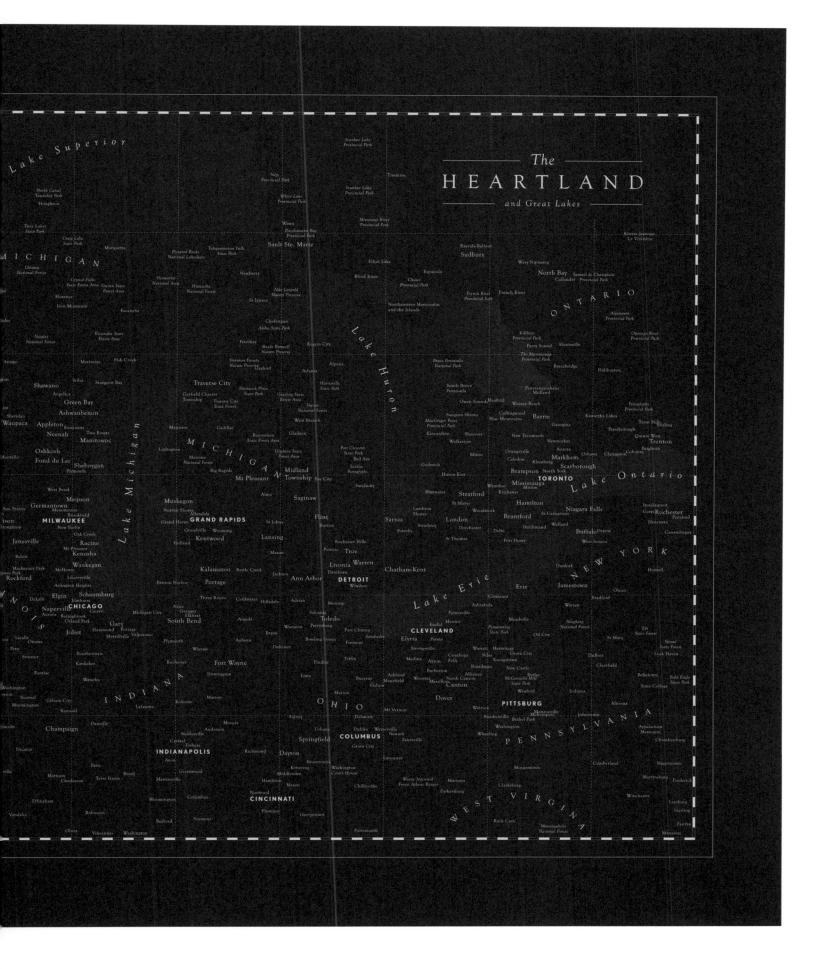

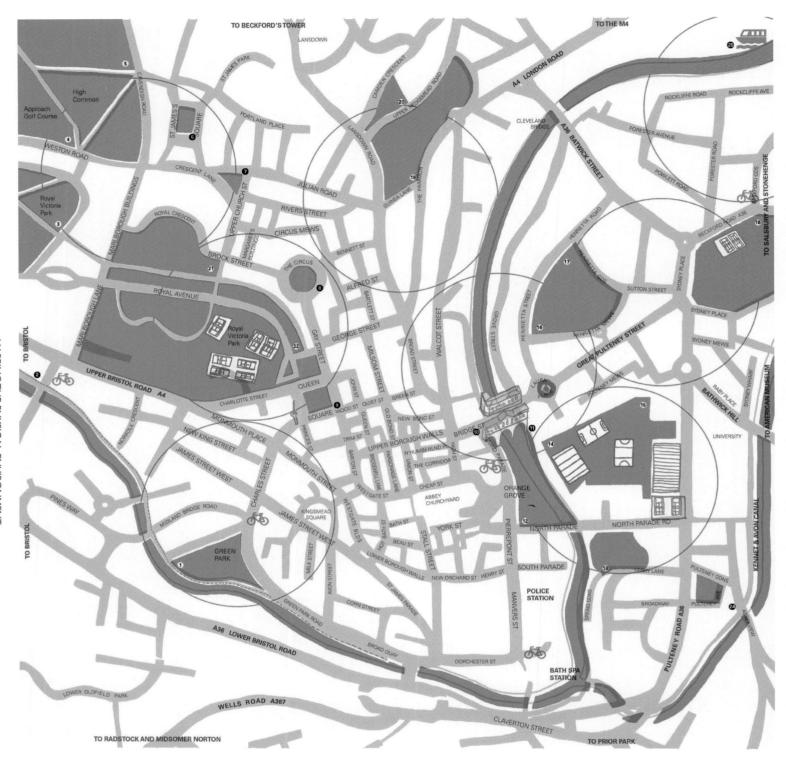

Bath °C Thermo Colour Map

This "magic" map is a hand-held activated map, based on Bath city, England. Using thermochromic inks and tyvek fabric, the map is activated at different temperatures, revealing layers of hand-illustrated buildings and attractions, showing the best places to visit depending on the weather. Designed as a roll map, the fabric is waterproof and crumpleproof, allowing it to be easily stored in a bag. The map is colour-coded to specific external environmental temperatures, which allows tourists, visitors and residents alike to have a new experience of Bath.

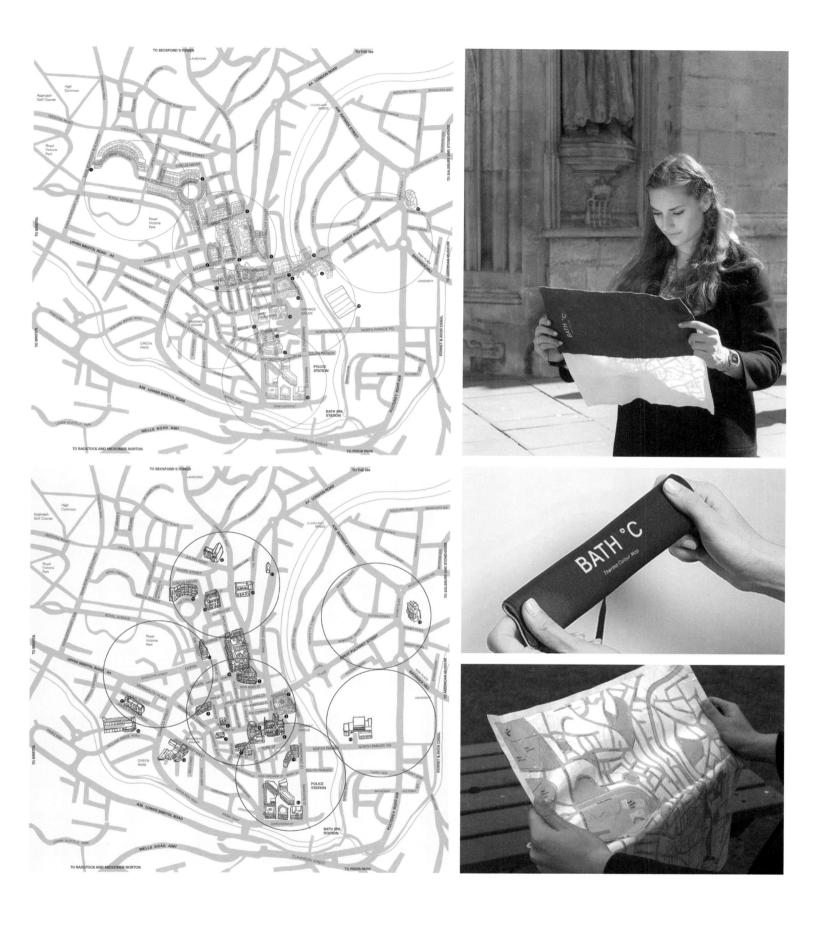

DESIGN Camilla Hempleman-Adams COUNTRY/REGION UK

MAPPING THE PHYSICAL ENVIRONMENT

Map Art

Tompsett likes to experiment with different styles and subjects, but his main focus is on map art and city skylines, a genre in which he has become a trend-setter. These three artworks are picked from his map art series. The World Map Painted Splashes is created from gold, burgundy and purple paint splashes, and the following two maps depict the city of San Francisco in different colour palettes. The colourful one draws land areas filled with five selected colours and the sea in light blue, while the other is a watercolour background with land areas overlaid and darkened.

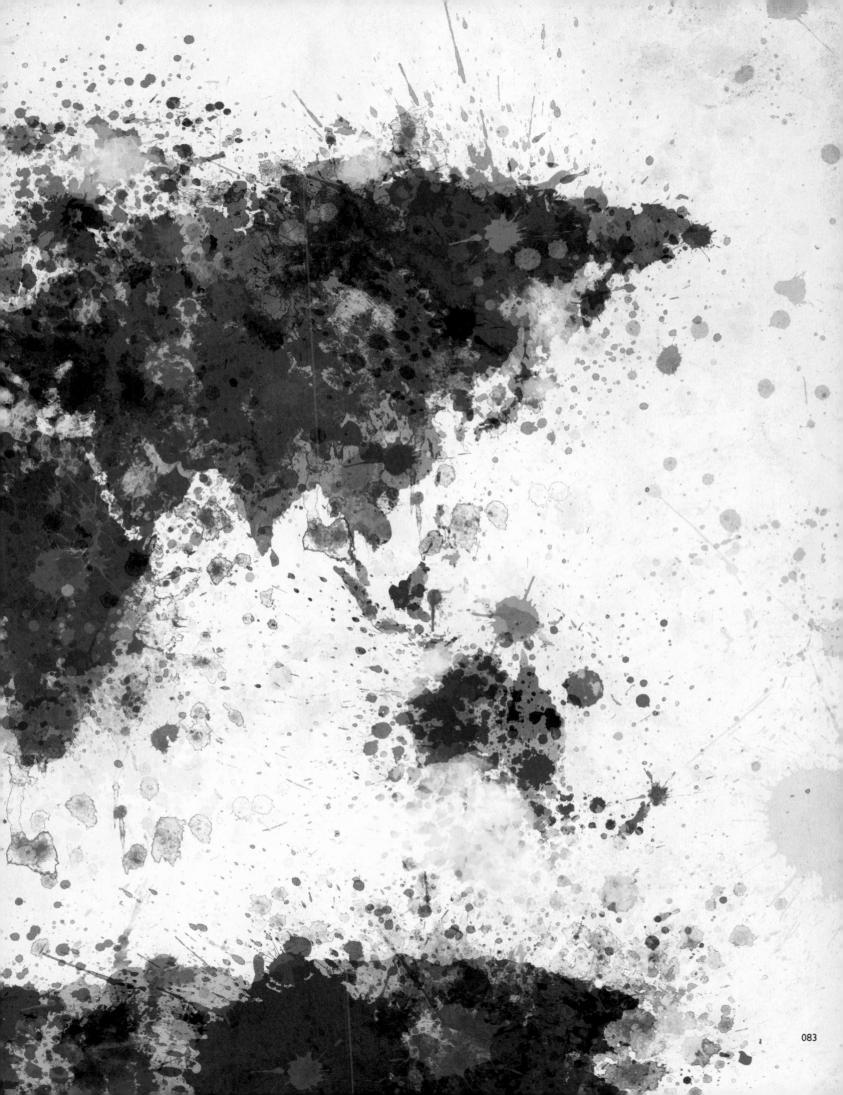

MAPPING THE PHYSICAL ENVIRONMENT

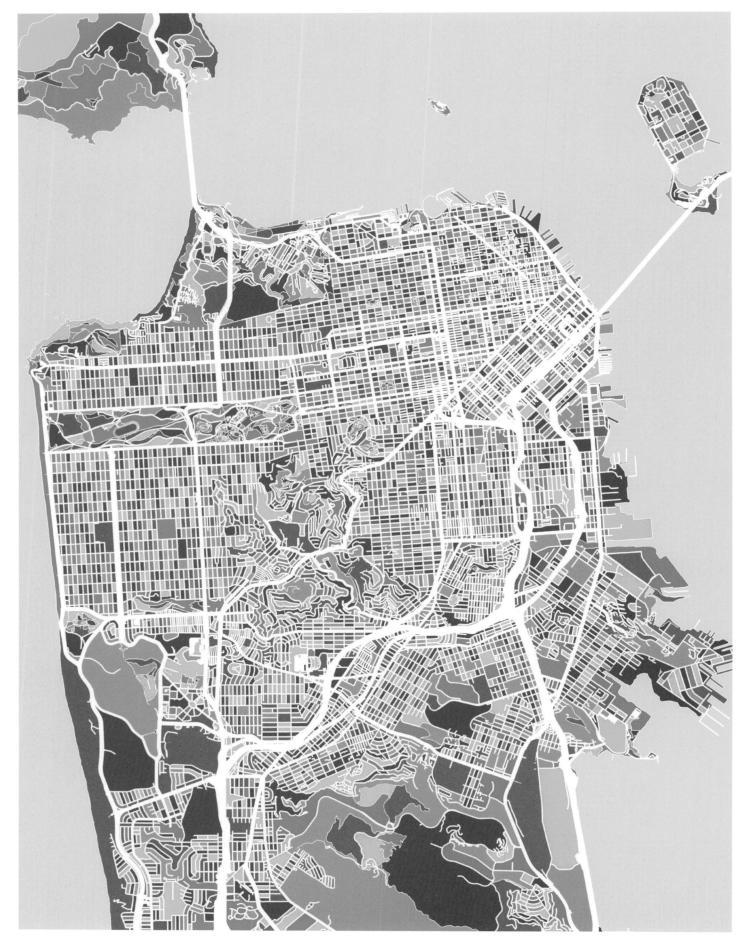

SAN FRANCISCO

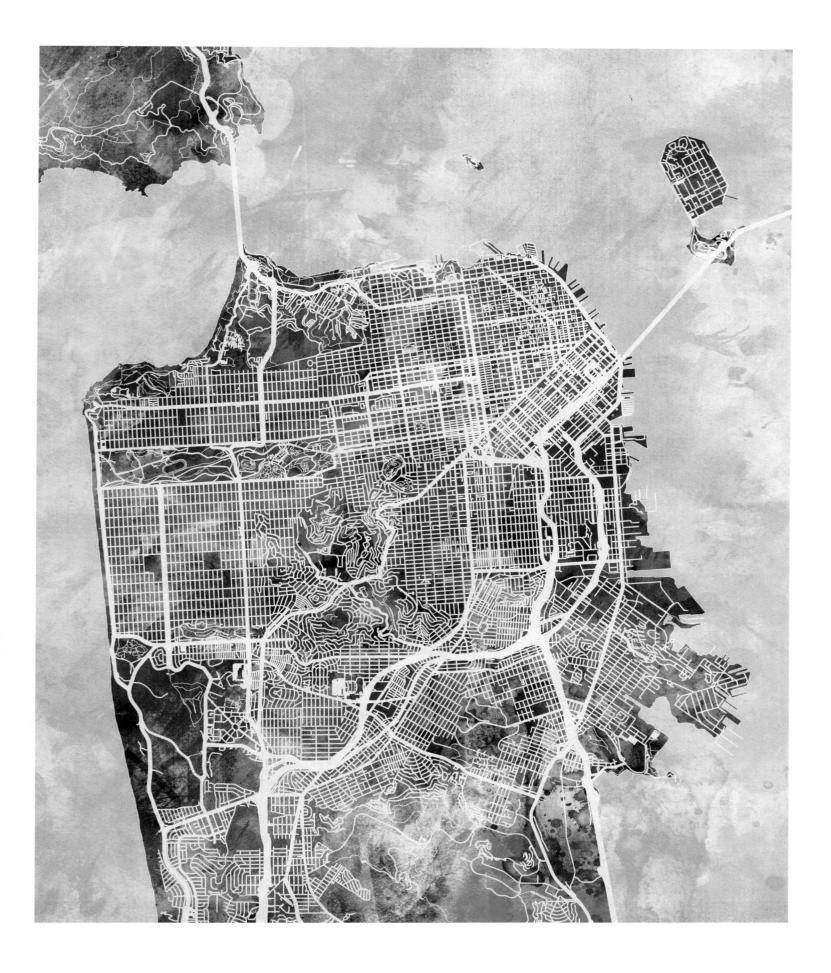

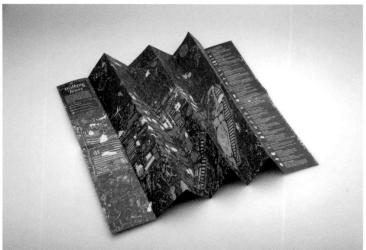

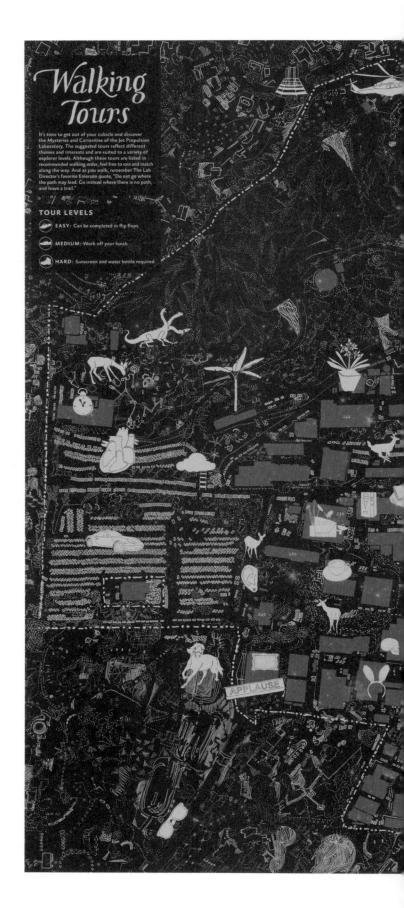

Mysteries and Curiosities of the Jet Propulsion Laboratory

NASA Jet Propulsion Laboratory is a place where employees need to use GPS to find their way around. For one, buildings have numbers instead of names. Second, buildings are identified by the number of when they were funded, instead of by location. For example, Building 67 is perplexingly located between Buildings 238 and 138. So the design team plotted this map which could be a suggested guide (but not an authoritative one) for tourists to this mysterious and curious place known as the Jet Propulsion Laboratory. The map itself is divided into two sections. The front is an Insider's Guide to JPL. The back provides several walking tours, which encourage Lab exploration. Whether visiting the world's most stable clock or the weavers who hand-stitch the thermal blankets for every mission, or simply finding a new place to have lunch, this map offers a fresh perspective on the overlooked aspects of the Lab's culture that make it so unique.

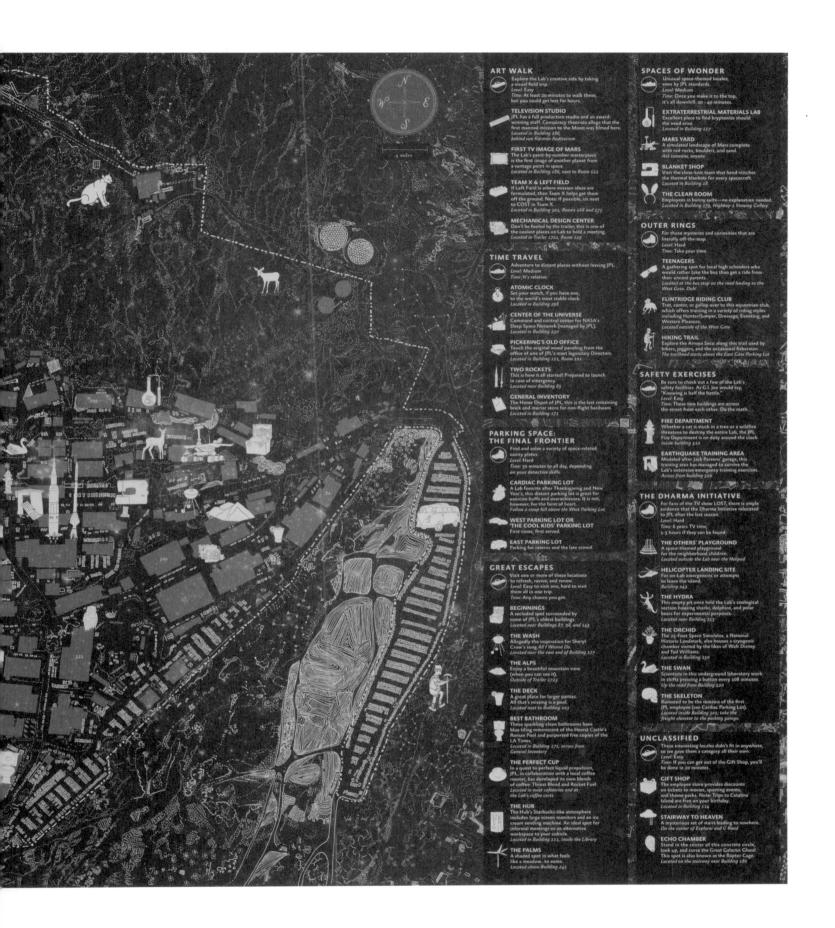

Here's Your Jetpack
AN INSIDER'S GUIDE TO JPL

A Brief History of Time

October 31, 1936 — The Suicide Squad performs its first motor tests in the Arroyo Seco near Devil's Den.

July 1, 1944 — The Lab is officially named the Jet Propulsion Laboratory.

January 31, 1958 — Explorer 1 becomes the first satellite launched by the United States.

January 1, 1959 — JPL transfers from the U.S. Army to NASA.

August 27, 1962 — Mariner 2 becomes the first spacecraft to successfully fly by another planet and return data.

November 28, 1964 — Mariner 4 returns the first images ever taken of another planet's surface by a spacecraft.

June 2, 1966 — Surveyor 1 makes the first American soft-landing on the Moon.

March 18, 19— — Goldstone's 6— antenna recei— first spacecra— Goldstone i— three structur— would later b— NASA's Deep — Network.

JPL Through the Looking Glass

PEOPLE, OUR GREATEST ASSET
JPL is a community of trailblazers, constantly pushing the limits of space exploration. United by a common mission, we seek to go where no one has gone before.

Groups Sections Divisions

THE BUSINESS OF SPACE TRAVEL
Every business has an organizational structure and JPL is no different. Each JPL employee is assigned to a Group. This Group, along with other Groups, makes up a Section. Several Sections constitute a Division, and several Divisions form a Directorate.

DIRECTORATES
The greater JPL pie is divided into nine slices called Directorates. Each Directorate is charted with its own role and responsibilities ranging from business administration and safety, to research into Earth, Mars, and Deep Space.

Rocket Men
Meet the Directors who have transformed JPL from a rocket-building facility to one that conducts space exploration.

THEODORE VON KÁRMÁN (1938–1944) — Dr. von Kármán made considerable contributions to the field of aerodynamics, and was awarded the first National Medal of Science by President Kennedy.

FRANK MALINA (1944–1946) — Dr. Malina helped establish the research and testing facilities that would become JPL. He also helped develop many of JPL's early successes for the U.S. Army.

LOUIS DUNN (1946–1954) — Under Dr. Dunn's leadership, JPL developed its first post-war guided missile, the Corporal.

WILLIAM PICKERING (1954–1976) — Dr. Pickering led JPL's efforts to launch the first U.S. satellite, Explorer 1. He also won JPL's transfer from the U.S. Army to NASA.

BRUCE MURRAY (1976–1982) — Dr. Murray was part of the imaging team for the early Mariner missions to Mars and was a forceful advocate for planetary exploration. After his JPL tenure, he returned to Caltech, where he is currently an emeritus professor.

LEW ALLEN, JR. (1982–1990) — Dr. Allen had a long and successful career in the military before becoming JPL's Director.

EDWARD STONE (1991–2001) — With a specialty in cosmic radiation, Dr. Stone became project scientist of the Voyager mission. After a decade as Director, Dr. Stone returned to Caltech where he is still a Voyager project scientist.

CHARLES ELACHI (2001–) — With an expertise in imaging radar, Dr. Elachi helped develop instruments that study Venus and Earth. He is currently the science team lead for the Cassini spacecraft's imaging radar instrument.

Source: www.jpl.nasa.gov

Eureka!

JPL has more patented intellectual property than all the other NASA centers combined. In fact, more than 200 U.S. companies have taken advantage of JPL's innovations. The inventors on Lab have contributed to commercial use in the fields of:

- Charge-coupled detectors or CCDs (now widely used in digital cameras)
- Advanced GPS receivers
- Image-processing techniques such as image restoration, mosaic effects, map projects, and three-dimensional "fly-through" animations
- Wireless communications, including deep space antennas, precision-timing systems, signal detection, and digital processing
- Digital imaging such as CAT scanning, ultrasounds, cardiac angiography, and nuclear magnetic resonance
- Miniaturization such as miniature infrared sensors used to locate cancerous tumors, and tiny camera chips placed in pills to photograph the digestive system
- Robotics, including robotic microsurgery, autonomous operations, and hazard avoidance visualization
- Lightweight optics and wavefront sensing and control
- Electronic monitoring systems that can remotely detect concealed weapons, heartbeats, and biometrics

Sources: JPL 101; "Into the Black" by Peter J. Westwick; National Space Technology Applications Office (NSTA).

The Suicide Squad

JPL was started by a group of Caltech students, a high school dropout, and a known occultist. Dubbed the "Suicide Squad", the group earned its nickname after repeatedly escaping explosions and asphyxiation during their early rocket tests. Like any team of super heroes, each member brought a unique talent to the group.

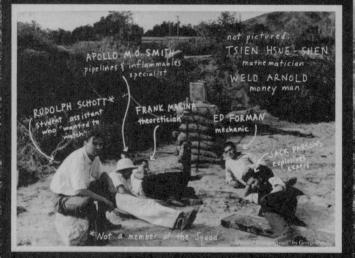

- RODOLPH SCHOTT* — student assistant who wanted to watch
- APOLLO M.O. SMITH — pipelines & inflammables specialist
- FRANK MALINA — theoretician
- Not pictured: TSIEN HSUE-SHEN — mathematician
- WELD ARNOLD — money man
- ED FORMAN — mechanic
- JACK PARSONS — explosives expert

*Not a member of the Squad

Lab Lingo

As when joining any exclusive club, new JPL hires need to know certain lingo. Here is a list of essential terms and definitions to help ease your transition.

AEROGEL: The lightest solid ever manufactured at 99.8 percent air. Also referred to as "Solid Smoke."

CASH OR CARD: The cafeteria does not accept credit or debit cards. Rather, it only accepts cash or a Caltech Dining Card. Thank you, darling.

CLEANROOM: A specially constructed area that provides a controlled environment for chemical, microbial, radiological, and/or particle contamination control.

GRAVITY ASSIST: A clever method of using energy from a planet to help speed a spacecraft on its way.

JPLer: A JPL employee.

LANYARD: The material used to hold up an employee badge — the most coveted being a mission lanyard.

PI: A Principal Investigator (PI), the science lead on a mission.

PURPLE PIGEON: An outside-the-box idea that could lead to a future mission.

RDO FRIDAYS: A regular day off, or RDO, that allows employees who work a 9/80 schedule (i.e., 80 hours of work in 9 days) to take every other Friday off from work.

SYSTEMS ENGINEERING: An interdisciplinary field that focuses on how complex engineering projects should be designed and managed over the life cycle of a project. JPL is a leader in this field.

TIGER TEAM: A small, nimble group of a mission's best people who are pulled together to quickly diagnose and fix a problem.

QUIET HOUR: Not a nap, but rather a meeting with your manager where you can talk about anything.

WAM: A work authorization memo (WAM), the process that enables JPL managers/supervisors to delegate and authorize work for a specific cost account (i.e., the way you get paid).

Safety Signs A–Z

Because of the dangers inherent in rocket science, JPL has taken extra steps to ensure that safety is a top priority. Below is a sample of the large variety of safety signs on lab that you may not see at another place of business.

MAPPING THE PHYSICAL ENVIRONMENT

August 20 & September 5, 1977	June 28, 1978	May 4, 1989	December 2, 1993	February 11, 2000	January 4 & 25, 2004	November 4, 2010
Voyager 1 and 2 fly by Jupiter and Saturn while Voyager 2 also visits Uranus and Neptune. The Voyager missions would become JPL's longest-lived, with both spacecraft currently operating and returning data.	Seasat, an experimental satellite, flight-tests four instruments that use radar to study the Earth and its seas. Many subsequent Earth-orbiting instruments developed at JPL owe their legacy to this mission.	Magellan launches and later uses imaging radar to map 99 percent of the Venetian surface over four years.	An optical flaw is discovered in the Hubble Space Telescope's main mirror. JPL's Wide Field and Planetary Camera 2 saves the mission by correcting the space telescope's vision.	The Shuttle Radar Topography Mission acquires enough data to obtain the most complete near-global mapping of our planet's topography to date. Google uses these images for the first version of Google Maps.	Two mobile geologists named Spirit and Opportunity land on Mars. The rovers successfully complete a three-month primary mission on opposite sides of Mars and continue an extended mission for over seven years.	EPOXI encounters Comet Hartley 2. The EPOXI mission reused the Deep Impact spacecraft bus to catch up to another comet. This is the first spacecraft to visit two comets!

Source: www.jpl.nasa.gov

An INSIDER'S GUIDE to the Mysteries & Curiosities of the JET PROPULSION LABORATORY

177 Acres / +150 Buildings on Lab / ~5,000 Employees / ~1,000 PhDs / 2 National Historic Landmarks / TV Studio, Mars Yard, and Extraterrestrial Materials Lab / Expertise in Planetary Exploration, Earth Science, Telecommunications, Astronomy, and Physics / Developed and Manages the Deep Space Network / Lead U.S. Center for Robotic Exploration / Missions to Every Planet in the Solar System

NASA CENTERS

JPL is a division of Caltech but is also a federally funded research and development center (FFRDC). JPL is the only NASA Center that is managed by a university.

1. (HQ) NASA Headquarters: Washington, DC
2. (ARC) Ames Research Center: Moffett Field, CA
3. (DFRC) Dryden Flight Research Center: Edwards, CA
4. (GRC) Glenn Research Center: Cleveland, OH
5. (GSFC) Goddard Space Flight Center: Greenbelt, MD
6. (JPL) Jet Propulsion Laboratory: Pasadena, CA
7. (JSC) Johnson Space Center: Houston, TX
8. (KSC) Kennedy Space Center: Cape Canaveral, FL
9. (LARC) Langley Research Center: Hampton, VA
10. (MSFC) Marshall Space Flight Center: Huntsville, AL
11. (SSC) Stennis Space Center: Bay St. Louis, MS
12. (WFF) Wallops Flight Facility: Wallops Island, VA

Office of the Director
Business Operations Directorate
Engineering and Science Directorate
Solar System Exploration Directorate
Office of Safety and Mission Success
Mars Exploration Directorate
Astronomy, Physics, & Space Technology Directorate
Earth Science & Technology Directorate
Interplanetary Network Directorate

Signs of Life

"They may not wear lab coats or design spacecraft, but the wildlife that shares JPL's 177-acre campus is also part of its culture along with the human inhabitants. The Lab was built from the arroyo, or dry creek, up into the side of the San Gabriel Mountains. Lab employees learn quickly that they are simply allowed the courtesy of sharing the land." — JPL 101

Tracks clockwise from top left: Coyote, Bobcat, Ring-tailed Cat, Ground Squirrel, Mule Deer, Opossum

DIURNALS
Mule Deer (1)
Bobcat
Ring-tailed Cat
Tree Squirrel
Ground Squirrel

REPTILES
Garter Snake (2)
Gopher Snake
King Snake
Rattlesnake
Arroyo Southwestern Toad

NOCTURNALS
Coyote (3)
Opossum
Gray Fox
Mountain Lion

BIRDS
Red-tailed Hawk (4)
Great Horned Owl
Blue Jay
Peregrine Falcon
Least Bell's Vireo
Coastal California Gnatcatcher

TREES
Australian Fire Wheel (5)
Olive Tree (6)
Citronella Lemon-Scented Eucalyptus (7)
Coral Tree (8)
Brazilian Pepper Tree
Dawn Redwood Tree
Silk Floss Tree
Manzanita

INSECTS
Black Widow
Tortoise Beetle

PLANTS
Poison Sumac

The Caltech Connection

Who does a JPL employee work for—Caltech or NASA? JPLers are employees of Caltech, not civil servants. In contrast, the buildings in which they work, all the way down to the furniture and pencils, are property of the U.S. Government.

CALTECH

JPL is approximately 7 miles or a 16 minute drive (without traffic) to the California Institute of Technology. This is roughly the route you would take when traveling between the two institutions.

Source: Google Maps

Cosmic Callings

The odd cadre of jobs on Lab shows that many JPLers did not follow the advice of their high school guidance counselors. It is this wide range of skills, working toward a common mission, that make space travel possible. Here is a list of JPL's Cosmic Callings:

Auto Mechanic
Ethics Advisor
Firefighter
Glassblower*
Historian
Industrial Hygienist
Interplanetary Navigator
Locksmith
Magnetic Cleanliness Engineer
Mail Carrier
Microdevices Engineer
Parking Program Coordinator
Risk Communication Specialist
Thermal Blanket Weaver
Traffic Analyst
Visual Strategist

*Retired

Introduction

For a place that depends on logic and reason, the Lab's layout is anything but. In fact, a running joke at JPL is that its employees need to use GPS to find their way around the Lab. For one, buildings have numbers instead of names. Secondly, buildings are ordered in the number in which they were funded, instead of by location. For example, Building 67 is located between Buildings 238 and 138.

Intrigued by this dichotomy and wanting to know more about JPL aside from the four walls of my cubicle, I came up with a plan. Armed with a GPS tracking device, camera, and a trusty pair of shoes, I walked to every building on Lab in numerical order. What I thought would take a Saturday afternoon took 22 hours over the span of four days at a walking distance of 52.2 miles.

The resulting map is a reflection of this wacky experiment, research at the Lab's library, and conversations with other JPL employees. The map itself is divided into two sections. The front is an *Insider's Guide to JPL* containing information I wish someone had explained to me when I began working at the Lab.

The back provides several *Walking Tours*. In the same way that JPL encourages space exploration, these tours encourage Lab exploration. Whether visiting the world's most stable clock, the weavers who hand-stitch the thermal blankets for every mission, or simply finding a new place to have lunch, this map offers a fresh perspective on the overlooked aspects of the Lab's culture that make it so unique.

The map is not meant to be an authoritative guide, but rather a conversation starter, a poster, or simply a celebration of the mysterious and curious place known as the Jet Propulsion Laboratory.

— Luke Johnson

Website: mysteries.jpl.nasa.gov

Questions & Comments:
mysteries@jpl.nasa.gov

CURATION
Luke Johnson

DESIGN
Erin Ellis, Christiane Holzheid

COLLABORATORS
Dan Goods, Nora Mainland, Anisse Gross, Catherine Haradon

THANKS TO
Cozette Hart, Becky Campos, Victor Luo, Randii Wessen, Frank O'Donnell, Joe Courtney, Hunter Sebresos

FIRST EDITION

JPL

MAPPING THE PHYSICAL ENVIRONMENT

Pure Journeys

This detailed map encourages users to explore New Zealand and shows what the country can offer to tourists and adventurers. All the islands are represented, with the map showcasing their quirks and treasures. Espinosa undertook research to capture each region's vibe and highlights. He also tried to achieve a balance between whimsicality and realism, because the map is meant to represent real driving routes around the country.

DESIGN Pablo Espinosa COUNTRY/REGION Mexico

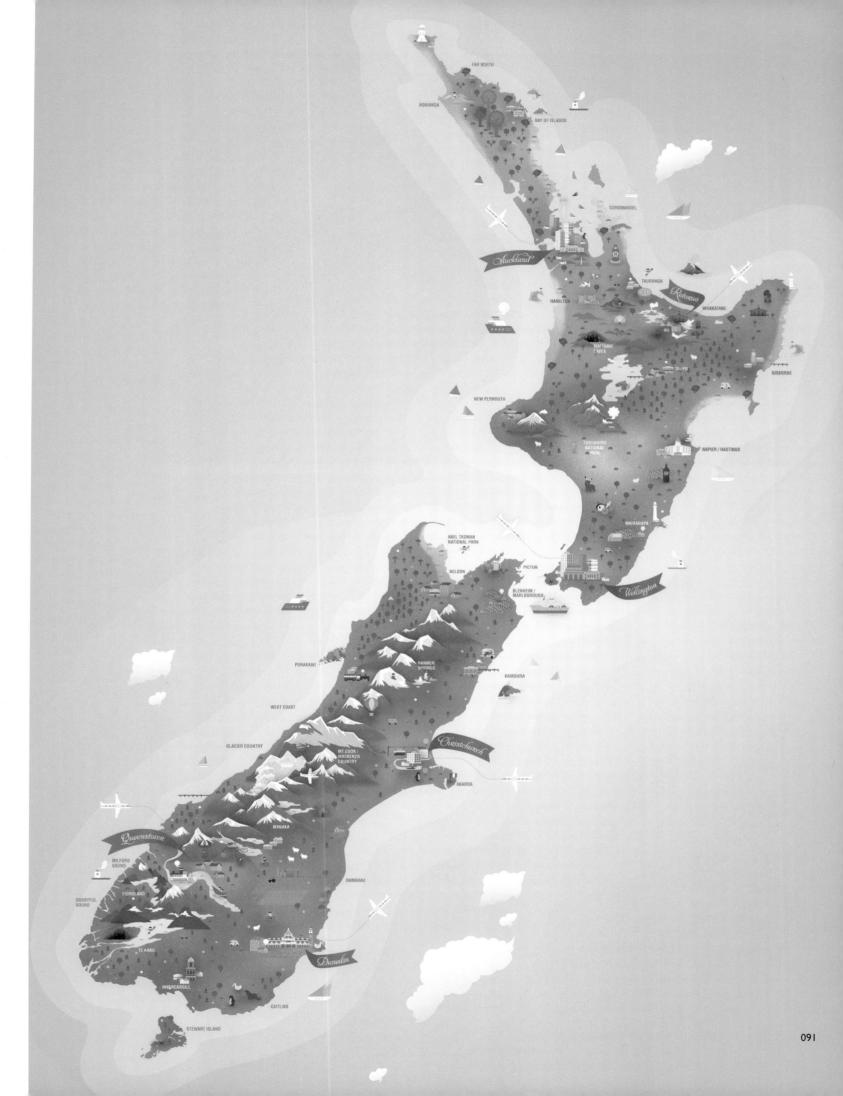

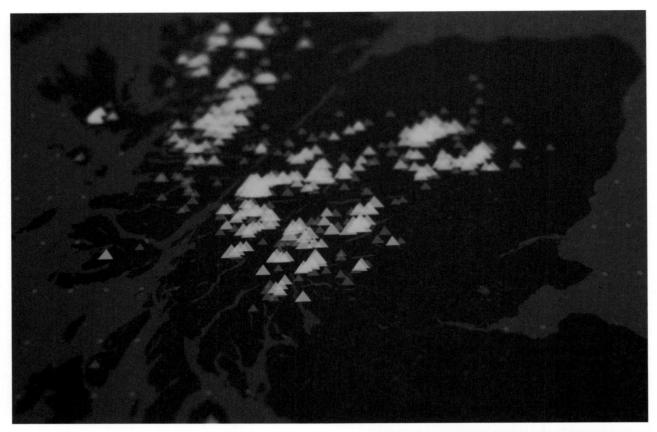

Processing: Scottish Mountains

Processing was used to produce this map of Scotland's Munros & Corbetts (types of Scottish mountains). This technique allowed for markers to be precisely positioned and scaled according to mountain height. The designer achieved both creative style and accuracy with this composition.

SCOTTISH MUNROS & CORBETTS

▲ **MUNRO**
MOUNTAIN WITH A HEIGHT
OVER 914.4M
TOTAL — 282

⊤ HIGHEST
BEN NEVIS
1344M

◆ LOCATION
56°47'48.7"N,5°00'12.6"W

⊥ LOWEST
BEN VANE
915.8M

◆ LOCATION
56°14'12.9"N,4°49'02.4"W

▲ **CORBETT**
PEAK THAT IS BETWEEN
762.0M AND 914.4M
TOTAL — 221

⊤ HIGHEST
SGURR NAN CEANNAICHEAN
913M

◆ LOCATION
57°29'11.5"N,5°11'30.0"W

⊥ LOWEST
BEINN NA H-UAMHA
762M

◆ LOCATION
56°44'41.8"N,5°24'28.3"W

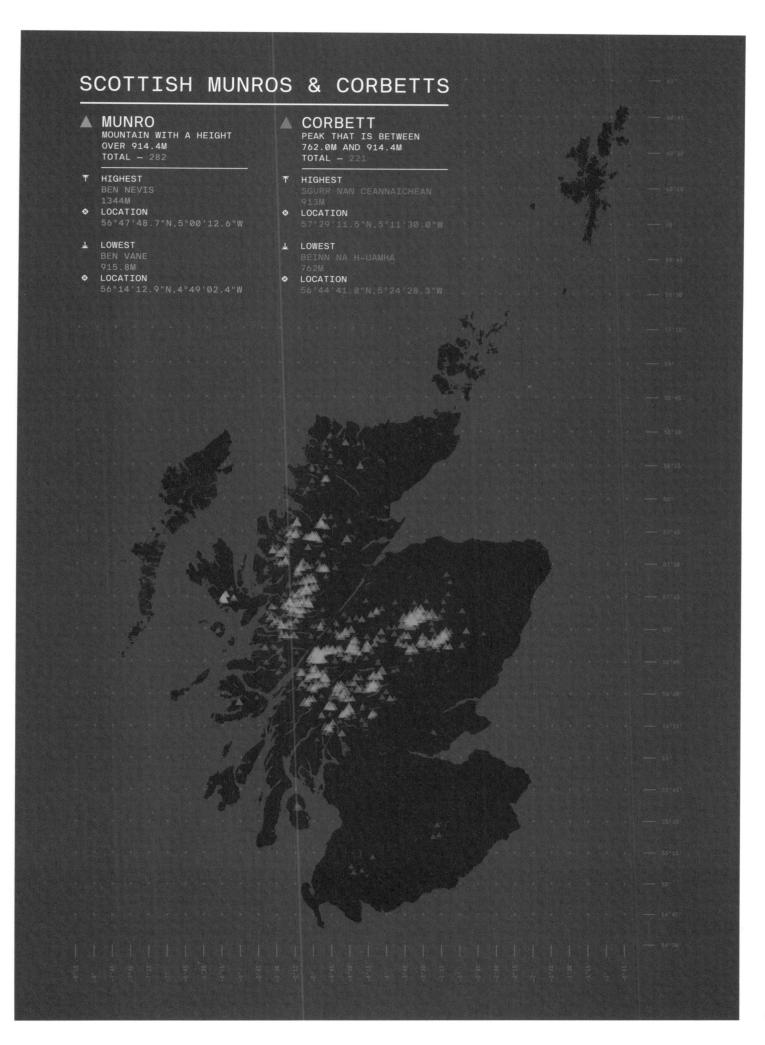

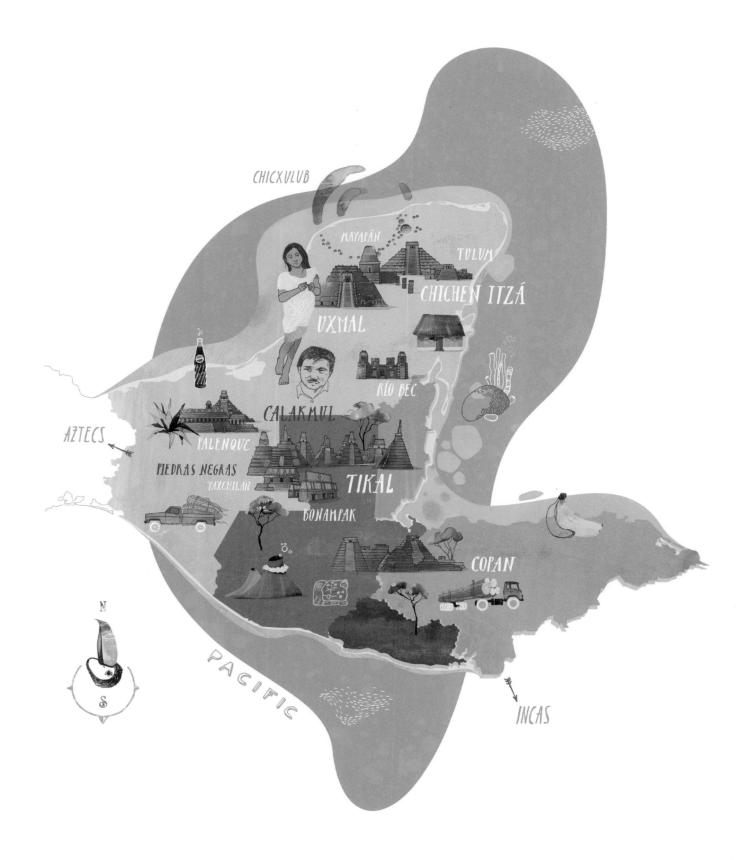

Map of Mesoamerica

This map of Mesoamerica shows the main sites of pre-classical Maya culture that are still in nearly-original condition. It is not only a topographic overview with architectural structures; it also gives an inside look at important eras and suggests their context today. The Chicxulub impact in the north of Yucatán formed the landscape and laid a foundation for human habitation, from the ancient Maya to modern times. To capture the feel of this whole area, the map is coloured like a landscape, be it semi-desert or forest.

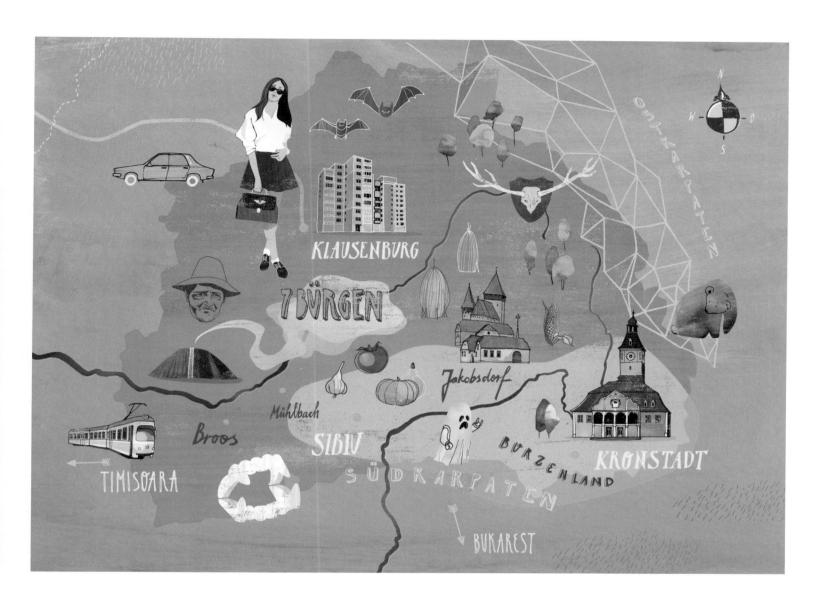

Map of Transylvania

This is an illustrated map of Transylvania, a historical region in the central part of Romania. This area is often represented in cliché, with references to Dracula, but this map presents a more realistically down-to-earth portrait.

DESIGN Tilo Richter COUNTRY/REGION Germany

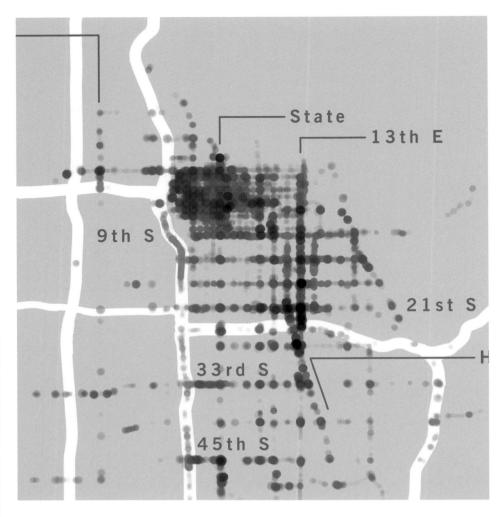

STOP MAP

SALT LAKE CITY TO OREM PROVO

Stop Map

During five years of running around the Salt Lake City-Provo Metro, Hull tracked a lot of traffic and stop lights, filtering all those tracks for speed, the patterns of where the freeway backs up and which major roads have a comparatively better flow. In town, the designer depicts unsurprising high-traffic areas in downtown Salt Lake, Sugarhouse, Park City and State Street in Orem. On the interstate, few people are surprised by the Point of the Mountain congestion, as well as the stretch from north Orem to American Fork, and the I-15/215 interchange. As the graphic shows, there is usually quick traffic on I-215 or I-80.

DESIGN Jonathan Hull COUNTRY/REGION USA

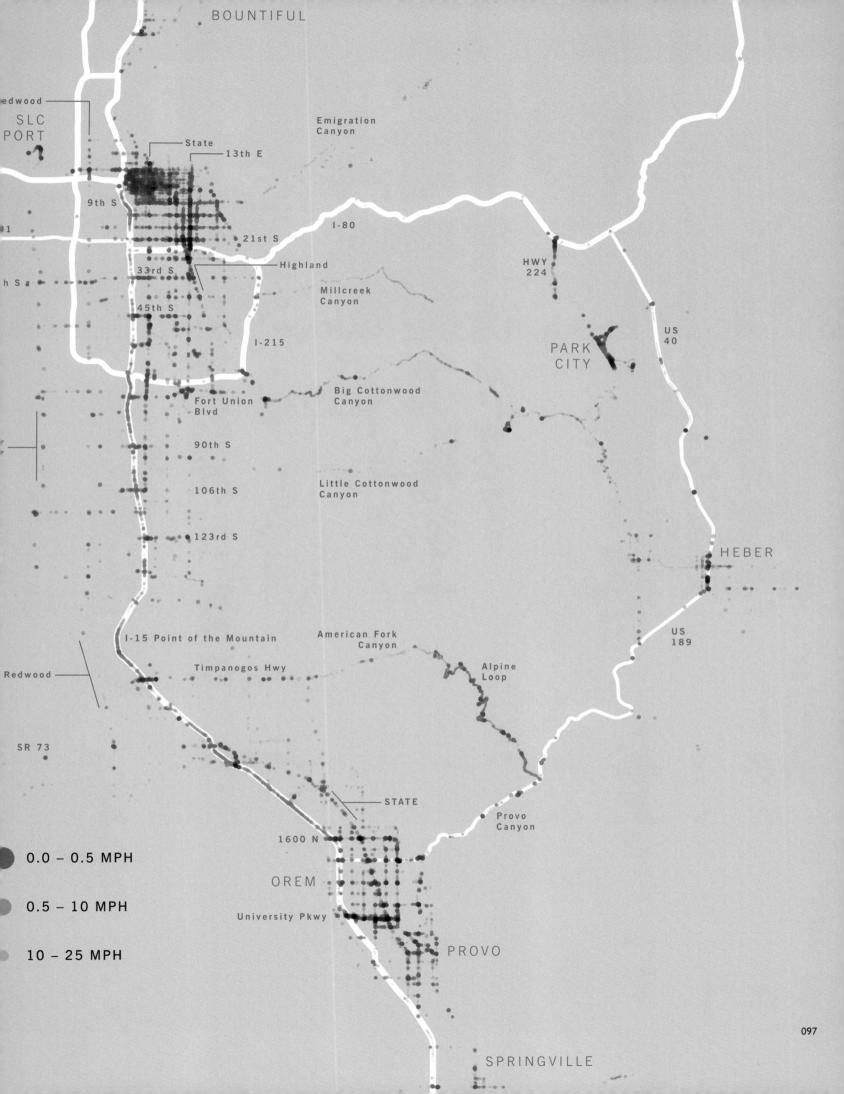

Moscow Metro Map

Named "Moscow Anthill", this art piece is an exclusive Moscow metro map made of natural materials. Representing the lines of the metro system by real birch branches, the designer expresses a metaphor and his nod to all the "ants" – the metropolitan citizens, who have built this beautiful city, metro and life!

DESIGN Raushan Sultanov COUNTRY/REGION Russia

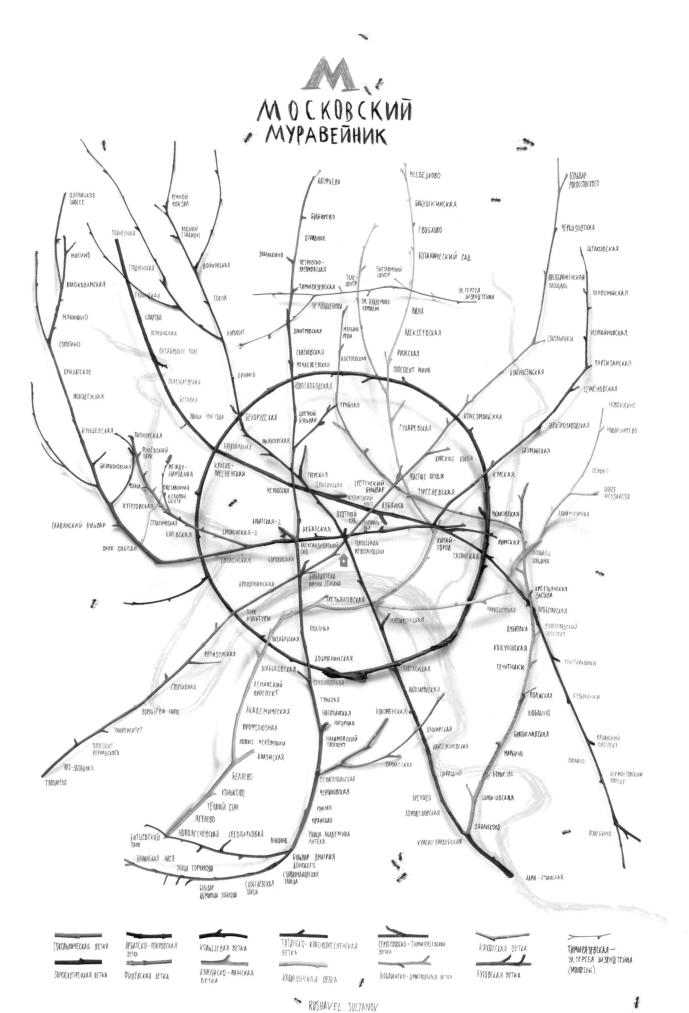

MAPPING THE PHYSICAL ENVIRONMENT

London: the Capital of Romance

This mosaic illustration was for the 2012 Saint Valentine's special issue of *Evening Standard* magazine. To correspond to this theme, a red heart was created in the centre of this map collage of fractional photos taken in London. The grid on which the mosaic is based is actually a very accurate map of the London metropolitan area.

DESIGN Charis Tsevis COUNTRY/REGION Greece

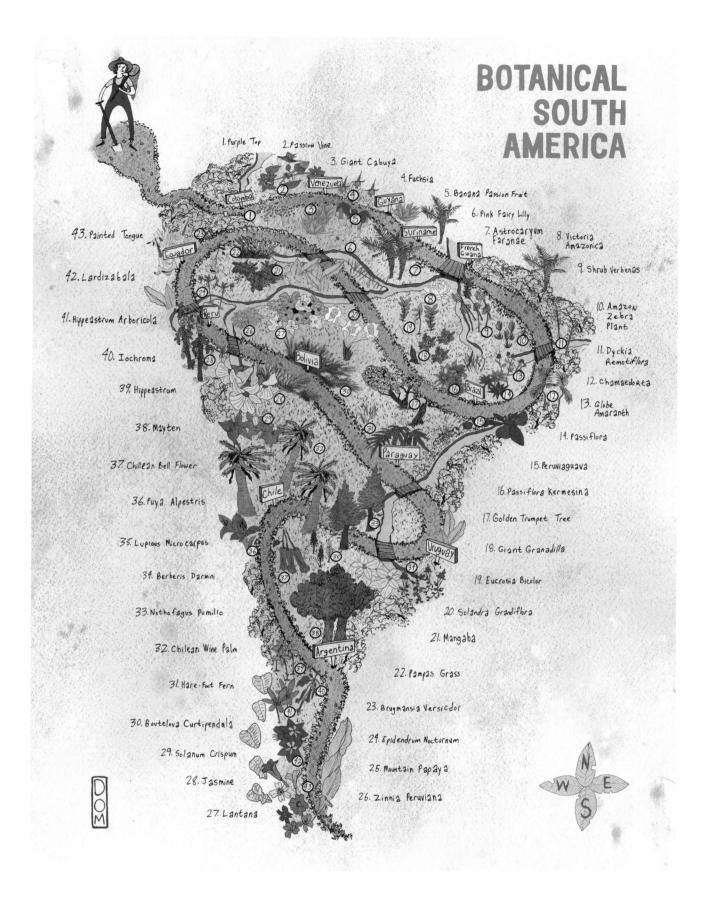

Botanical South America

Botanical South America is an info-graphic illustrated map made to characterize and capture the immense landscape, jungle and botanical life that thrives on the continent of South America. All the different plant life specific to each South American country is neatly organized on the map. To emphasize the plants and add to the character of the image, Civiello incorporated a softened edge into the outline of the continent, which gave the map an organic and natural shape as plants might have, while also maintaining its actual shape.

DESIGN Dom Civiello COUNTRY/REGION USA

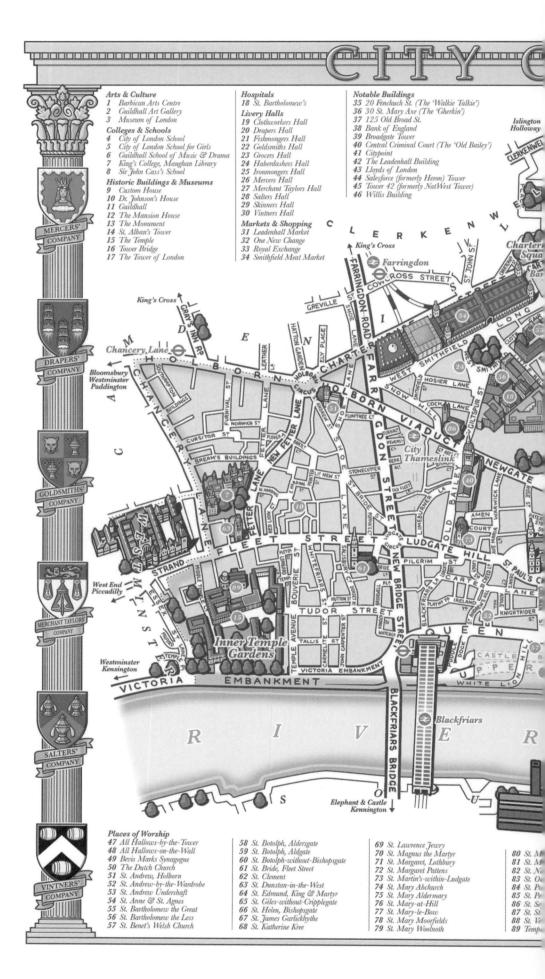

The City of London Illustrated Map

The design of this map of the historic centre of London is inspired by decorative antique map prints and the map art of MacDonald Gill (1884-1947). The coat of arms at the top centre is the official arms of the City Of London, a historic administrative entity separate from the rest of the metropolis, while along the left and right edges are twelve shields representing the "Great Twelve" Livery Companies or historic trade guilds. The border decoration is inspired by classical architecture, featuring two Corinthian columns supporting a lintel; this makes reference to both the original Roman founders of the city and the neo-classical architecture that abounds: the Bank of England and St Paul's Cathedral being two prominent examples.

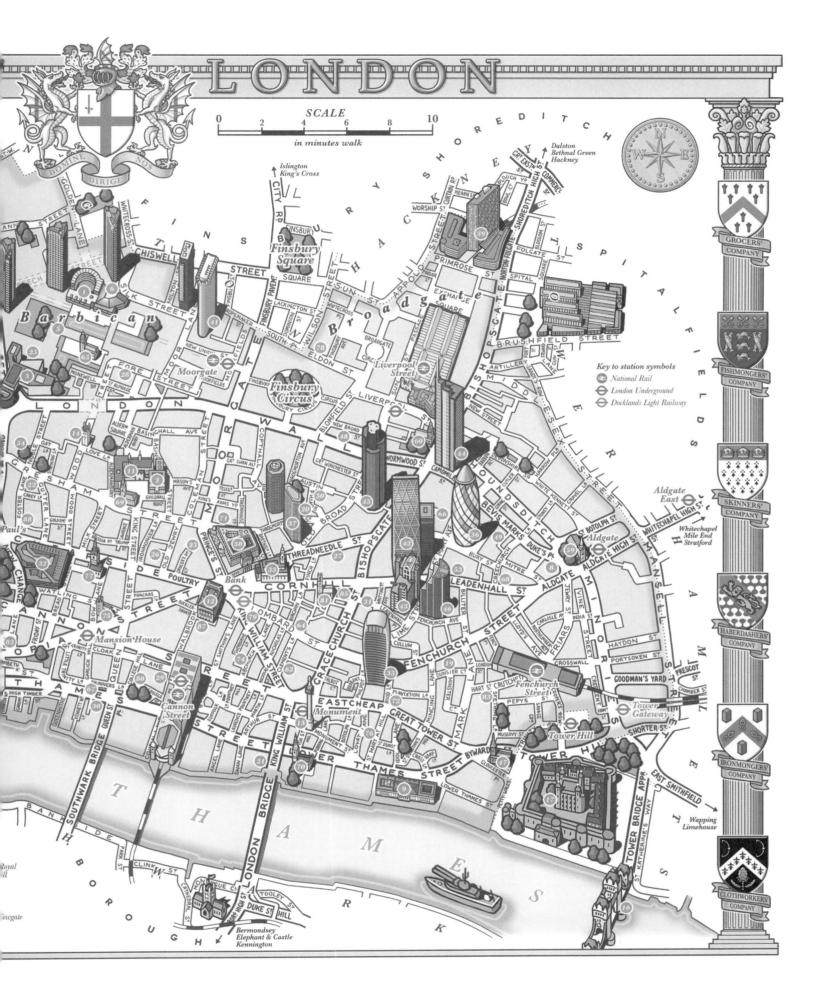

An Illustrated Map of Laurie Lee's Journey through Spain

This map illustrates the journey taken by the English writer Laurie Lee (1914–97) across Spain between 1935 and 1936, recounted in his memoir *As I Walked Out One Midsummer Morning* (published in 1969). This tale of a young man's solo journey on foot across Spain in the months before its devastating civil war is a fascinating read, vividly describing a poor agrarian society that seems unrecognizable today.

The design includes illustrations of places that Lee visited along his journey, including Vigo, Valladolid, Toledo and Seville. These were drawn to appear as they would have in the mid-1930s. The border was inspired by traditional Spanish tile decorations.

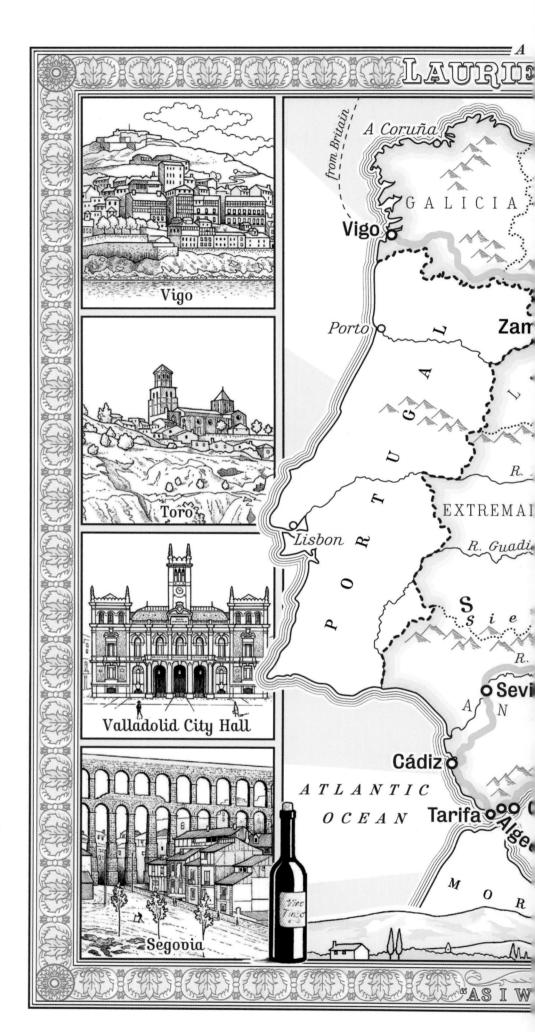

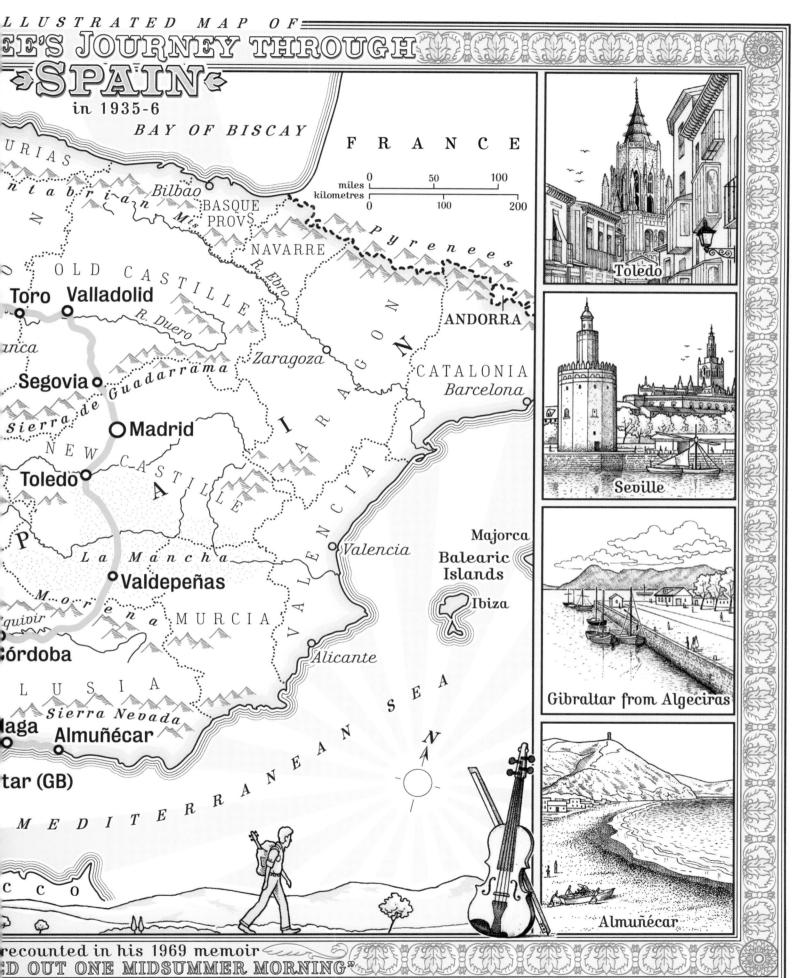

Illustrated Map of Central London

This design was inspired by decorative antique map prints and the map art of MacDonald Gill (1884-1947). It is embellished with illustrations of various famous and prominent landmarks in elevation, including major museums, churches, skyscrapers and attractions. Locations of all railway stations, major termini and London Underground stations are labelled.

The border decoration features coats of arms of the eight boroughs that appear on the map (Camden, City of Westminster, Hackney, Islington, Kensington & Chelsea, Lambeth, Southwark and Tower Hamlets) and the City of London (a separate administrative entity). Four illustrations in each corner show scenes and locations in different parts of the capital.

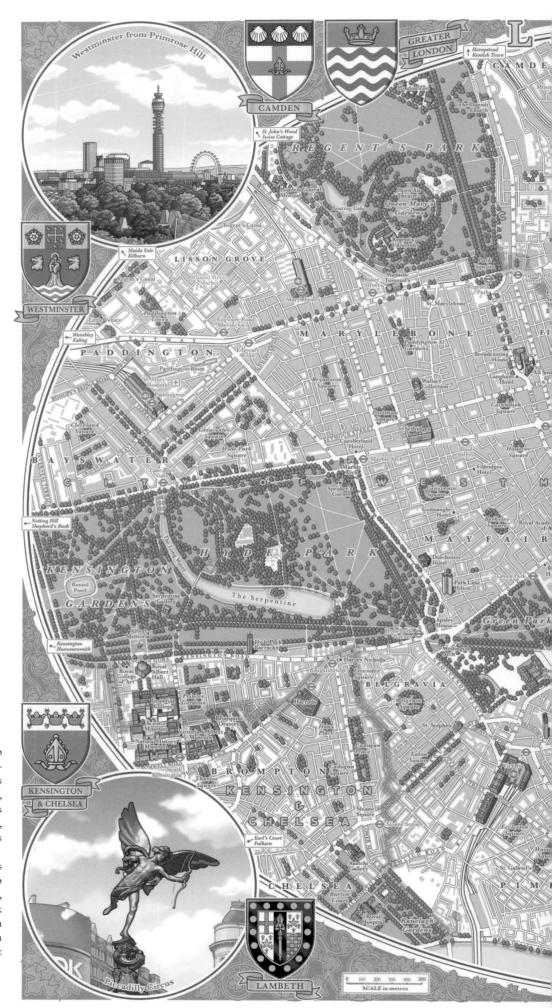

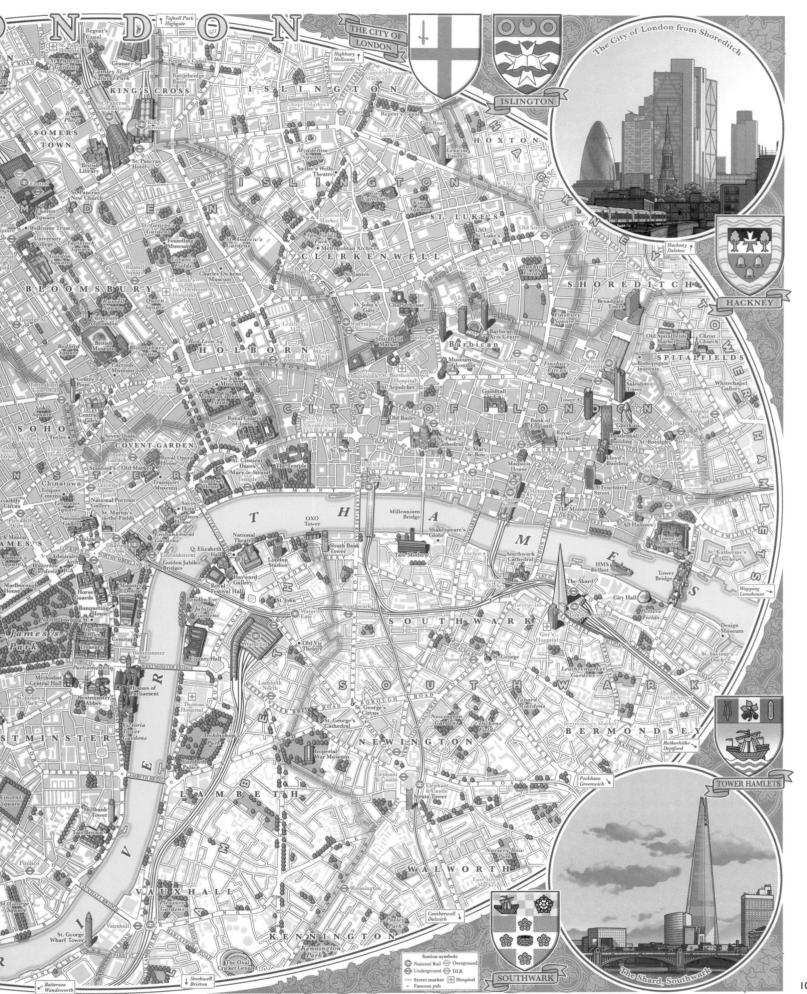

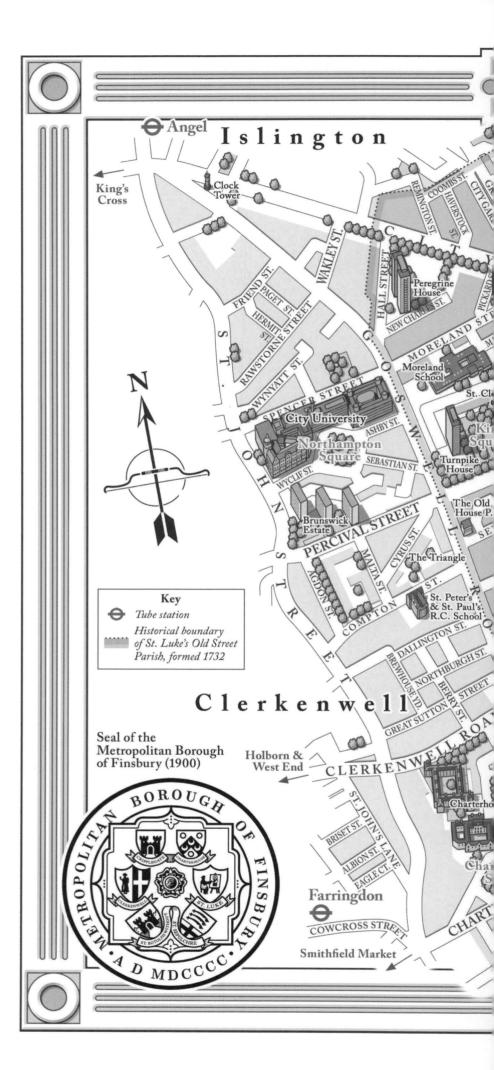

The Neighbourhood of St Luke's, London EC1

St Luke's Trust is a charitable organization based in the St Luke's neighbourhood in east-central London. Hall was commissioned by this organization to design a decorative map of the area for use in publicity and to sell as a print. The intention was to raise the profile of this mostly residential neighbourhood, located between the City, Angel, Clerkenwell and Shoreditch/Hoxton, which is little known to most people nowadays and is commonly referred to simply as "Old Street" owing to that station's location nearby. The map's design includes the coat of arms of the local borough of Islington and the seal of Finsbury, the old borough that was incorporated into Islington in 1965.

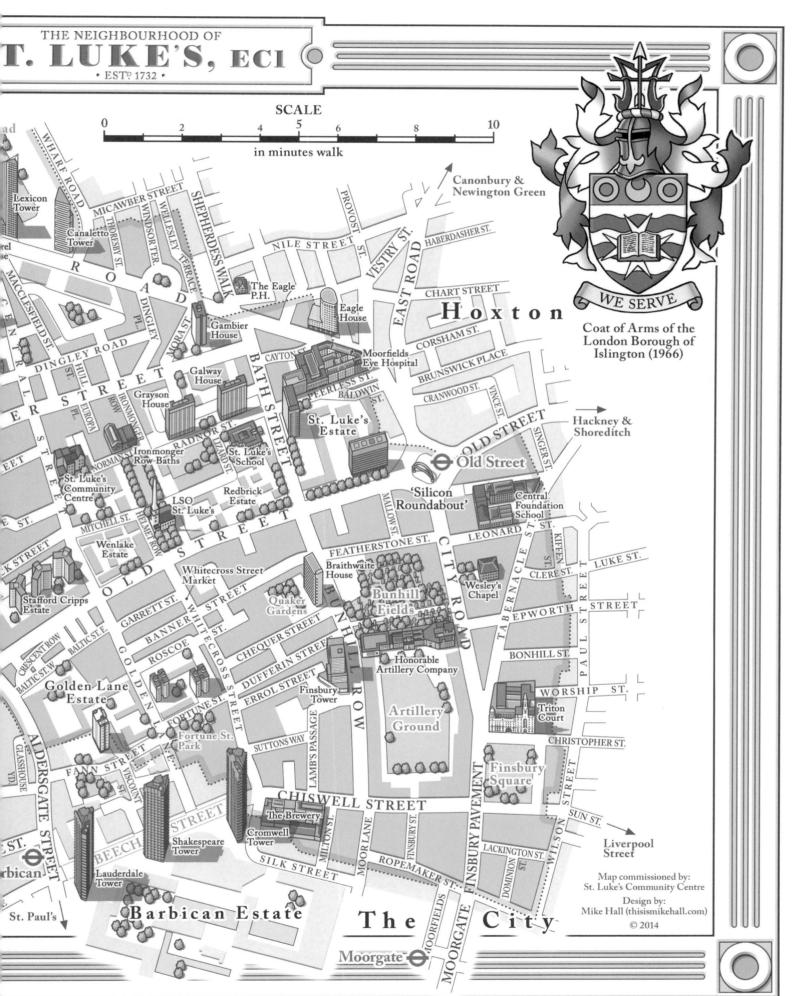

Blue Roads Map

A lot of the time nowadays we are overloaded and overwhelmed by so much information and demands on our time and energy. This concern inspired Norman to use an everyday blue biro to colour in the land areas of a map between the roads. In this way, she hopes to convey the beauty and importance of not knowing, of being quiet and finding your own path.

DESIGN Louise Norman COUNTRY/REGION UK

The Wash Roads Map

Norman used an everyday black biro to colour in the areas of land between the roads of a map, leaving only the green spaces free. Using a repetitive process of filling in each area blocks out all information and creates a new, simpler map reflecting her hand/mind and the process used to achieve it. Leaving the green spaces as they are evokes the wildness of nature and how it will always try to reclaim a space or map.

DESIGN Louise Norman COUNTRY/REGION UK

Time & Tide 2015

Composed of multi-layered hand-cut worlds, this work shows various natural forces at play in the oceans such as currents and tides, as well as tracks of ferry routes and other vessels. While the land-masses overlap and shift from layer to layer, the different tracks interweave and suggest new, complex tracks and patterns.

DESIGN Emma Johnson COUNTRY/REGION UK

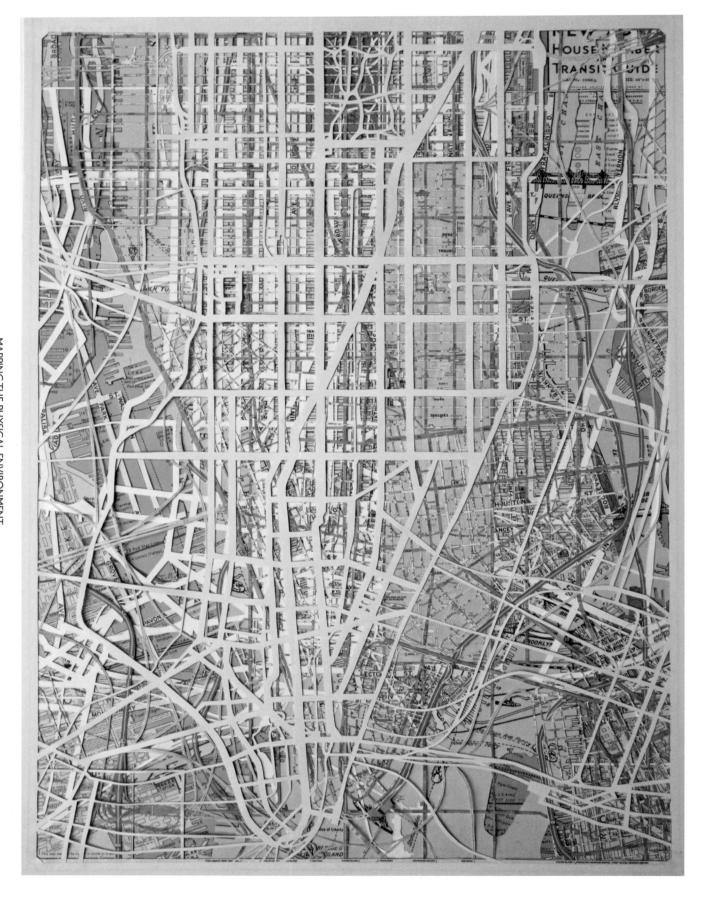

Manhattan Transit 2014

This work interprets a multi-layered hand-cut map of Manhattan. Cutting through the formalized grid-type structure of the city by superimposing, inverting and subverting its structure, a new complex grid structure emerges – still recognizable, but gridlocked.

DESIGN Emma Johnson COUNTRY/REGION UK

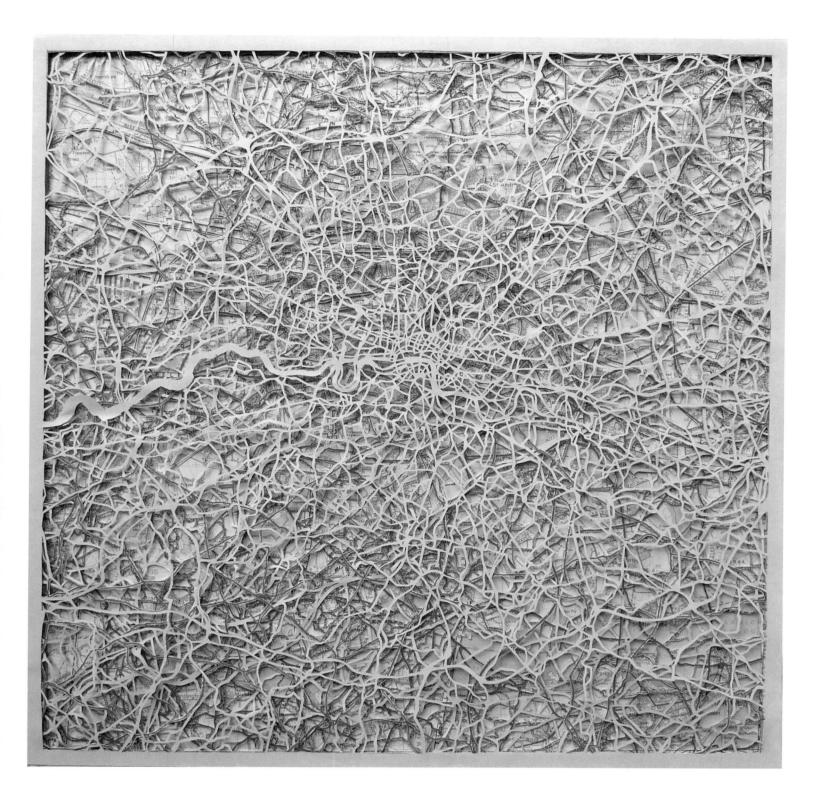

Dislocation: Time & Place 2011

The paper-cut map is composed from places the artist has lived in throughout her life, mapping her own personal journey. Its dissection and "dislocation" represent the fragmented nature of memory, time and history as well as a celebration of the intricate aesthetics of mapmaking.

DESIGN Emma Johnson COUNTRY/REGION UK

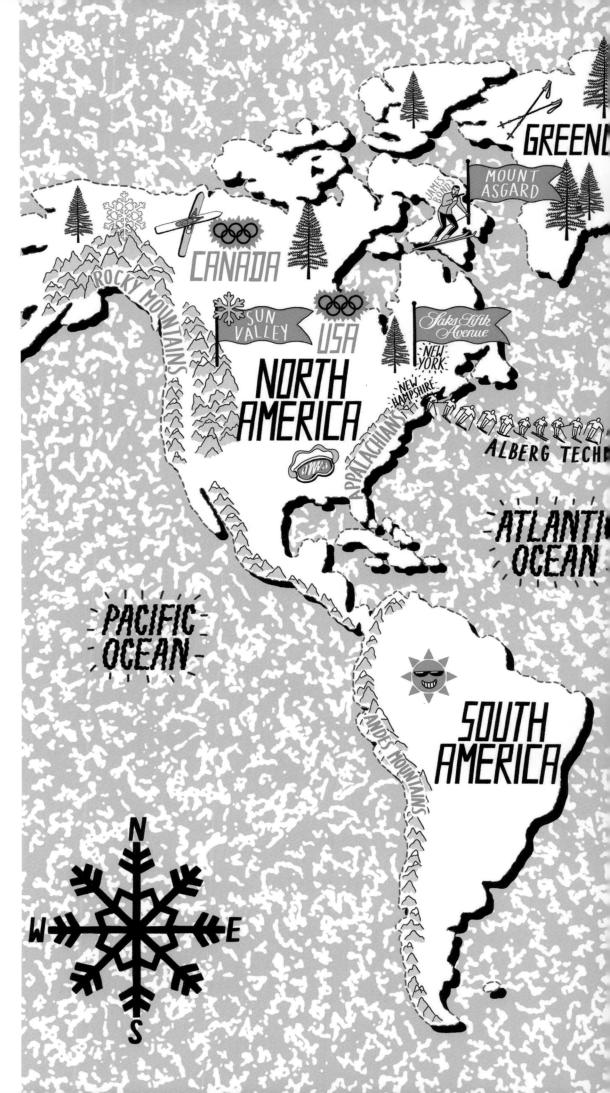

Moving Mountains Map

This is a world map about skiing and ski fashion, which was a part of the "Moving Mountains" Winter exhibition at Somerset House. The small symbols on the map represent different events and ski fashion items that are associated with the sport, as well as locations of several Winter Olympic Games. The design of the map was meant to be youthful and fresh.

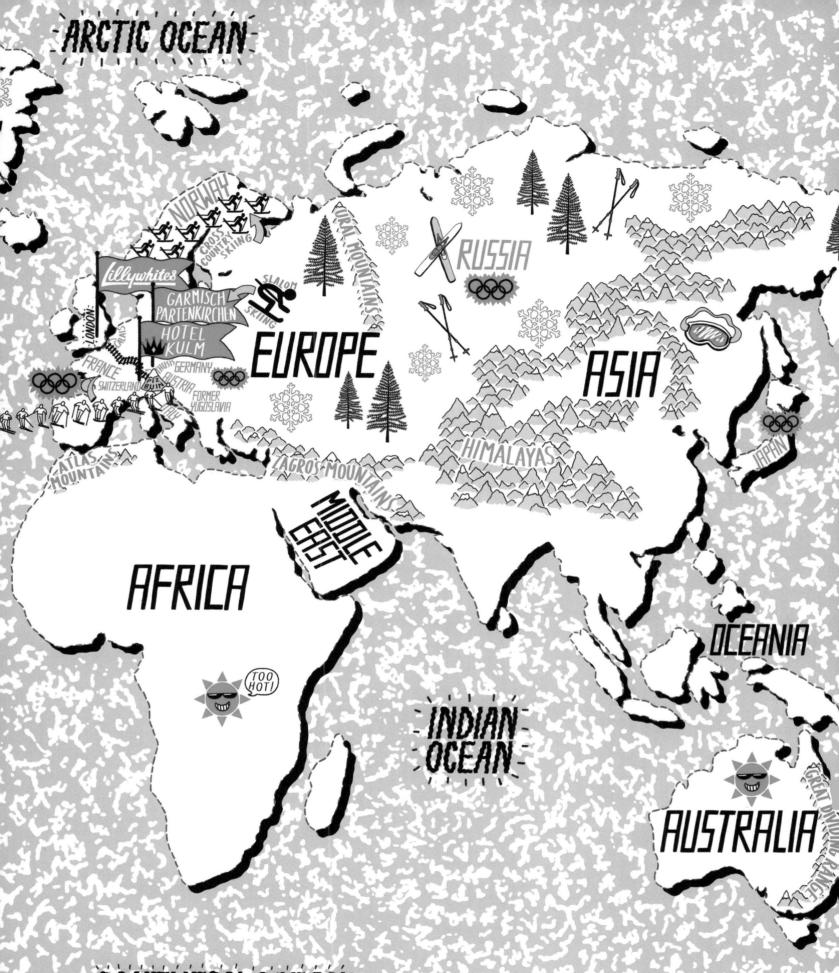

MAPPING THE PHYSICAL ENVIRONMENT

The Greatest Adventure

The brief of this project was to provide a guide for people who want to visit and explore Bandung, West Java, Indonesia, by introducing the town's tourist attractions, especially its theme parks, through an illustrated map. The theme parks set the tone for the design of the map, which includes the routes connecting them, along with other nearby venues. The names of the locations are shown in the legend. The characters and icons of this map were inspired by Wes Anderson's piece "Moonrise Kingdom".

118 DESIGN Owi Liunic COUNTRY/REGION Indonesia

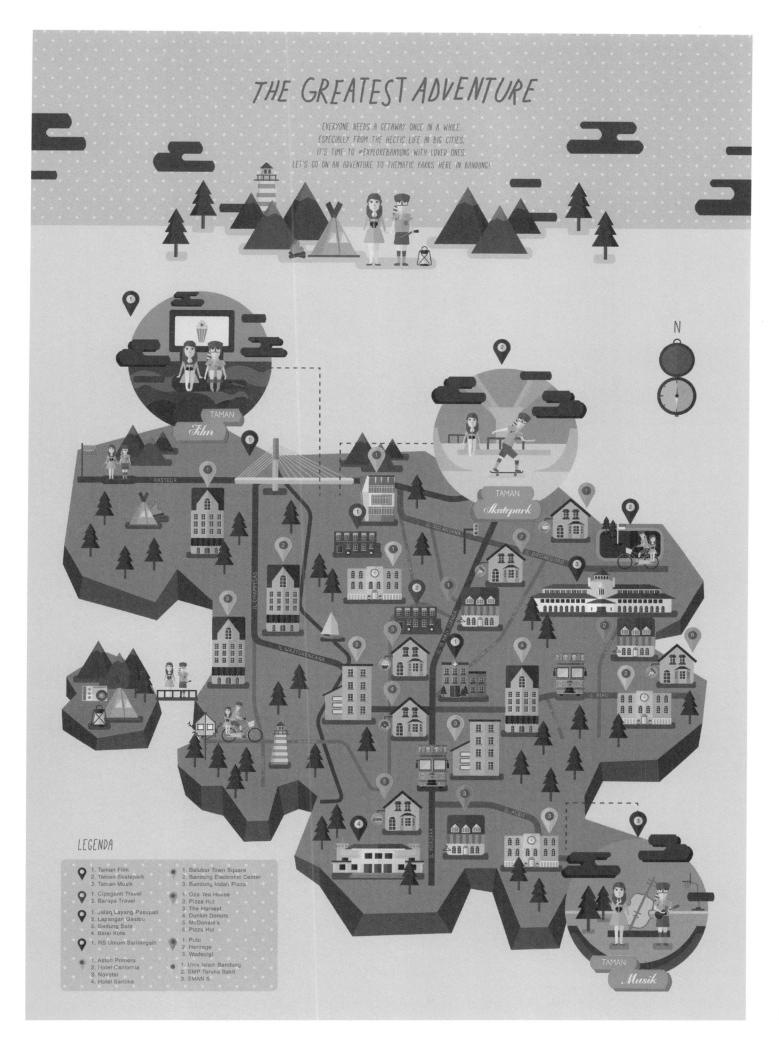

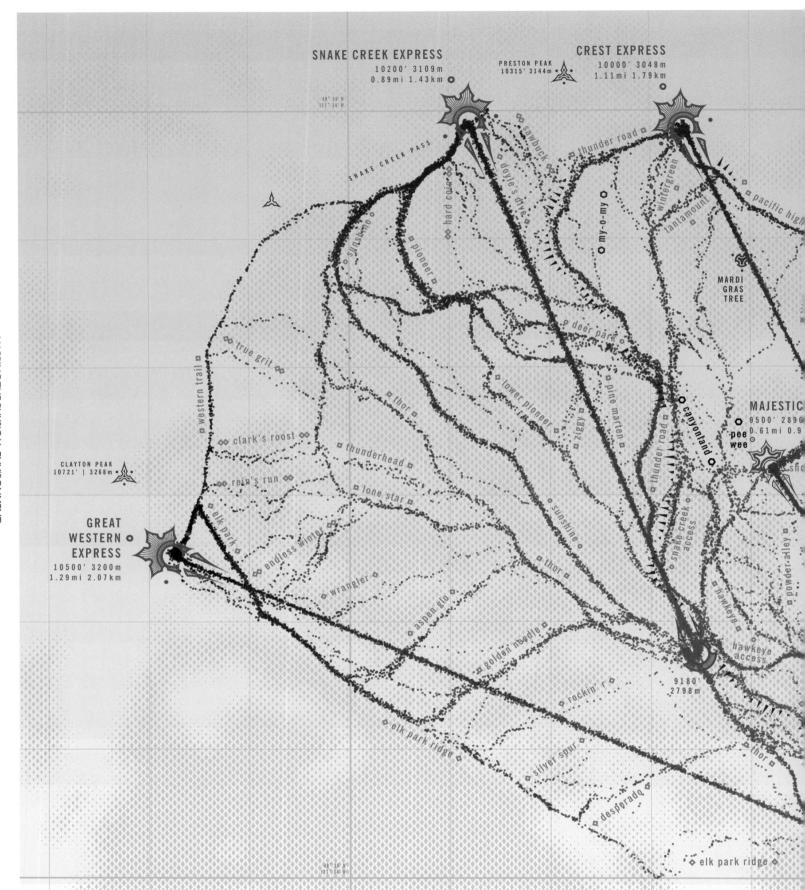

Brighton Resort Trail Map

This map was created via GPS, mapping resort trails at Brighton Resort, Utah over multiple seasons. The first task of the mapmaking project was to reconcile the resort's trail map with the reality of the mountain and trail markers. The designer also created complex markers for the lifts, as well as a patterned background based on the forest at the resort.

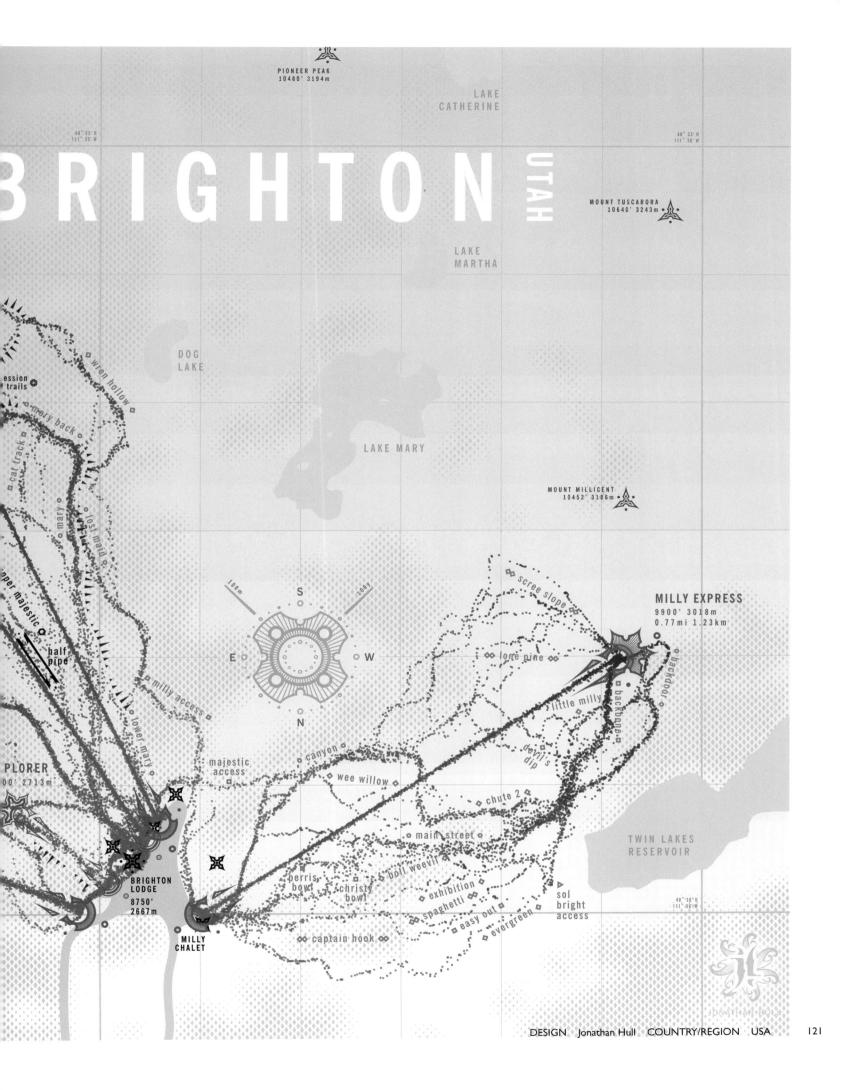

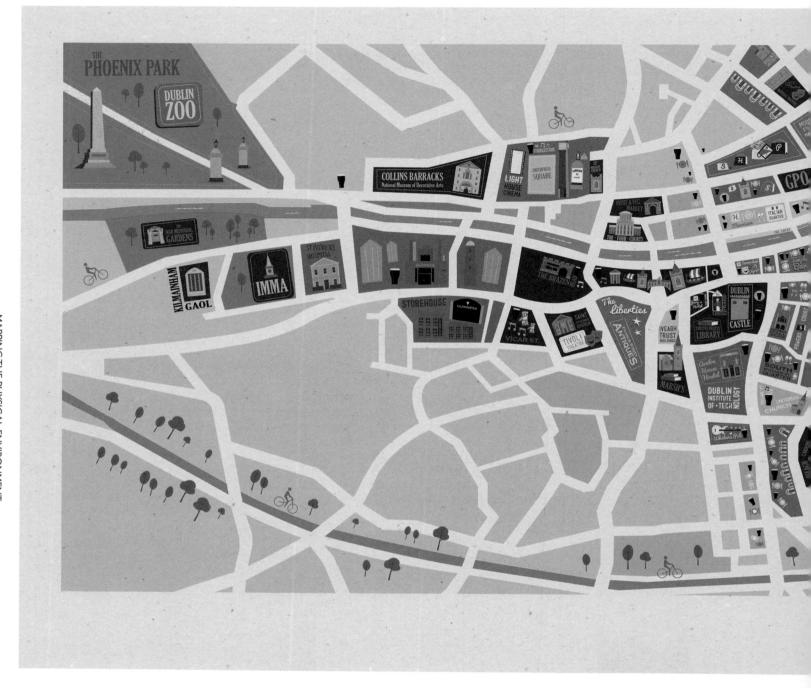

Dublin City Map

This is a large tourist wall map of Dublin City for the Dublin Visitor Centre. The map aims to be an informative visitors' guide as well as an attractive piece of art which will encourage people into the store. A palette featuring Georgian colours was used to reflect some of the city's architecture. The designer also introduces the appeal of the city into the map by illustrating the buildings and cultural attractions in a light-hearted way.

DESIGN FIRE / Peter Donnelly Illustration COUNTRY/REGION Ireland

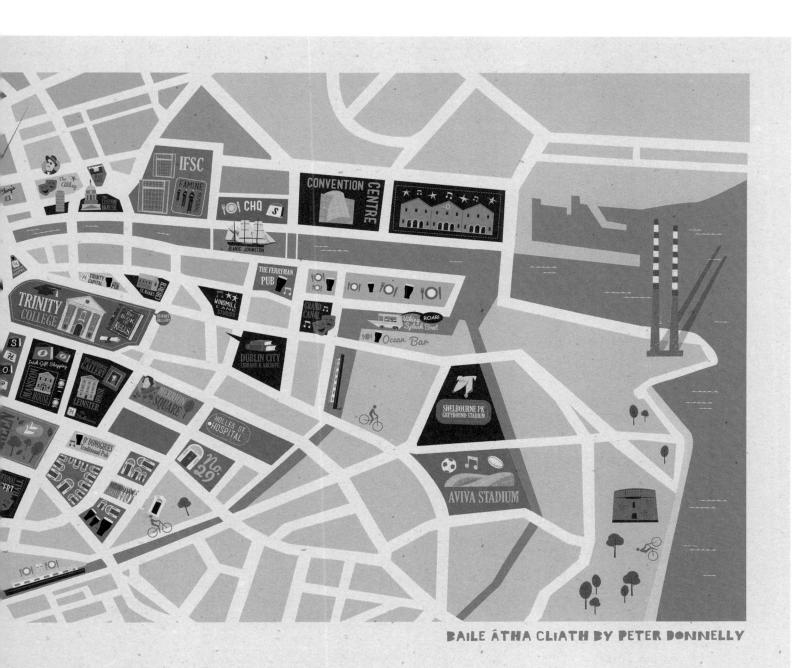

BAILE ÁTHA CLIATH BY PETER DONNELLY

Sky Map

Sky map is an educational infographic visualizing apparent motion of the stars during the longest night of the year (the Winter Solstice in the northern hemisphere, lasting almost 17 hours from around 3 p.m. on 23 December to around 7 a.m. on 24 December). This particular night sky shows the longest journey of visible stars above our heads. The project was based on observed source data provided by the Planetarium in Silesia, a scientific and astronomical centre in Poland.

DESIGN Paulina Urbańska COUNTRY/REGION Poland

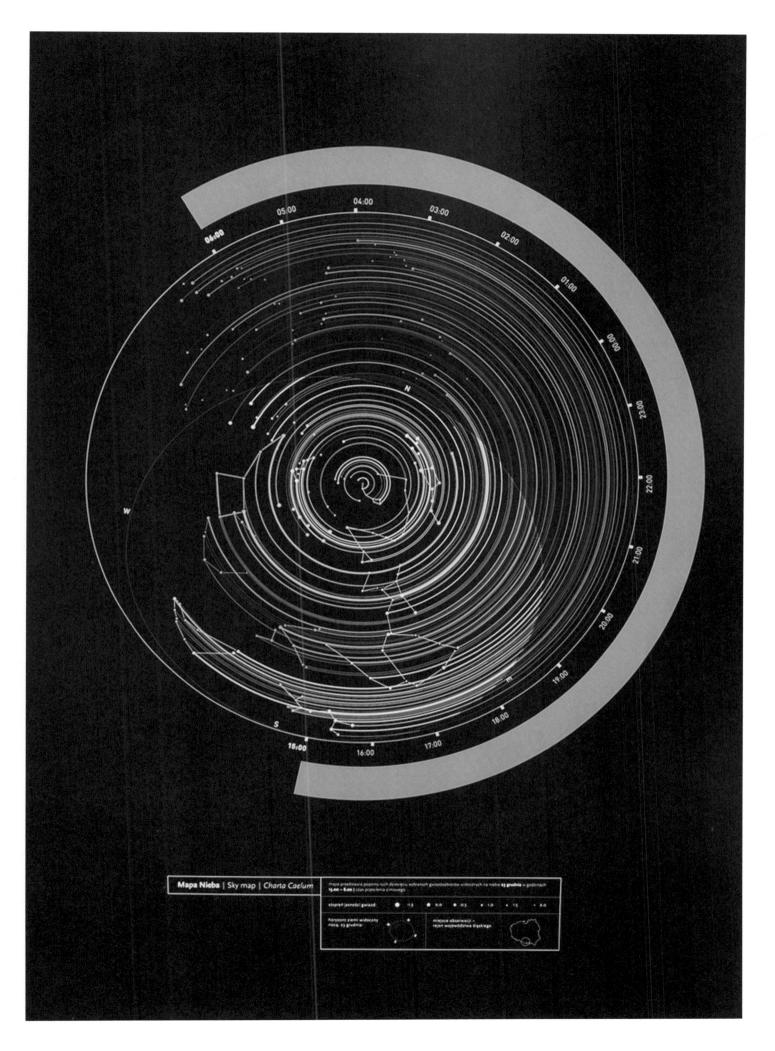

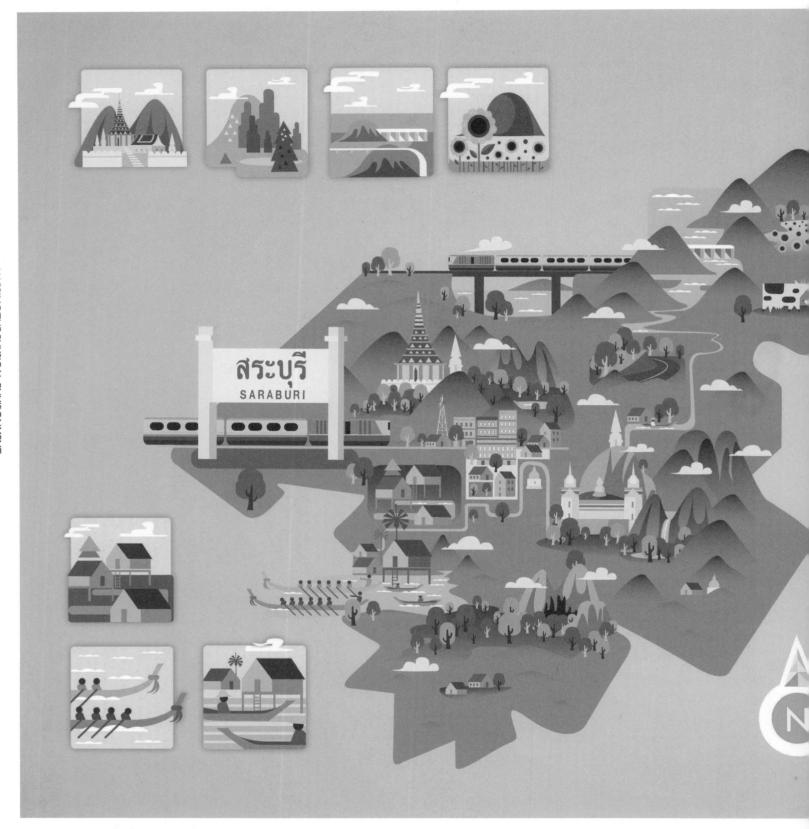

Guide to Saraburi

The illustration was meant to be a guide for tourists in Saraburi, Thailand, showing the landmarks of the city. Yeukprasert created the icons by simplifying the best-known landmarks in a graphic form for easy recognition.

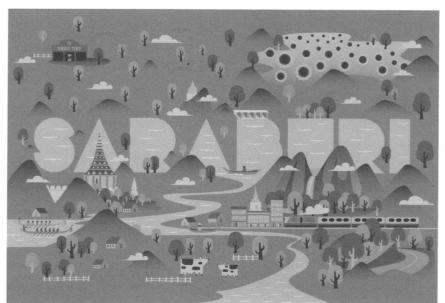
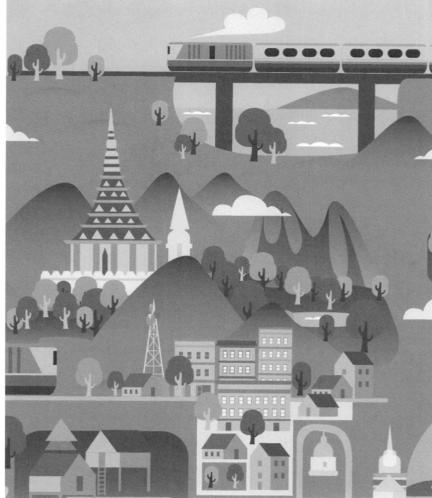

DESIGN Chinapat Yeukprasert COUNTRY/REGION Thailand

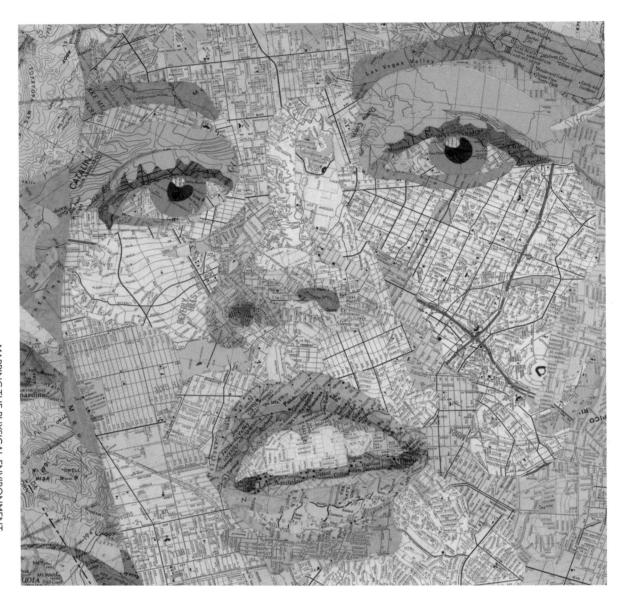

Shauna

This is an inlaid map collage of Colleen Applegate (1963–84), a porn star known as Shauna Grant. It makes use of certain areas of Los Angeles, such as the San Fernando Valley, which have become geographic centres for the production of pornography. The map collage of Shauna reflects upon the relationship between persona, pornography and place, and how it has redefined specific cultural regions.

DESIGN Matthew Cusick COUNTRY/REGION USA

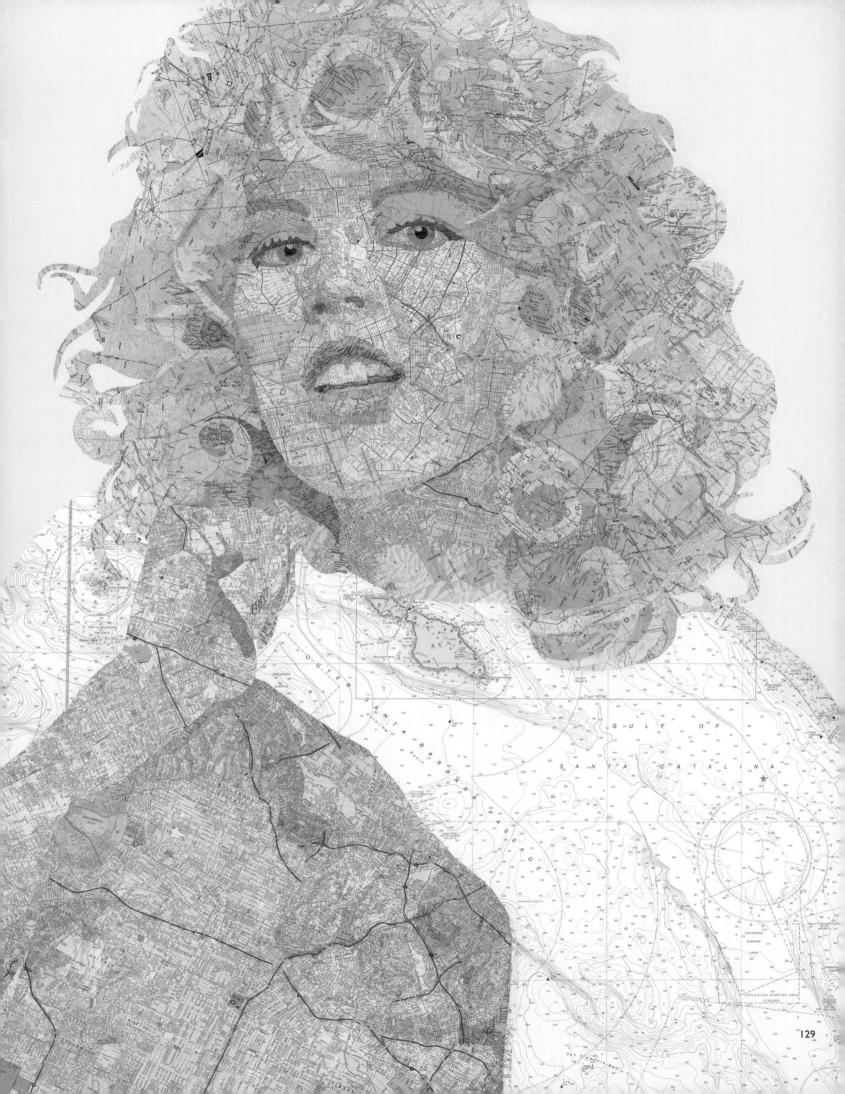

Topographical Map

MAPPING THE PHYSICAL ENVIRONMENT

Wadi Fukin

**From Battir to Berlin in Memory of the downfall of Berlin Wall
Battir Landscape Ecomuseum, Balloons for Freedom,**
November 9, 2014

- **Battir Limit**
- **Unesco Research Limit**
- **Jaffa-Jerusalem Rail Road**
- Asphalted Road
- Gravel Road
- Foot Trail
- **Trails Start Point**
- Spring
- Stream
- Watershed's Limit

Khirbet Battir (Canaanite Remains)
Khirbet Kuruzlah
Roman Necropolis
Defense Site

Qasr (Watch Tower) Lime Kiln Shrine

Tomb, Rock-cut Tomb
Cave, Rock Hole

Monumental Tree

Wine and Oil Press

Armistice Line 1949
Battir Land behind the Armistice Line 1949

© Battir, Jasmine D. Salachas & Hervé Quinquenel, cartographers

Husan

Beitar Ilit Colony

Battir Map

A UNESCO World Heritage site, Battir is a Palestinian village located in the West Bank, on the 1949 Armistice Line. Since 2007, a project has been carried out by a multidisciplinary team of Palestinian professionals to explore the characteristics of this 12 sq km territory. These topographical maps are the achievements of the project, and are useful for studying the site and bringing international attention to its recognition and protection.

DESIGN Jasmine Desclaux-Salachas COUNTRY/REGION France

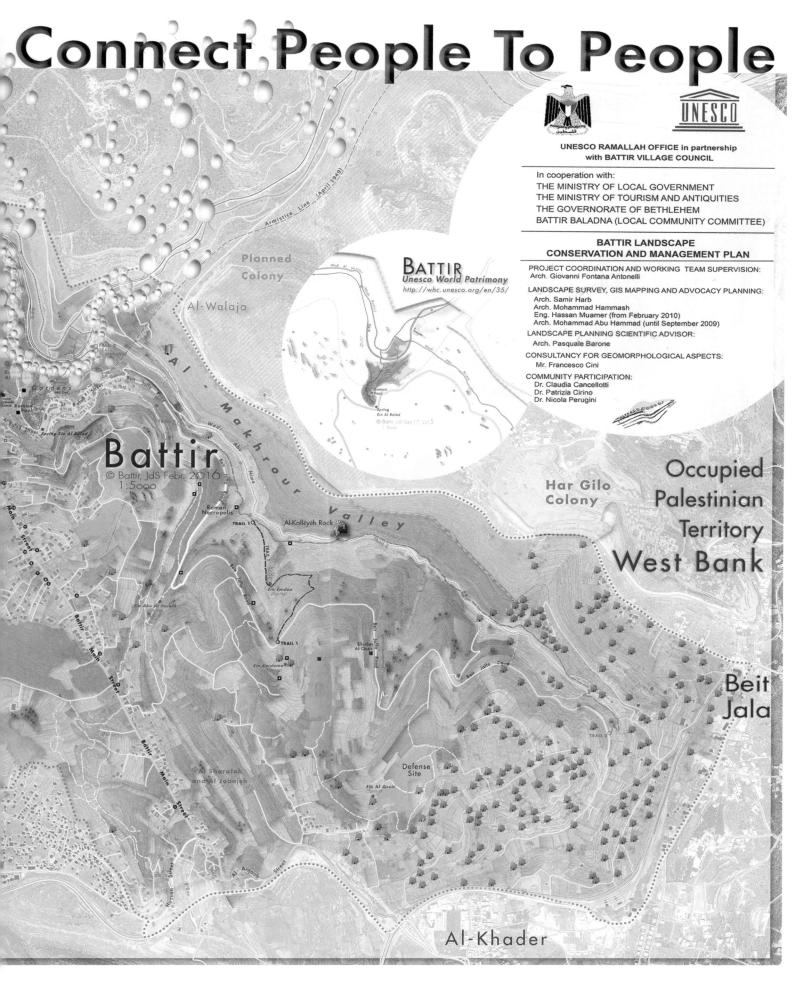

**UNESCO RAMALLAH OFFICE in partnership
with BATTIR VILLAGE COUNCIL**

In cooperation with:
THE MINISTRY OF LOCAL GOVERNMENT
THE MINISTRY OF TOURISM AND ANTIQUITIES
THE GOVERNORATE OF BETHLEHEM
BATTIR BALADNA (LOCAL COMMUNITY COMMITTEE)

**BATTIR LANDSCAPE
CONSERVATION AND MANAGEMENT PLAN**

PROJECT COORDINATION AND WORKING TEAM SUPERVISION:
Arch. Giovanni Fontana Antonelli

LANDSCAPE SURVEY, GIS MAPPING AND ADVOCACY PLANNING:
Arch. Samir Harb
Arch. Mohammad Hammash
Eng. Hassan Muamer (from February 2010)
Arch. Mohammad Abu Hammad (until September 2009)

LANDSCAPE PLANNING SCIENTIFIC ADVISOR:
Arch. Pasquale Barone

CONSULTANCY FOR GEOMORPHOLOGICAL ASPECTS:
Mr. Francesco Cini

COMMUNITY PARTICIPATION:
Dr. Claudia Cancellotti
Dr. Patrizia Cirino
Dr. Nicola Perugini

- Battir Limit
- Unesco Research Limit
- **Jaffa-Jerusalem Rail Road**
- Asphalted Road
- Gravel Road
- Foot Trail
- ○○○○ Trails Start Point
- TRAIL 1
- TRAIL 2
- TRAIL B
- TRAIL C
- • Spring
- Stream
- Watershed's Limit
- Khirbet Battir (Canaanite Remains)
- Khirbet Kuruzlah (Roman Castrum)
- Roman Necropolis
- Defense Site
- Qasr (Watch Tower)
- Lime Kiln
- Shrine
- Tomb, Rock-cut Tomb
- Cave, Rock Hole
- Wine and Oil Press
- Monumental Tree
- Monumental Stone, Rocks
- Terraces, Retaining Walls
- Cliff
- Highvoltage and Electric Line
- ----- Armistice Line 1949
- Battir Land behind the Armistice Line 1949

0 300 600 m
Scale : 1:15 000

Summer 2013 in Battir: Ali Muammar, Itidal Muammar, Ehab Muammar, Bader Al Buthma -Battir. And Sylvain Gonnet -Surveyor, France
April/May 2014: New Survey by Hervé Quinquenel -Cartographer/GIS-Eng. France - Orienteering Map Collaborative Project of Battir
Sept.17, 2015: Mapping and Coordination since May 2012, Jasmine D. Salachas - Cartographer, les Cafés-cartographiques

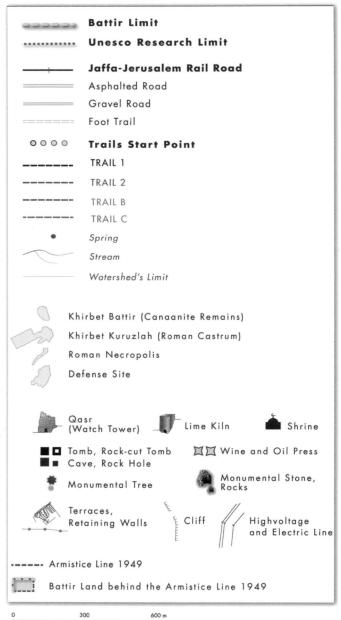

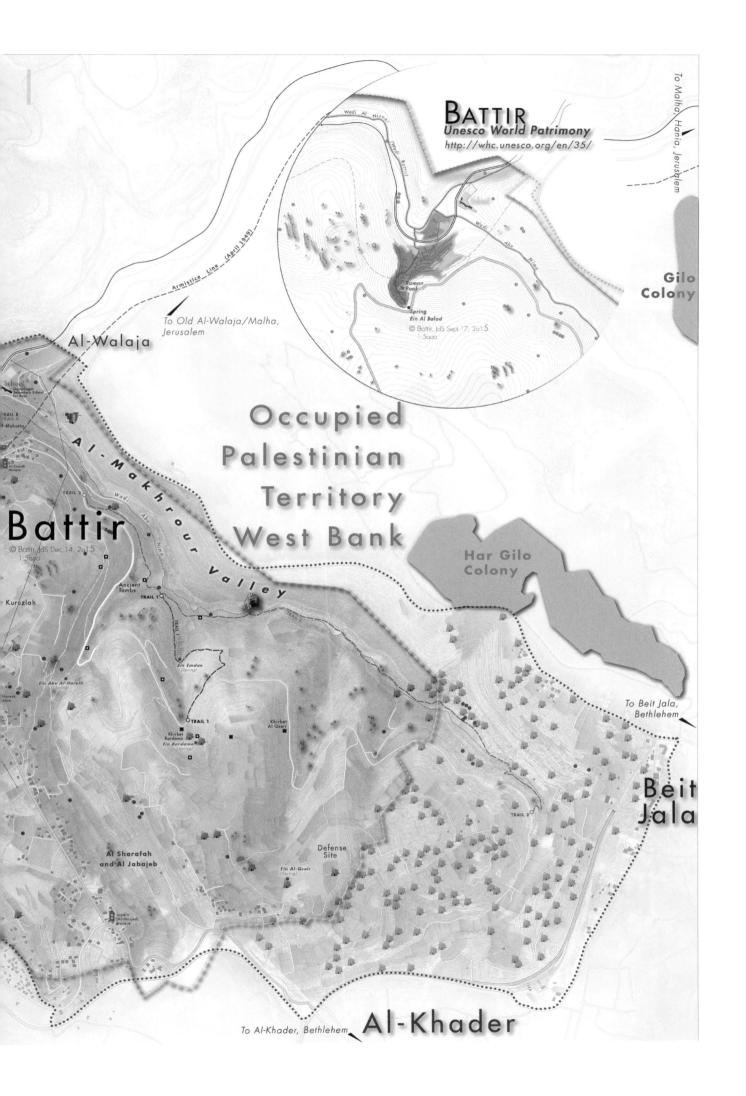

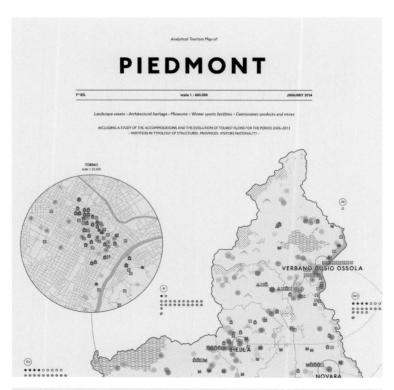

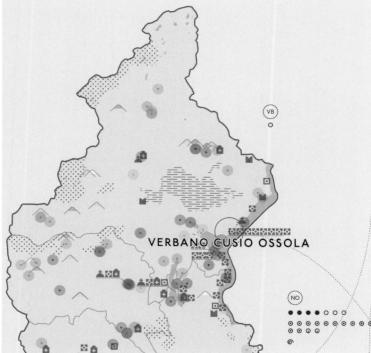

Data extraction by ItaliaNLP Lab.

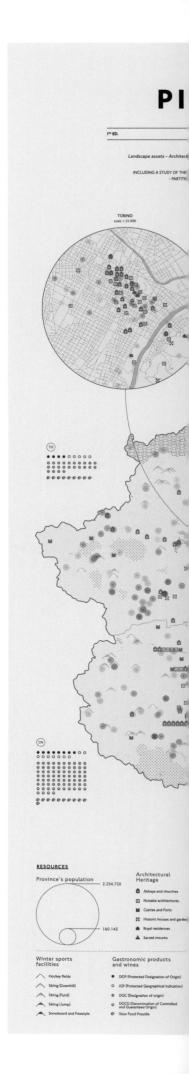

The Analytical Tourism Map of Piedmont

Based on open data, the Analytical Tourism Map of Piedmont aims to investigate tourism resources in a complete and detailed way, considering both the attractions of this region of northern Italy and the evolution and dimension of tourist flows and accommodation. On the left side of the poster, the Piedmont map shows the most important architectural heritage buildings, museums, winter sports facilities, gastronomic products and wine, etc.. Every element is located on the map, and it's easy to identify the beauties of different areas and the best places to visit. On the right side, the visualization shows the categories of tourist flows and compares the accommodation distributed through the eight provinces of Piedmont between 2006 and 2012.

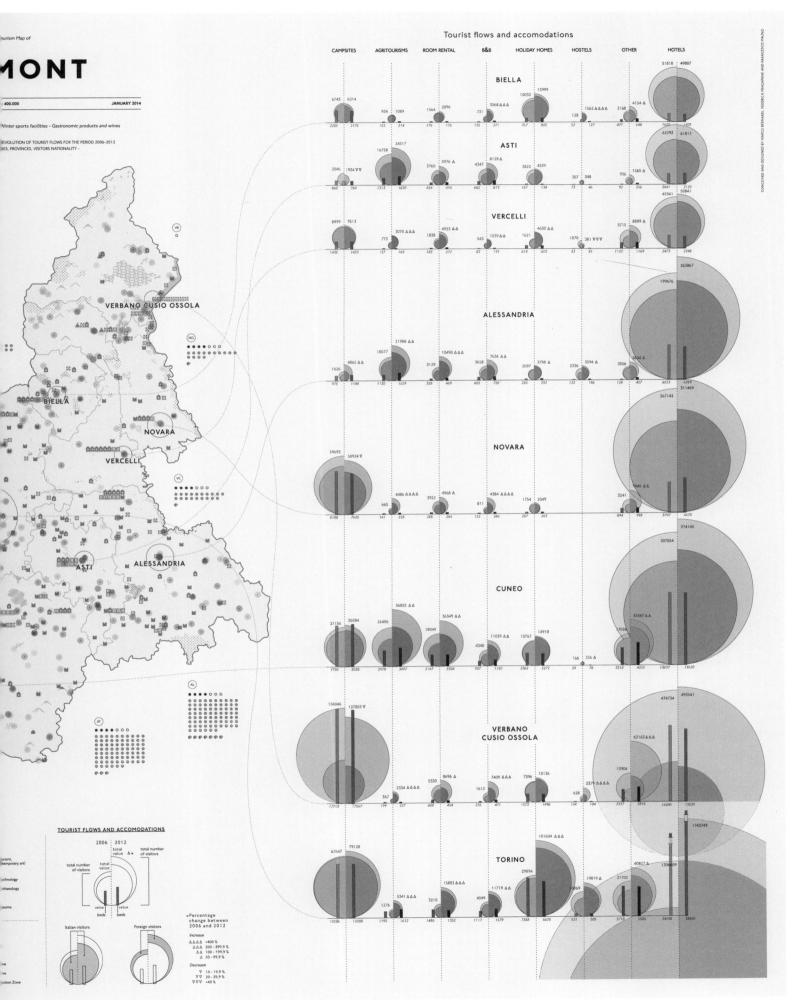

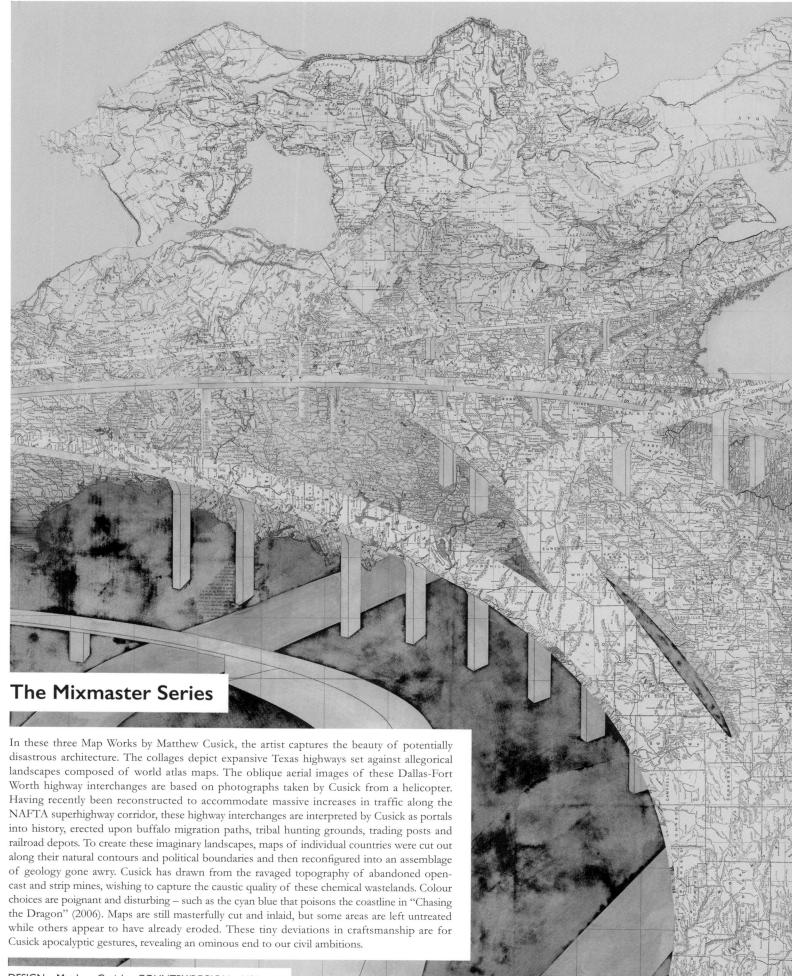

The Mixmaster Series

In these three Map Works by Matthew Cusick, the artist captures the beauty of potentially disastrous architecture. The collages depict expansive Texas highways set against allegorical landscapes composed of world atlas maps. The oblique aerial images of these Dallas-Fort Worth highway interchanges are based on photographs taken by Cusick from a helicopter. Having recently been reconstructed to accommodate massive increases in traffic along the NAFTA superhighway corridor, these highway interchanges are interpreted by Cusick as portals into history, erected upon buffalo migration paths, tribal hunting grounds, trading posts and railroad depots. To create these imaginary landscapes, maps of individual countries were cut out along their natural contours and political boundaries and then reconfigured into an assemblage of geology gone awry. Cusick has drawn from the ravaged topography of abandoned opencast and strip mines, wishing to capture the caustic quality of these chemical wastelands. Colour choices are poignant and disturbing – such as the cyan blue that poisons the coastline in "Chasing the Dragon" (2006). Maps are still masterfully cut and inlaid, but some areas are left untreated while others appear to have already eroded. These tiny deviations in craftsmanship are for Cusick apocalyptic gestures, revealing an ominous end to our civil ambitions.

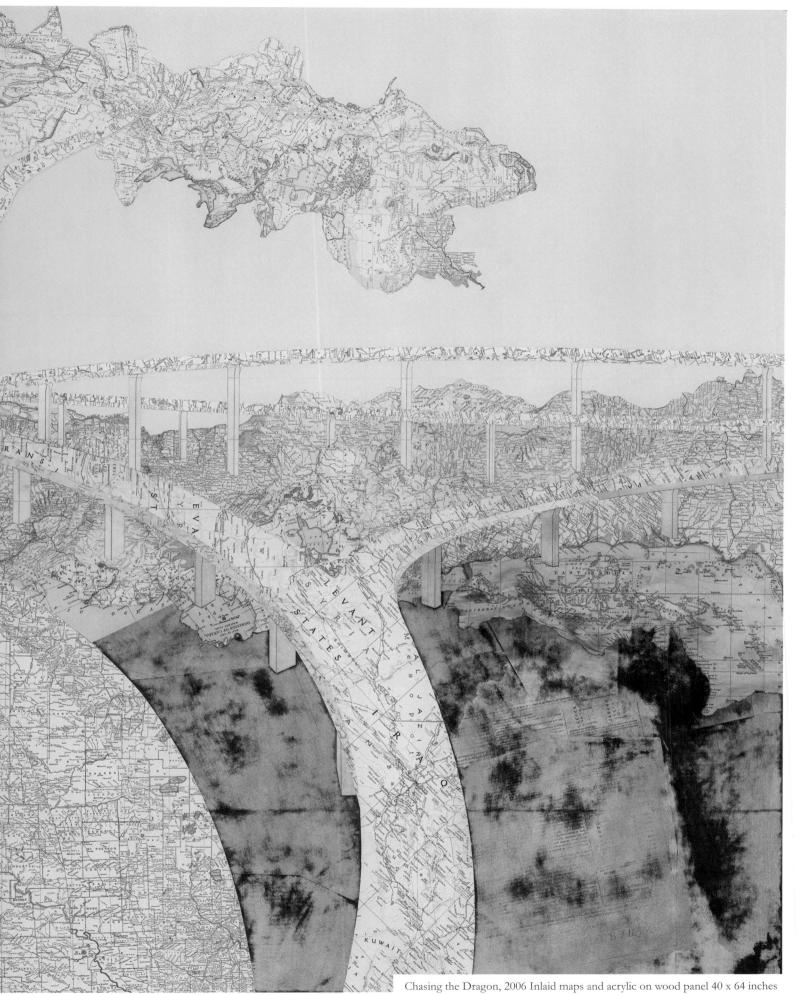

Chasing the Dragon, 2006 Inlaid maps and acrylic on wood panel 40 x 64 inches

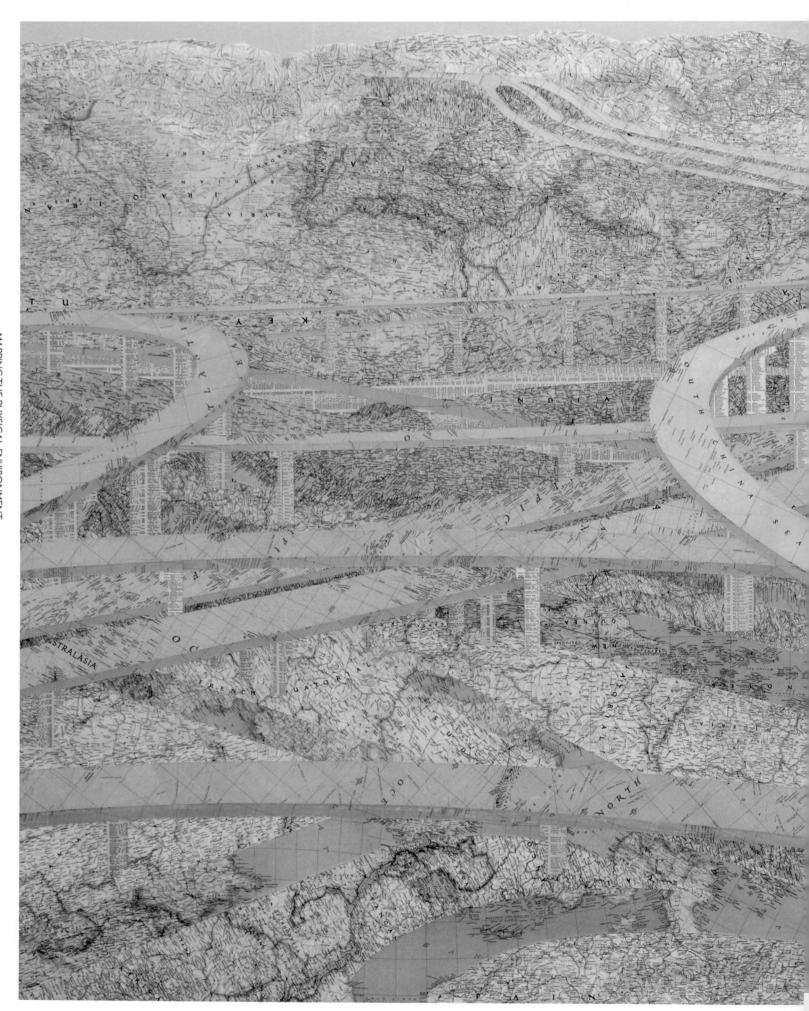

MAPPING THE PHYSICAL ENVIRONMENT

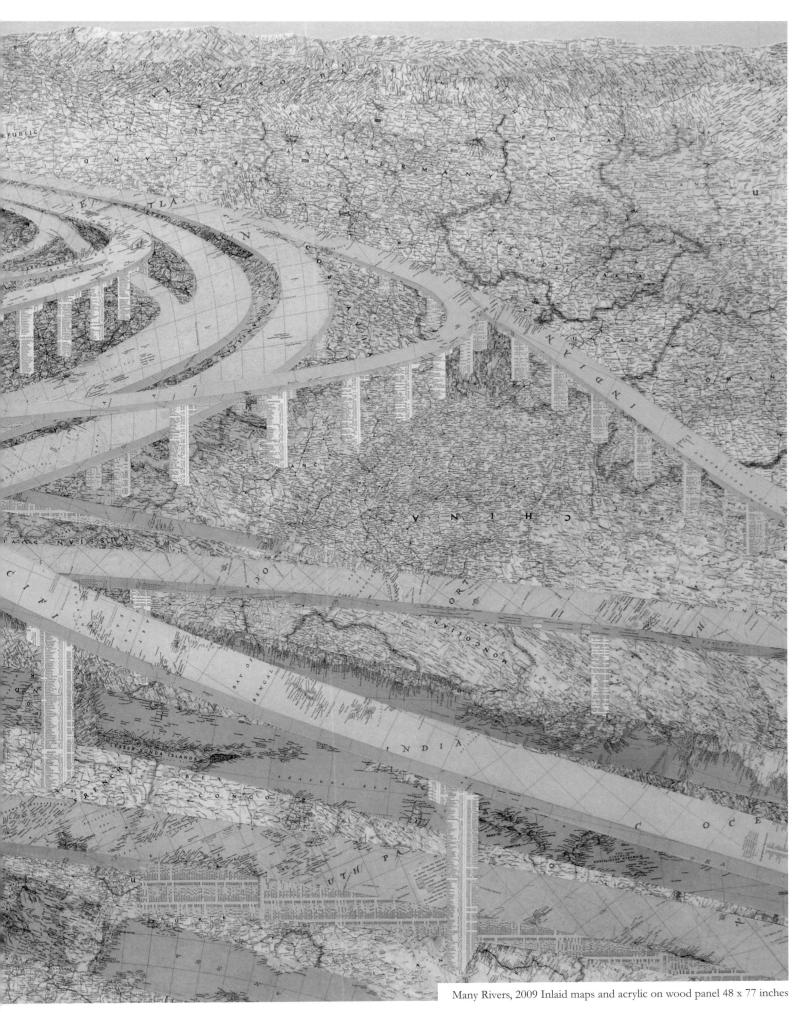

Many Rivers, 2009 Inlaid maps and acrylic on wood panel 48 x 77 inches

MAPPING THE PHYSICAL ENVIRONMENT

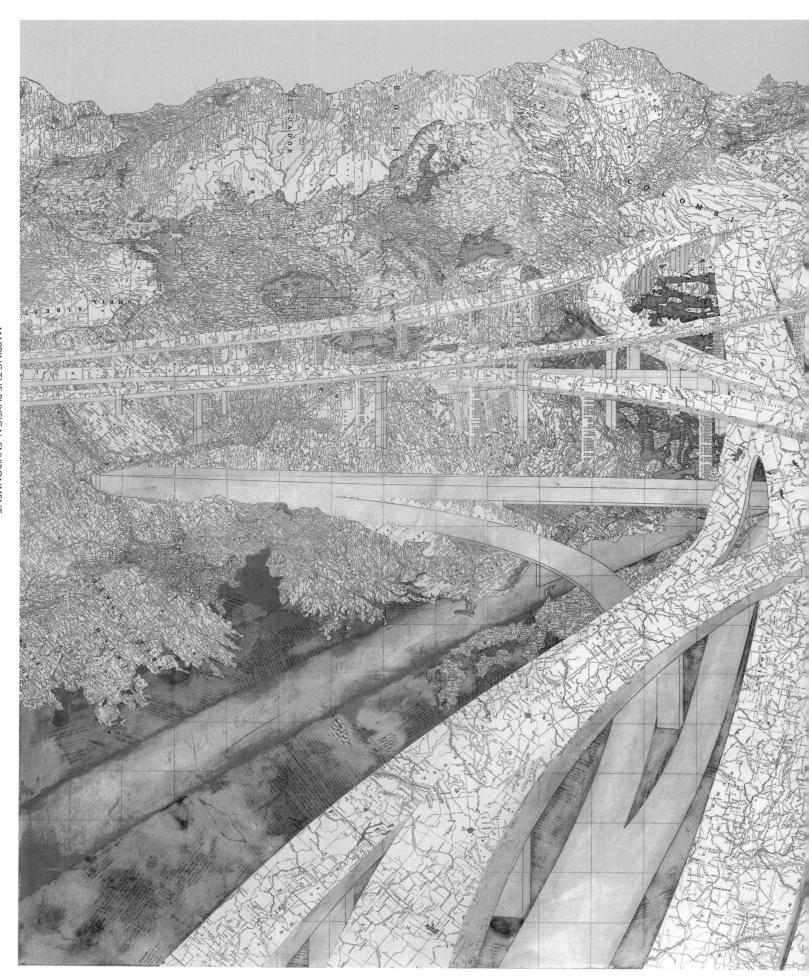

140

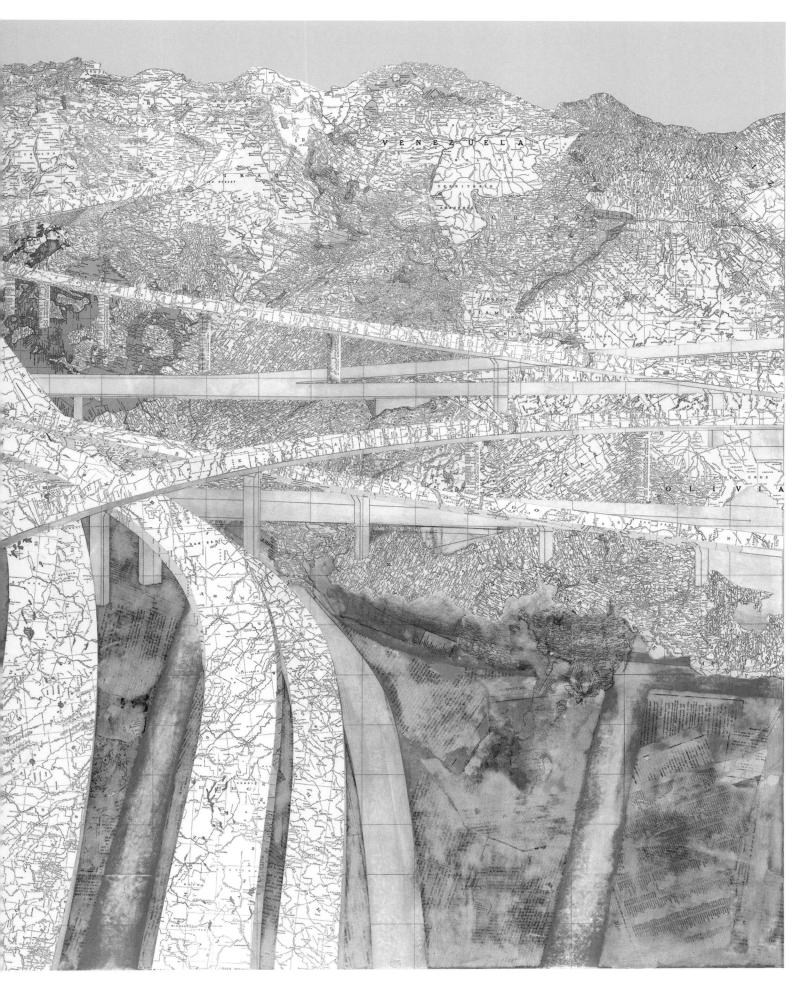

"Course of Empire" (Mixmaster II), 2006 inlaid maps and acrylic on wood panel, 48 x 77 inches

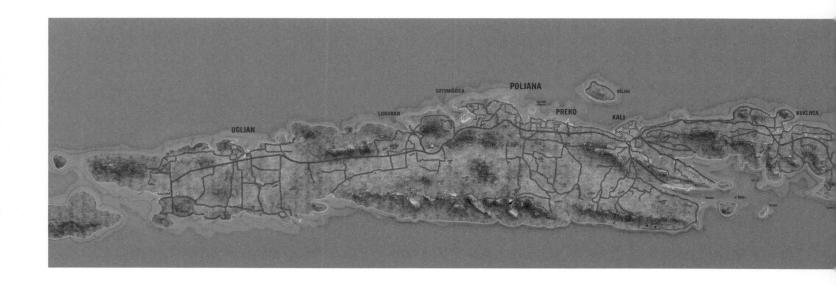

Ugljan & Pasman

This map is a combination of vector and raster graphics. The work shows the map of the two beautiful islands of Ugljan and Pasman, in the Zadar Archipelago, Croatia. It was created with concentration, patience and eye for detail. The map has twenty separate thematic layers and can be modified to desired size without loss of any resolution.

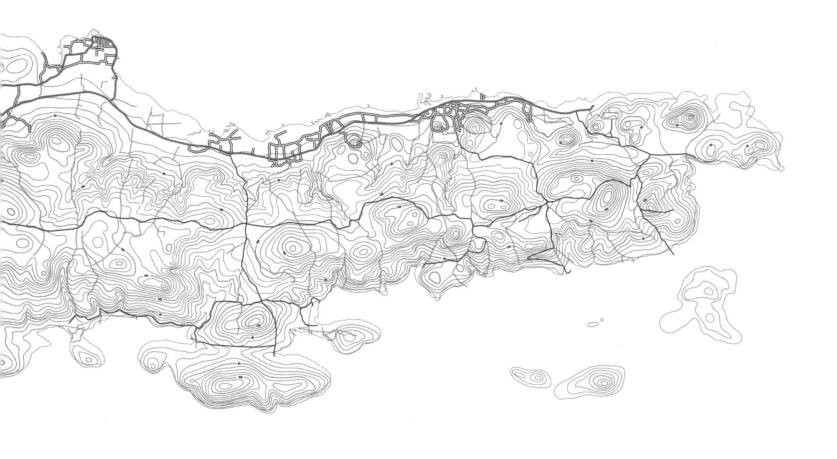

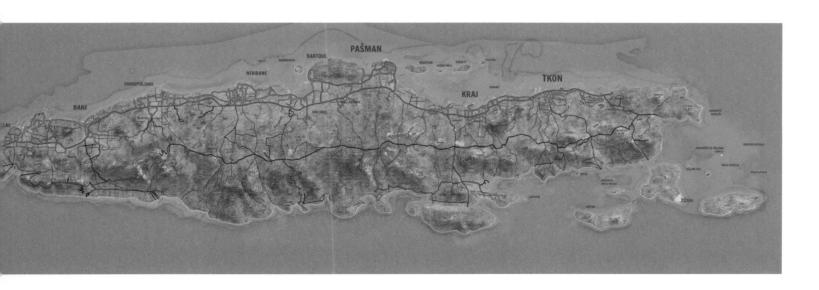

DESIGN Martina Sikiric COUNTRY/REGION Croatia 143

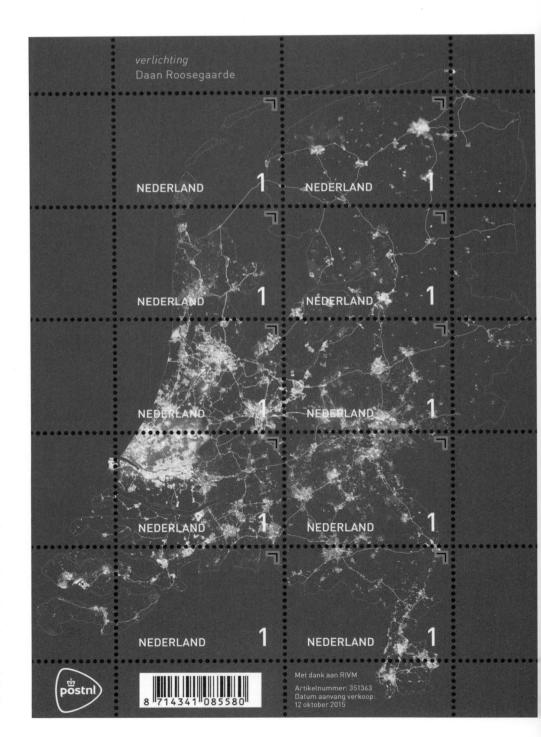

Enlightened Postal Stamps

This project is a map as stamps. Each separate stamp features a different piece of the Netherlands and together the stamps form a complete map when joined in the correct positions. In designing the stamps, Roosegaarde was inspired by aerial photos taken by André Kuipers and satellite photos of the region, after which he incorporated his own interpretation, showing the Netherlands in a unique way – as a network of light seen from space, shaped by the cities and roads of the country.

The result is a Dutch map we have never seen before. The amazing network of light establishes connections, making an ominous and poetic piece. It gives us an insight into human behaviour and the impact it has on our landscape. In this way, the map as stamps offers both literal and figurative enlightenment.

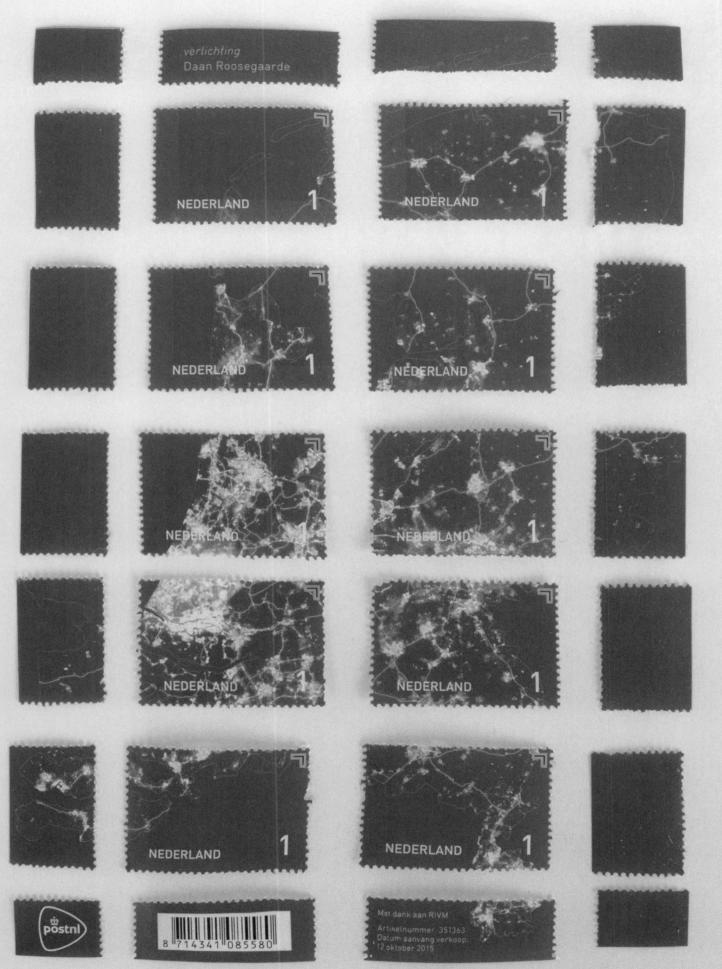

Nakhon Si Thammarat Province

The Potential of
Micro Hydro Power Installation (KW)

The Potential of
Solid Waste Energy Installation (MW)

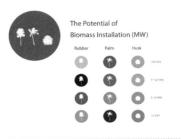
The Potential of Wind Energy Farm
Installation along the coastline (1.5 MW)

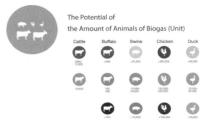
The Potential of
Biomass Installation (MW)

The Potential of
the Amount of Animals of Biogas (Unit)

MAPPING THE PHYSICAL ENVIRONMENT

Nakorn Si Thammarat Power Development Plan

This map visualizes the power development plan for Nakorn Si Tammarat, a city in southern Thailand. All reused bio power comes from wind, livestock, plants, waste and water.

DESIGN MYDM co. ltd COUNTRY/REGION Thailand

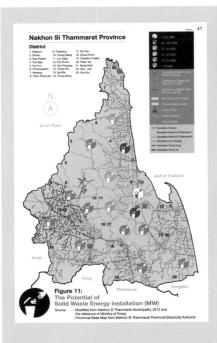

Figure 11:
The Potential of
Solid Waste Energy Installation (MW)

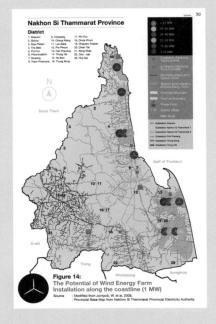

Figure 14:
The Potential of Wind Energy Farm
Installation along the coastline (1 MW)

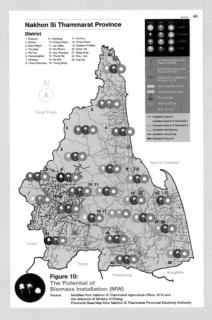

Figure 10:
The Potential of
Biomass Installation (MW)

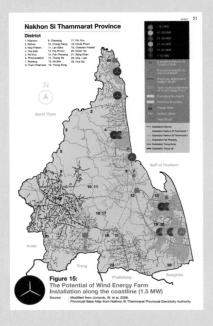

Figure 15:
The Potential of Wind Energy Farm
Installation along the coastline (1.5 MW)

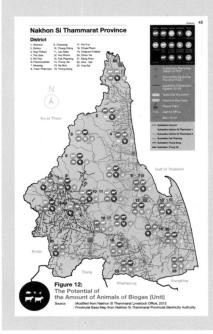

Figure 12:
The Potential of
the Amount of Animals of Biogas (Unit)

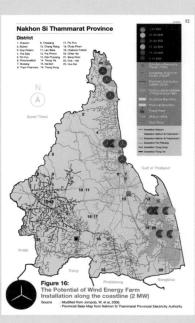

Figure 16:
The Potential of Wind Energy Farm
Installation along the coastline (2 MW)

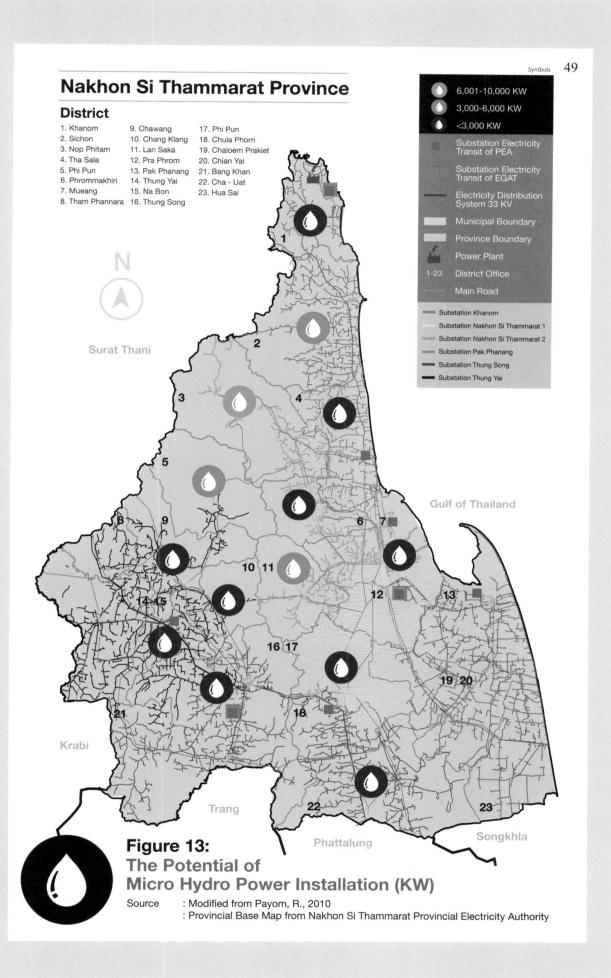

Figure 13: The Potential of Micro Hydro Power Installation (KW)

Source : Modified from Payom, R., 2010
: Provincial Base Map from Nakhon Si Thammarat Provincial Electricity Authority

Nikolai Przewalski

This map illustrates the adventures and discoveries of the Russian geographer and explorer Nikolai Przewalski (1839–88). Part of a documentary about him, it was made in a similar style to motion graphics. It puts visual emphasis on the places through which Przewalski travelled on the way to his never-reached ultimate goal – the Tibetan city of Lhasa.

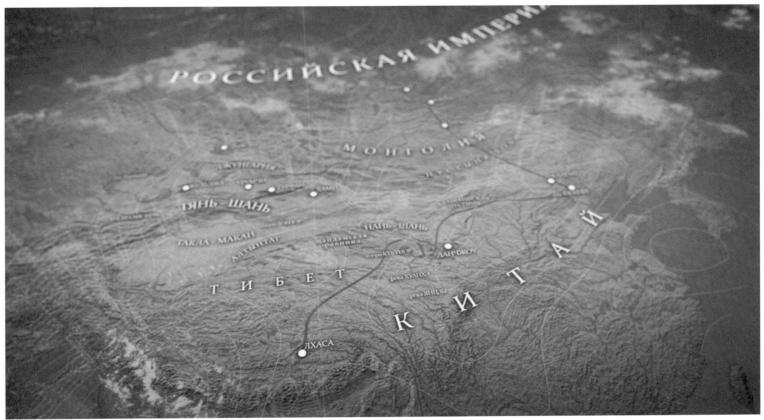

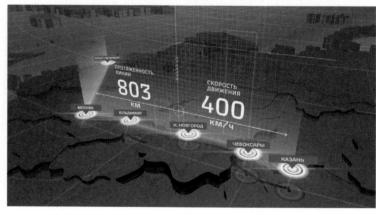
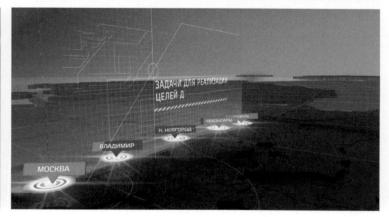

RZD Map

This interactive map aims to display the prospects for rail transport development in Russia, which is planning a high-speed rail line that will link remote regions of the country into a single network. Achieving the objective required a bright and contemporary infographic work, showing the relevant map and geo-information. The work was featured as part of a presentation to a major railway company and is a motion graphic presentation made by means of the program Cinema 4d.

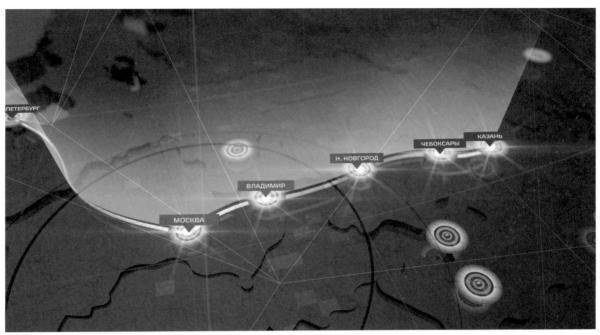
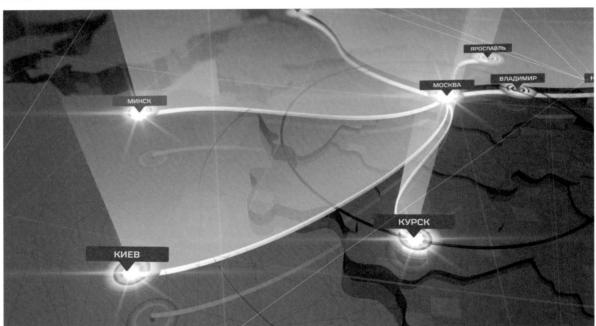

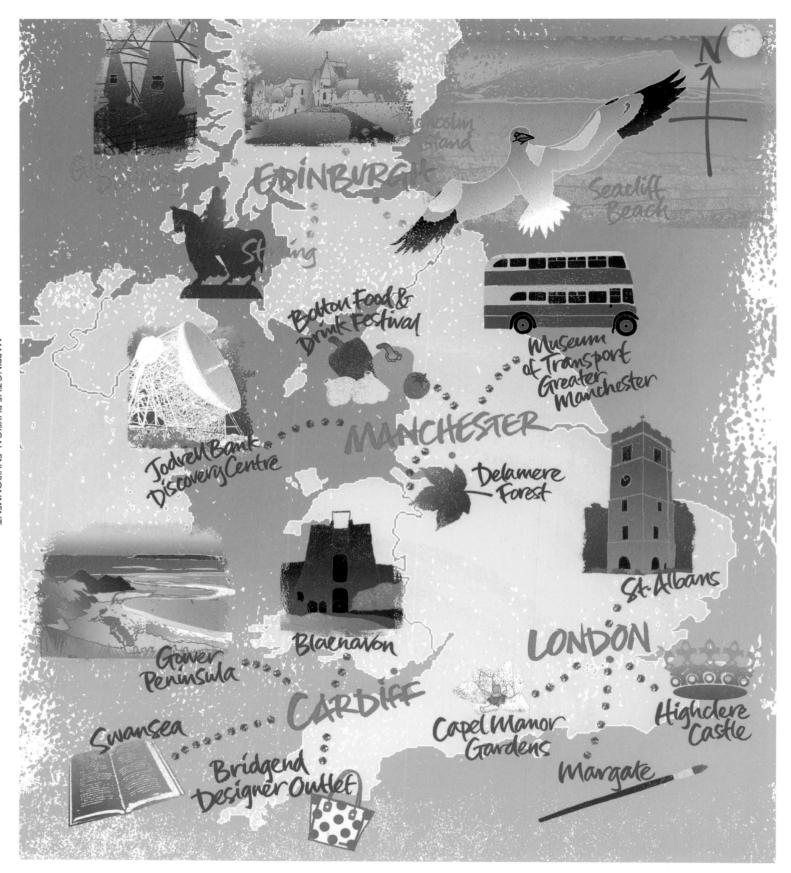

Two Maps for "Summer Day Tripping in the UK"

Rowland was commissioned by Sainsbury's Bank's *Money Matters* magazine to create two maps for their summer issues. The subject was day trips in the UK – one aimed at readers interested in family entertainment and one of general interest. Each place name was individually hand lettered and this lettering was also used to punctuate the body copy of the articles.

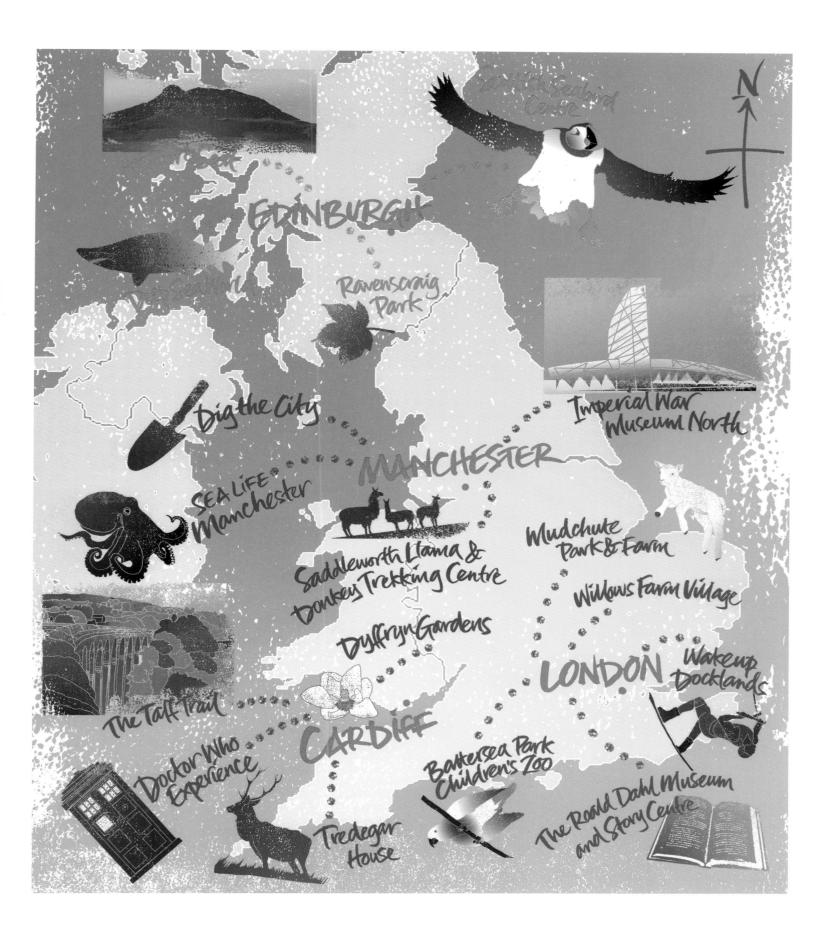

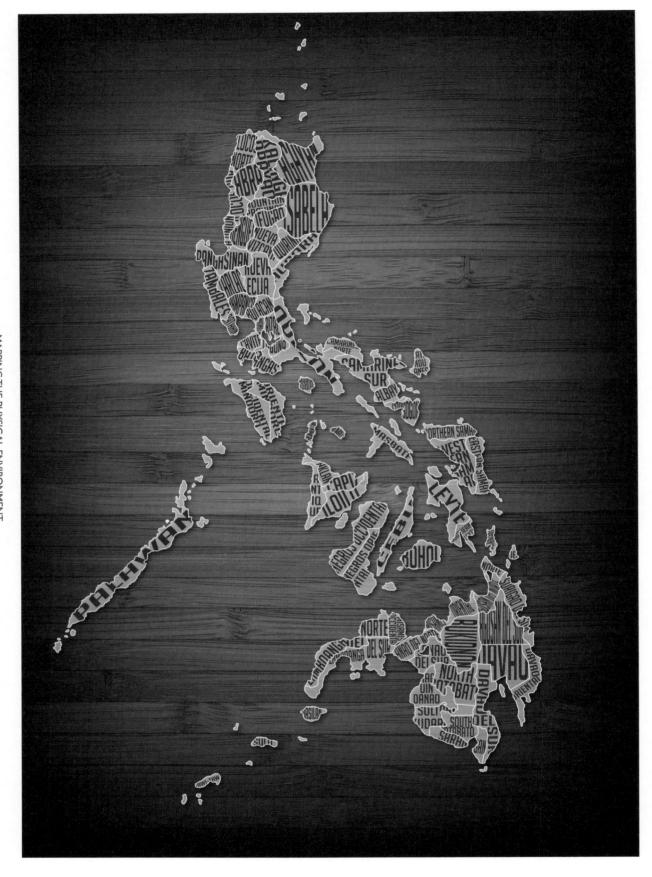

Topographic Typography

Inzon represents each province of the Philippines by its name in this map. But the names don't quite fit the shape of the borders; the consequent obscurity creates a challenge for viewers familiar with Filipino topography to identify each province by its name. It also serves as a convenient reference.

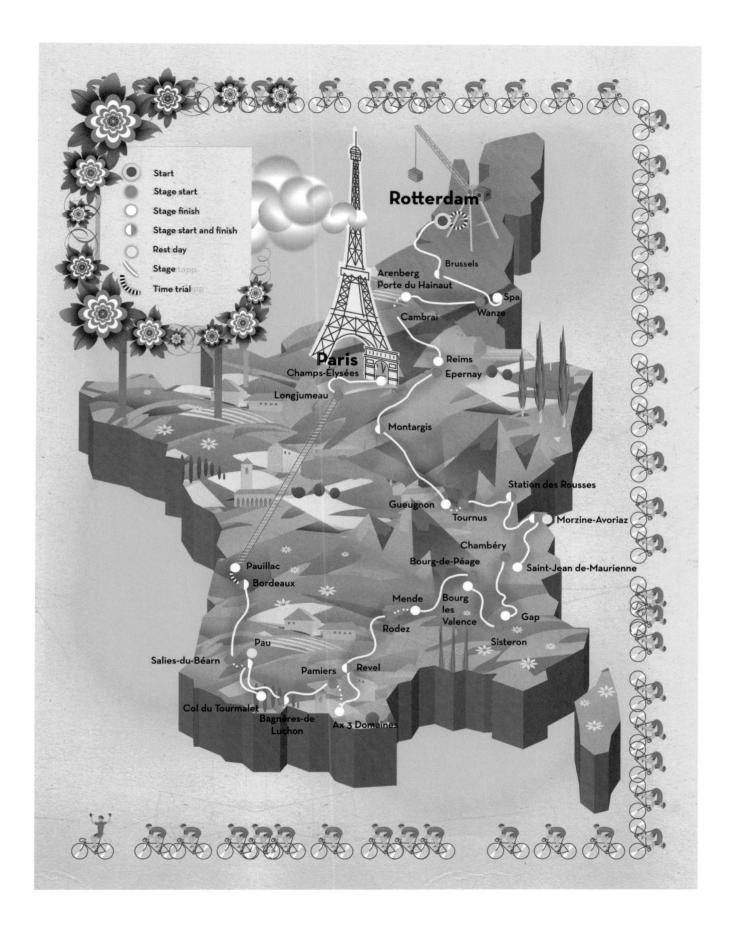

Tour de France Map

This map was for *Kadens*, a Swedish cycling magazine. Against a background suggesting countryside, it shows the route of the Tour de France 2010, one of cycling's Grand Tours. That year, the race visited three countries: the Netherlands, Belgium and France, finishing as usual in Paris.

DESIGN Nils-Petter Ekwall COUNTRY/REGION Sweden

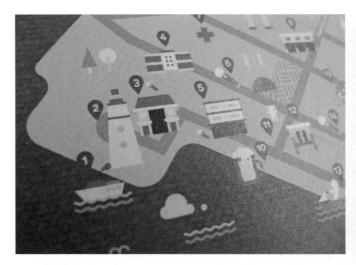
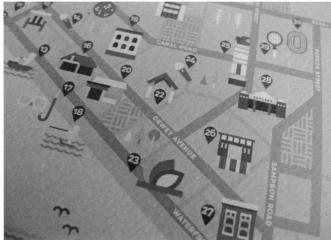
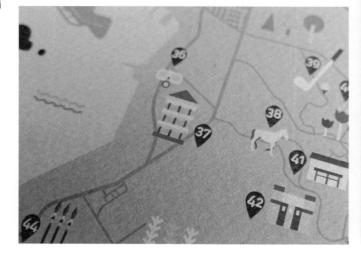

Ad Summit 2014 Subic Map

This project was a partnership between Jo Malinis and Raxenne Maniquiz. It is a map of Subic, in the Philippines, created for *Adobo* magazine's Ad Summit Pilipinas 2014 Festival Guide. The maps on the left are zoomed-in versions of the bay area. The right-hand page shows the whole of Subic.

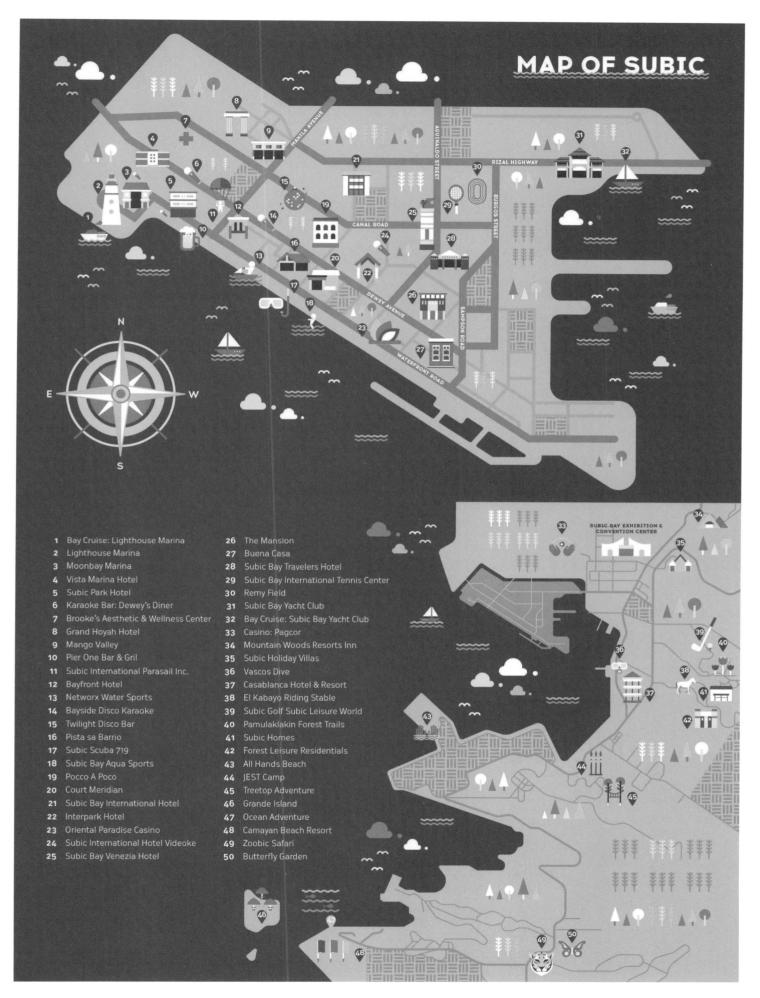

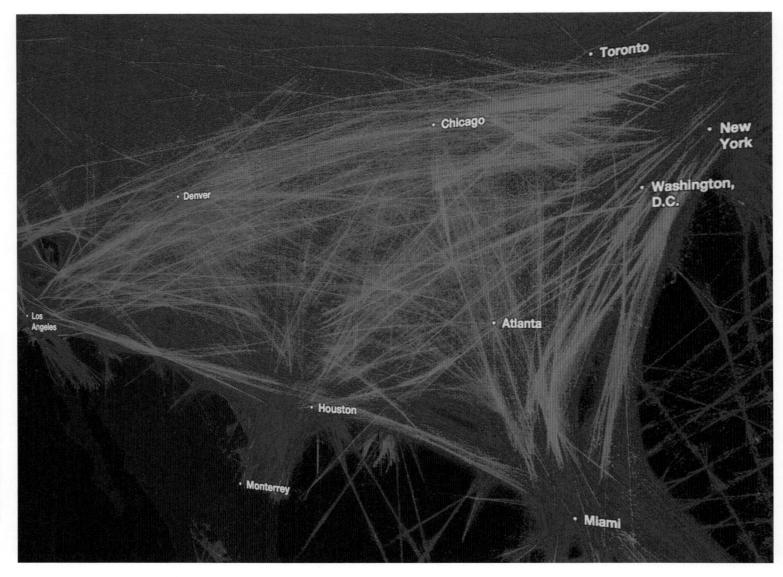

Flight Paths of the World Map

This map aimed to visualize plane routes around the world. The map drawing was based on the flight data collected during a single whole month, October 2012. The results of such monitoring amounted to about one billion "dots" which then were put on a map. Using red for lower-altitude flights and blue for higher, the map produces some very beautiful patterns of different flight paths across the world. It also allows visualization of the "roads", "highways", "intersections" and "junctions" used by airplanes.

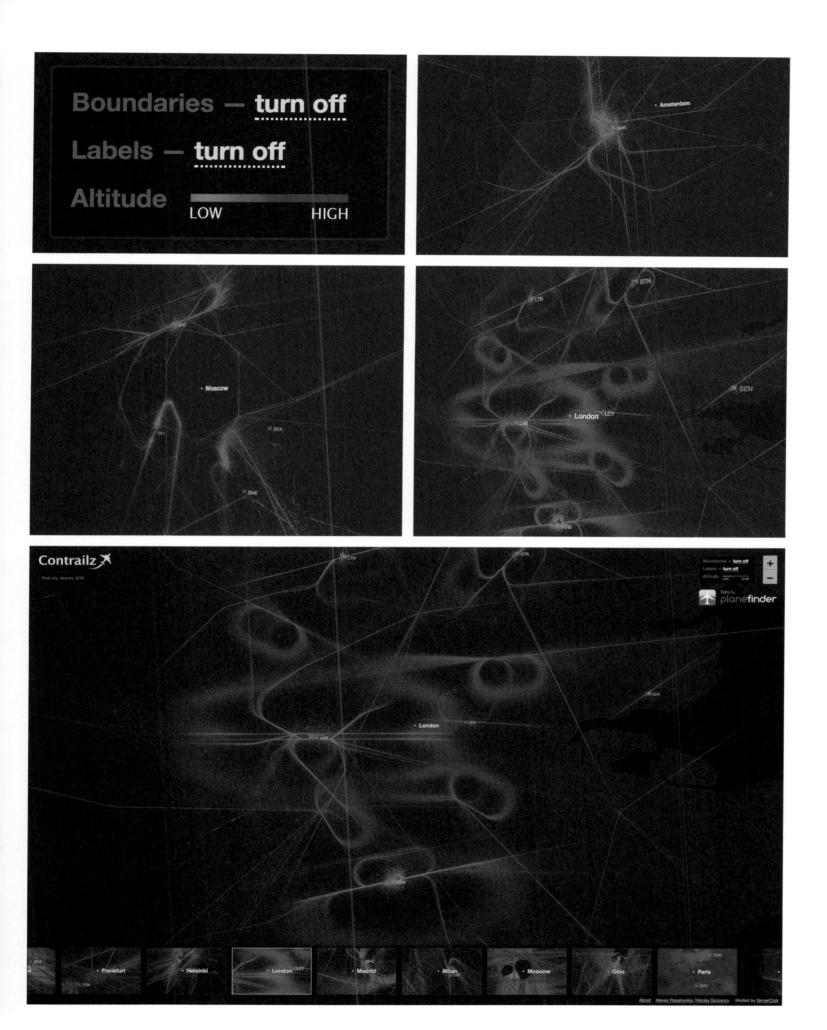

DESIGN Alexey Papulovskiy & Nikolay Guryanov COUNTRY/REGION Russia

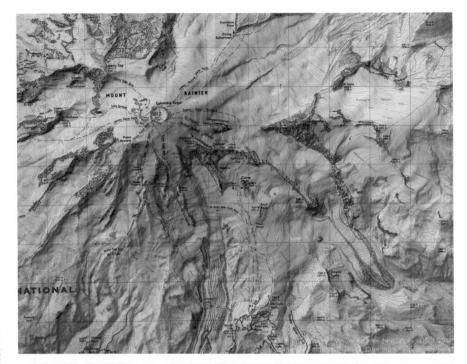
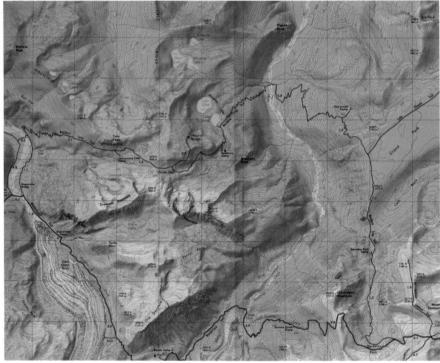

Mount Rainier National Park Map

Mount Rainier National Park Centennial Edition is a huge, elaborately coloured relief map of the northwest USA's Mount Rainier National Park, published by Stanley Friedman Maps Company for the park's centennial (1999). Drawn according to the standards of National Geographic Institute (France) topographical maps, its precision conveys great detail.

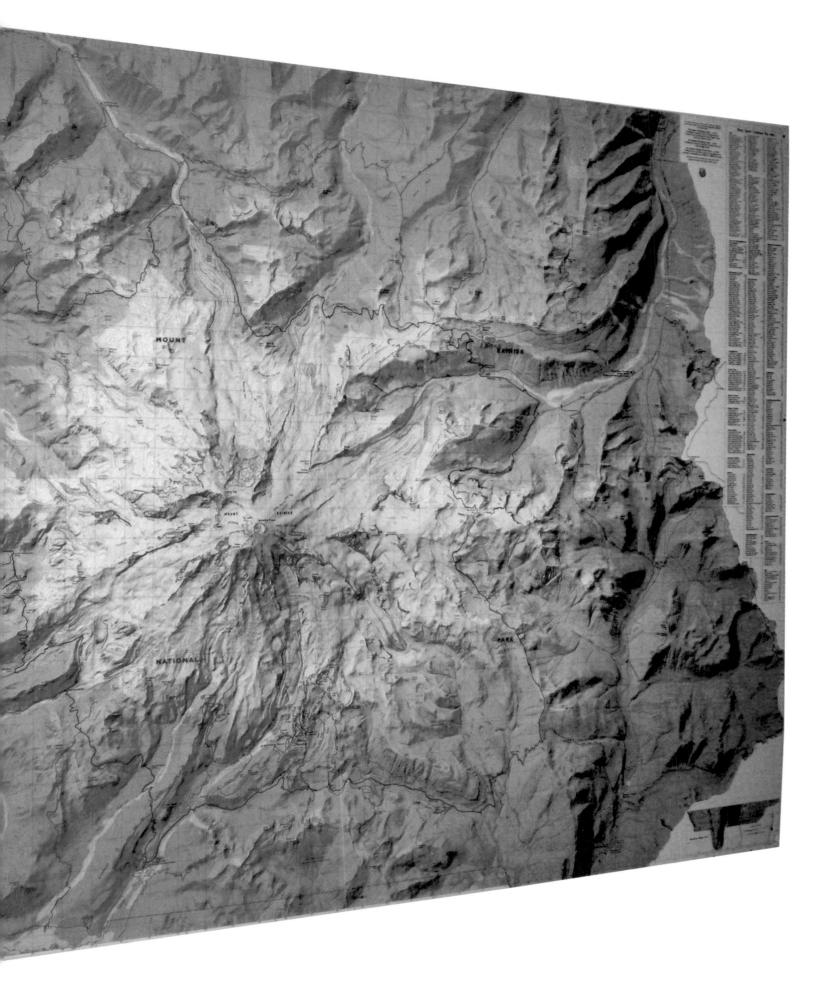

© Stanley Maps, Mount Rainier Nat. Park, US 1999 Jasmine D. Salachas, Chuck Kitterman - Cartographers

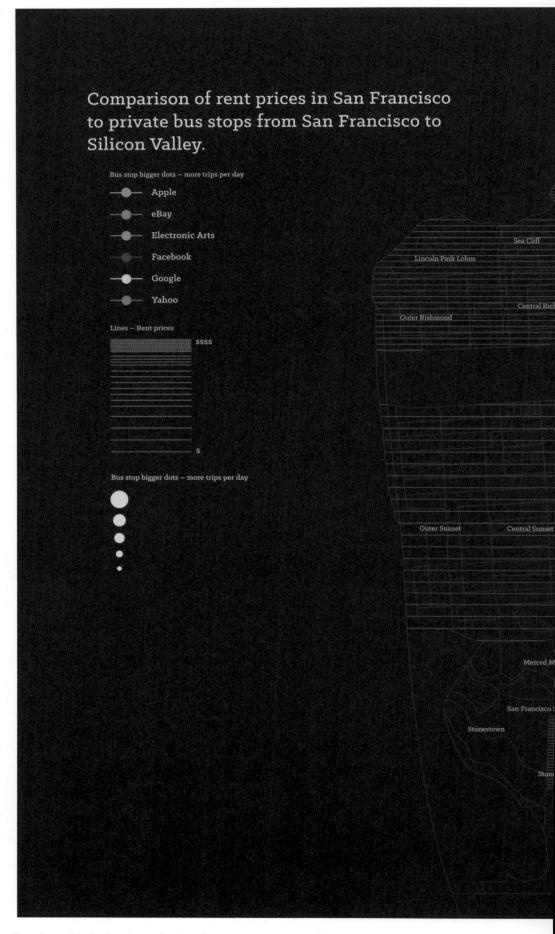

Mapping San Francisco

This infographic map combines rent prices in San Francisco with the locations of private bus stops on routes to Silicon Valley. By combining these two things that San Francisco can't stop thinking about into a pretty infographic, it matter-of-factly shows the correlation of rent prices and proximity to shuttle-bus access to the major high-tech employers. A few colours and different spacing and lines were adopted to create a simple yet clear and direct map.

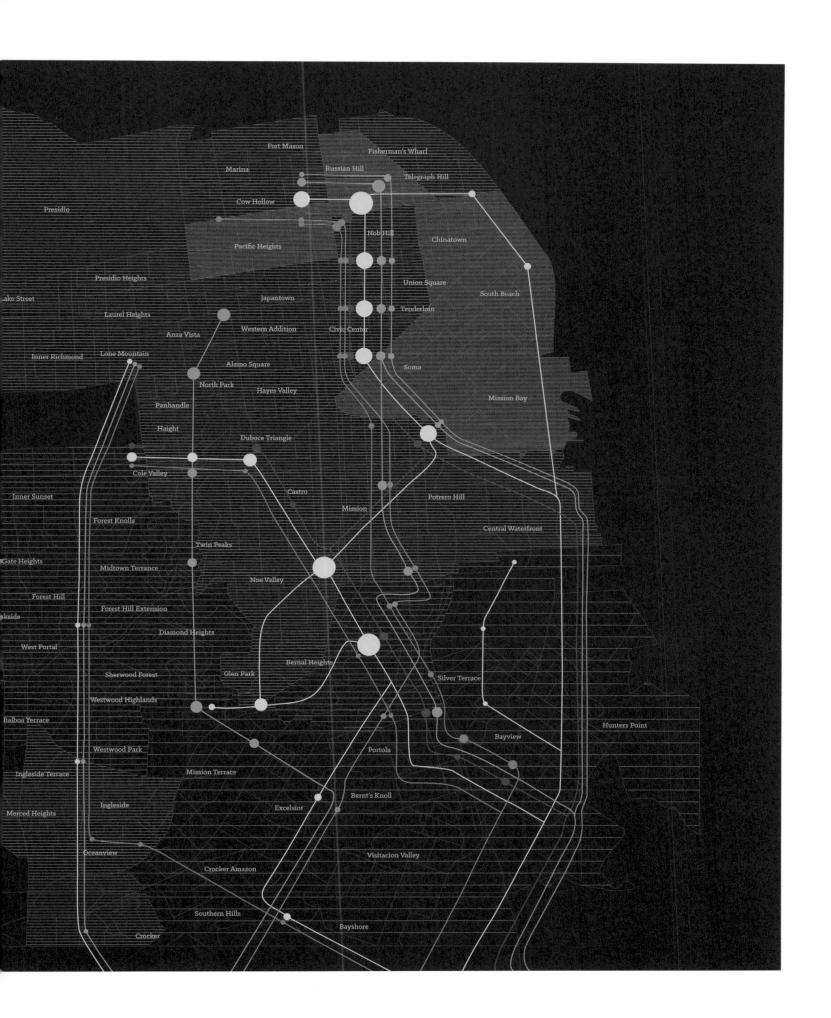

DESIGN Suwanna Ruayrinsaowarot COUNTRY/REGION USA

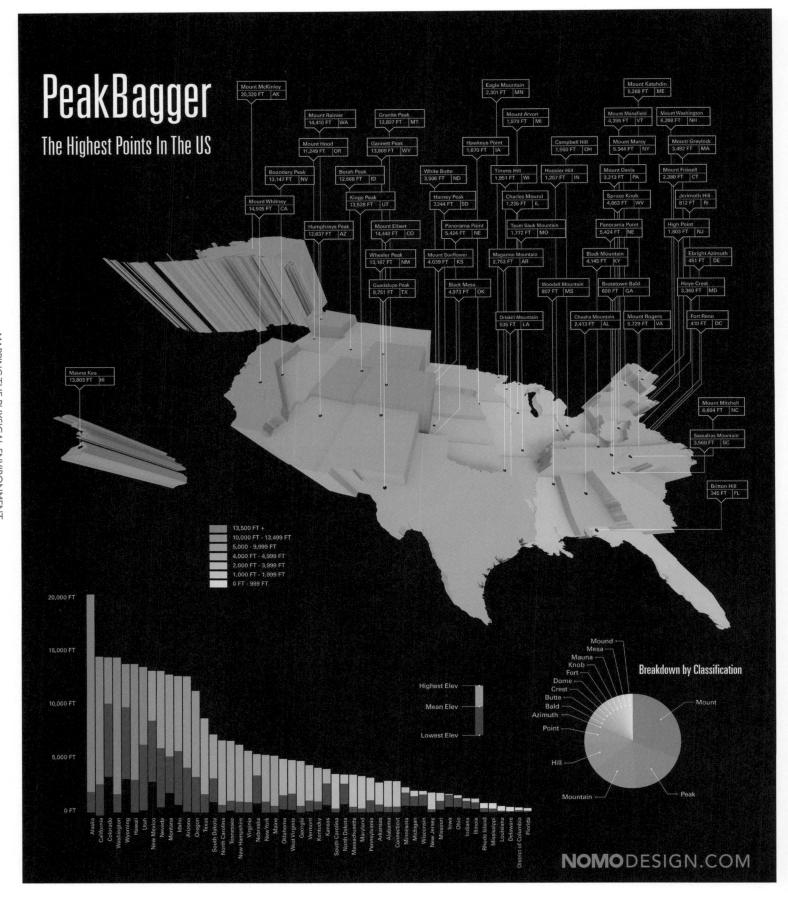

PeakBagger: The Highest Points in the US

PeakBagger is a 3D visualization of the highest points in each state of America. A pie chart illustrates the classification name of each landmark – mountains, peaks, points etc. A bar chart also illustrates the highest, average and lowest elevations for each state.

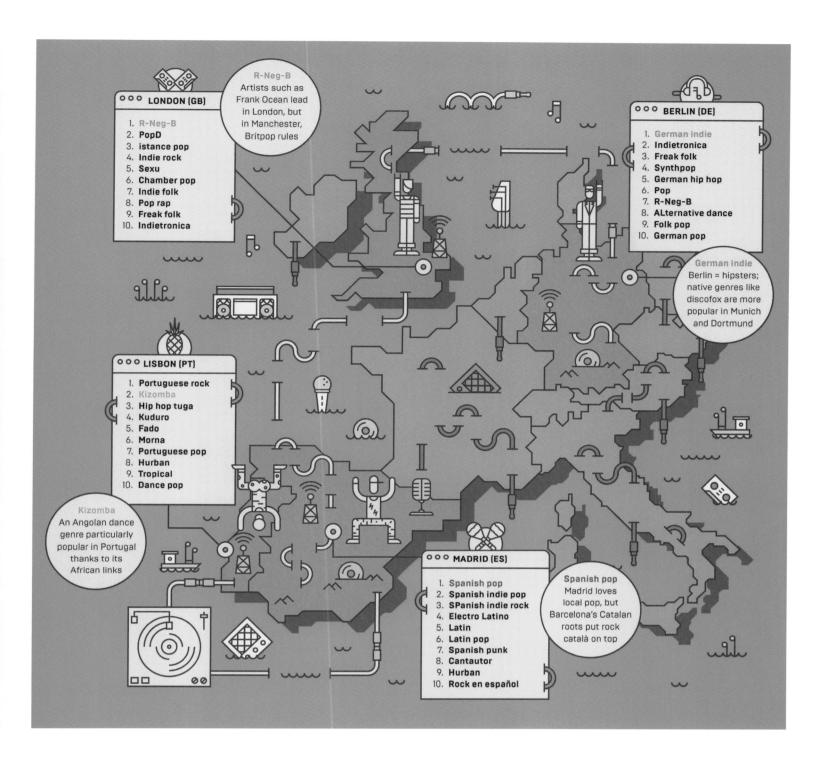

Spotify EU Map

This map was created in order to reveal what the EU is listening to, based on Spotify data. The design duo have portrayed the different moods of four countries – the UK, Germany, Portugal and Spain – via a sparkling, colourful map. These four countries are coloured peacock blue, with small stylized characters representing the main music style played in each. A "record player" wired into each nation lists its ten most popular genres. Everything is smartly integrated to make a simple and impactful composition.

DESIGN relajaelcoco studio COUNTRY/REGION Spain

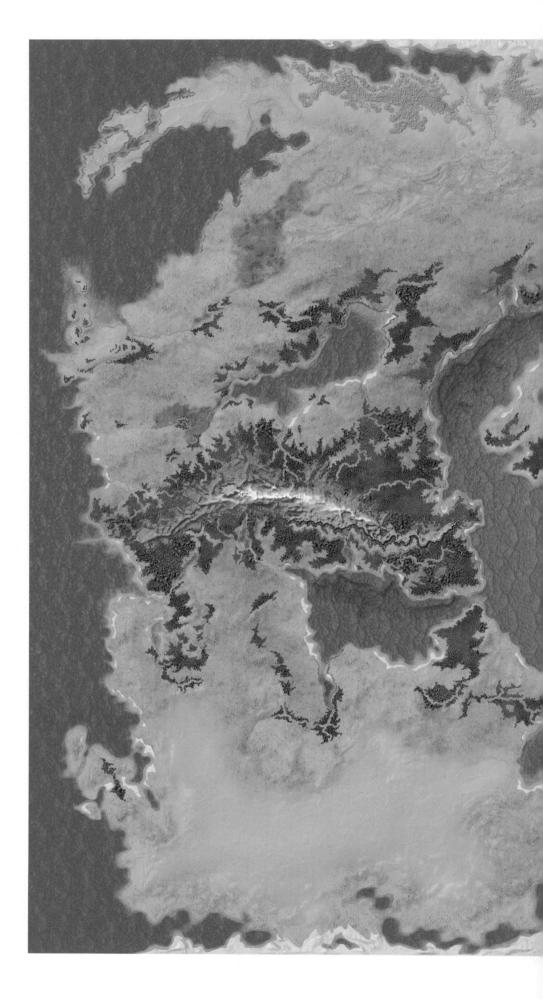

Ougeoma

Ougeoma is a fictional map created purely for the joy of world making. The work is rendered richly as if it were a physical landscape in topographic view rather than a graphical, informative map.

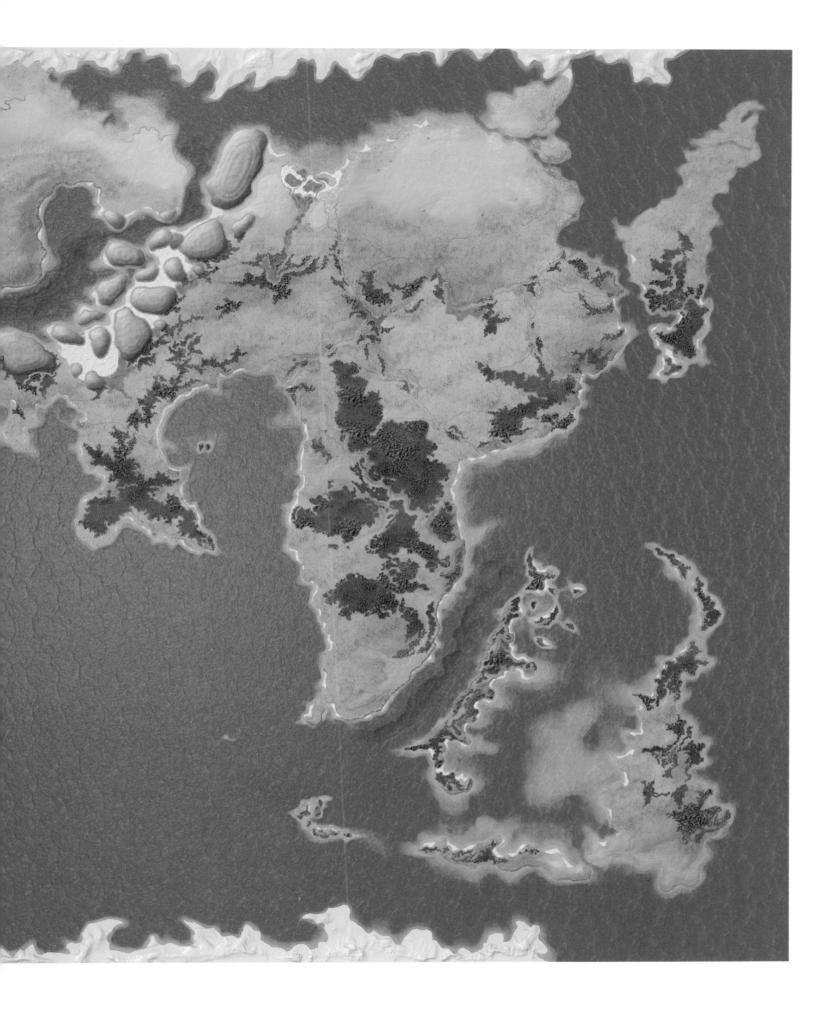

DESIGN Sam Williams Studio COUNTRY/REGION Australia

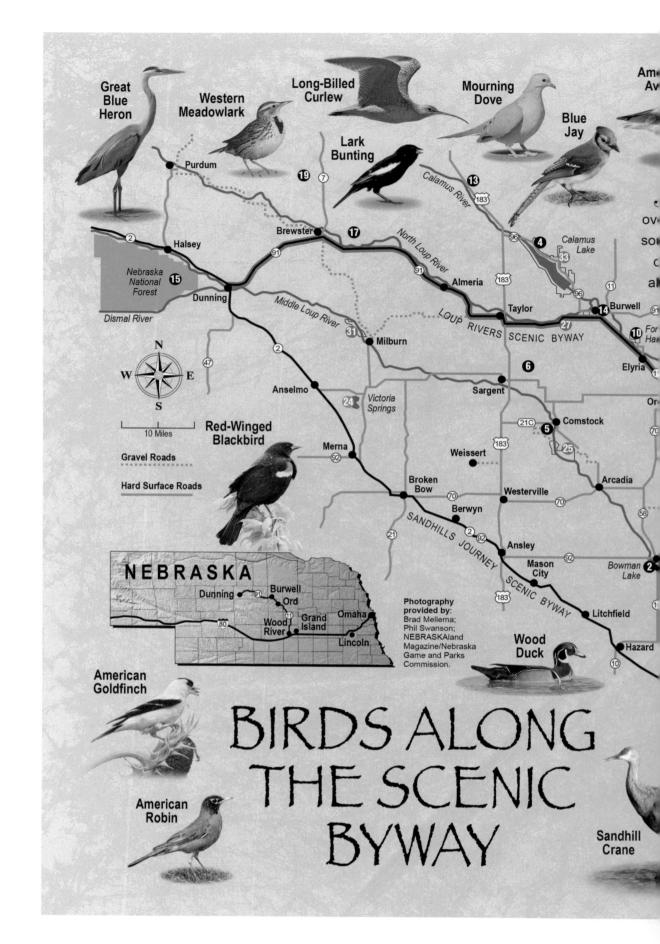

Great Bird Watching

This map is part of a brochure for the Loup Rivers Scenic Byways group, to promote bird watching in their locality in Nebraska, USA. The brochure opens up to a map of the Scenic Byway area. On the right side is a numbered data chart, which is keyed to the map. Above and below are images of distinctive birds of the region.

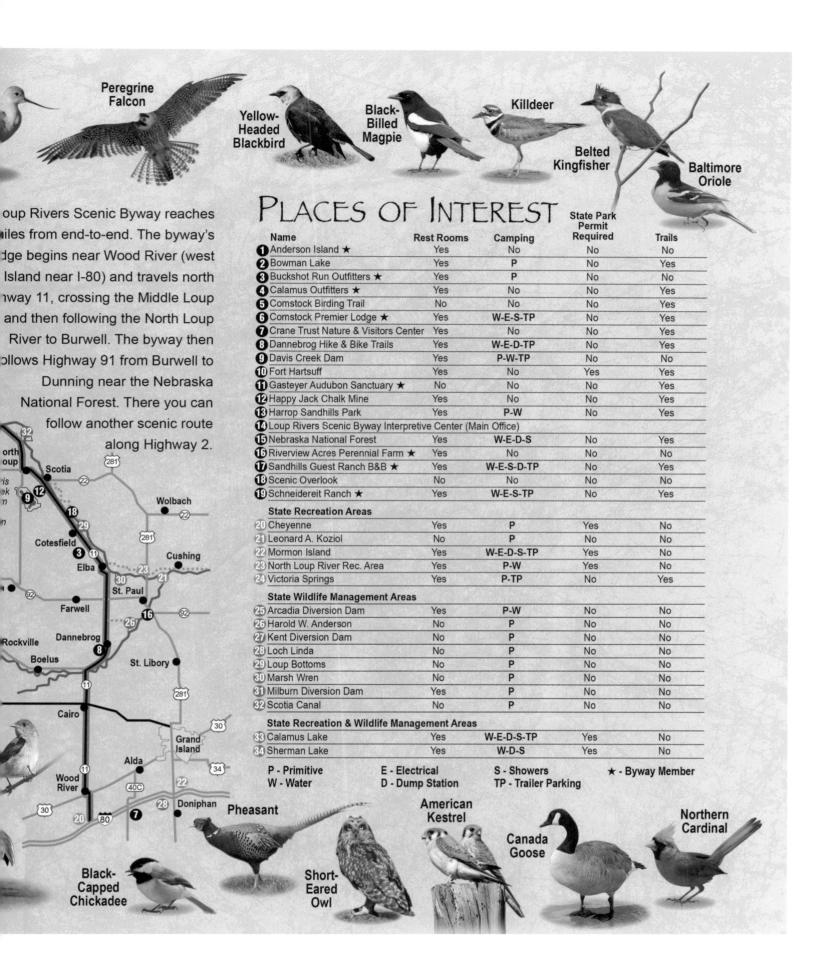

oup Rivers Scenic Byway reaches
iles from end-to-end. The byway's
dge begins near Wood River (west
Island near I-80) and travels north
way 11, crossing the Middle Loup
and then following the North Loup
River to Burwell. The byway then
ollows Highway 91 from Burwell to
Dunning near the Nebraska
National Forest. There you can
follow another scenic route
along Highway 2.

Places of Interest

#	Name	Rest Rooms	Camping	State Park Permit Required	Trails
1	Anderson Island ★	Yes	No	No	No
2	Bowman Lake	Yes	P	No	Yes
3	Buckshot Run Outfitters ★	Yes	P	No	No
4	Calamus Outfitters ★	Yes	No	No	Yes
5	Comstock Birding Trail	No	No	No	Yes
6	Comstock Premier Lodge ★	Yes	W-E-S-TP	No	Yes
7	Crane Trust Nature & Visitors Center	Yes	No	No	Yes
8	Dannebrog Hike & Bike Trails	Yes	W-E-D-TP	No	Yes
9	Davis Creek Dam	Yes	P-W-TP	No	No
10	Fort Hartsuff	Yes	No	Yes	Yes
11	Gasteyer Audubon Sanctuary ★	No	No	No	Yes
12	Happy Jack Chalk Mine	Yes	No	No	Yes
13	Harrop Sandhills Park	Yes	P-W	No	Yes
14	Loup Rivers Scenic Byway Interpretive Center (Main Office)				
15	Nebraska National Forest	Yes	W-E-D-S		Yes
16	Riverview Acres Perennial Farm ★	Yes	No	No	No
17	Sandhills Guest Ranch B&B ★	Yes	W-E-S-D-TP	No	Yes
18	Scenic Overlook	No	No	No	No
19	Schneidereit Ranch ★	Yes	W-E-S-TP	No	Yes
	State Recreation Areas				
20	Cheyenne	Yes	P	Yes	No
21	Leonard A. Koziol	No	P	No	No
22	Mormon Island	Yes	W-E-D-S-TP	Yes	No
23	North Loup River Rec. Area	Yes	P-W	Yes	No
24	Victoria Springs	Yes	P-TP	No	Yes
	State Wildlife Management Areas				
25	Arcadia Diversion Dam	Yes	P-W	No	No
26	Harold W. Anderson	No	P	No	No
27	Kent Diversion Dam	No	P	No	No
28	Loch Linda	No	P	No	No
29	Loup Bottoms	No	P	No	No
30	Marsh Wren	No	P	No	No
31	Milburn Diversion Dam	Yes	P	No	No
32	Scotia Canal	No	P	No	No
	State Recreation & Wildlife Management Areas				
33	Calamus Lake	Yes	W-E-D-S-TP	Yes	No
34	Sherman Lake	Yes	W-D-S	Yes	No

P - Primitive E - Electrical S - Showers ★ - Byway Member
W - Water D - Dump Station TP - Trailer Parking

DESIGN Sidney Jablonski COUNTRY/REGION USA

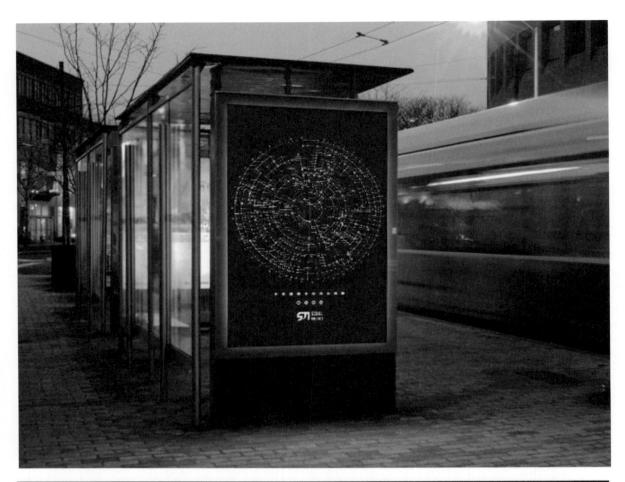

Seoul Metro

With emphasis on vibrancy, balance and consistency, the inspiration for this metro map for the capital of South Korea came from the Asian philosophical concept of Yin and Yang, found in many traditional Korean designs (including the national flag). This Yin-Yang element is seen throughout the map design, for instance in the river in the centre and in transfer stations.

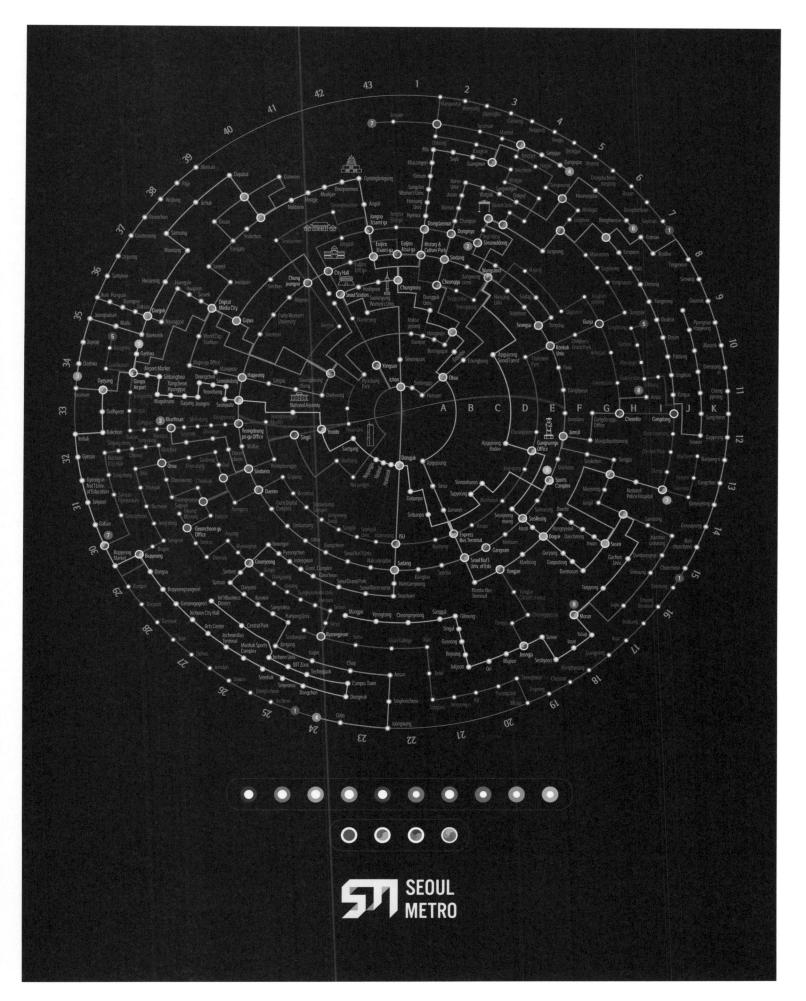

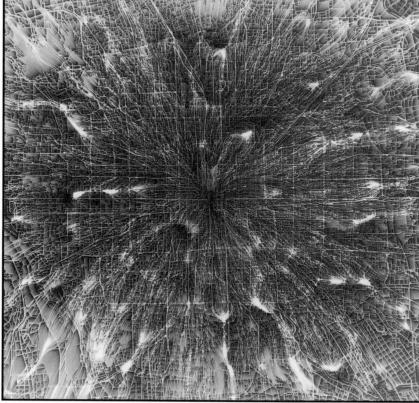

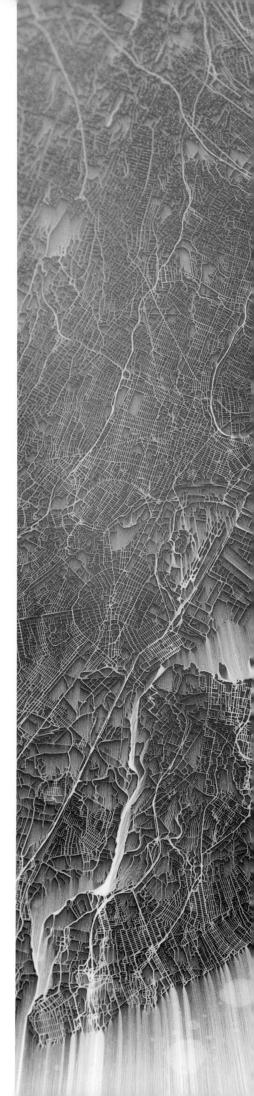

Flowing City Map

These evocative maps are part of a series of maps entitled Flowing City Map created for an exhibition which explores cities, their environments and the relation between them. Chaotic Atmospheres represented the cities' influence on the environment as a kind of invisible fluid that overflows from the city to its surroundings. City maps were retrieved and roads were highlighted. Then, with the help of a 3D processing software, the artist created the "fluid" by simulating an erosion on the maps.

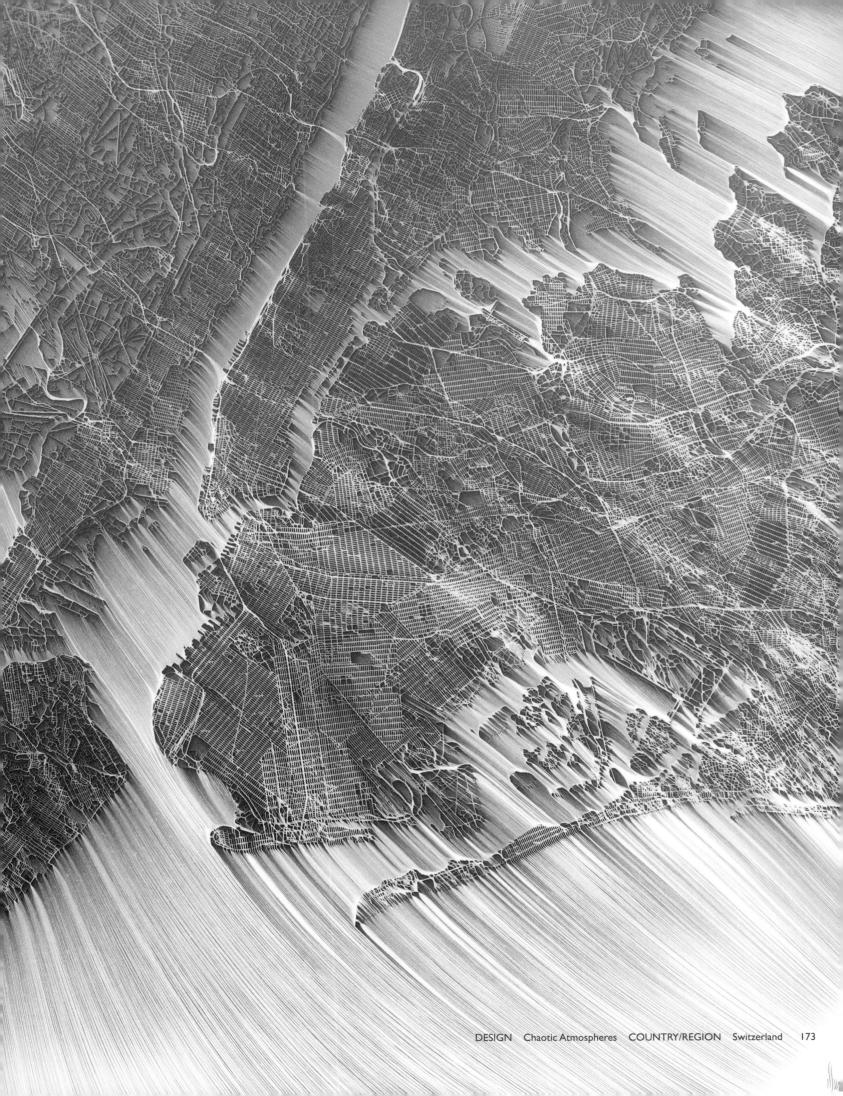

DESIGN Chaotic Atmospheres COUNTRY/REGION Switzerland 173

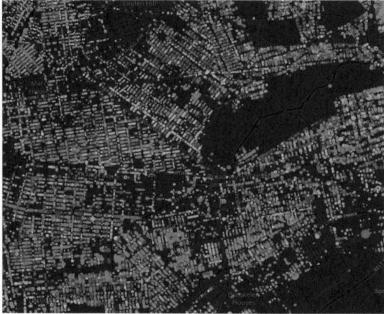

NYC Street Trees by Species

New York City's urban forest provides numerous environmental and social benefits, and street trees compose roughly one quarter of that canopy. This NYC Street Trees by Species map shows the distribution and biodiversity of the city's street trees, based on the 2005 New York City tree census, conducted by the Department of Parks and Recreation.

- All Trees
- American Linden
- Amur Maple
- Baldcypress
- Birch
- Black Locust
- Callery Pear
- Chinese Elm
- Crabapple
- Dawn Redwood
- Eastern Redbud
- Eastern White Pine
- English Oak
- European Hornbeam
- Flowering Cherry
- Flowering Dogwood
- Ginkgo
- Goldenrain Tree
- Green Ash
- Hackberry
- Hawthorn
- Hedge Maple
- Honeylocust
- Horsechestnut
- Japanese Maple
- Japanese Pagoda Tree
- Japanese Tree Lilac
- Japanese Zelkova
- Katsura Tree
- Kentucky Coffeetree
- Littleleaf Linden
- London Planetree
- Magnolia
- Mulberry
- Northern Red Oak
- Norway Maple
- Pin Oak
- Poplar
- Purpleleaf Plum
- Red Maple
- Sawtooth Oak
- Schubert Cherry
- Serviceberry
- Silver Linden
- Silver Maple
- Sugar Maple
- Swamp White Oak
- Sweetgum
- Sycamore Maple
- Tree of Heaven
- Tulip Tree
- White Oak
- Willow Oak

FILTER BY SPECIES

DESIGN Jill Hubley COUNTRY/REGION USA

MAPPING THE PHYSICAL ENVIRONMENT

Long Island City, Queens, New York

Environs Map Series

The Environs Map Series comprises documents of psycho-geographic mapping. Overlain on an exact geographical map of each place is a collage of original photography, image compositing and illustration, which is at once highly objective and subjective. The maps seek to capture the essence of the environment at the moment that the information and imagery are captured and created.

DESIGN JL Cartography / Jonathan E. Levy COUNTRY/REGION USA

Carroll Gardens, Brooklyn, New York

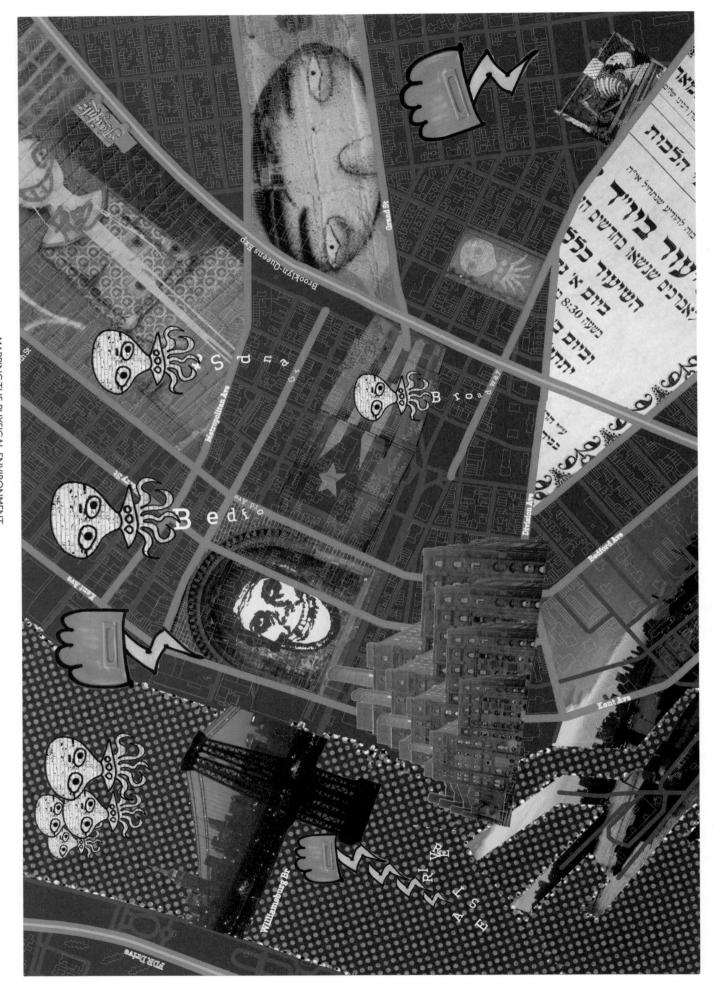

Williamsburg, Brooklyn, New York

Chapel Hill, North Carolina

Mappemonde

A world map hammered in the wall reveals continents and nations in the gaps in the surface, holes and cracks, while the untouched smooth white wall surface represents oceans.

Here, the world map is not only a picture of the world but also reminds the viewer of the physical presence of the artist. Its scale and contours are defined not by the size of the wall or an exhibition space but by the distance between his body and the piece of work, and the space between his two arms. Just imagine him engraving the world's image, hammer in hand, when confronted with a blank wall.

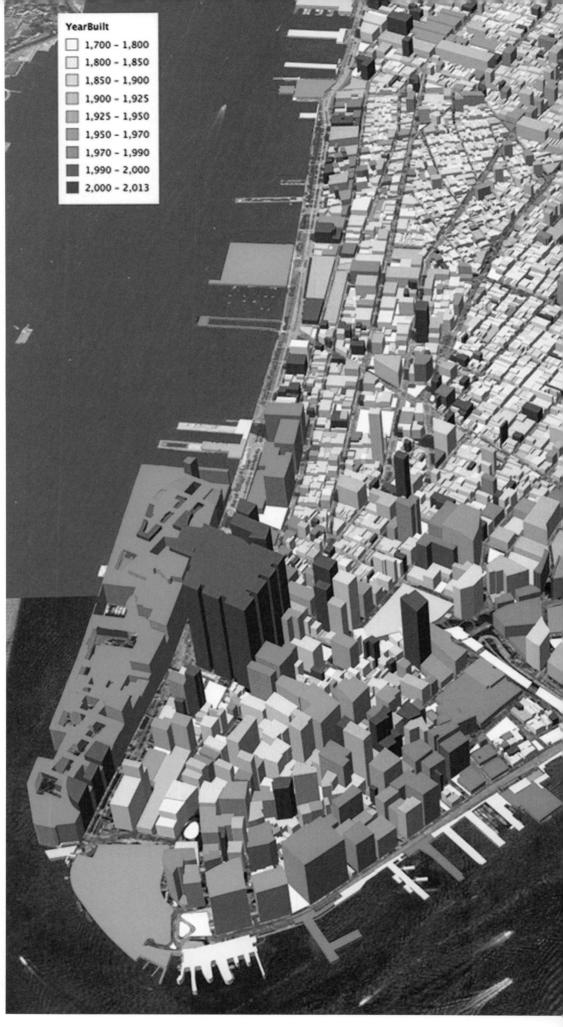

Lower Manhattan by Year Built

This 3D mapping of buildings in Lower Manhattan shows both their height and the year in which they were built, from 1700 to the present. The lightest colour indicates the oldest buildings, through to dark orange-brown for the newest. The data to create this map came from New York City's Department of City Planning.

City Layouts

Topography, architecture and traffic routes give every city a unique structure. These conditions create the typical and individual inner structure of a city.

Luis Dilger didn't only want to show such structures in the conventional way from above. He also wanted to include the exact three-dimensionality of topography and buildings – a real-world visualization. By importing satellite-based data into a 3D program, he visualizes the fine lines and contours of architecture and streets. He then edits every detail individually until a minimalistic yet realistic view of the city is achieved. These unique maps show some of the major cities of the world from an entirely new perspective. They represent a perfect mix of information and visual fascination.

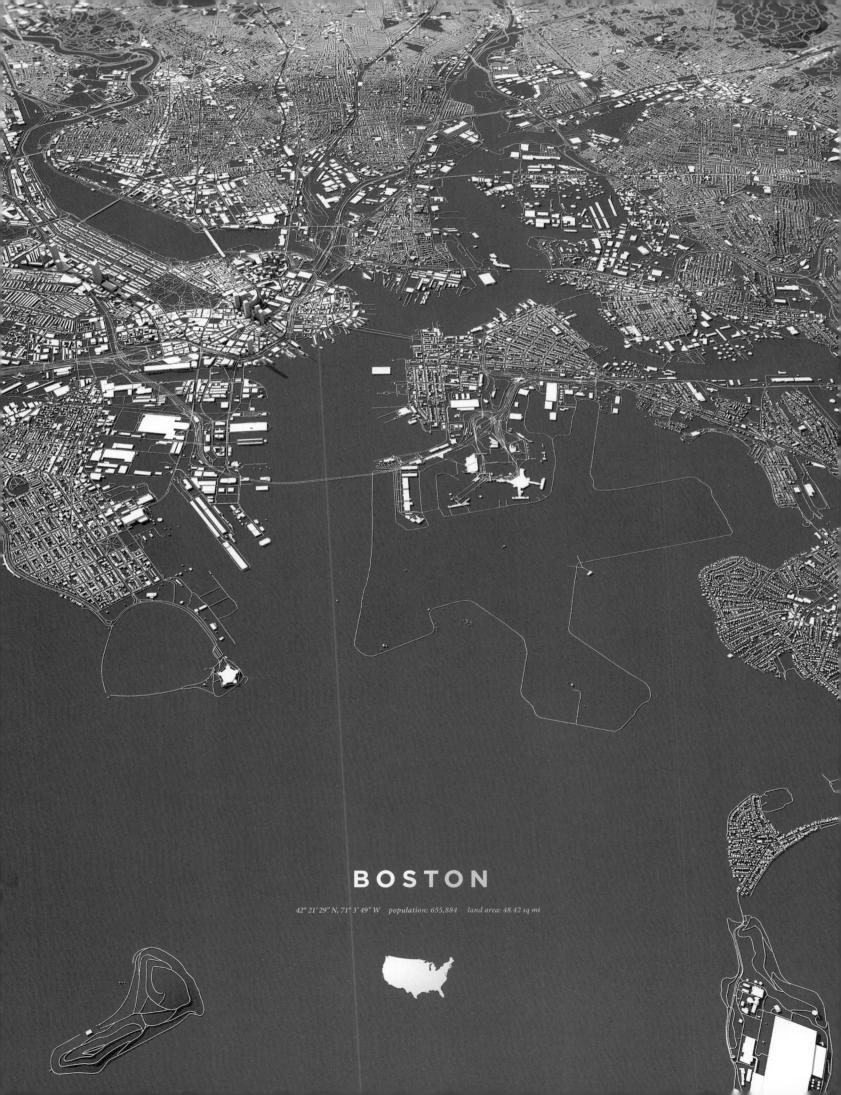

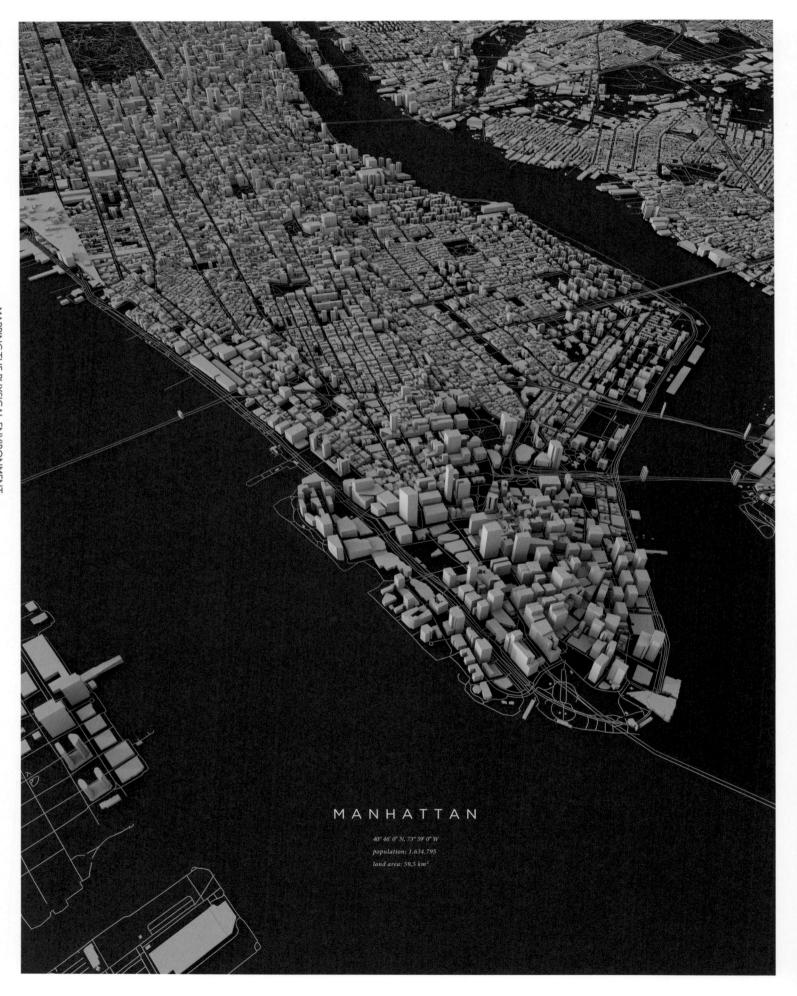

MAPPING THE PHYSICAL ENVIRONMENT

MANHATTAN

40° 46' 0" N, 73° 59' 0" W
population: 1.634.795
land area: 59,5 km²

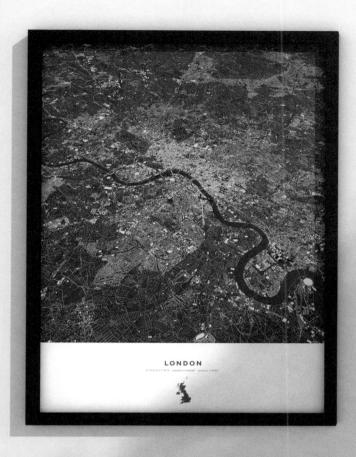
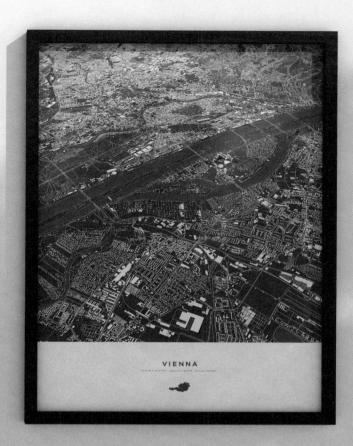
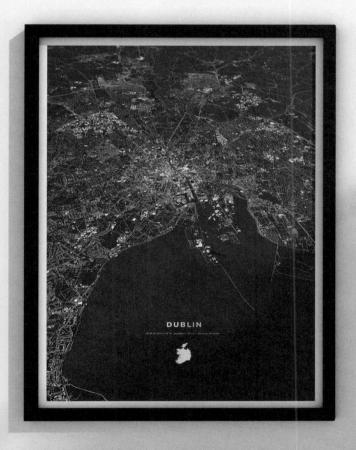
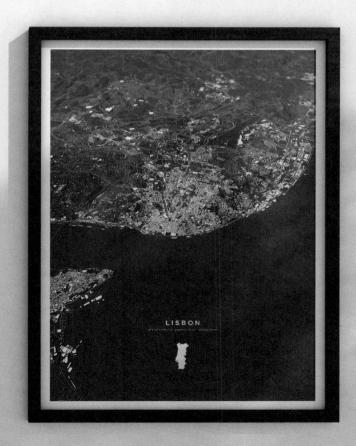

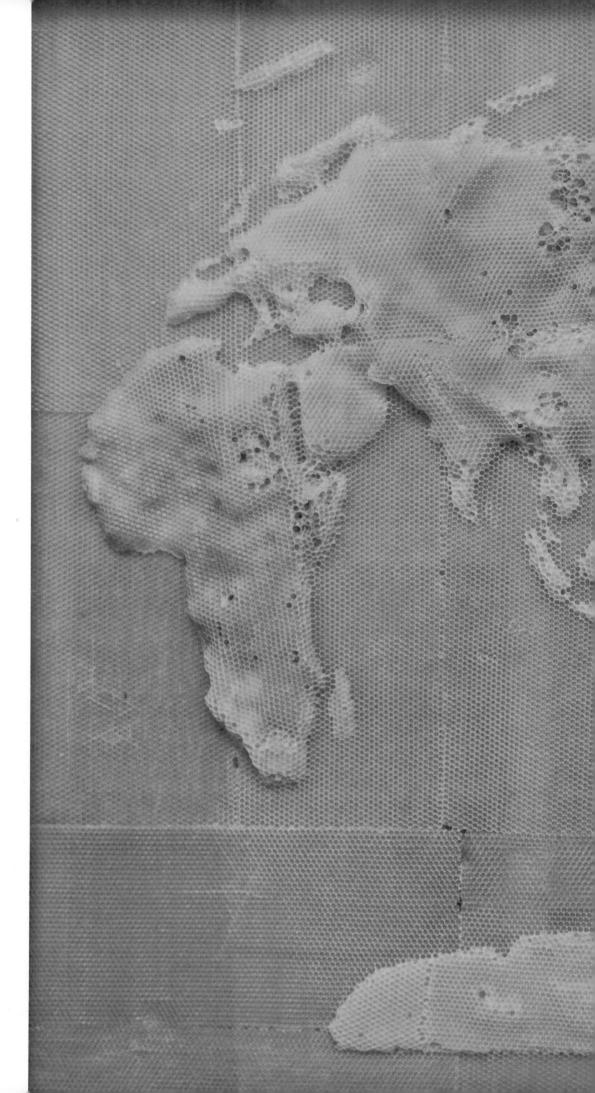

Yuansu Series

The Yuansu Series is a partnership between Chinese artist Ren Ri and bees. The art piece takes the form of a relief sculpture.

Ren undertook an experiment in creating these works. He sought the help of bees, clearing one corner of the beehive and replacing it with relief maps. Amazingly, the bees accepted the invading object and continued shaping their comb on the undulating terrain relief. However, they didn't simply accept the choices humans imposed on them by just following the relief. Instead, they bit into its high points and entered the space to continue their honeycomb building, while filling the lower points with honey based on their needs. The resulting maps are great and natural despite the "damage" – numerous holes – inflicted on the maps by the bees. Actually, it is these holes that make the natural art pieces. The end result was a true collaboration between the artist and the bees.

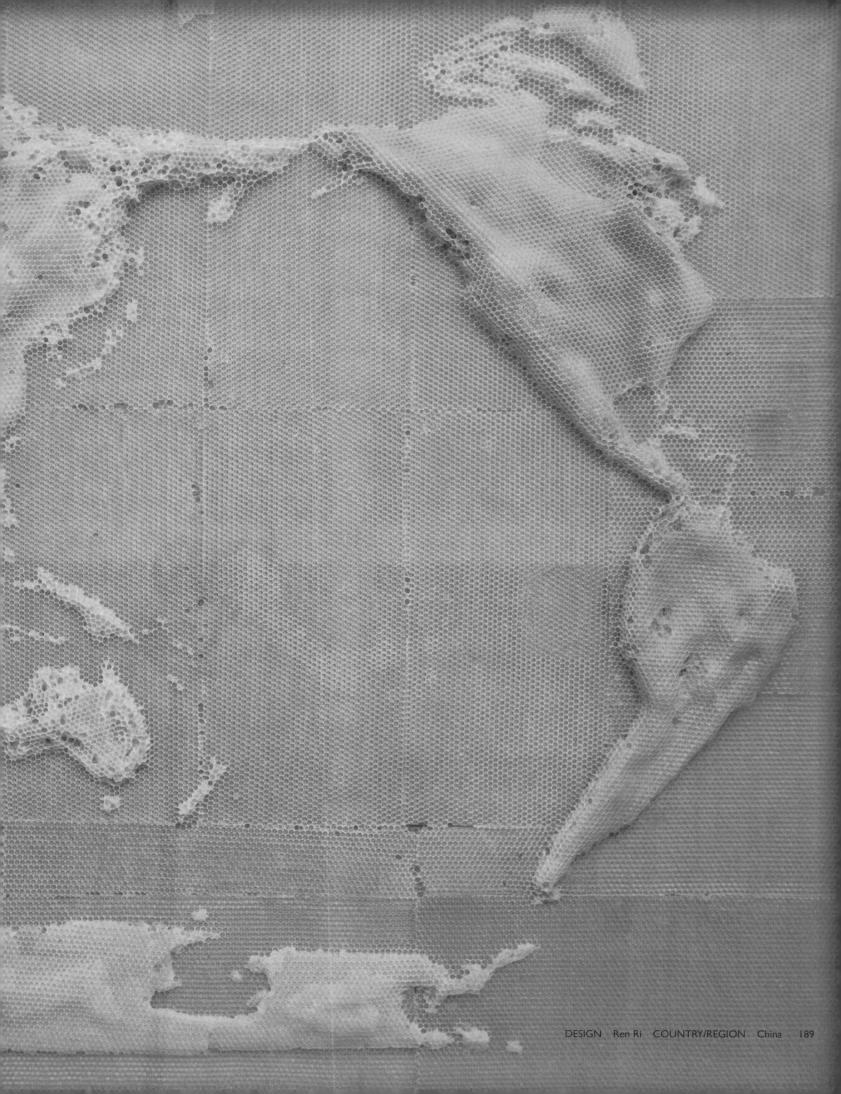

PART 2

MAPPING HUMAN ACTIVITY

This section showcases maps portraying a variety of activities and covering topics including culture, economics and politics.

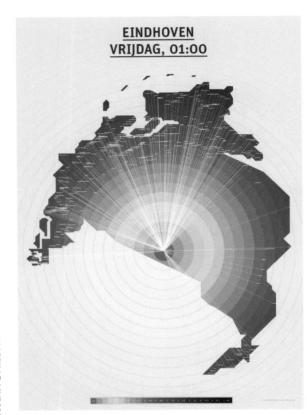
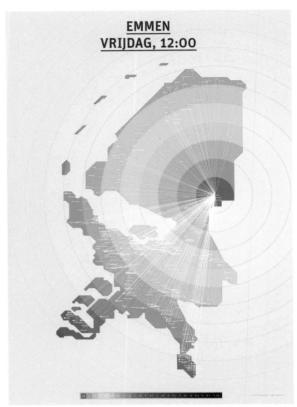
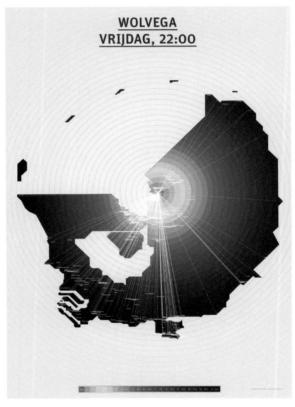
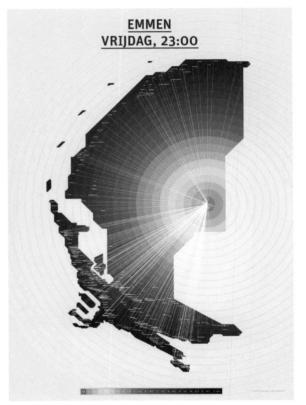

TimeMaps

Unlike traditional maps of the Netherlands, this interactive map focuses on time rather than actual distances between different locations within the country. In the Netherlands, trains bring people to their destinations easily and quickly; to some extent they decide the distance between two places. From the perspective of Amsterdam, for instance, the Netherlands is relatively small because of the quick and easy connections to other cities. But seen from a remote and small village such as Wolvega, the Netherlands is much bigger.

The hour of day is just as important as the location to or from which one travels. At night the map of the Netherlands would expand, because there are no trains, while in the morning it would shrink once trains commence. The map of the Netherlands will never be the same.

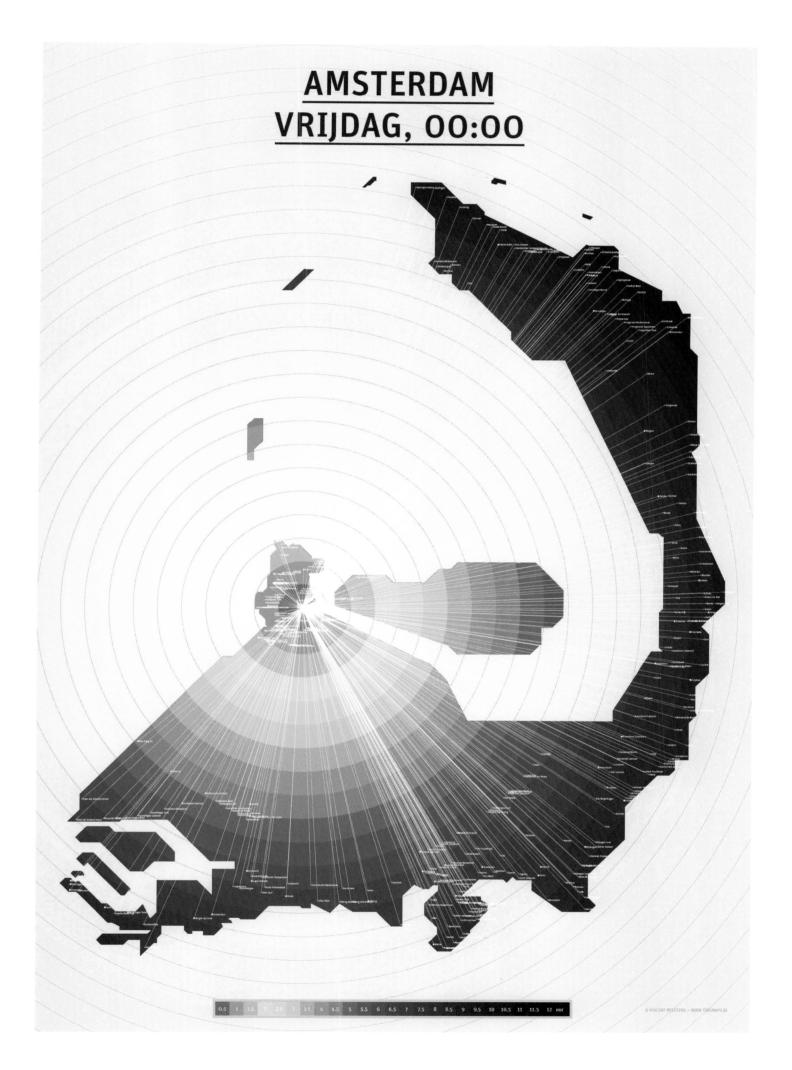

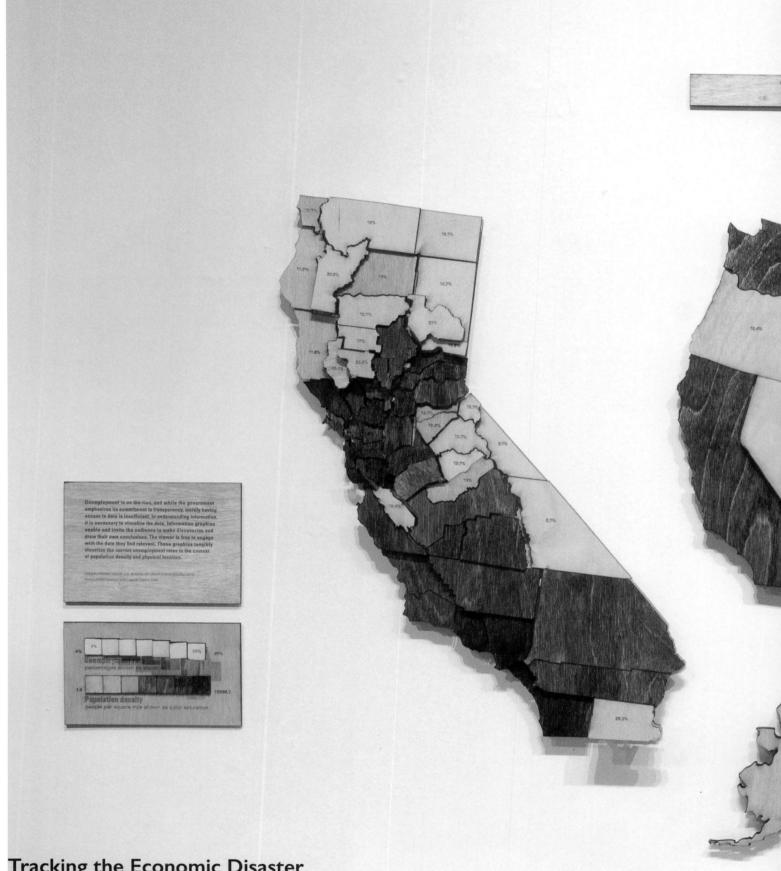

Tracking the Economic Disaster

Daniel Mason made this hardwood map to visualize the data of the economic crisis of 2008, trying to show the audience the overall impact of the crisis in a more straightforward way. He used the medium of wood and the method of elevation for this art piece. The elevation of the pieces is used to show the unemployment rate in a given county or state, and the colour of the stain indicates the population density of the area. This piece was created for an audience in California, so it was designed to show the California context in the economic crisis at both national and county level.

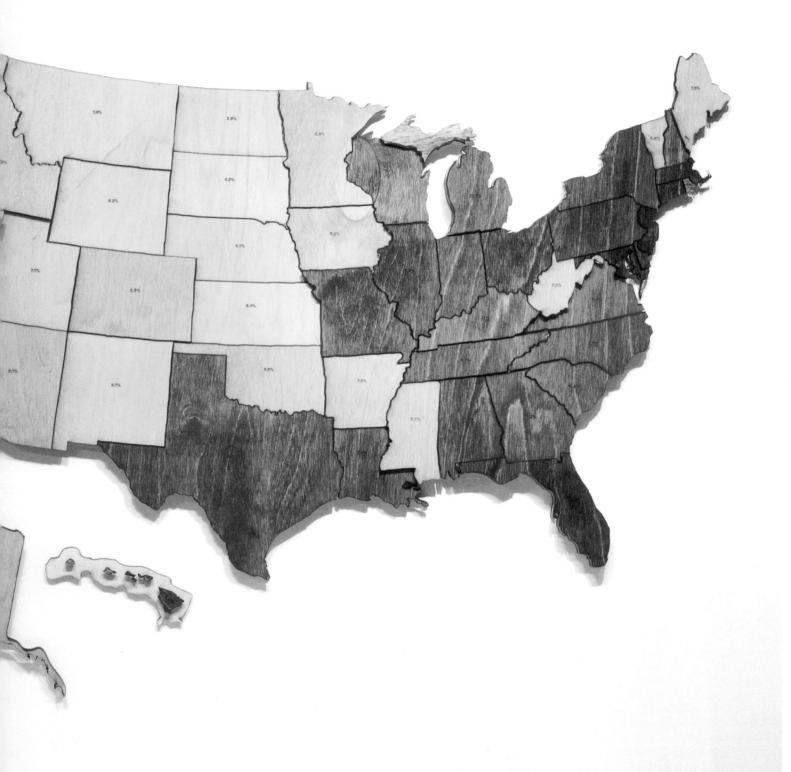

Goods of Spain Map

This colour illustrated poster was realized in collaboration with Walk With Me, a company that realizes and sells Spanish products. The idea was to represent the distribution of the main elements of Spanish production, from cocaine to *ensaimada* pastries. A realistic representation of the country was based on the statistics and data collected by Walk With Me. The poster was enriched with further information such as a decorative compass card, a seasons footer and the constellations above Spain.

DESIGN relajaelcoco studio/ Pablo Galeano & Francesco Furno COUNTRY/REGION Spain

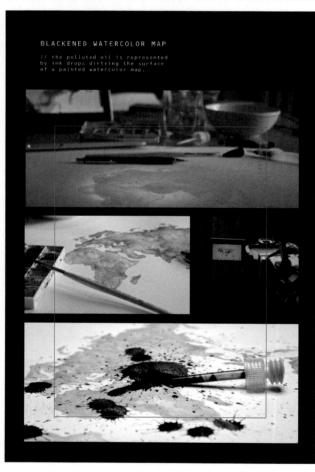
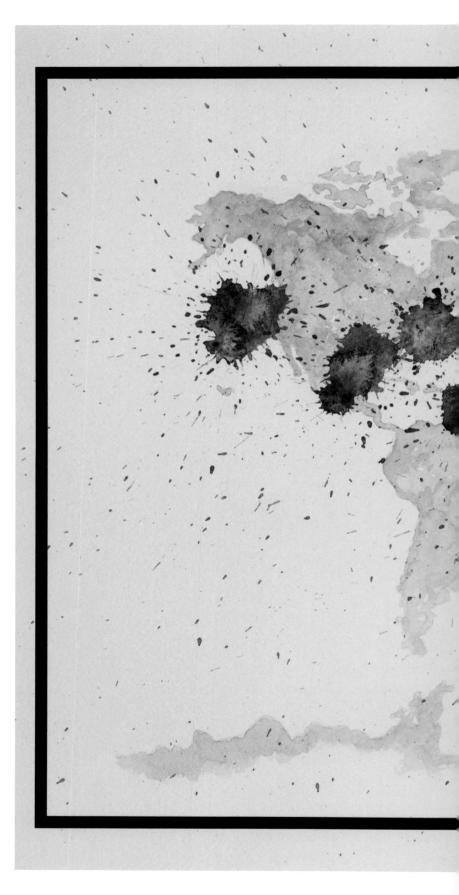

The Blackened Watercolor Map

The aim of this map was to visualize the pollution of oil spills. The designer represented the spilled oil as ink drops dirtying the surface of a watercolour map. Colours give focus to the black drops. He furthermore presented a pollution spread process as a control panel of a Marine Radar Display. The data recorded the largest accidents between 1910 and 2010.

// Is that just a drop?

DESIGN Cecilia Della Longa COUNTRY/REGION Italy

GP History Book

This map depicts the history of GP Group and its business activities around the world since its establishment in 1860. The predominant green colour of the illustration echoes the group's logo colour, enhancing a playful and light-hearted picture.

DESIGN Mandala Studio (Bangkok) ILLUSTRATOR Chinapat Yeukprasert COUNTRY/REGION Thailand

Grand Tour

Grand Tour was a section developed for *IL*, a monthly news magazine connected with the Italian financial newspaper *Il Sole 24 ORE*, from December 2009 to September 2011. It comprises a series of articles about the life of historical characters, including Friedrich Nietzsche, Alexander von Humboldt, The Beatles, Primo Carnera and Giovanni Paolo II, shown through infographic language.

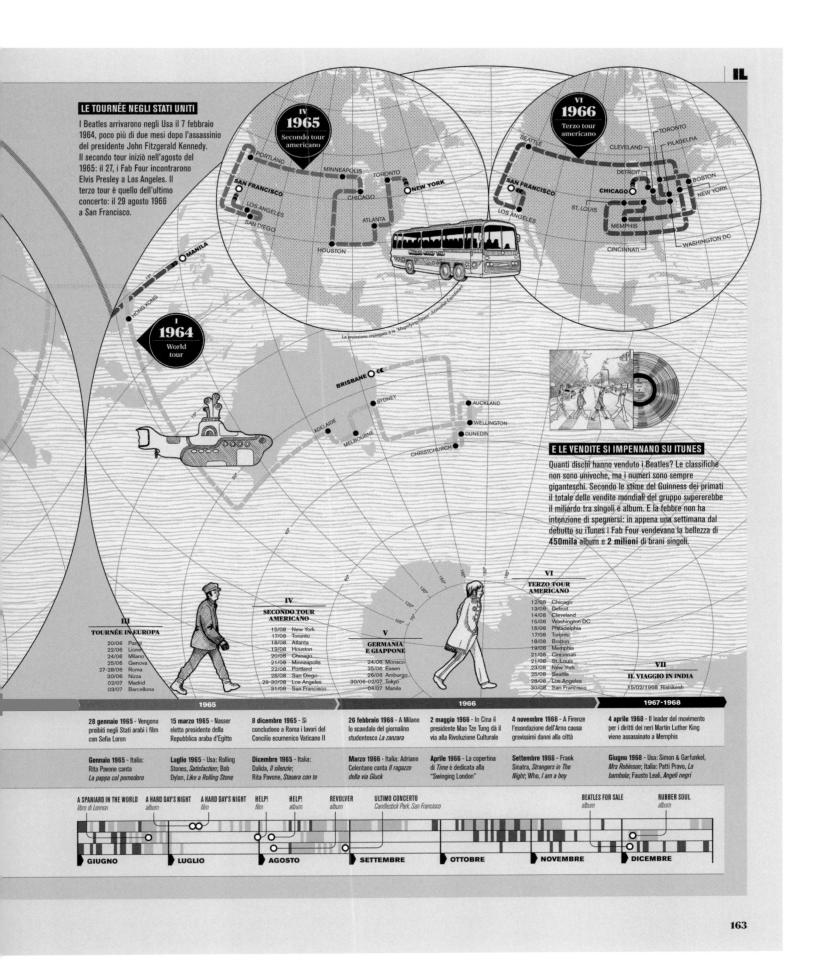

MAPPING HUMAN ACTIVITY

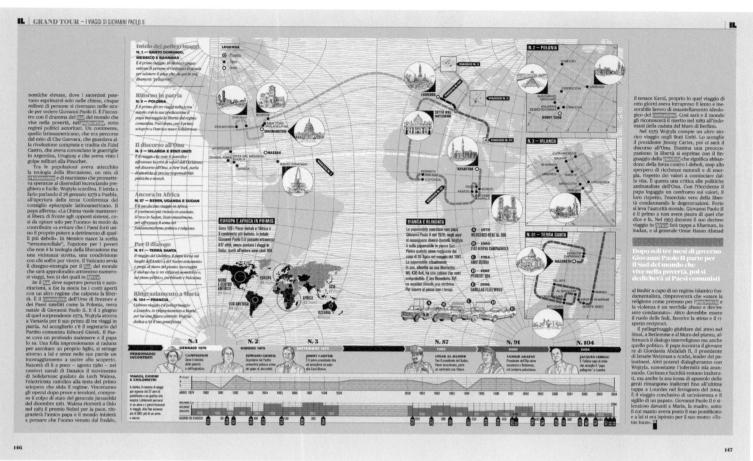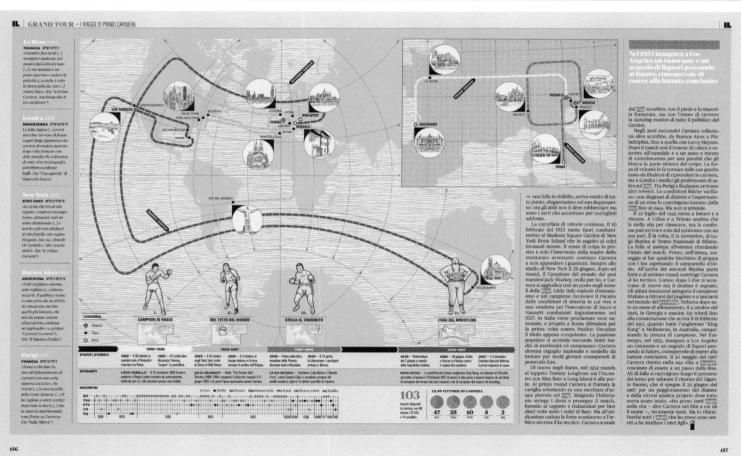

JUST RIDE
BIKE OFTEN

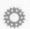 Documentation of road and mountainbike rides in the DFW metroplex.
Information was collected through a span of three months.
All data was collected using the 'MountainBike' iPhone app.
Individual rides are depicted by a mountainform whose size corresponds to length of the ride.

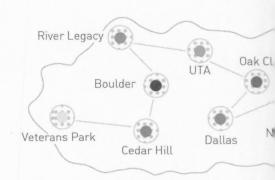

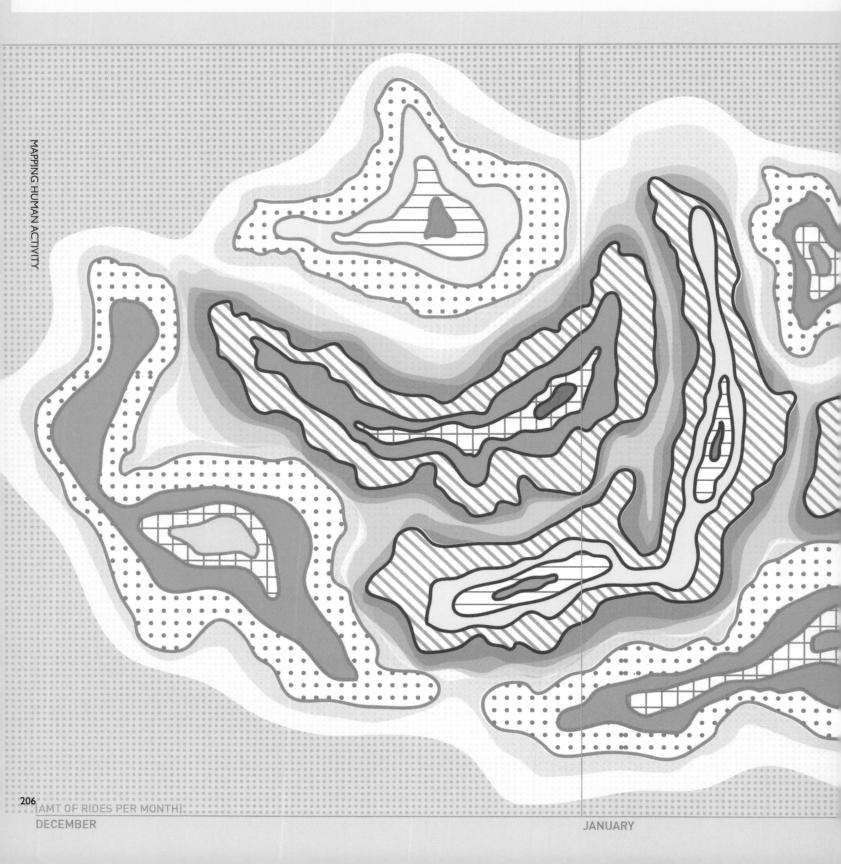

MAPPING HUMAN ACTIVITY

206
[AMT OF RIDES PER MONTH]
DECEMBER JANUARY

LOCATION MAP

Ft. Worth

Trinity Trails

ELEVATION CHANGE

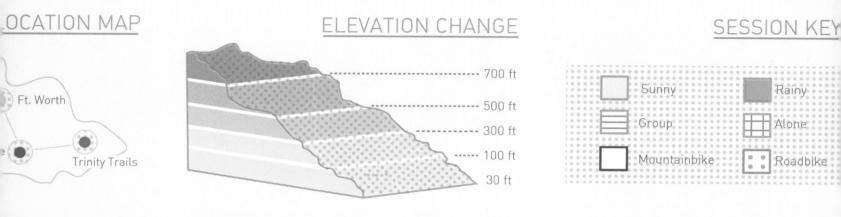

700 ft
500 ft
300 ft
100 ft
30 ft

SESSION KEY

Sunny — Rainy
Group — Alone
Mountainbike — Roadbike

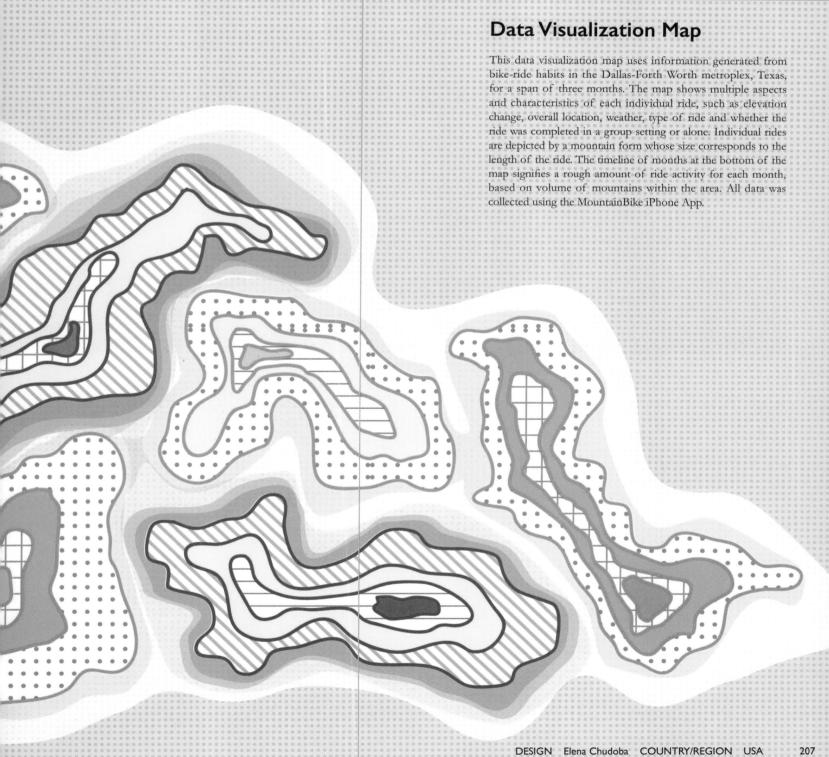

Data Visualization Map

This data visualization map uses information generated from bike-ride habits in the Dallas-Forth Worth metroplex, Texas, for a span of three months. The map shows multiple aspects and characteristics of each individual ride, such as elevation change, overall location, weather, type of ride and whether the ride was completed in a group setting or alone. Individual rides are depicted by a mountain form whose size corresponds to the length of the ride. The timeline of months at the bottom of the map signifies a rough amount of ride activity for each month, based on volume of mountains within the area. All data was collected using the MountainBike iPhone App.

FEBRUARY

DESIGN Elena Chudoba COUNTRY/REGION USA

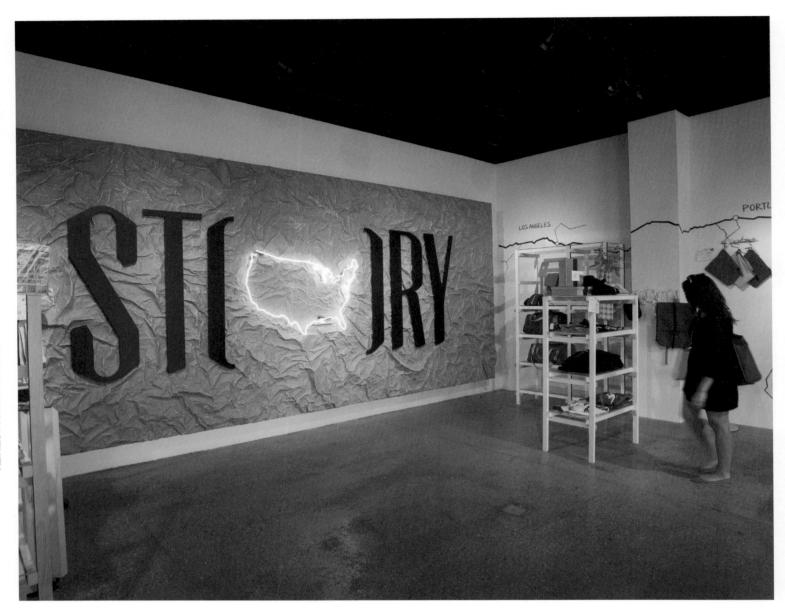

MAPPING HUMAN ACTIVITY

Made in America STORY

STORY is a concept retail space that re-imagines itself every four to eight weeks, shutting its doors to redesign and merchandise the entire space according to a new theme.
The theme for October 2013 was Made in America. On the inside wall, the "O" letter of STORY was transformed into a map of the USA framed by luminous material, and the store was divided into regions marked by a road map customers could follow along the walls. Each region was merchandised with products made in the corresponding region of the United States (the Midwest section of the store carried products made in the Midwest, etc.). This project applies map design to business activity.

DESIGN Philip Johnson COUNTRY/REGION USA

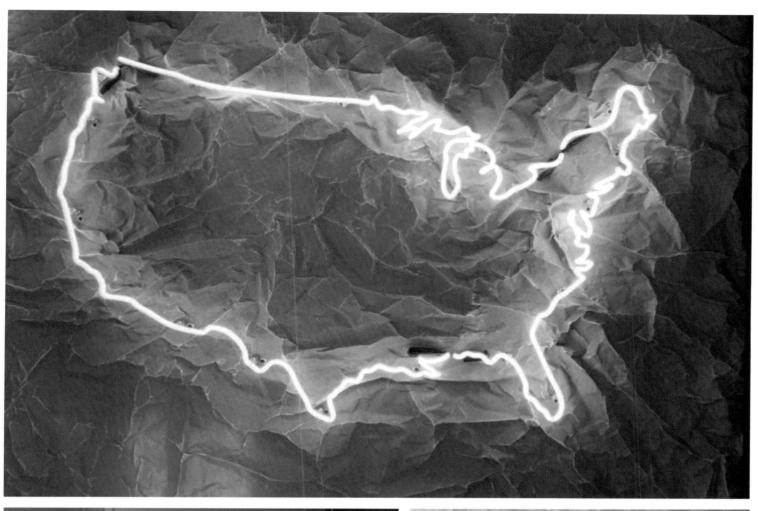

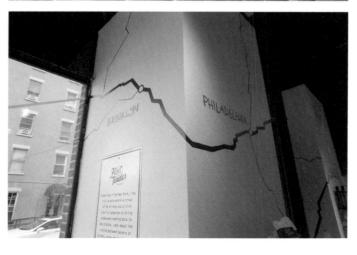

Ecumenopolis
– Mapping Project

This collage is a mapping of the designer's friend MF's journeys during the past decade. The materials used came from his collected items during the travels – city maps, subway maps, transport cards, tickets etc. It may be seen as a portrait of MF, but also as a map of an imaginary city – Ecumenopolis, created from the fragments of different cities all over the world.

DESIGN Vladislava Savic COUNTRY/REGION Serbia

BBVA Infographics

This project was undertaken for the Spanish bank BBVA, for *Marca BBVA*, an internal publication about BBVA life. Two double-page infographics based on BBVA data were used to illustrate the best hits of 2012.
The second double page features a map of the world with the most important goals reached in 2012 by the BBVA company worldwide. Relajaelcoco studio developed everything using the corporate colour palette of the bank – various shades of blue – along with a vector system is inspired by the BBVA logo shapes. A strong visual result was the outcome.

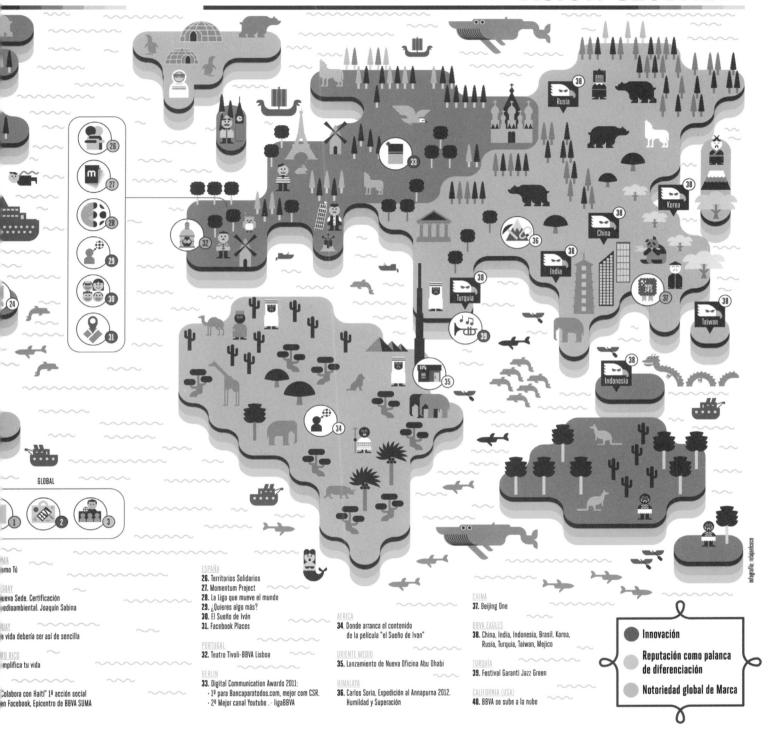

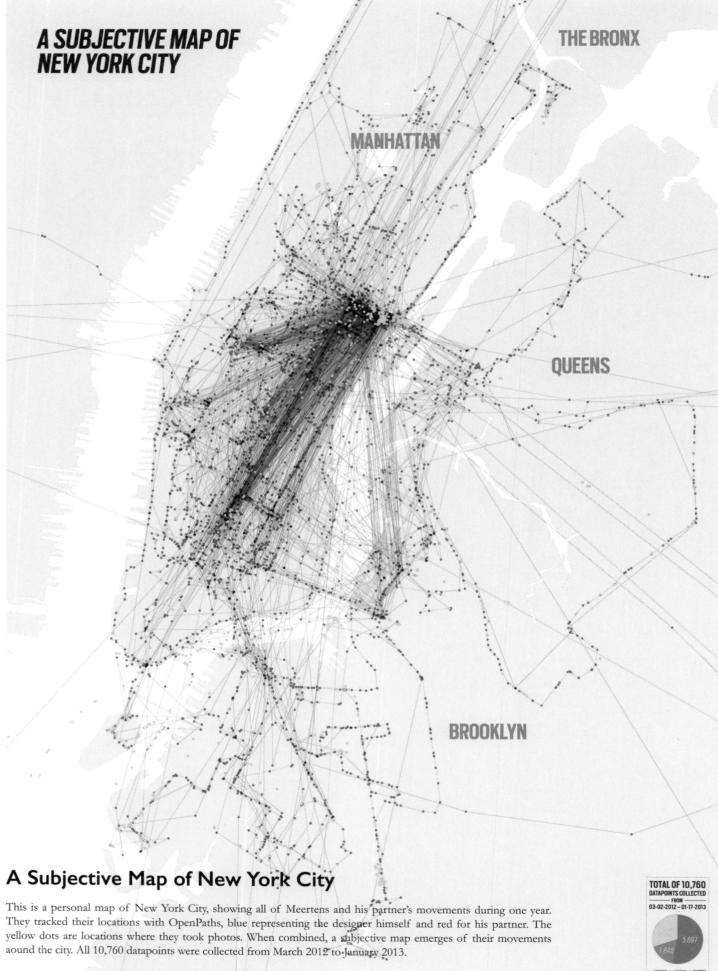

A Subjective Map of New York City

This is a personal map of New York City, showing all of Meertens and his partner's movements during one year. They tracked their locations with OpenPaths, blue representing the designer himself and red for his partner. The yellow dots are locations where they took photos. When combined, a subjective map emerges of their movements aound the city. All 10,760 datapoints were collected from March 2012 to January 2013.

DESIGN Vincent Meertens COUNTRY/REGION Netherlands

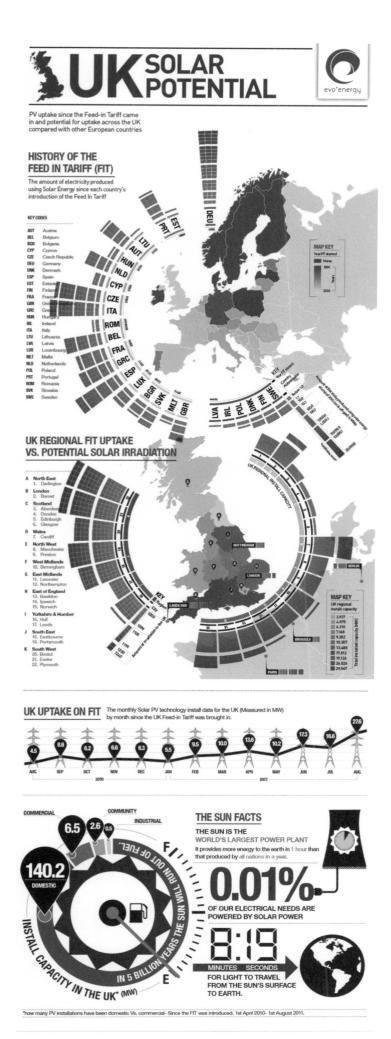

UK Solar Potential

The data visualization shows the UK's solar potential, comparing regions and countries that have taken up the government feed-in tariff from 1991 to 2010.

DESIGN Leigh Riley COUNTRY/REGION UK

MAPPING HUMAN ACTIVITY

101 New York Sights Map

Rod Hunt was commissioned to illustrate the 101 New York Sights map for Circle Line Sightseeing Cruises. The key aims were to show all of the 101 New York landmarks seen on the full island circumnavigation of Manhattan, while keeping the map uncluttered. A bold graphic simplified approach to depicting Manhattan Island with detailed buildings and attractions was chosen as the best solution.

216 DESIGN Rod Hunt COUNTRY/REGION UK

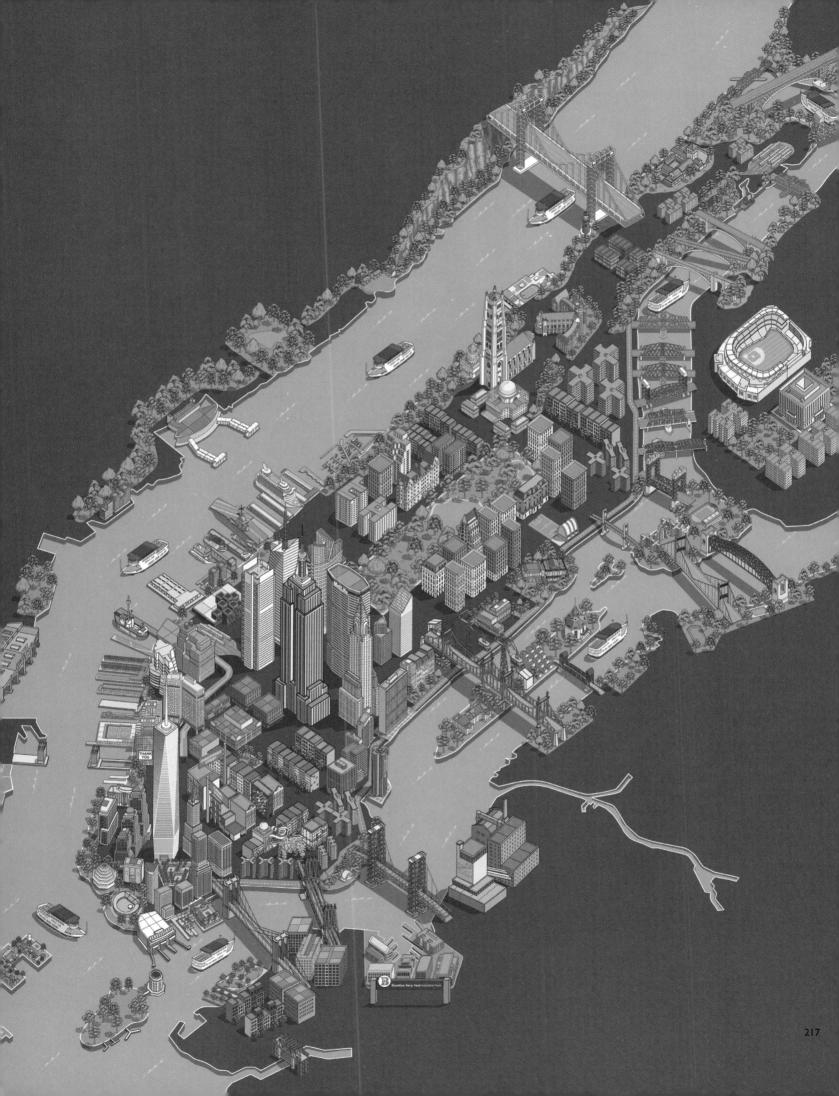

GEOGRAFIA DI UNA TRAGEDIA

Geografia Dell' Amianto

The map shows the correlation between asbestos contamination and the cancer mesothelioma in Italy. The density of red lines measures the mortality caused by mesothelioma. The blue dots denote the asbestos-polluted areas reported by the Italian government.

38mila siti censiti: una frazione delle aree a rischio. Ma, per la prima volta, *Wired* li rende noti

COS'È
L'amianto è composto da fibre larghe appena 10 millesimi di millimetro, una dimensione che ne favorisce l'infiltrazione nelle membrane e in altri tessuti del corpo umano. L'infiammazione che ne consegue degenera molto spesso in tumore.

BASTA UNA FIBRA
Non esiste una concentrazione soglia sotto la quale l'amianto è innocuo: 1 fibra per litro d'aria è il limite di guardia indicato dall'Oms. Basta infatti questa concentrazione per aumentare il rischio di tumore entro gli 80 anni in un individuo. In Italia il limite è da 2 a 20 fibre per litro per gli ambienti di vita contaminati, fino a 100 fibre per litro negli ambienti di lavoro.

DOVE COLPISCE
Il mesotelioma pleurico è il cancro più spesso causato dall'amianto, ma l'Oms indica la fibra può causare anche altre forme di tumore.

Faringe e Laringe
Polmoni
Pleure
Pericardio
Esofago
Stomaco
Peritoneo
Colon
Ovaie
Tunica Vaginale

70 ANNI DI VELENI
Dal dopoguerra alla messa al bando nel 1992 l'Italia ha prodotto oltre 3,7 milioni di tonnellate di amianto e ne ha importate almeno altri 1,8. La mortalità per il solo mesotelioma pleurico è in aumento con un massimo previsto nel 2025.

1956
Varate le prime norme antiasbestosi.

1981
La causa civile contro Eternit e Inail accerta i danni da amianto.

1992
La legge 2 bandisce l'estrazione l'importazio l'esportazio il commercio la produzione di amianto

PRODUZIONE DI AMIANTO (ESPRESSA IN TONNELLATE)

Produzione nazionale
Importazioni
Esportazioni

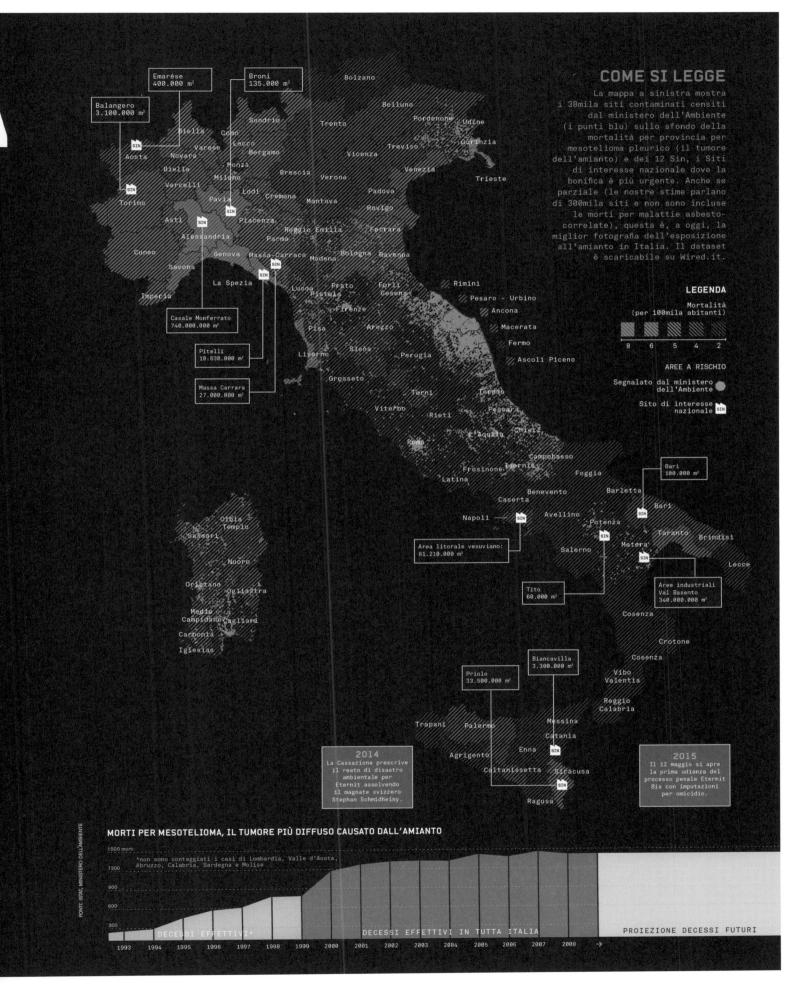

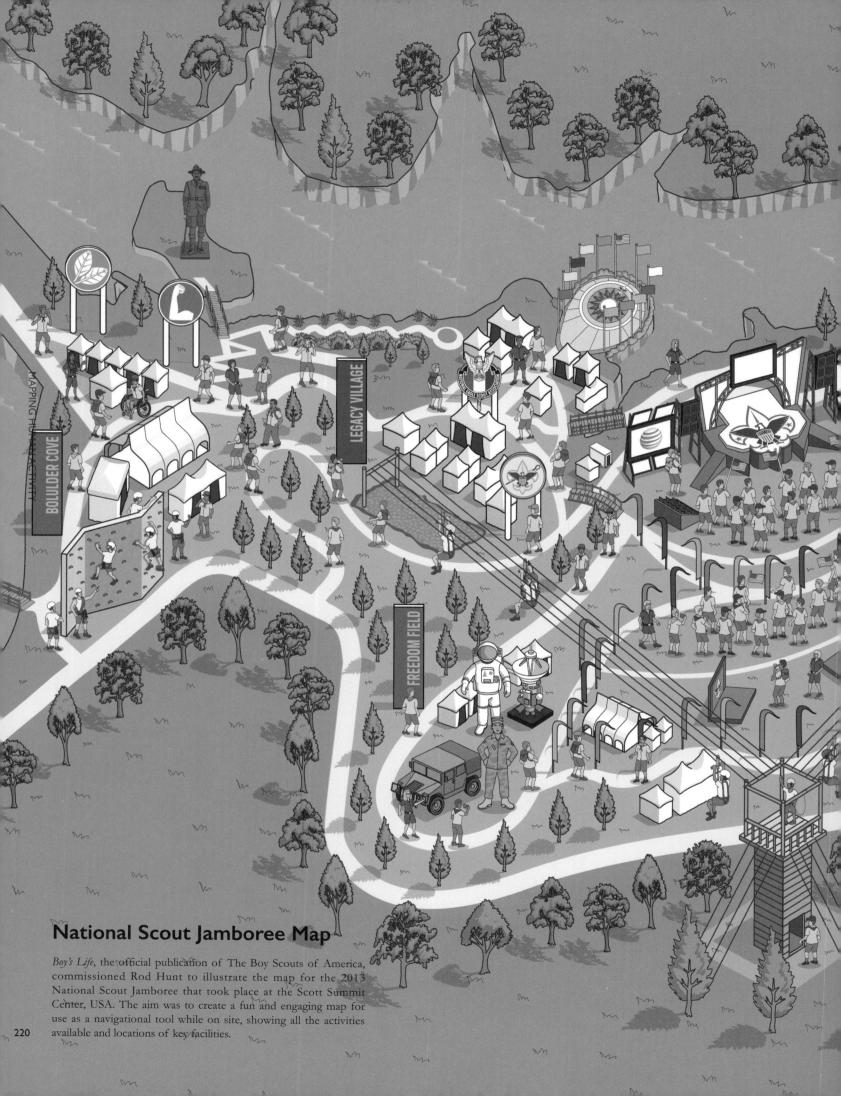

National Scout Jamboree Map

Boy's Life, the official publication of The Boy Scouts of America, commissioned Rod Hunt to illustrate the map for the 2013 National Scout Jamboree that took place at the Scott Summit Center, USA. The aim was to create a fun and engaging map for use as a navigational tool while on site, showing all the activities available and locations of key facilities.

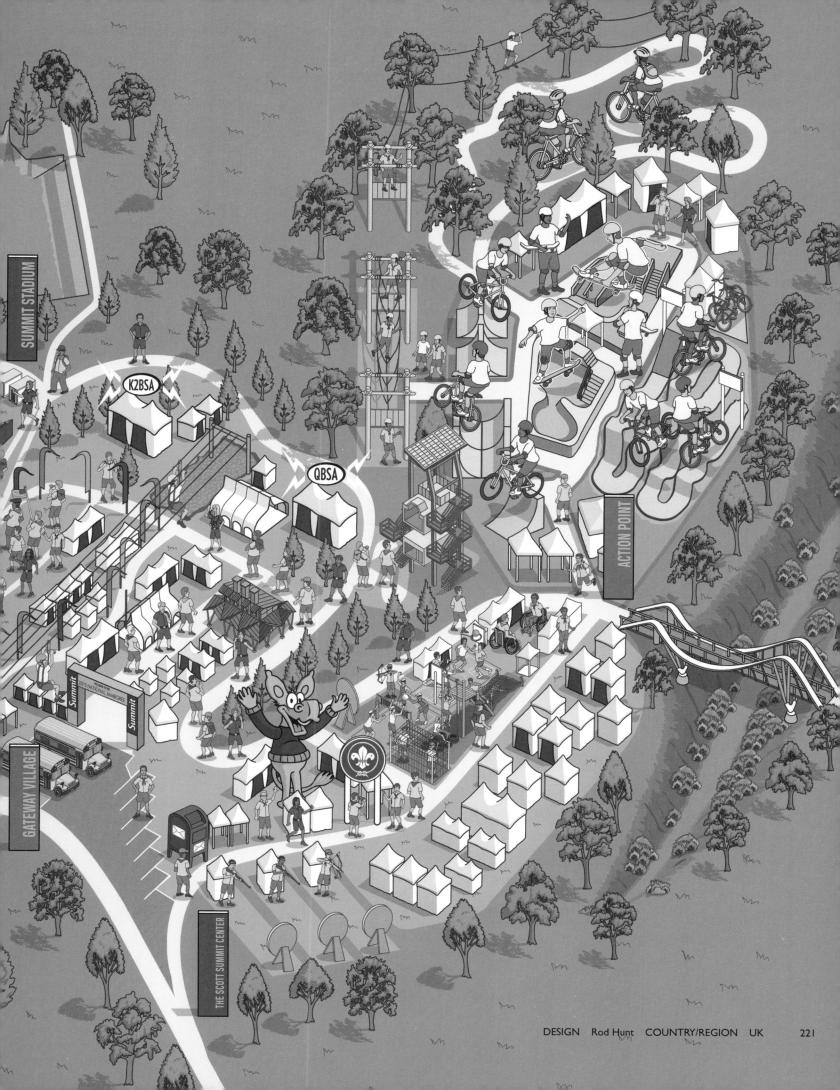

DESIGN Rod Hunt COUNTRY/REGION UK

MAPPING HUMAN ACTIVITY

| 1900 TO 2011 | TOTAL **EARTHQUAKES** MAPPED BY NUMBER | TALLEST **BUILDINGS** MEASURED IN HEIGHT | LARGEST **DOMES** MEASURED IN DIAMETER |

Earthquakes, Buildings and Domes

This map was created to find out how some of the most phenomenal physical structures would compare against the amount and location of earthquakes that have happened in the last century. Circles reflect the number of earthquakes, while bar charts reflect the height of buildings and diameter of domes.

222 DESIGN Carrie Winfrey COUNTRY/REGION USA

AROUND THE WORLD

118 MANUFACTURING FACILITIES 11 SALES OFFICES 6,449,645 SQ FT 599,192 SQ M

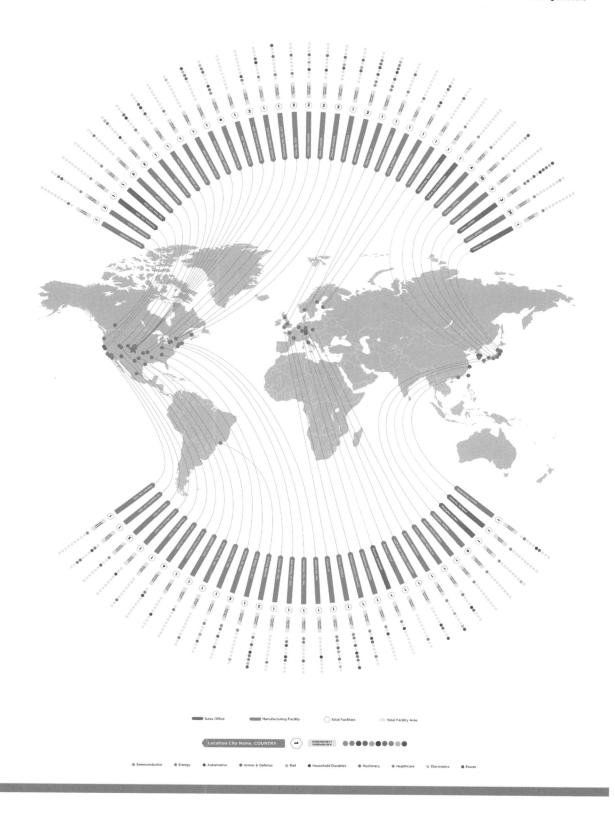

Around the World

The goal of this map was to highlight the global presence of the US semiconductor and engineering company CoorsTek, making its employees and customers aware of its size and reach. The finished poster was sent around the world to each facility to hang in its lobby and other high-traffic areas, showing off the size of the company, its manufacturing capacity and the variety of industries that it serves around the world.

DESIGN CoorsTek, Inc. / Will Manning COUNTRY/REGION USA

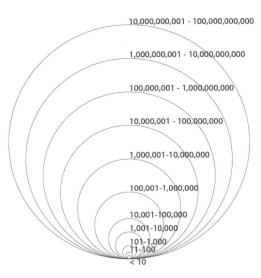
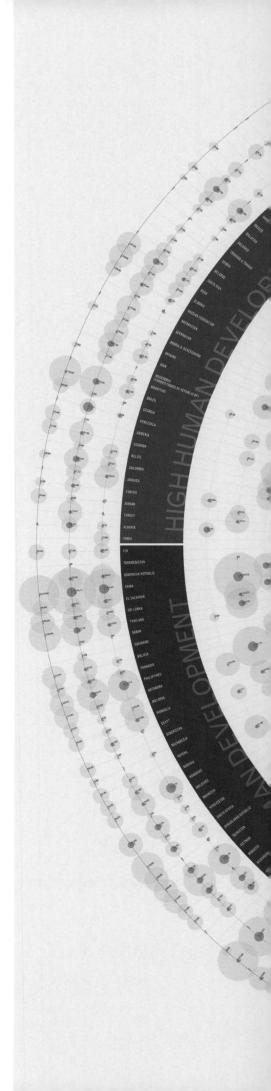

MAPPING HUMAN ACTIVITY

UNDP Project

This information graphic provides a visual reference for data previously only depicted in numeric spreadsheets provided by scientists and governments, plotting the alarming number of people affected and killed by water-related natural disasters for a time period of thirty years. It also reveals those countries most in need of disaster-recovery resources.

DESIGN Rhiannon Fox COUNTRY/REGION Bermuda

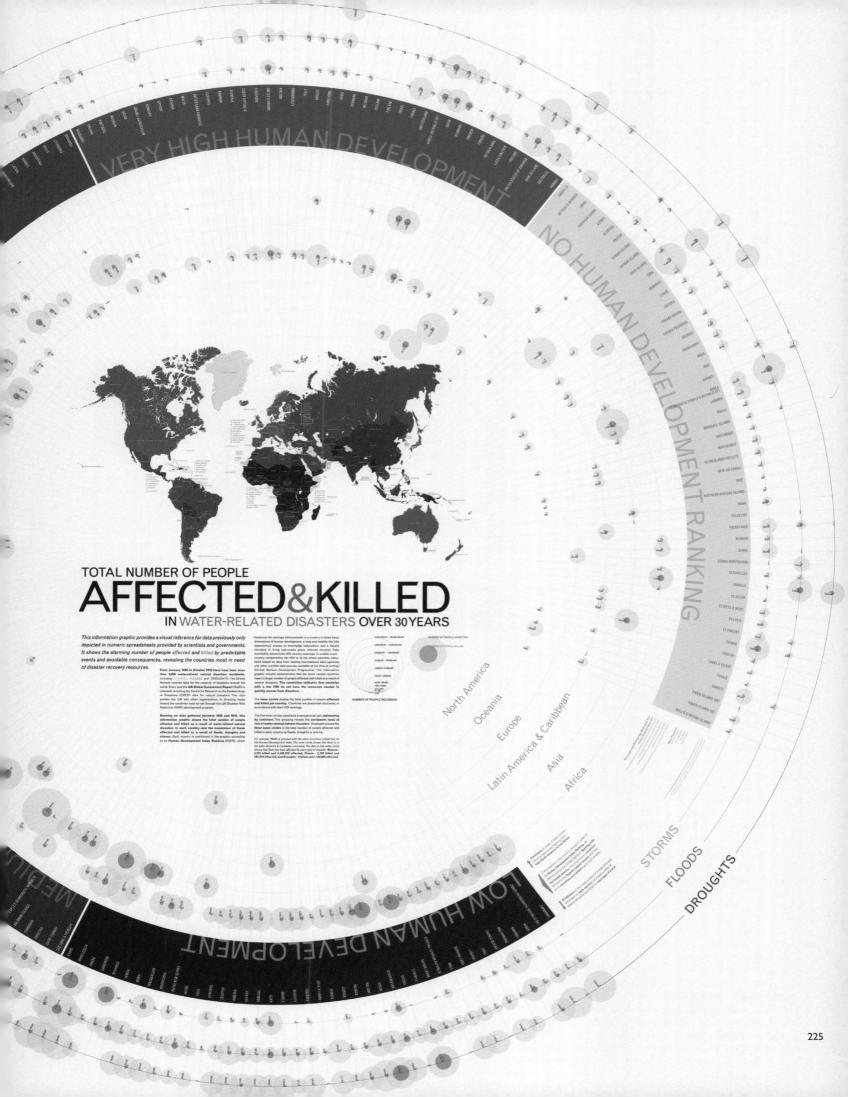

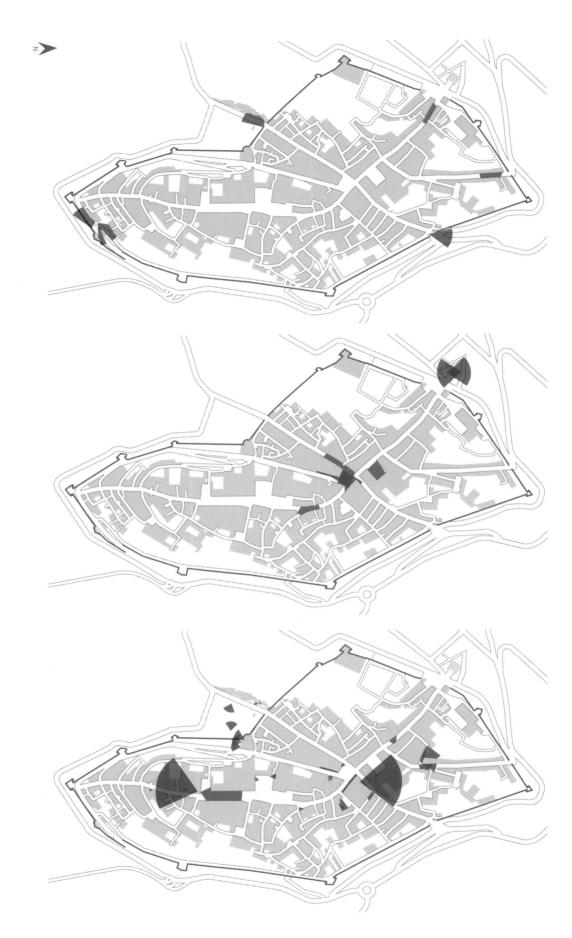

Atlas of Public Spaces in Urbino/Controlled Areas

Controlled Areas is part of the *Atlas of Public Spaces in Urbino*, a project analyzing different aspects of public space in Urbino, Italy, led by Joost Grootens at ISIA Urbino. This part focused on mapping the video surveillance areas of public spaces, in particular the old town centre. The video surveillances were divided according to strength of typology and category. Observing the map, viewers can see clearly where surveillance is dense and comparatively sparse areas.

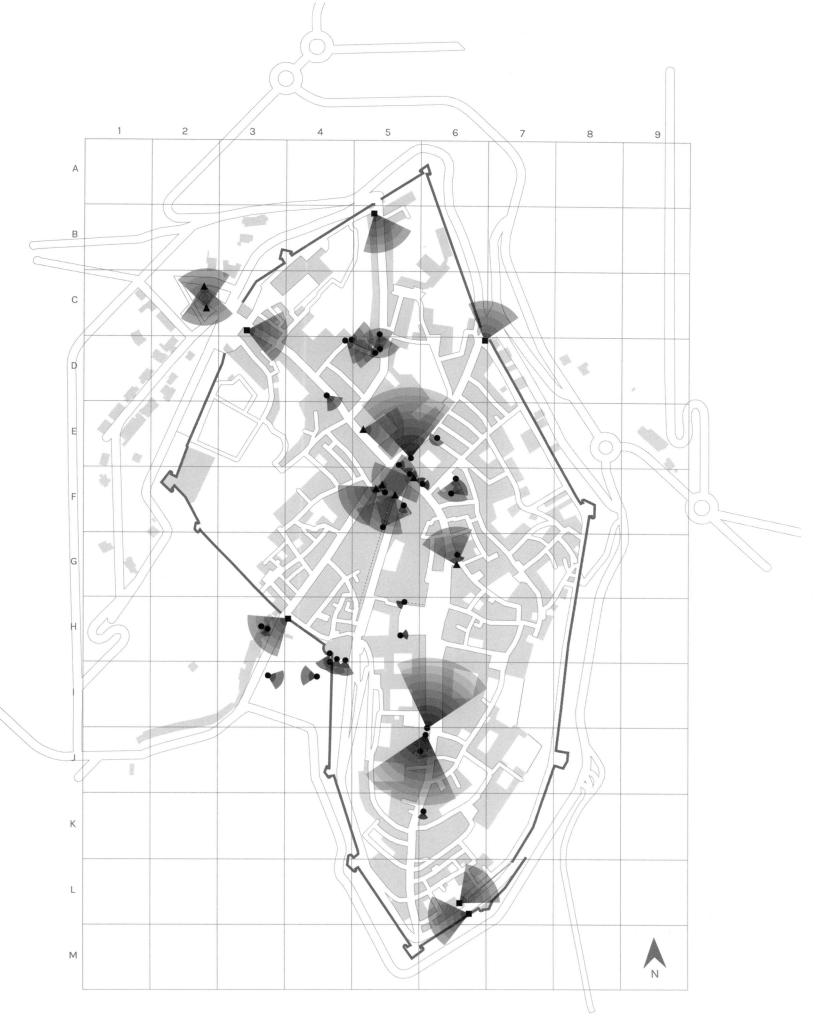

DESIGN Arianna Di Betta, Veronica Maccari COUNTRY/REGION Italy

Blackout 2003

This project is a narrative infographic of the worst blackout in US history. The Northeast blackout of 2003 was a widespread power outage that occurred throughout parts of the Northeastern and Midwestern United States and the Canadian province of Ontario on Thursday, 14 August 2003, just before 4:10 p.m.. While some power was restored by 11 p.m., many did not get power back until two days later. At the time, it was the second-most widespread blackout in history, after the 1999 Southern Brazil blackout. The blackout affected an estimated 10 million people in Ontario and 45 million people in eight US states.

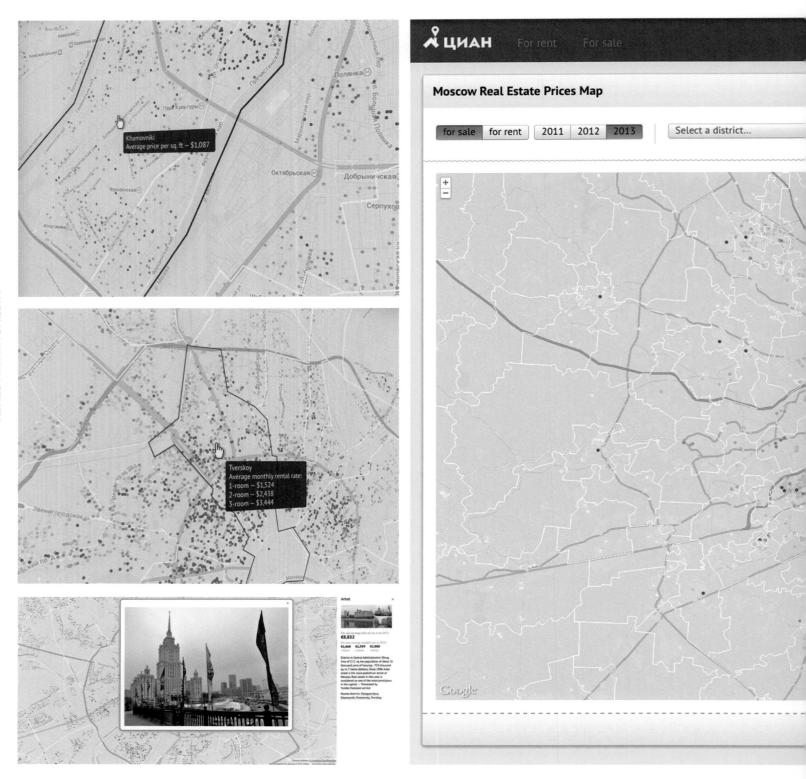

Moscow Real Estate Prices Map

This work aims to be the most detailed and accurate map of property prices in Russia's capital city.
The interactive map shows how real estate prices in Moscow have changed over the three years 2011, 2012 and 2013. Properties are represented on the map by dots which are coloured according to price. If you select a neighbourhood on the map you can find out the average price per square foot in that area. Selecting an area will also load a neighbourhood review in the map's sidebar.

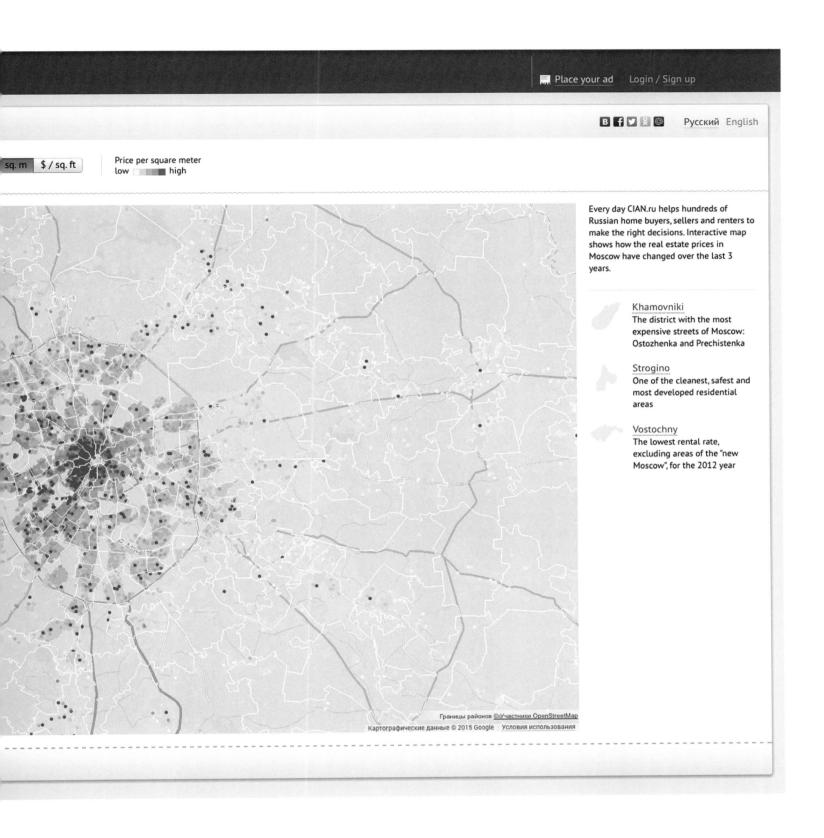

CHOCOLAT SWISSQUOTE JANVIER 2012

La carte du monde du chocolat

Principaux fabricants de chocolat
Ventes de chocolat et confiseries, en milliards de dollars

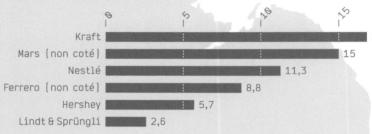

- Kraft: 16,8
- Mars (non coté): 15
- Nestlé: 11,3
- Ferrero (non coté): 8,8
- Hershey: 5,7
- Lindt & Sprüngli: 2,6

Principaux broyeurs de fèves
Production, en milliers de tonnes

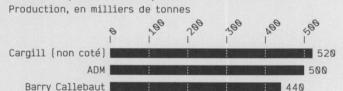

- Cargill (non coté): 520
- ADM: 500
- Barry Callebaut: 440

Principaux pays producteurs de cacao

Trois pays produisent plus de 65% du cacao mondial.

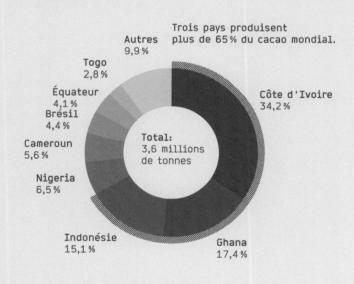

- Côte d'Ivoire 34,2%
- Ghana 17,4%
- Indonésie 15,1%
- Nigeria 6,5%
- Cameroun 5,6%
- Brésil 4,4%
- Équateur 4,1%
- Togo 2,8%
- Autres 9,9%

Total: 3,6 millions de tonnes

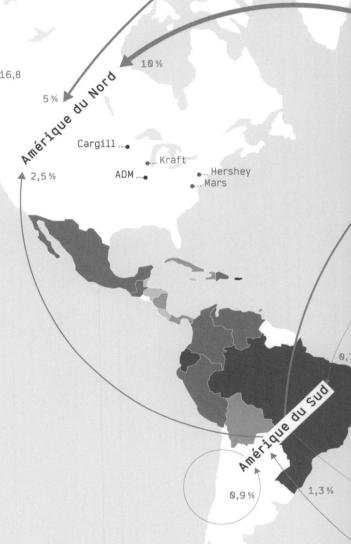

Amérique du Nord 10%, 5%, 2,5%
Cargill, Kraft, ADM, Hershey, Mars
Amérique du Sud 0,9%, 1,3%

Source: International Cacao Organization, Infographie: Benjamin Schulte / LargeNetwork

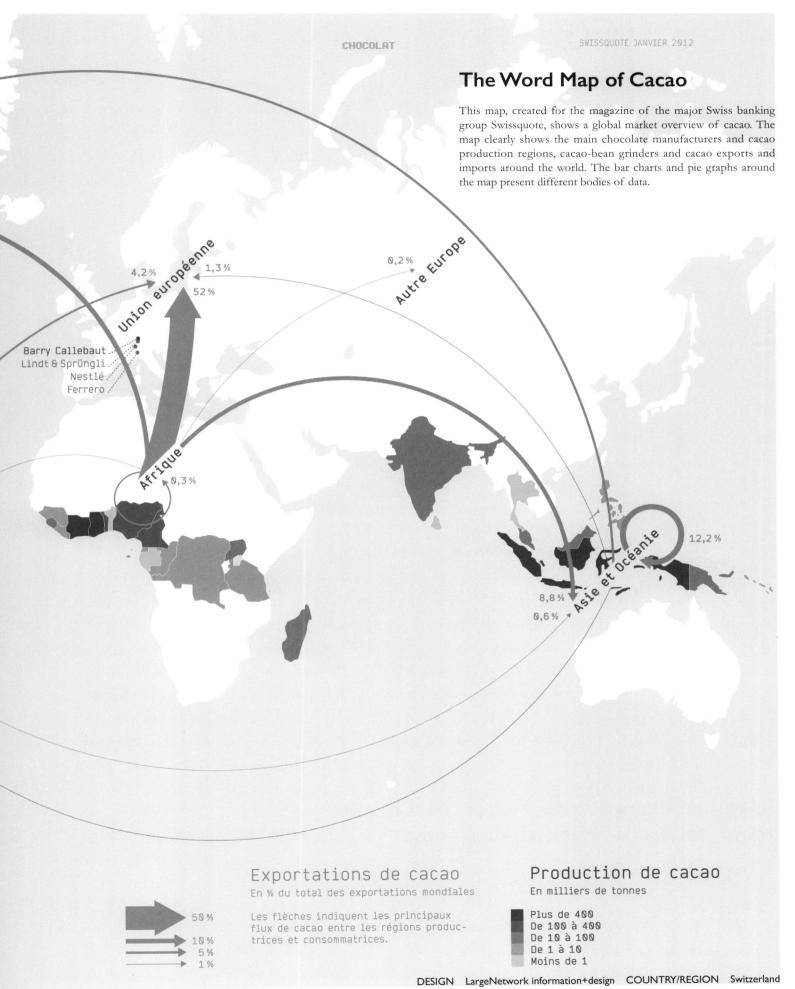

Figure 1

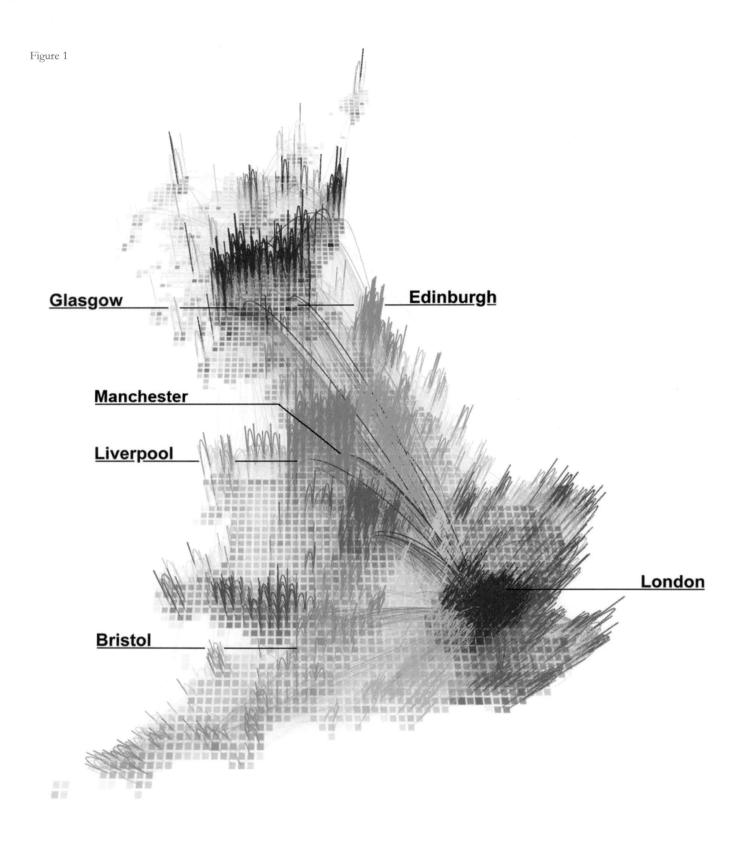

Borderline: Redrawing the Map of Great Britain from a Network of Human Interactions

This map visualizing the geography of talk in Great Britain was created for a paper titled "Borderline: Redrawing the Map of Great Britain from a Network of Human Interactions", which aims to find the answer to the question "Do regional boundaries defined by governments respect the more natural ways that people interact across space?". Full article available at: *http://dx.plos.org/10.1371/journal.pone.0014248*

Figure 1. The geography of talk in Great Britain. This figure shows the strongest 80% of links, as measured by total talk time, between areas within Britain. The opacity of each link is proportional to the total call time between two areas, and the different colours represent regions identified using network modularity optimization analysis.

Figure 2

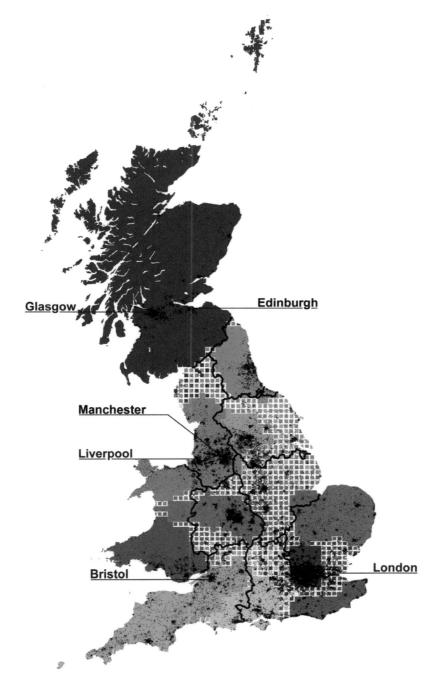

Figure 2. The core regions of Britain. By combining the output from several modularity optimization methods, MIT obtained the results shown in this figure. The thick black boundary lines show the official Government Office Regions partitioning, together with Scotland and Wales. The black background spots show Britain's main towns and cities, some of which are highlighted with a label.

Figure 3

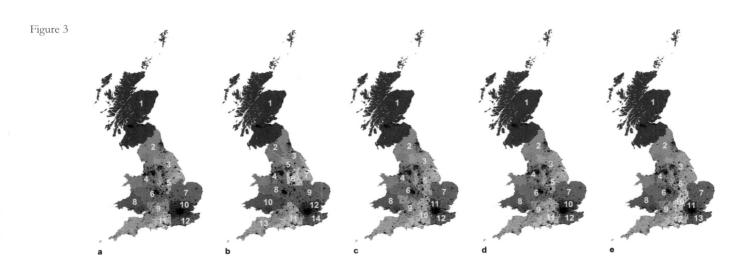

Figure 3. Defining regions through the spectral modularity optimization. Results of five different modularity optimization algorithms.

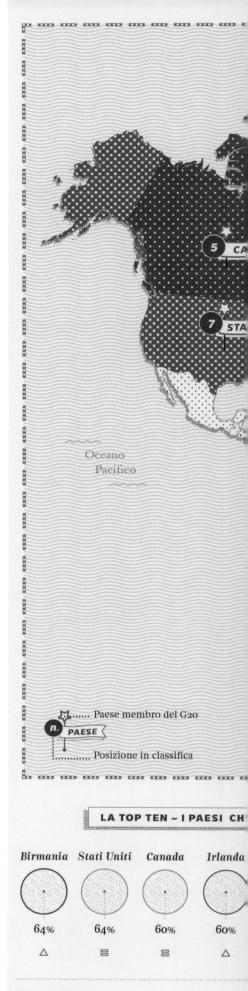

World Giving Index

This artwork is for the *Corriere della Sera*, one of the most important Italian newspapers. The visualization shows the results of research relating to the "World Giving Index", conducted by the Charities Aid Foundation in more than 160 countries, with the aim of providing an insight into the scope and nature of charitable giving around the world.

DESIGN Sara Piccolomini COUNTRY/REGION Italy

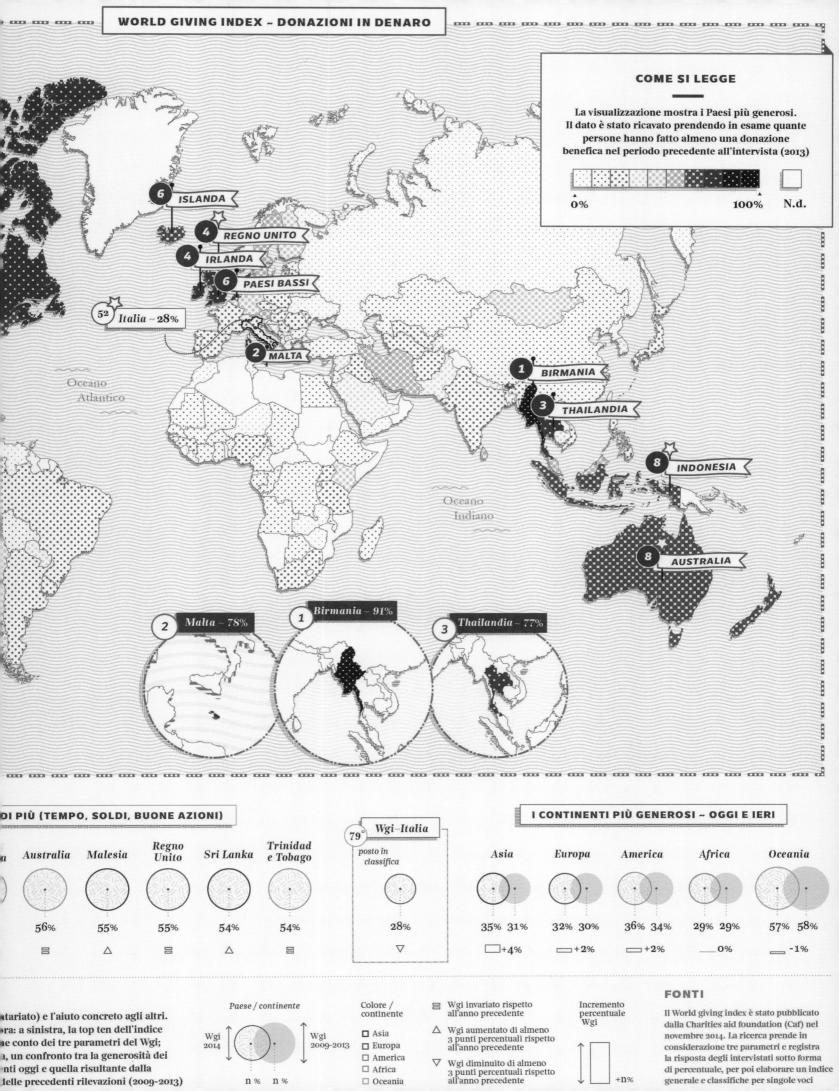

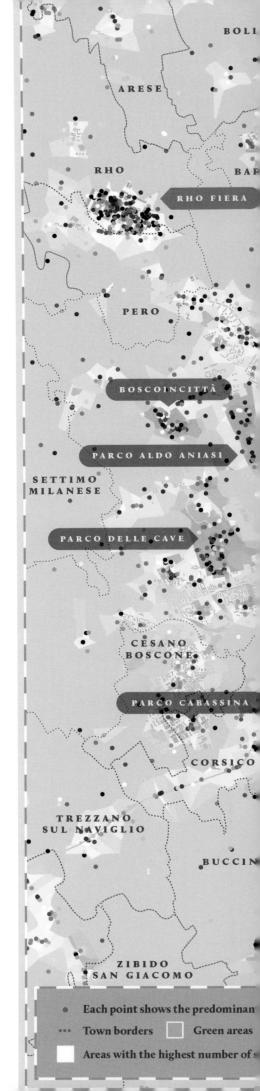

Blank Map

The map shows predominant colours of photos taken in Milan. It is based on data from www.panoramio.com. The initial concept for the project was to represent the city examined as if it were a "blank map", i.e. making sure that the shape emerged showing only the predominant colours of the pictures, taken by locals and tourists. Using map data (buildings, roads and parks) from OpenStreetMap, the design team took full advantage of Voronoi Diagram in their experiment and obtained this interesting final result.
The resulting map indicates that the most photographed areas are parks and stations, usually near parks and water areas, so there is a clear predominance of green and blue. Buildings, ground and shade are common reasons for dark colours in the photos and data.

DESIGN Valerio Pellegrini & Michele Mauri COUNTRY/REGION Italy

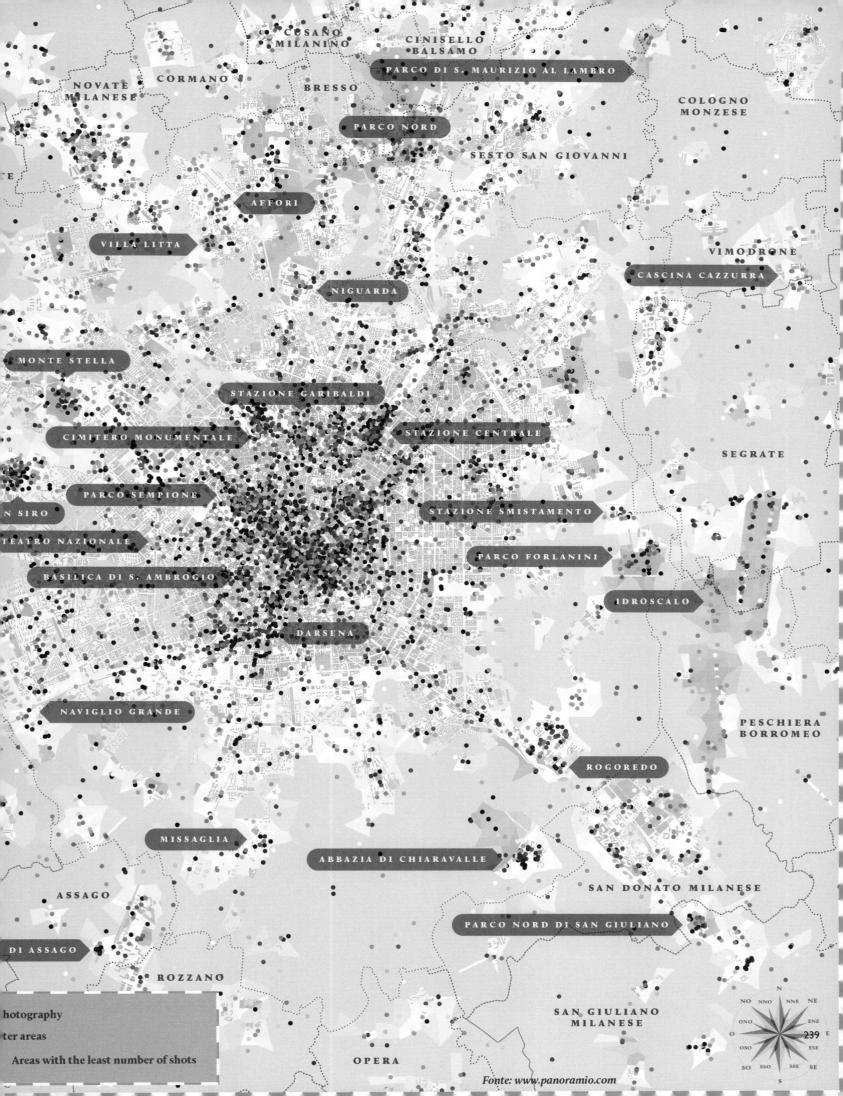

The Future of Thailand

This map was an illustration created for the London-based global affairs magazine *Monocle* (issue 66, vol. 07, September 2013). Its aim is to give a visual form to the Thai government's infrastructure-building megaproject for the future.

DESIGN Winks Creatives ILLUSTRATOR Chinapat Yeukprasert COUNTRY/REGION Thailand

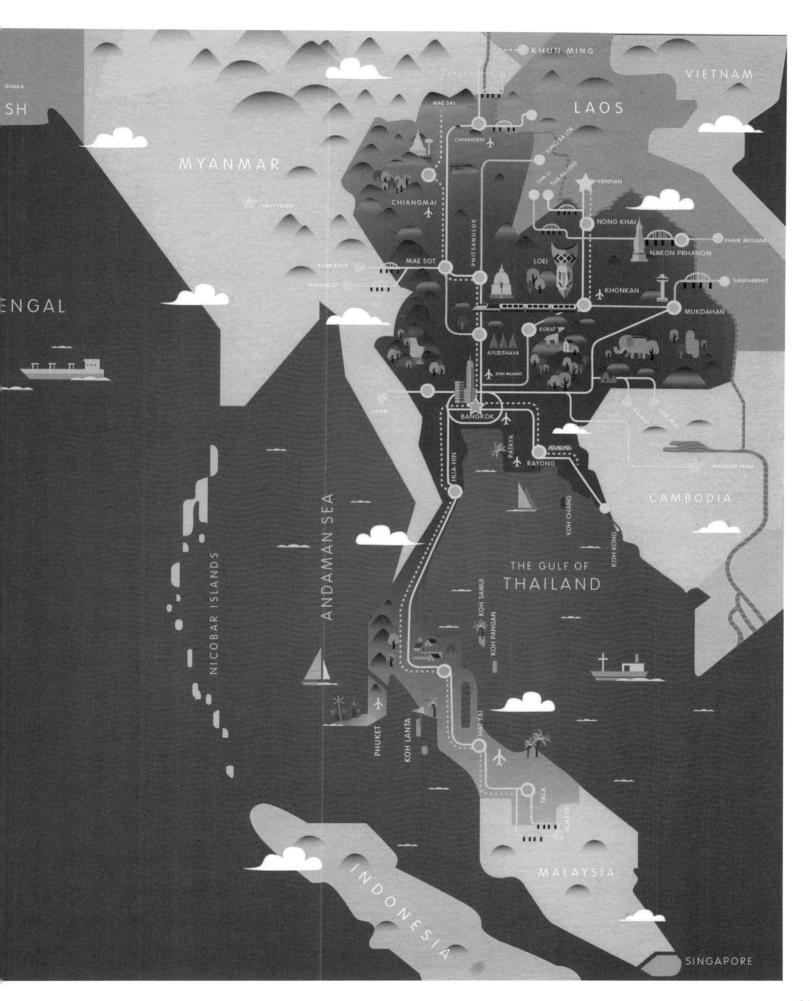

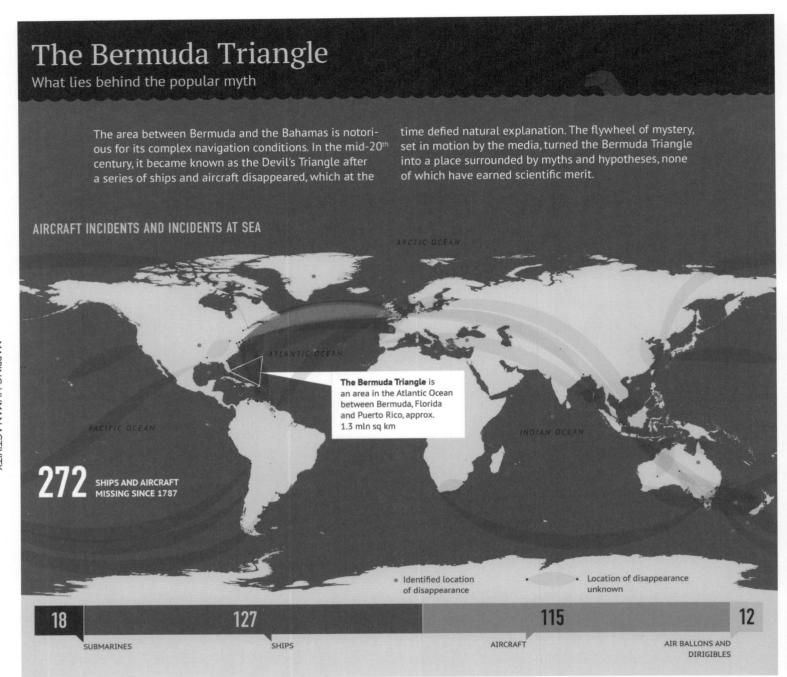

Bermuda Triangle

The area between Bermuda and the Bahamas has long been notorious for its complex navigation conditions. In the mid-twentieth century, it became known as the Devil's Triangle or Bermuda Triangle after a series of ships and aircraft disappeared, apparently defying logical scientific explanation. These maps and diagrams probe the mysterious truth, charting disappearances in the Triangle and geographical and other forces at play that may have affected events.

DESIGN Infographic Studio of Rossiya Segodnya International Information Agency COUNTRY/REGION Russia

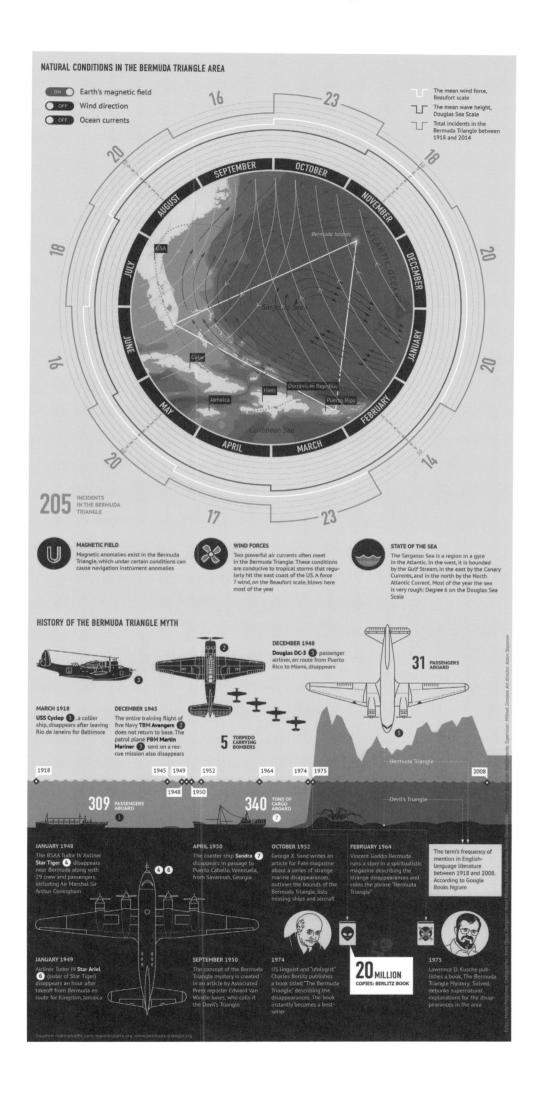

THE DAM NE

THREE GORGES DAM
CHINA

THE YANGTZE IS REVERED FOR ITS ROLE IN
WHO INHABIT ITS BANKS, BUT WITH THE BL
HYDROPOWER PROJECT ALONG THE THREE
CHINESE PEOPLE IS SEVERELY ABOUT TO CH
SOCIAL, ENVIRONMENTAL AND ECOLOGICAL

VOLUME OF WATER
- 525,000 cubic feet per second at the end of the 3 gorges area (Yichang).
- 847,000 Cubic Feet per second at Wuhan.
- 1,100,000 cubic feet per second at it's mouth.
- 3rd volume entering the sea behind the Congo and the Amazon.

THE CATCHMENT AREA REPRESENTS
- 25% OF CHINA'S ENTIRE CROPLAND
- 33% OF CHINA'S POPULATION, 350 MILLION PEOPLE
- 40% OF CHINA'S PRODUCE OF GRAIN
- 70% OF CHINESE RICE CROP
- 40% OF AGRICULTURAL AND INDUSTRIAL OUTPUT OF CHINA

THE YANGTZE RIVER

The Yangtze river is pinnacle to China's soul and history, great battles have been fought, villages turned into towns and towns into cities. People hid away from the modern world and were able to carry on a way of life unchanged for hundreds of years here.

Tourists come from across the globe to catch a glimpse of what traditional China once was, a sight that can no longer be seen along the banks of the river. The main attraction of the Three Gorges still stand tall above the water level, but somewhat less so towering now.

The middle course effected by the damming stretches 630 miles between Yibin in Sechan and Yichang in Hubei. The river passes through the worlds largest city, with 30 million plus residents in Chongqing, a million of which will also have to be relocated as the dam rises the banks to a level which will allow large ships to come in to port.

Yangtze Facts
- 3rd Largest river in the world.
- More than 700 tributaries drain 1.8 km², approximately 20% of China's land.
- The growing season within this area lasts for more than 6 months.

According to legend these amazing carvings of mountainous terrain were formed by the goddess Yao Ji to redirect the Yangtze around the petrified remains of a dozen dragons she had slain for tormenting peasants. One wonders what Yao Ji would have to say about the mile long Three Gorges dam project now threatening to swallow up the land she once moulded.

The Chinese say If you haven't traveled up the Yangtze, you haven't been anywhere.

LANDSLIDES

There is a significant increase in the risk of landslides in the 3 gorges area of

- Since 2004, landslides have forced the relocation of more than 13,000 people in the county.
- In 2003, just months after the 135 meter water level was achieved, 700m³ feet (20m³ meters) of rock slid into the Qinggan river adjoined to the Yangtze causing 20 meter high waves that claimed the lives of 14 people.
- The raise of the water levels to 156 meters in 2006 created dozens of landslides that occurred within a 20 mile distance of the 3 gorges dam.
- Landslides have produced waves as high as 50 meters (165ft). In July a mountain along a tributary collapsed, dragging 13 farmers to their deaths and drowning 11 fishermen.
- In Badong county, November 20 4000 cubic yards (3,050m³) of tumbled onto a highway burying and killing at least 30 people.
- 99 villages in Mioche, 10 miles upstream of the Yangtze, saw la behind them split creating 200m cracks. Residents were evacuate cave for safety.
- One official said that the shore reservoir had collapsed in 91 pla a total of 36 kilometers (22 mile already caved in.
- Two incidents in May 2009 whe 50,000m³ (1,800,000 cu ft) and 20,000m³ (710,000 cu ft) of mat plunged into the flooded Wuxia of the Wu River.

HOW IS A LANDSLIDE CAUSED?

Water seeps into loose soil at the base of rocky cliffs, destabilizing land and making it pro The reservoir water level fluctuates, engineers partially drain the reservoir in the summer t flood waters and raise it again at the end of flood season to generate power. This disturbs

The Damned

The Three Gorges Dam in China is the largest hydroelectric-power project in the world. Riley researched the sociological, environmental and ecological effects the dam has had on its surrounding environment along the Yangtze River, and presented the data through this infographic design in an informative, detailed way.

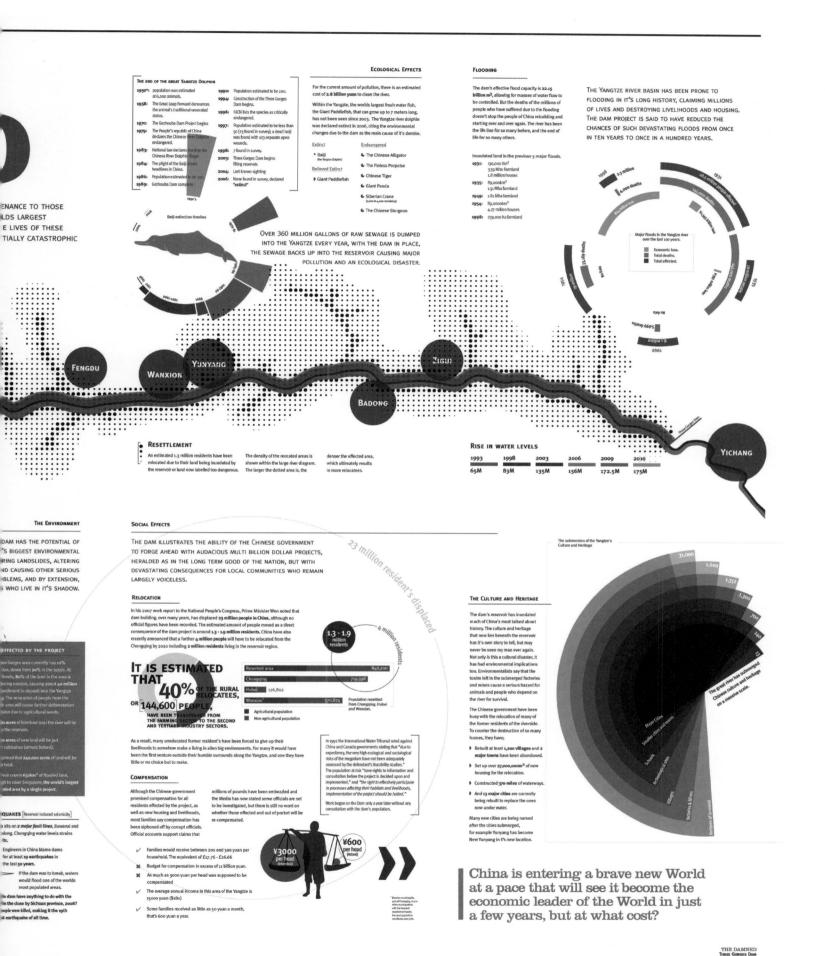

Crossing Paths

As I have grown up, and traveled to more places, I find myself communicating with people who are from, and live, all over the world. I often hear from my friends "I can't keep track of everyone you know, they are everywhere!" This made me realize the paths I have traveled have crossed over other people's paths. Everyone I communicate with is unique in where they are from, where I met them, and where they live currently. I discovered that people who didn't know each other were connected based on locations and by plotting these points of their locations through various stages in their lives, relative to my locations during these phases of my life would be quite interesting.

Crossing Paths

Gribbin is an avid traveller, interested in the people and connections she has made throughout the world. This biographical infographic shows the various locations on the map where people Gribbin communicates with are from (square), where she met them (circle) and their current location (triangle). Each person is assigned a specific colour, which defines them individually as well as their relationship to the designer. Gribbin's home area around New York merits two levels of close-up boxes.

The map reveals how these people are connected to each other geographically even if they have never met. It also shows that certain groups of people tend to remain clustered in the same location, while others seem to jump all over the map.

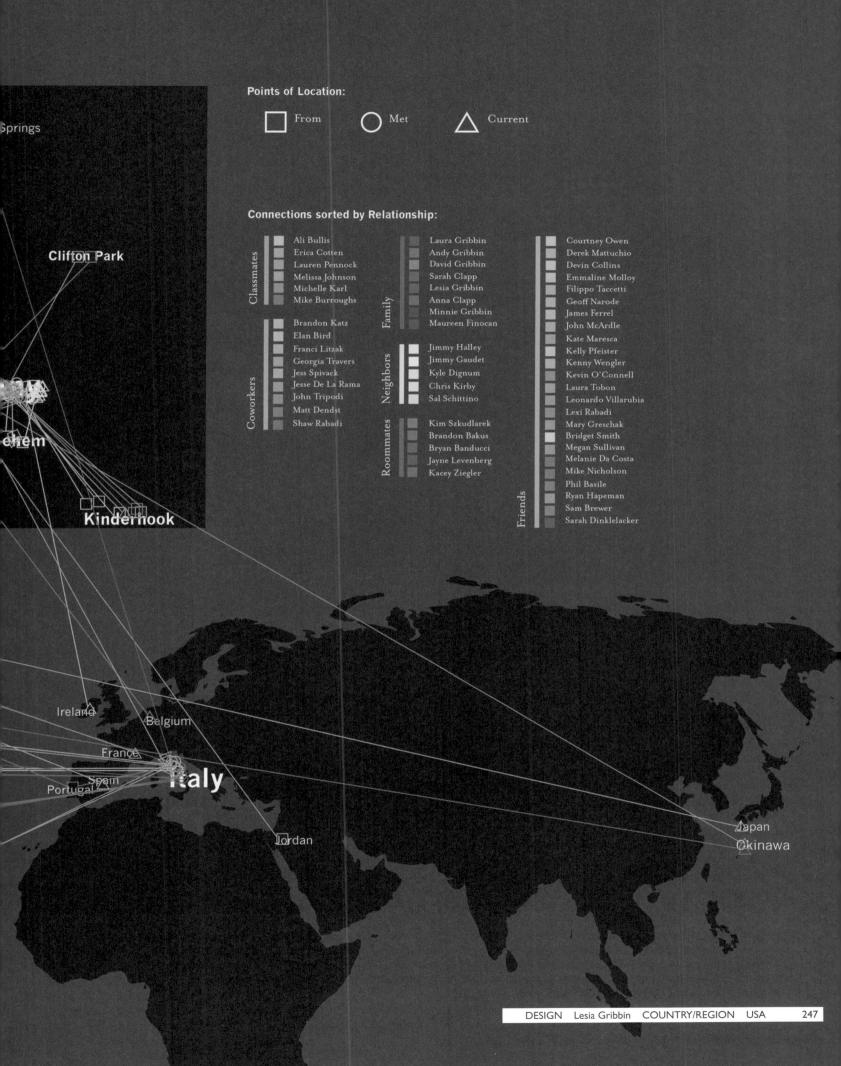

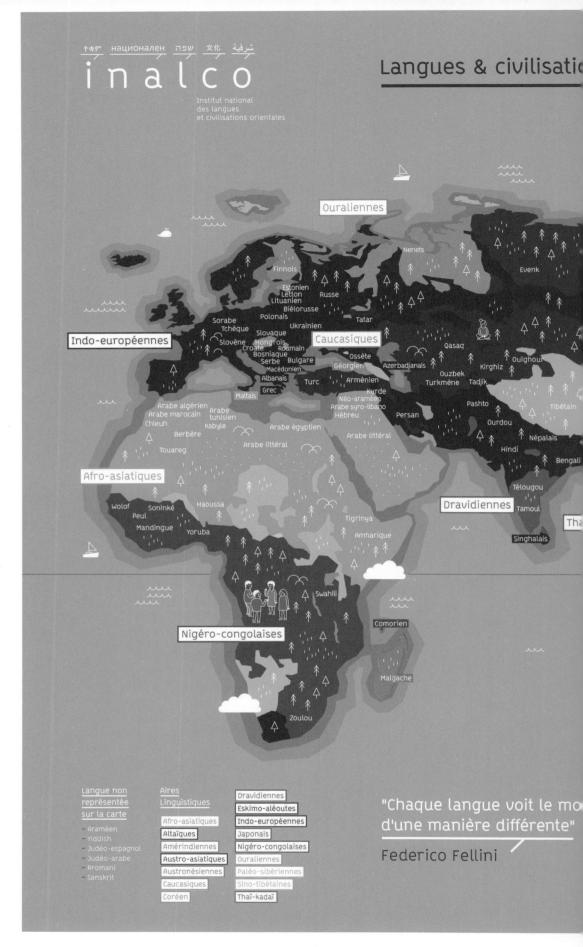

Brochure Design for INALCO

The National Institute of Oriental Languages and Civilizations (INALCO, also known as Langues O') is a French higher-education and research establishment renowned for teaching languages and civilizations outside those of Western Europe.

This world map is part of a brochure made for INALCO. On the back of the brochure, the map presents different languages taught at the institute. To avoid a representation of the world focused on Europe, Graphéine proposed an unusual representation; the resulting excellently illustrates the promise of openness to the world.

DESIGN Graphéine ILLUSTRATIONS Carole Perret COUNTRY/REGION France

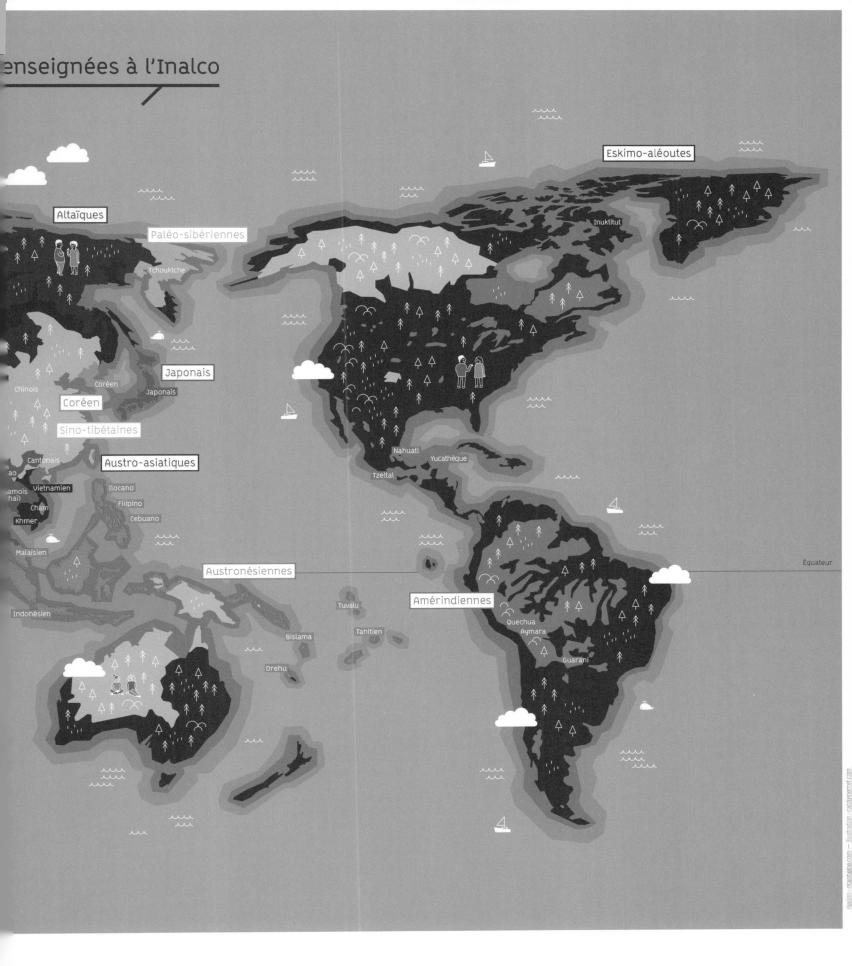

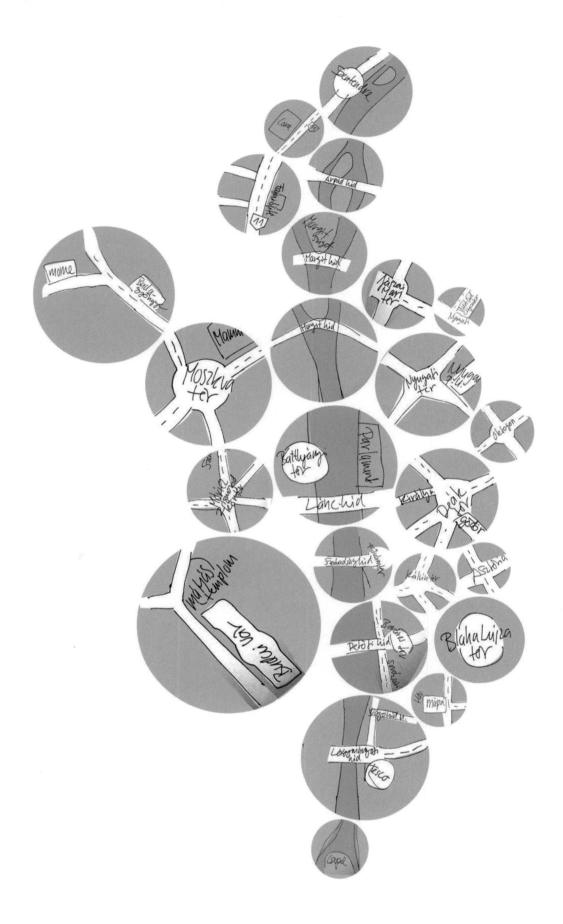

Submap

Submap is a developing mapping series that visualizes location- and time-based data on distorted maps.
The project developed from the idea of drawing a subjective map of Budapest that represents the designers' preferred places or memories in the city. As places were recognized to be emotionally 'closer' to the team they would be enlarged, while those of less importance would lose focus and become smaller. A web-based tool which can distort maps according to one or more locations was then developed.

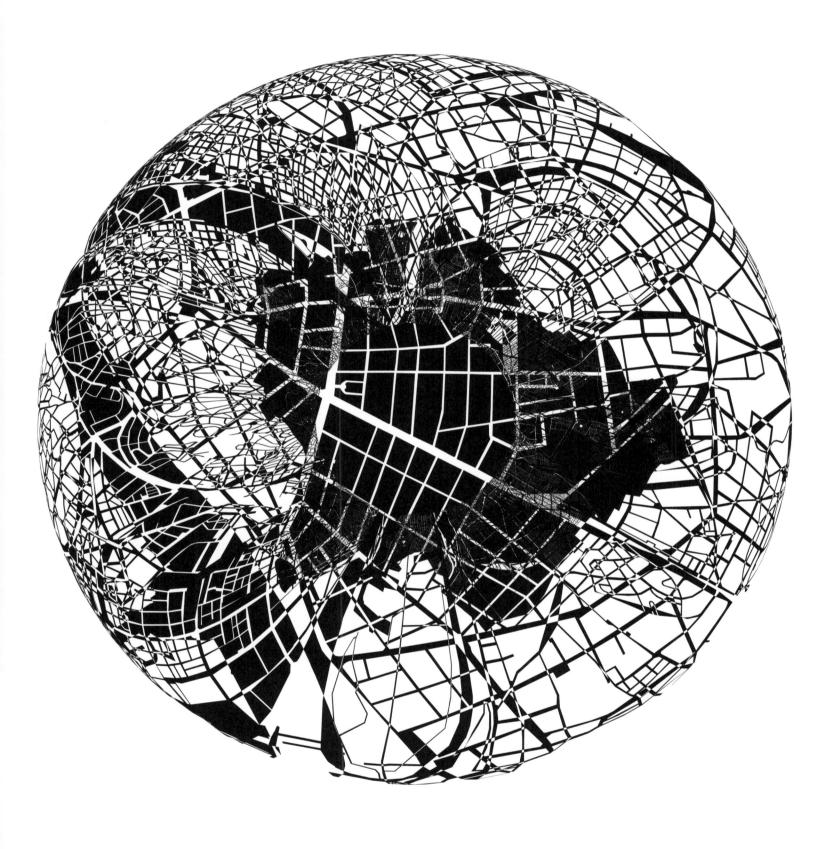

In the first version of Submap, the design team presented a map which shows the city from their point of view. They chose Kitchen Budapest, where they all work together, as the epicentre of these unique, spherical, perspectival distortions.

This screenshot is from an updated version of Submap named Ebullition which visualizes and sonificates data pulled from one of the biggest news sites in Hungary, origo.hu. In the 30-frames-per-second animation, each frame represents a single day; each second covers a month, from December 1998 until October 2010. Whenever a Hungarian city or village is mentioned in any domestic news on the origo.hu website, it is translated into a force that dynamically distorts the map of Hungary. The sound follows the visual outcome, creating a generative ever-changing drone.

The newest version of Submap was produced by Kitchen Budapest and UrbanCyclr. It untangles the invisible pattern of bike traffic in Budapest, using data on 100,000 kilometres of biking routes collected from individual bikers, overlaid on the city map. All distortions of the map reflect more biking activities in that respective area of the city. A 24-hour map animation reveals the daily biking patterns of a growing community of urban bikers in Budapest. The image above is a screenshot.

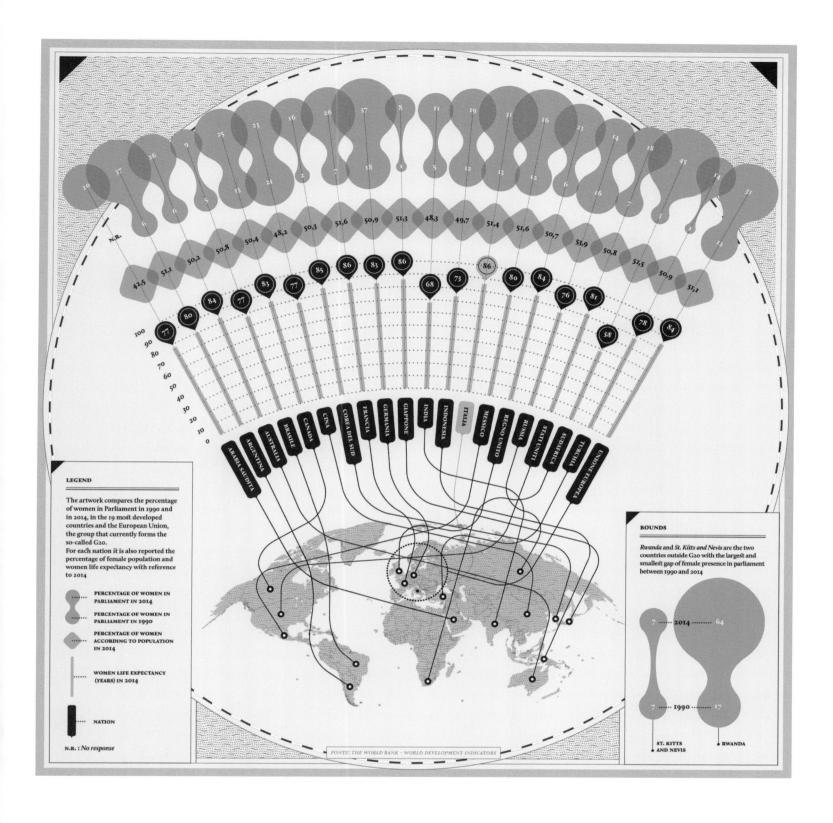

Women in Development

The project shows the presence of women in various positions in the G20 group of nations. Reading from the bottom of the visualization to the top, it represents, for each of the G20 nations, the average life expectancy of women in 2014, the percentage of women compared to the total population and, finally, the respective percentages of women in parliament in 1990 and 2014.

DESIGN Valerio Pellegrini COUNTRY/REGION Italy

INDEX

A

Adrienne Langer
P76
http://www.adriennelanger.com/

Alexey Papulovskiy & Nikolay Guryanov
P158/ P230
http://stat.cian.ru/en

Alfalfa Studio
P59
http://alfalfastudio.com/

Andreas Nilsson
P54
http://andreasnilsson.wix.com/andreas

Antoine Corbineau
P42
http://www.antoinecorbineau.com/

Arianna Di Betta, Veronica Maccari
P226
https://www.ariannadibetta.com

B

Bianca Tschaikner
P28/ P44
http://www.biancatschaikner.com/

C

Camilla Hempleman-Adams
P80
http://camillahempleman.com/

Carrie Winfrey
P222
http://carriewinfrey.com/

Cecilia Della Longa
P198
http://www.ceciliadellalonga.com/

Chaotic Atmospheres
P172
http://www.chaoticatmospheres.com/

Charis Tsevis
P100
http://www.tsevis.com/

Chinapat Yeukprasert
P126
https://www.behance.net/chinapat

Chinapat Yeukprasert & Mandala Studio (Bangkok)
P200
https://www.behance.net/chinapat

Chinapat Yeukprasert & Winks Creatives
P240
https://www.behance.net/chinapat

Ciera Shaver
P46
http://www.cierashaver.com/

Craig Woodward
P20
https://www.behance.net/craigwoodward

CoorsTek, Inc. / Will Manning
P223
http://coorstek.com/

D

Daan Roosegaarde
P144
https://www.studioroosegaarde.net/

Daniel Gaona AKA Mr. Tacho
P12
http://www.mrtacho.com/

Daniel Mason
P194
http://www.daniel-mason.com/

Dénes Sátor
P10
https://www.behance.net/satord

Design Ahoy
P78
http://www.designahoy.com/

Dex from Run For The Hills & Anna Burles
P22
http://runforthehillslondon.com/

Dmitriy Vorontzov
P148/ P150
https://www.behance.net/woodmal

Dom Civiello
P101
http://www.domciviello.com/

Drill Design
P60/ P62
http://www.drill-design.com/

E

Elena Chudoba
P206
https://www.behance.net/elenachudoba

Emma Johnson
P112/ P114/ P115
https://emmaporium.wordpress.com/

F

FIRE / Peter Donnelly Illustration
P122
http://donnellyillustration.com/

Francesco Franchi, Davide Mottes & Danilo Agutoli
P202
https://www.behance.net/davidemottes

G

Gloria Spallanzani
P74
http://www.gloriaspallanzani.com/

Graphéine
P248
http://www.grapheine.com/

H

Hargreaves and Levin
P56
http://www.hargreavesandlevin.com/

I

Infographic Studio of Rossiya Segodnya International Information Agency
P242
http://ria.ru/infografika/

J

Jasmine Desclaux-Salachas
P130/ P160
https://www.facebook.com/CafesCartographiques

Jean Denant
P180
http://www.jeandenant.fr/

Jenni Sparks
P16/ P64/ P116
http://www.jennisparks.com/

Jill Hubley
P174
http://www.jillhubley.com/project/nyctrees

JL Cartography / Jonathan E. Levy
P176/ P182
http://www.jlcartography.com/

Jonathan Hull
P24/ P26/ P96/ P120
https://www.behance.net/jonathanorjack

Ju Hyun Kang
P38
http://hey-jude.kr/

K

Kitchen Budapest - Attila Bujdosó, Krisztián Gergely, Dániel Feles, Gáspár Hajdu, László Kiss (sound/music), Tamás Bereznai (graphic)
P250
http://kibu.hu/

Konstantin Varik
P14
http://varik.ru/

L

LargeNetwork information+design
P232
http://www.largenetwork.com/

Leigh Riley
P215/ P244
http://design.rileigh.co.uk/

Lesia Gribbin
P246
http://www.lesiagribbin.com/

Louise Norman
P110
http://cargocollective.com/louisenormandesign

Lucas Briceno, Bao-Anh Bui & Brendan Gerard
P66
http://www.lbrcn.com/

Luis Dilger
P184
http://www.luisdilger.com/

Luke Johnson & Christiane Holzheid & Erin Ellis
P86
http://cargocollective.com/erinellis/Curiosities-Map

M

Marc Inzon
P154
http://www.marcinzon.com/

Marco Bernardi, Federica Fragapane & Francesco Majno
P134
https://www.behance.net/FedericaFragapane

Martina Sikiric
P142
https://www.behance.net/msart

Massimiliano Mauro
P218
http://massimilianomauro.com/

Matthew Cusick
P128/ P136
http://mattcusick.com/

Matthew Picton
P68
http://matthewpicton.com/

Michael Tompsett
P82
http://michael-tompsett.artistwebsites.com/

Mike Hall
P102/ P104/ P106/ P108
http://www.thisismikehall.com/

MIT SENSEable City Lab
P234
http://senseable.mit.edu/

MYDM co., ltd
P146
http://www.mydm.me/home.html

N

N+studio/Ningchao Lai
P228
http://ningchaolai.com/

Nils-Petter Ekwall
P155
http://www.nilspetter.se/

NOMO Design/Jerome Daksiewicz
P164
http://nomodesign.com

O

Owi Liunic
P118
https://www.behance.net/owiliunic

P

Pablo Espinosa
P90
http://sugacyan.com/

Paul Mathisen
P18
http://www.paulmathisen.com/

Paul Mullen
P92
http://www.paulmullen.co.uk/

Paulina Urbanska
P124
https://www.behance.net/paulinaurbanska

Philip Johnson
P208
http://www.philipjohnson.com/

R

Raushan Sultanov
P98
https://www.behance.net/Rushavel

relajaelcoco studio
P165
http://www.relajaelcoco.com/

relajaelcoco studio/ Pablo Galeano & Francesco Furno
P196/ P212
http://www.relajaelcoco.com/

Ren Ri
P188
http://weibo.com/u/2757365410

Rhiannon Fox
P224
http://www.rhiannonfox.com/

Rod Hunt
P216/ P220
http://www.rodhunt.com/

Ruth Rowland & Seven Publishing Group
P152
http://ruthrowland.co.uk/

S

Sam Williams Studio
P166
https://samwstudio.wordpress.com

Sara Drake
P48
http://www.saradrake.com/

Sara Piccolomini
P236
http://www.sarapiccolomini.com/

Sidney Jablonski
P168
https://www.behance.net/SidJ

Steph Marshall
P72
http://www.stephmarshall.co.uk/

Studio MaMa
P156
http://studiomama.ph/

Sung H. Cho
P170
http://www.sunghcho.com/

Suwanna Ruayrinsaowarot
P162
http://www.suwannar.com/

T

Tilo Richter
P53/ P94
http://www.newyorktilotokyo.com/

Tomasz Kowal
P30/ P32/ P36
http://www.tomaszkowal.pl/

V

Valerio Pellegrini
P253
https://www.behance.net/valeriopellegrini

Valerio Pellegrini & Michele Mauri
P238
https://www.behance.net/valeriopellegrini

Vincent Meertens
P192/ P214
http://www.vincentmeertens.com

Vladislava Savic
P210
https://www.behance.net/VladislavaSavic

W

Wu, Jui-Che
P52
https://www.behance.net/wujuiche

Z

Z.CHENG LEO
P50
http://www.liaozcheng.com/

ACKNOWL EDGEMENTS

We would like to thank all the designers and contributors who have been involved in the production of this book; their contributions have been indispensable to its creation. We would also like to express our gratitude to all the producers for their invaluable opinions and assistance throughout this project. And to the many others whose names are not credited but have made specific input in this book, we thank you for your continuous support.